ROXY PAINE

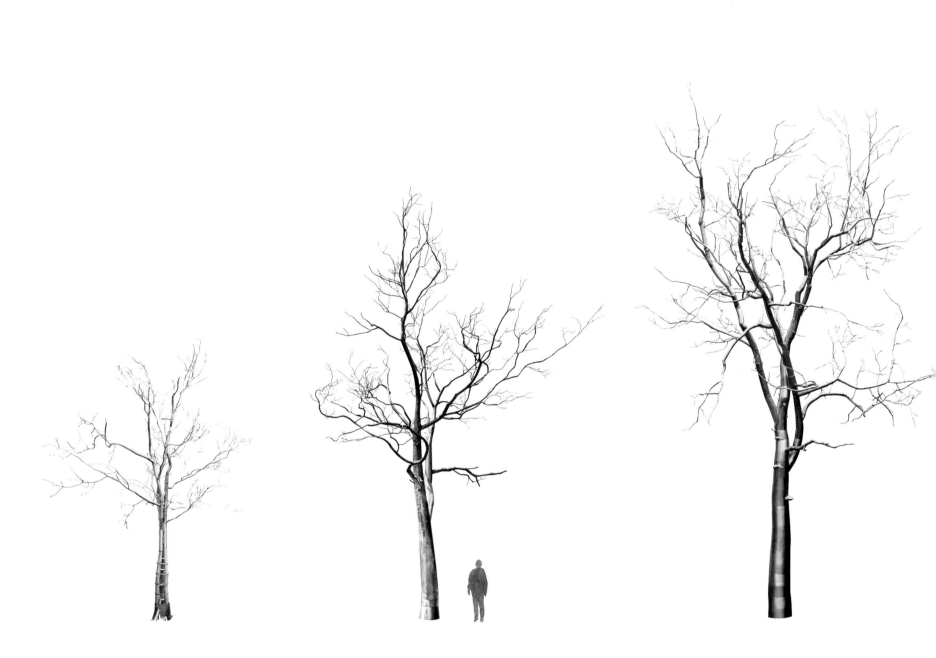

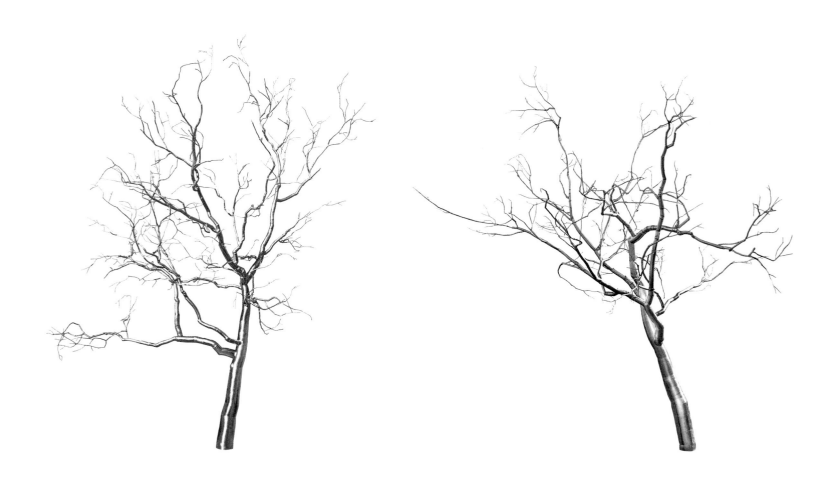

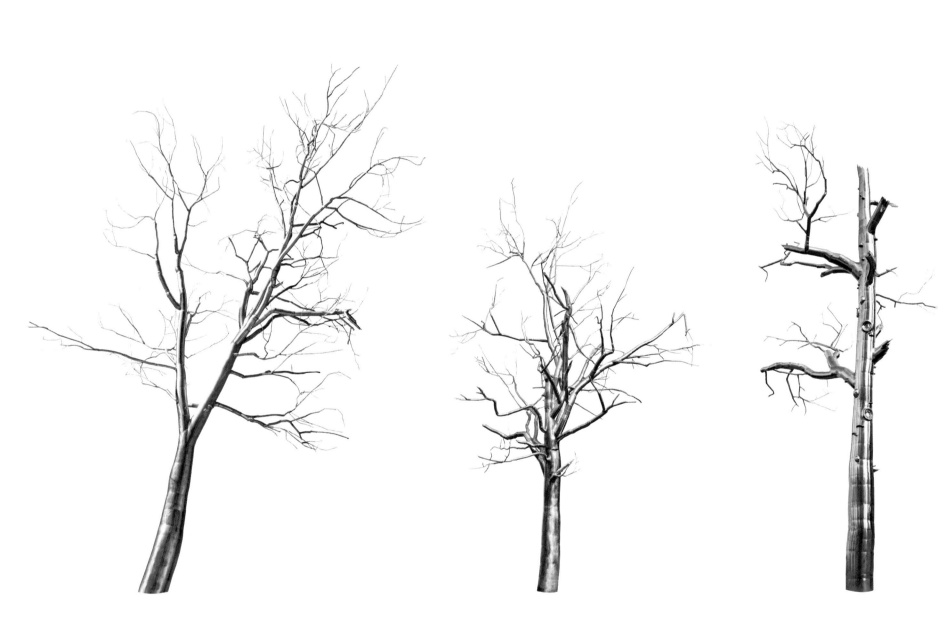

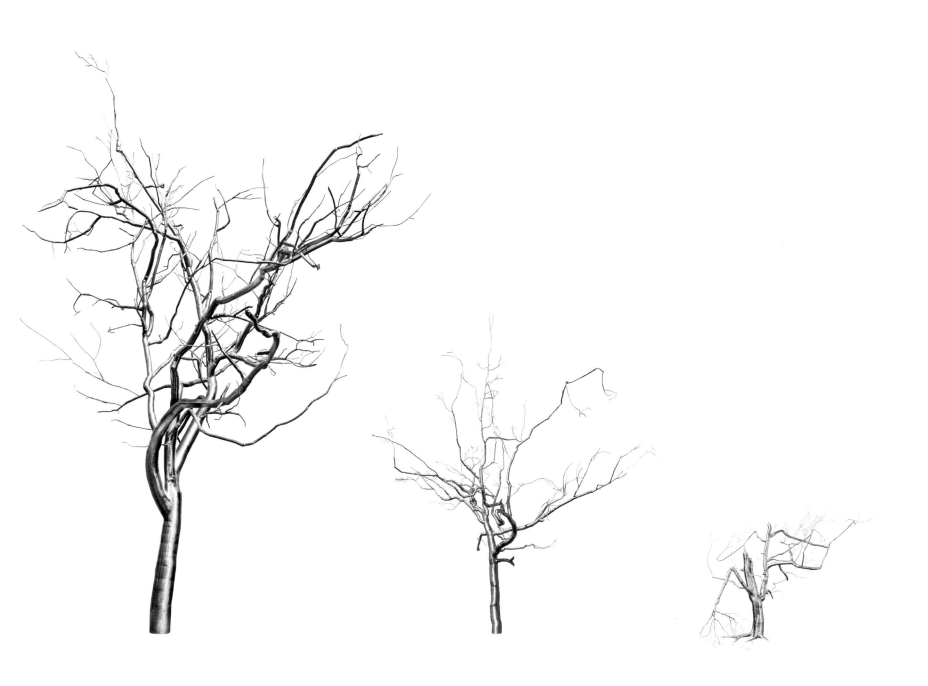

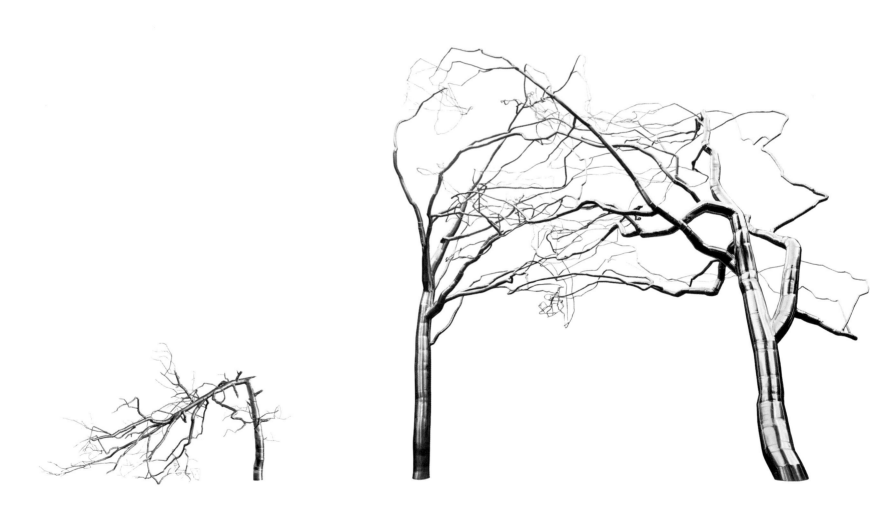

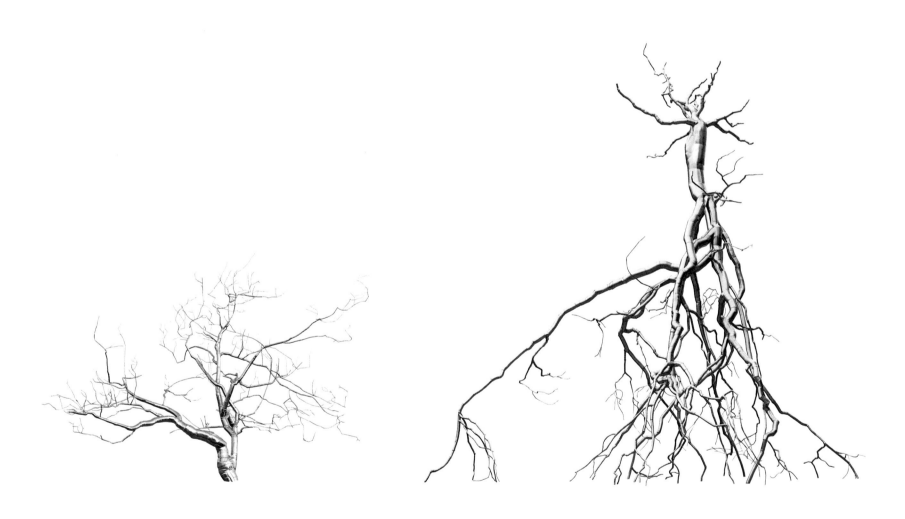

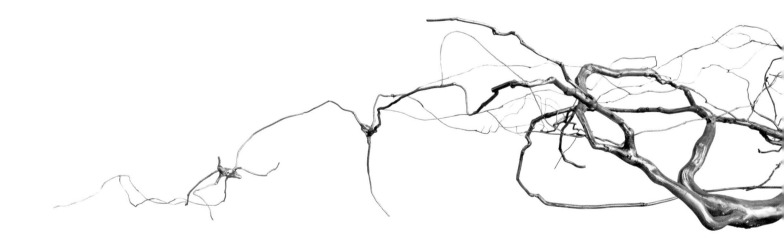

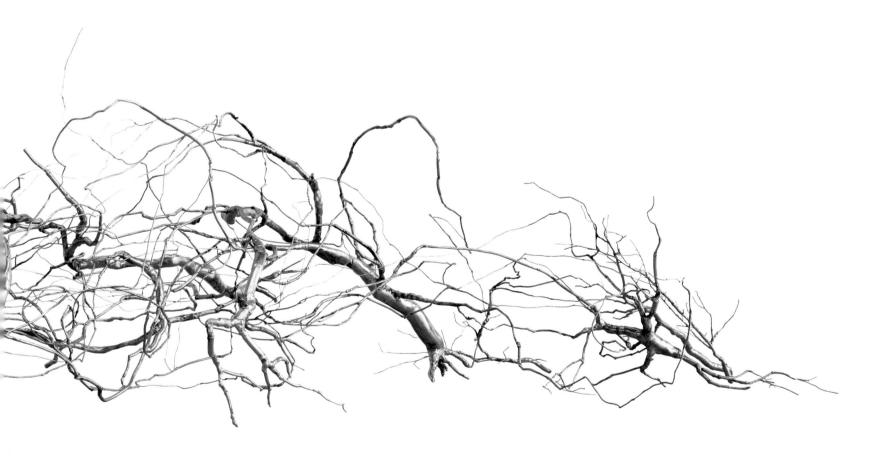

ROXY PAINE

ELEANOR HEARTNEY

Prestel

Munich · Berlin · London · New York

Cover: Model for **Maelstrom**, 2008. Stainless steel, 19 x 80 x 36 in.
Front endpapers: Drawing for **Maelstrom**, 2008. India ink on paper, 22 ½ x 30 in.
Pages 2–3: **Impostor**, 1999; **Transplant**, 2001; **Bluff**, 2002; **Substitute**, 2003; **Interim**, 2003
Pages 4–5: **Split**, 2003; **Breach**, 2003; **Defunct**, 2004; **Placebo**, 2004; **Palimpsest**, 2004; **Misnomer**, 2005
Pages 6–7: **Fallen Tree**, 2006; **Conjoined**, 2007; **Olive**, 2007; **Inversion**, 2008
Pages 8–9: Model for **Maelstrom**, 2008
Back endpapers: Photographs of **Maelstrom** in progress, 2008

© Prestel Verlag, Munich · Berlin · London · New York, 2009

Prestel Verlag
Königinstrasse 9, D-80539 Munich
Tel. +49 (89) 242908-300
Fax +49 (89) 242908-335

Prestel Publishing Ltd.
4, Bloomsbury Place, London WC1A 2QA
Tel. +44 (020) 7323-5004
Fax +44 (020) 7636-8004

Prestel Publishing
900 Broadway, Suite 603
New York, N.Y. 10003
Tel. +1 (212) 995-2720
Fax +1 (212) 995-2733

www.prestel.com

Library of Congress Control Number: 2008942979

British Library Cataloguing-in-Publication Data: A catalogue record for this book is available
from the British Library.

The Deutsche Bibliothek holds a record of this publication in the Deutsche Nationalbibliographie;
detailed bibliographical data can be found under: http://dnb.dde.de

Prestel books are available worldwide. Please contact your nearest bookseller or one of the above
addresses for information concerning your local distributor.

Editorial direction: Christopher Lyon
Design: Hans Werner Holzwarth, Berlin
Origination: Gert Schwab, SchwabScantechnik, Göttingen
Printed and bound by Druckerei Uhl, Radolfzell

Printed in Germany on acid-free paper

ISBN 978-3917-4137-8

CONTENTS

INTRODUCTION

In the spring of 2009, Roxy Paine's Maelstrom swept across the roof of New York's Metropolitan Museum of Art like a monument to the fury of nature. Composed of stainless-steel pipe formed to echo tree trunks and branches, the temporary installation evoked the aftermath of a terrible storm, perhaps a hurricane or a tornado. The whiplash lines also might have been seen as a diagram of the natural force itself, or as a metaphor for some inner state of turbulence, a mental storm, or an epileptic seizure. But the resolute materiality of the sections of stainless steel welded together, with seams fully evident, returned viewers to the mundane. They remind one of the industrial provenance of the pipes and of the role such conduits play in the circulatory systems of buildings and factories.

Maelstrom exemplifies the interplay between the realms of nature, humanity, and technology at the heart of Paine's work. It also illuminates the continuities between the apparently disparate series of works that he continues to produce. While many artists follow a fairly straightforward trajectory, creating a succession of works that build upon a central set of ideas, Paine has worked simultaneously on three distinct bodies of work, which, from a formal standpoint, appear unrelated. Works he calls Dendroids, the family to which Maelstrom belongs, consist of treelike sculptures, constructed from stainless-steel industrial pipe, which are installed in outdoor settings. Paine's hand-fabricated Replicants represent plant life, often noxious weeds and fungi (many of them poisonous). They are usually presented as "fields," to use Paine's term: horizontally placed or vertically hung rectangular surfaces that seem to represent a sample of a potentially much larger area. A third series consists of machines programmed to create unique drawings, paintings, or sculptures. Paine also occasionally creates works not part of a series — a mysteriously writhing object sheathed in canvas, for instance, or "do-it-yourself kits" of component parts for constructing never-to-be-completed art works.

These series, lacking a common "signature style," might at first appear to be created by different artists. Yet they are all manifestations of a core set of philosophic concerns. Their connections are subterranean, not unlike the underground network of mycelia that forms the vegetative part of the fungi that emerge here and there on the forest floor. To grasp Paine's artistic vision, it is thus necessary to deal with his oeuvre as a whole, rather than by approaching it series by series.

I will examine Paine's work from four perspectives, each following a set of ideas through each of the series. The first perspective is the conflict between nature and industry as it has played out in the American imagination. The second deals with language systems as a metaphor in Paine's work. Identifying similar underlying organizational structures in

the disparate realms of nature and industry, Paine attempts to reconcile the conflict between these two realms while embracing the roles played by chance and variation in ensuring the continuing vitality of both. A third perspective on Paine's works is suggested by his concern with control and chaos, especially as these relate to mankind's efforts to tame nature through mechanization. A final viewpoint is offered by Paine's complex dialogue in his work with the tenets of modernism and postmodernism.

These four points of view converge in Paine's embrace of contradiction and paradox, seen in all of Paine's work. His art repeatedly joins apparently irreconcilable concepts and uses languages forged in one discipline to illuminate another. Humor erupts, too, as disparate elements are combined, providing engaging hooks to draw the viewer into considering deeper issues.

Through his works, Paine asks: Do we exist inside or outside of nature and technology? What is our relationship to the machines we have created? Can we draw a firm line between the processes of nature, whose forms are determined by genetic or geologic laws, and those of technology, which operates in apparently similar ways following mathematical algorithms? And where does that leave us, as we attempt to make sense of our place in the universe? Paine's fabricated fungi, metal trees, and machine-made art works have an immediate appeal, but they also serve as vehicles for considering some of our most profound dilemmas.

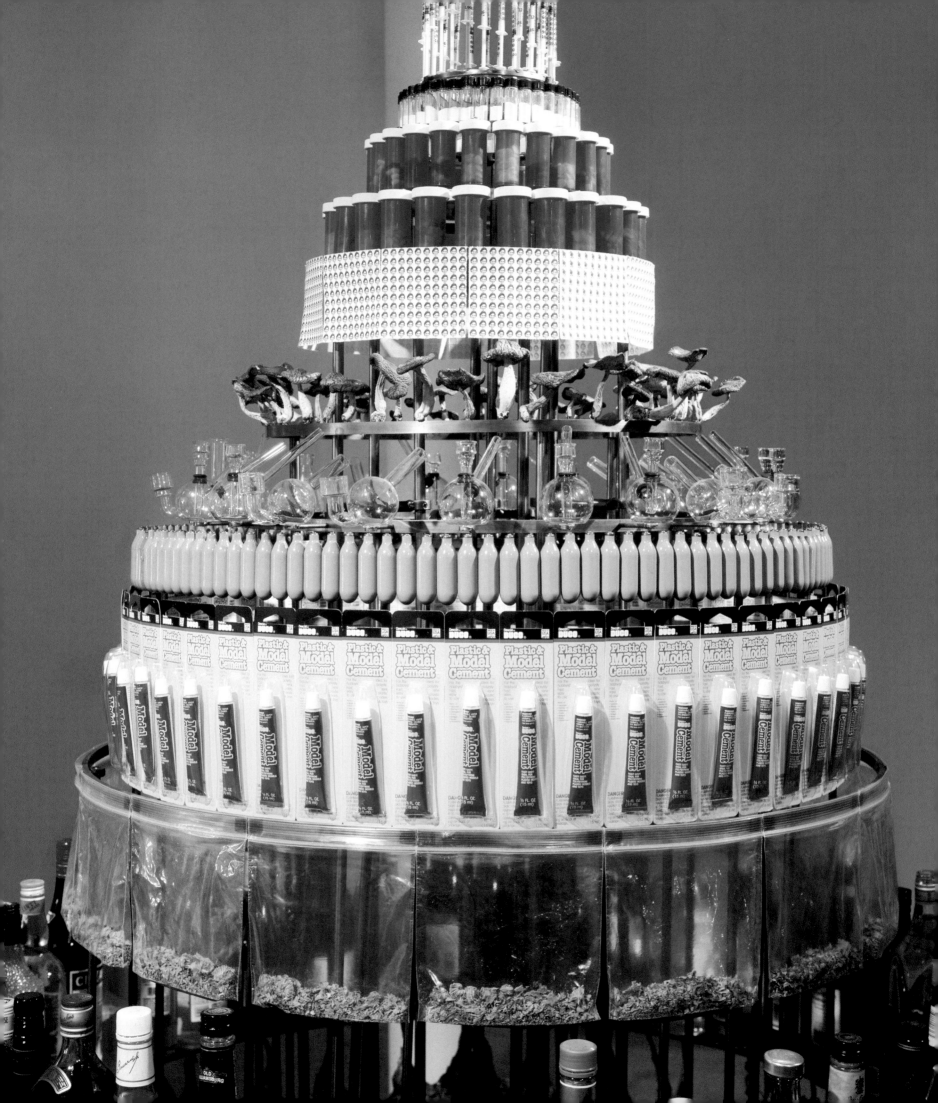

THE MACHINE AND THE GARDEN

Roxy Paine is the product of what was in many ways an archetypal American upbringing. Born in 1966 in New York City, Paine grew up in the suburbs of northern Virginia. The postwar suburbia of his childhood reflected America's effort to blend the best of city and country. However, as housing developments increasingly gobbled up open countryside, writers, singers, and filmmakers began to denigrate suburbia as a breeding ground of conformist values and an incubator of quiet desperation. One thinks of Malvina Reynolds's 1962 hit song "Little Boxes," films such as Mike Nichols's 1967 *The Graduate*, and novels like Sloan Wilson's *The Man in the Grey Flannel Suit*, made into a 1956 movie starring Gregory Peck, and Richard Yates's 1961 *Revolutionary Road*, the subject of a 2008 movie.

Paine himself has remarked that he experienced suburbia as a "twisted vision of nature. … What I remember about nature in the suburbs … were the borders. The natural world is totally controlled and manipulated in suburbia. Then there are border areas between housing developments; a small strip of land that is untamed and wild. … And when I got to be thirteen or fourteen, those areas were the areas where I went to do the illicit activities, like exploring alcohol and drugs."[1]

[1] Lynn M. Herbert, interview with Roxy Paine, in *Roxy Paine: Second Nature* (Houston: Contemporary Arts Museum Houston, 2002), 13.

This fascination with border states, both physical and psychological, fed into Paine's early art. Paine had a peripatetic student career; he ran away to California when he was fifteen and eventually landed in New Mexico, where he took classes at the College of Santa Fe. In 1988 he moved back East where he studied first painting and then sculpture at Pratt Institute in New York City before dropping out of school. In 1989 he landed in Williamsburg, a Brooklyn neighborhood in the throes of its own transformation from ethnic working class enclave to hipster artist hangout. Surrounded by other young artists equally disdainful of (and unconnected to) the mainstream New York art world, Paine found a milieu supportive of his quirky vision. He was co-founder of a collective gallery, Brand Name Damages, where he began to exhibit his art. His early works are characterized by a rebellious humor, and in them one can detect the seeds of his later concerns. Among these early works were a mechanized puppet made out of vegetables, a displaced sink, which was suspended from the ceiling so that its dripping faucet slowly eroded the soap bars stacked below, and a machine that dipped brushes into white paint, ketchup, and motor oil and splashed them on a nearby window. One of Paine's most elaborate early works, **Dinner of the Dictators** (1993–95; pp. 24–25), offered a carefully researched set of freeze-dried meals favored by twelve notorious dictators.

The work that really points the way toward Paine's future development is his 1993 **Drug Ziggurat** (p. 27). A meditation on Paine's by then quite extensive drug experimentation, it

consisted of a nearly eight-foot-high pyramid whose layers detailed, in order of ascending intoxication from bottom to top, Paine's history of exploring mood-altering substances. The lower layers are relatively benign, beginning with circles of beer cans and cups of coffee, but near the top they grow more dangerous, moving from various hallucinogens to a crown of heroin syringes. This inventory is, from one perspective, a perverse monument to the American obsession with escapism and transcendence. (Without too much exaggeration, it could be seen as the distorted cousin of everything from Emerson's Transcendentalism to the Marlboro Man's rugged individualism). But its format also reveals a quasi-scientific frame of mind, a desire to systematize absurdist forms of order and a preoccupation with states of potentiality. Drug Ziggurat, like many subsequent works, embodies a transitory condition, in which ordinary (and not so ordinary) objects and elements hint at transformations to come.

Drug Ziggurat also points to Paine's future work because it established the conditions for the first Replicants. To accompany Drug Ziggurat, Paine decided to create a floor work that consisted of a scattering of actual hallucinogenic mushrooms. However, when these began to decay and stink, he tried making mushrooms out of other materials. In the end, these were not part of Drug Ziggurat, but they initiated Paine's continuing practice of fabricating extremely lifelike vegetal forms. The Replicants are replete with irony. Although they are meticulous recreations of real plant species, they generally represent unloved or even reviled classes of flora. Hence they deliberately run counter to the salutary vision of nature that is so much a part of the American dream. Instead of celebrating the beauties or healing properties of the natural world, they remind us that in attempting to control or regulate the less beneficent forces of nature, humanity often finds itself in a losing battle.

Like Drug Ziggurat, a number of these early works have biographical roots. For example, Crop (1997; pp. 52–53), which at first glance looks like a rather straggly field of red flowers, takes on a darker aspect when one realizes that it is a painstaking recreation of opium poppy plants in all stages of development. In part a paean to Paine's then recently discarded heroin habit, the work is startling in its naturalism. To achieve this verisimilitude, Paine bought poppy seeds and grew them on a friend's field in Maine. He then cast leaves and petals from parts of actual plants and cut and manipulated them to create a sense of lifelike diversity. This work includes not just the poppy's alluring orange blossoms, but also new buds, seed pods that ooze a white epoxy milk, and withered plants ready to return to the (also manufactured) soil. By recreating the poppies in all their stages of life, Paine reminds us that nature is an unending cycle of growth and decay, a theme that recurs frequently in his work.

Paine has a quintessentially American fascination with the contradictions that grow out of the interactions between nature and industrial development. His work is a reflection of

Drawing for **Dinner of the Dictators**, 1992

2 Leo Marx, *The Machine in the Garden: Technology and the Pastoral Ideal* (London: Oxford University Press, 1964).

3 Marx, *Machine in the Garden,* 364.

the phenomenon described in 1964 by literary critic Leo Marx as the "complex pastoralism" of American art and literature.[2] Marx titled his study of this tendency *The Machine in the Garden,* a phrase that sums up his argument and might serve as a description of Paine's approach. Marx sees the American experience as a competition between the originating mythology of the new Eden, embraced by figures like Thomas Jefferson, who envisioned the New World as a place to return to traditional pastoral values, free of the corrupting urbanity and social hierarchies of the European homeland, and the promise, promoted by such thinkers as John Stuart Mill, of progress through scientific and technological innovation, again to be realized by the citizens of a democratic society free of feudal entanglements and Old World superstition.

The recurring visual metaphor for this conflict, which Marx locates in numerous literary works, including Henry David Thoreau's *Walden* and Nathanial Hawthorne's notebooks, is a train slicing through bucolic countryside. According to Marx, American culture is shaped by the tension and interplay between two great myths, both of which can be portrayed in positive and negative terms. The Garden, a symbol of nature that has been tamed and cultivated to respond to our needs, underlies our continuing nostalgia for the supposed simplicity and purity of rural life. But in our literature, the Garden can be seen either as the locus of moral strength and conservative values or as a dead weight on the spirit. The Machine, shorthand for our romance with technology, is equally two-sided, representing both an agent of progress and democracy and a harbinger of a future mired in exploitation and dehumanization. Its appearance inevitably and irrevocably alters our relationship to the Garden.

Marx traces the efforts of American writers to reconcile the Machine and the Garden through various iconic works of the creative imagination. In the end, however, he suggests that our greatest novels, notably such works as Herman Melville's *Moby Dick*, Mark Twain's *Huckleberry Finn*, and F. Scott Fitzgerald's *The Great Gatsby*, reveal the impossibility of any simple solutions to this conflict. He concludes, "The power of these fables to move us derives from the magnitude of the protean conflict figured by the machine's increasing domination of the visible world. . . . The resolutions of our pastoral fables are unsatisfactory because the old symbol of reconciliation is obsolete. But the inability of our writers to create a surrogate for the ideal of the middle landscape can hardly be accounted artistic failure. By incorporating in the work the root conflict of our culture, they have clarified our situation. They have served us well."[3]

Paine's work, no less complex, deals with this ambiguous relationship between the Machine and the Garden in visual terms. It emerges from a culture in which the idea of nature tends to be either idealized as a metaphor for timeless beauty and lost harmony or ridiculed as a retrograde fantasy that has been supplanted by the forward march of science and industry. One vision leads to a longing for simpler times or more authentic experience, the other to a potentially nightmarish vision of nature totally subjugated to man's will. The positions are nicely summed up in statements by two very different artists. On one side is Jackson Pollock's animistic declaration, "I am nature." For Pollock, nature was a mystical, unchanging reality and the quest for authentic experience involved a surrender to its sway. The other is painter

Peter Halley's deflating remark, "The jungle ride at Disney World may in fact be more real to most people than the real jungle in the Amazon. ... More and more people are becoming more comfortable in the simulated world than in the real one."[4]

[4] Peter Halley, quoted in "Criticism to Complicity," roundtable discussion moderated by Peter Nagy, *Flash Art* no. 129 (summer 1986): 46.

[5] Robert Smithson, "Frederick Law Olmstead and the Dialectical Landscape," reprinted in Nancy Holt, ed., *The Writings of Robert Smithson* (New York: NYU Press, 1979), 120.

Paine steers between these two positions. Nature, for him, is an intricate system that operates according to rules that are indifferent to human desires and needs. Mankind and mankind's product, technology, are equally part of that system and they are subject to the same rules. In works that are by turns witty, thought provoking, and paradoxical, Paine avoids these extreme positions. Instead, he simultaneously embraces nature as a rational structure and technology as an organic system.

In this he comes closer to the thinking of Robert Smithson, for whom nature and technology were inseparable. Smithson referred to humans as "geologic agents" and chose to see their actions as part of the larger set of forces shaping the landscape. He preferred the long view, suggesting that humans are simply part of the patterns of natural growth and decay, and that our waste dumps are the contemporary equivalent of the monuments of the ancient world. He was drawn to industrial sites, where he could dramatize these ideas. Justifying his obsession, he averred: "Modern day ecologists with a metaphysical turn of mind still see the operations of industry as Satan's work. The image of the lost paradise garden leaves one without a solid dialectic, and causes one to suffer an ecological despair. Nature, like a person, is not one-sided."[5]

Smithson was a native of the highly industrialized city of Passaic, New Jersey, which features frequently in his writings. Paine's interest in questions about humanity's place in the natural world is also informed by his childhood. In **Bad Lawn** (1998; pp. 48–49, 51), Paine restages the quest, so common in the suburban world of his childhood, to wrest a luxuriant, weed-free carpet of grass from the botanical barbarians at the gate. As with **Drug Ziggurat** and **Crop**, the piece reveals a systematizing mind at work, cataloguing the pests and conditions that can spoil a perfect lawn. While the work may appear at first glance to be a convincing slice of unloved nature, it is, in fact, an inventory of problems. These include browned and overgrown grass, plantain weeds, mushroom fairy rings, dandelions, puddles, muddy zones, bare patches, and sections of parched earth. Of course, these elements are only "bad" by the standards of suburban uniformity. Thus the work offers a humorous deflation of the myth of the Garden inherent in suburbia. From the homeowner's perspective, nature is an adversary that continually rebels against his efforts to force it to conform to suburban ideas of beauty. But from another perspective, this work represents the triumph of uncultivated nature over artifice.

Paine has continued to create Replicants along these lines, including fields of hallucinogenic psilocybin mushrooms, a wall work based on dry smut, a field of poison ivy, a crop of puffball mushrooms sprouting through cow pies, one of their natural habitats, and a weed-choked garden. Beginning in 1999, he began to add a new kind of manufactured life-form to his repertoire, the stainless steel Dendroids. Unlike the Replicants, which adhere closely to the forms of their models (though Paine has on occasion invented new species of fungus), the

Dendroids refer to trees but are obviously unreal. The first one, **Impostor** (1999; pp. 138–41), placed in a forest in Sweden, is perhaps the most realistic of the lot, but even this work is based on an amalgam of different species of trees. Fabricated from stainless steel, this work, like those that followed, had a rather alarming presence when set amid the forest's real elm and ash trees. This placement points to another crucial difference between the Dendroids and the Replicants. The Replicants tend to be displayed in galleries or museums, where their realism plays off against aesthetically-neutral built environments. By contrast, the steel Dendroids are usually placed out-of-doors, in areas where actual trees might appear. Thus these series of works maintain the tension between the Machine and the Garden in different ways—first by invading our constructed environments with reminders of unruly nature; second by invading bucolic (though as it often turns out, no less constructed) patches of cultivated nature with industrial facsimiles.

In an interview with curator João Ribas, Paine described the deliberate contradictions embodied by these works, explaining that the Dendroids are addressing a contradiction in materials: "They're made from the material most antithetical to the organic version; stainless steel is cold, heavy, unyielding, and industrial. The pipes the Dendroids are made from are used in pharmaceutical plants, heavy industry, and so on. There's a transformative aspect to those pieces, an alchemical transformation that is a potential symbol of the positive and negative consequences of technology."[6]

Tension between the myths of nature and technology seems particularly strong in **Bluff**, a fifty-foot-high stainless-steel tree that was created for the Public Art Fund as part of the 2002 Whitney Biennial and was temporarily situated in New York's Central Park (pp. 172–75). This work combined characteristics of different species of trees—oak, elm, and ash. Adding an intimation of mortality were steel shelf fungi that erupted from the trunk, recalling the organisms that sap the life from real trees (though not, of course, from this deathless and unchanging metal tree). The work's deliberate artifice underscored the artificial nature of Central Park itself, which was designed in 1858 by Frederick Law Olmstead and Calvert Vaux as the ultimate expression of the Garden ideal. Transformed from a swampy swath of low-income neighborhoods into a credible replication of a natural landscape, the park continues to be one of New York's best-loved attractions.

Bluff remained in place from early February to June of 2002, coinciding with the arrival of spring when the park bursts out in riotous display of flowering trees and plants. Although **Bluff** seemed relatively in sync with its still barren surroundings at the time of its installation, the sculpture appeared increasingly out of place as the season progressed. Chilly, cold, and unchanging in comparison to its verdant environment, **Bluff** seemed to defy the flow of time and the cycles of life otherwise so powerfully in evidence. Like the other Dendroids, it embodied a basic irony: it looked like a dead tree, but as a metallic form it would outlast any of the living trees surrounding it.

[6] João Ribas, "The AI Interview: Roxy Paine," *ARTINFO*, April 10, 2007, http://www.artinfo.com/news/story/9448/roxy-paine/.

Robert Smithson, **Glue Pour**, 1969. Vancouver, Canada. Art © Estate of Robert Smithson/Licensed by VAGA, New York, NY

The relationship between nature and technology plays out differently in a third body of work that Paine pursues simultaneously with his Dendroids and Replicants. These are his machines, which consist of elaborate apparatuses designed to perform functions that could be executed more simply and quickly by conventional means. For example, he has created four series of machines that make unique paintings and sculptures. His **PMU (Painting Manufacture Unit)** (pp. 108–9), built in 1999–2000, is a computer-programmed apparatus that paints canvases, mechanically miming the operations of modernist abstraction. The paint spews from a nozzle that repeatedly moves back and forth in front of the canvas, adding layer upon layer in the process. The final result is a thick encrustation of paint that sags at the bottom, terminating in a fringe of icicle-like drips. The two versions of **SCUMAK (Auto Sculpture Maker)** (1998 [pp. 82–84] and 2001 [pp. 88–89]) perform the same operation for sculpture, mechanically producing blobs of brightly colored polyethylene that somewhat resemble modernist biomorphic sculpture. Paine also has created **Drawing Machine** (2001; pp. 98–99), whose nozzle pools ink onto a sheet of paper according to computerized instructions.

As with his Replicants and Dendroids, these machines are full of ironies. They pay homage to the American obsession with time-saving devices, but in fact the **PMU** and **SCUMAK** machines operate so slowly that a product similar to theirs could be fashioned by hand in far less time. And while they may seem to be labor-saving devices, labor-intensive programming of the machine is required to ensure the creation of a series of unique objects.

A number of commentators have connected these works to the postmodern critique of artistic authorship and originality. In fact they have more to do with Paine's ongoing investigation of the relationship between nature and technology. The artworks made by these various machines usually are composed of multiple layers of material. The completed **Scumak** sculptures resemble softly rounded mounds of molten lava. The paintings made with another machine, **Paint Dipper** (1997; pp. 76–77), are built up from continued dips into a tank of paint and take on a striated appearance, like the strata of eroded rock. The drips at the bottom of the canvases suggest the uneven forms of stalactites hanging from the roof of a cave. Paine, who has always been fascinated by the processes by which geologic forms are produced over centuries and even millennia, notes that with his machines he has replicated such processes in a much-accelerated form. **Paint Dipper**, for instance, hastens the creation of stalactites by thousands of years. But, he adds, "I've been increasingly interested in geology, and the relationship to time is critical. For instance, with **Paint Dipper**, temporal relationships are inverted. It's creating stalactite incrustations at the bottom of the paintings in a process that normally takes many millennia … so from that perspective it's very quick. But the machines are also referencing automation and factory production. And from that position, they're extremely slow and plodding. I'm hoping to capture some strange in-between notion of time."

With **Erosion Machine** (2005; pp. 112–17) Paine makes this point even more forcefully. The machine produces the controlled erosion, within a chamber, of a five-thousand-pound block of sandstone, using a compressor, vacuum devices, and a computer programmed with various sets of data. Every product of this machine is eroded using a different data set, so

each is unique. Paine's machine thus creates patterns of stratification that are at once reflections of the internal structures of the stone, as more and less dense areas erode differently, and also physical records of data sets such as stock market fluctuations from 1998–2002, statistics about the use of methamphetamine and marijuana, crime figures, and even the weather data from Binghamton, New York, for the summer of 1990. The machine's sandstone formations are created over a period ranging from six weeks to three months, and as they slowly take shape, they begin to resemble the startling landscape that Paine admired during trips to the Grand Staircase–Escalante National Monument in southern Utah. In fact, the natural and machine-made patterns are based on similar processes of heating and cooling. Thus, in a way even more direct than in his other works, **Erosion Machine** erases the boundaries between nature and industry by graphically demonstrating a parallel between the actions of natural and mechanical forces.

Reflecting on the continuities he explores, Paine has said, "I think humans are both machine and nature." **Erosion Machine** operates simultaneously in both realms, he explains, using statistics from the realm of culture and society to create the kind of rock formations normally produced by nature. As a result, the machine's products seem both close to nature and far removed from it. As he points out, however, this sense of distance from nature is really only an illusion, since "stock market data is itself a portrait of nature, in the way one species on the planet has developed this system, and the way evolution has influenced it." [7]

Whether replicating natural forms with synthetic materials or simulating human creations and natural landscapes by mechanical means, Paine manages to steer clear of both cynicism and sentimentality. In his hands the Garden is as far from the Edenic dream as it is from a manufactured Disneyland. And the Machine is neither a destroyer of human individuality nor a guarantor of unambiguous human progress. Instead, as we shall see, Paine resolves the tension between nature and technology by discovering in them a common dependence on systems and patterns.

[7] Ribas, "AI Interview."

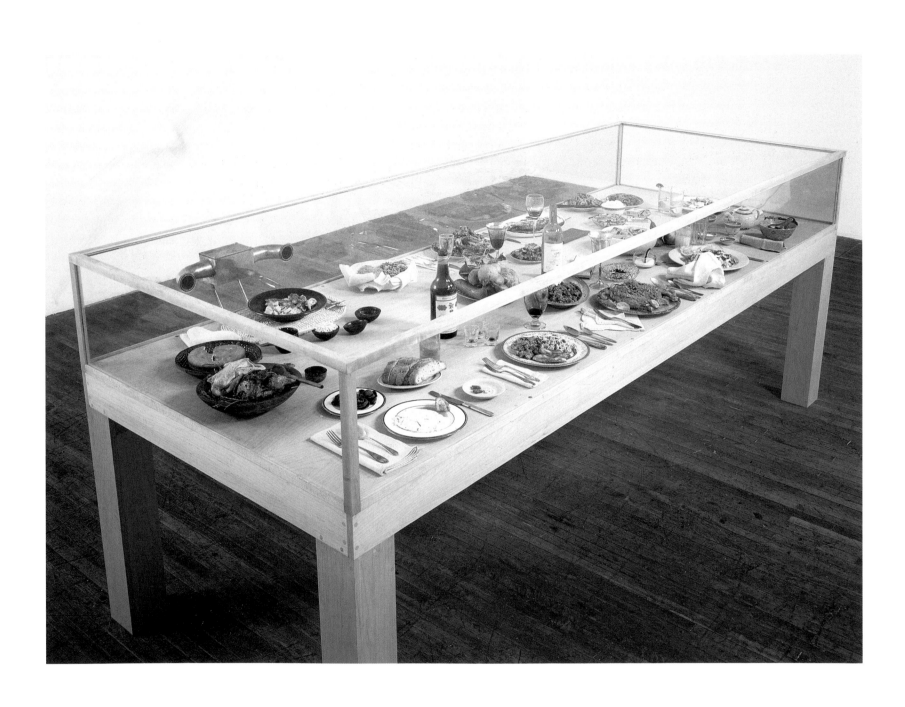

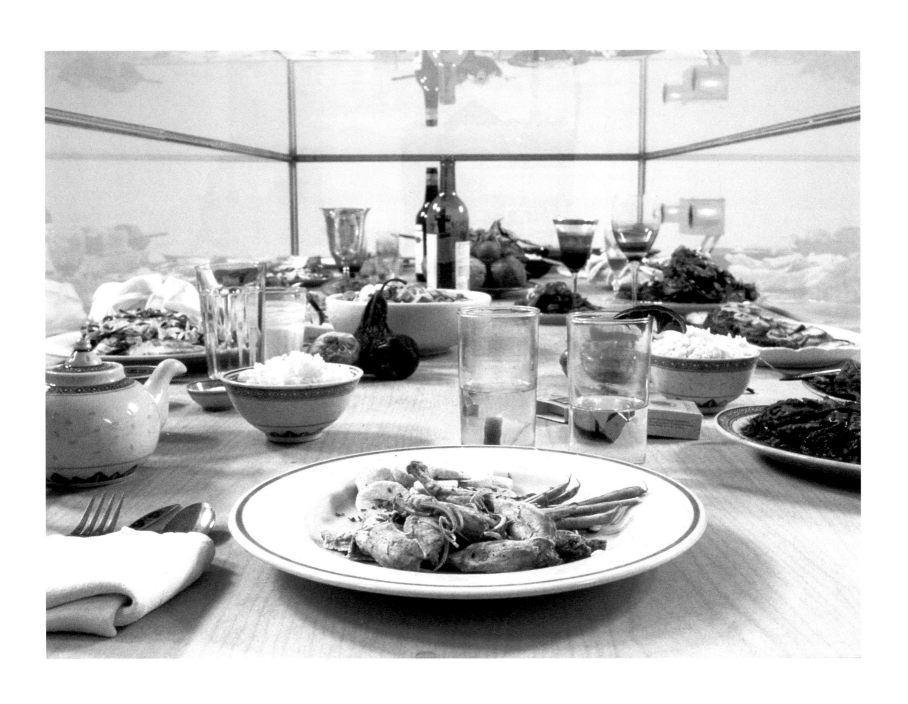

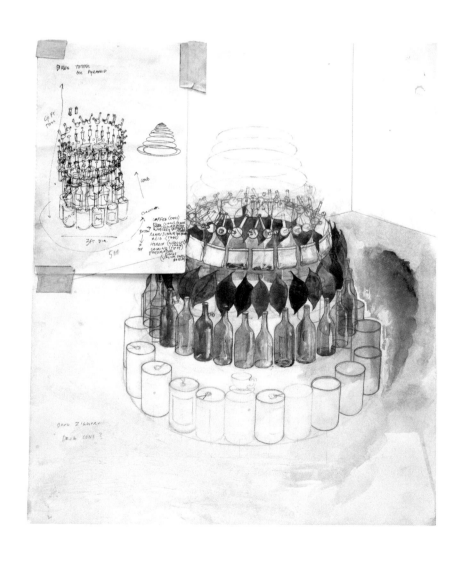

26 Above: Drawing for **Drug Ziggurat,** 1993; opposite: **Drug Ziggurat,** 1993

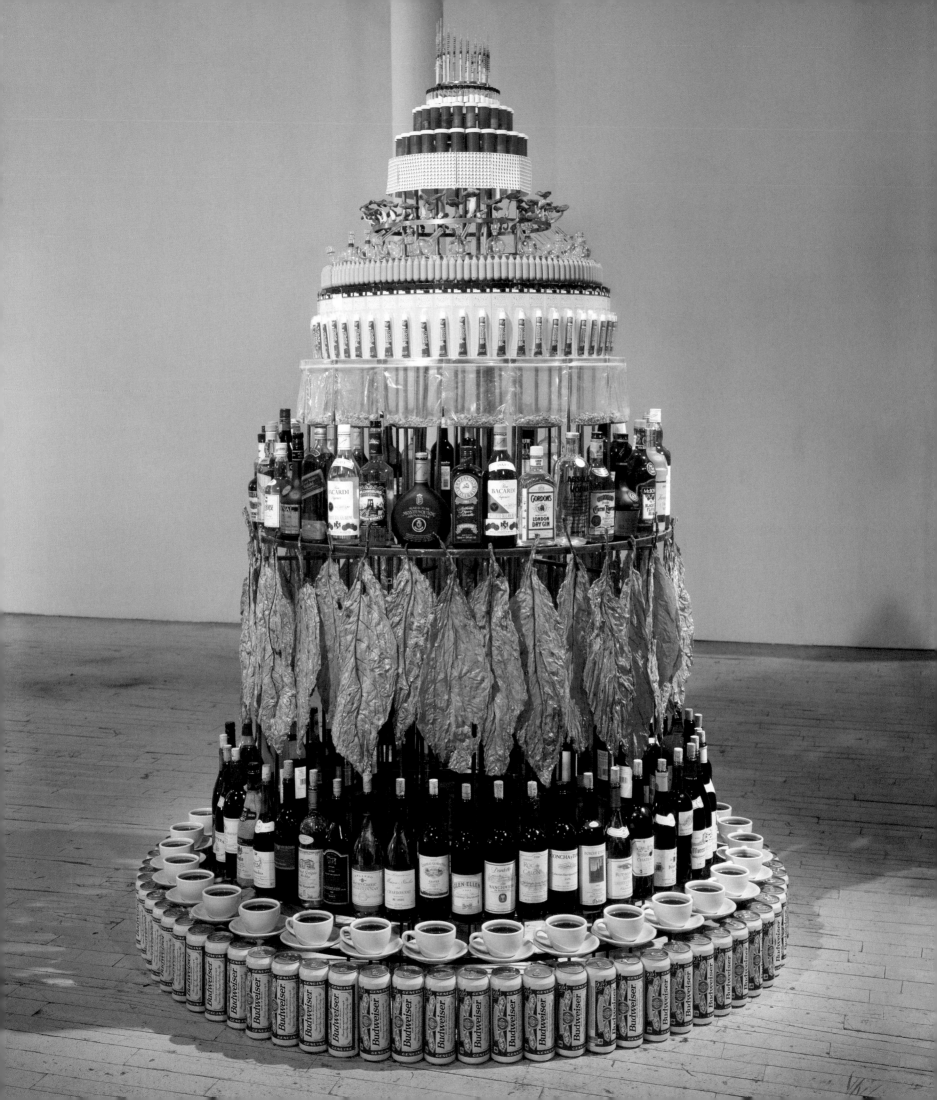

Every Ear in the NY Times on February 28, 1996, 1996

Where I'm at allowed the viewer to keep track of exactly where I was during the course of its exhibition. A computer collected this location information and used it to control servo motors holding a laser pointer. The laser pointed to my current location on a large aerial photograph of New York City. —R. P.

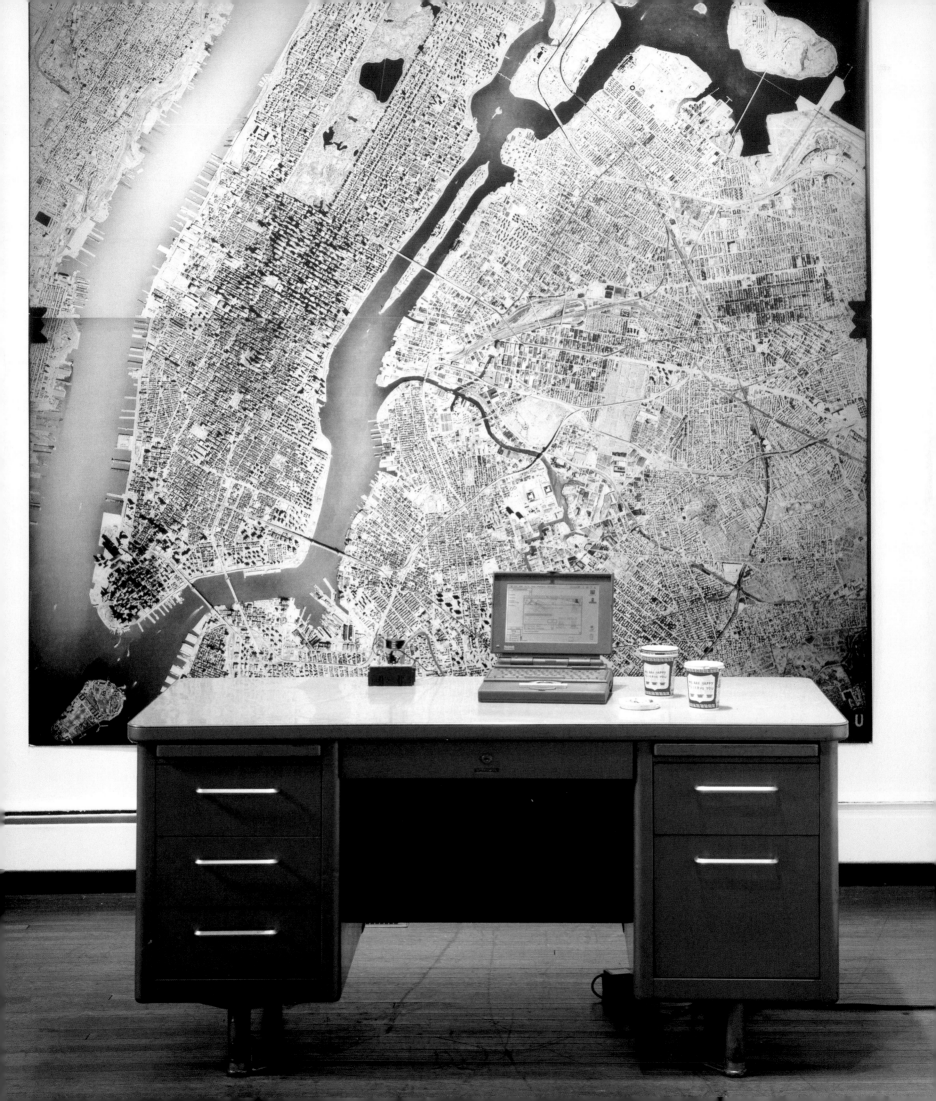

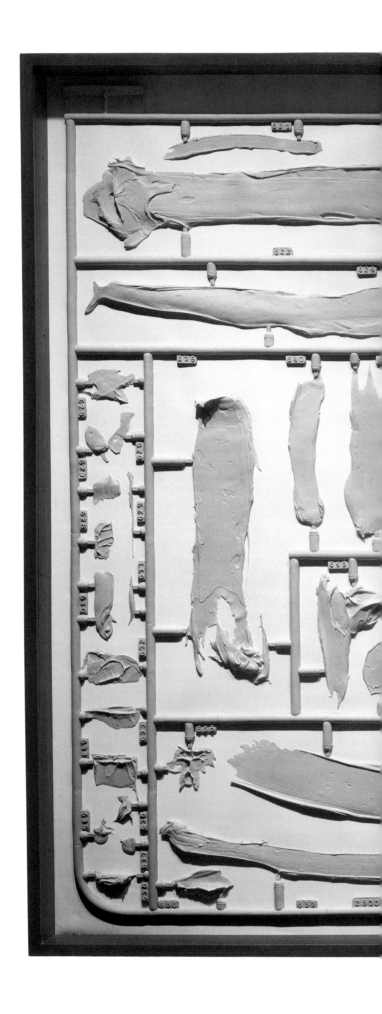

Model Painting, 1996; pages 36–37: **Model for an Abstract Sculpture,** 1997

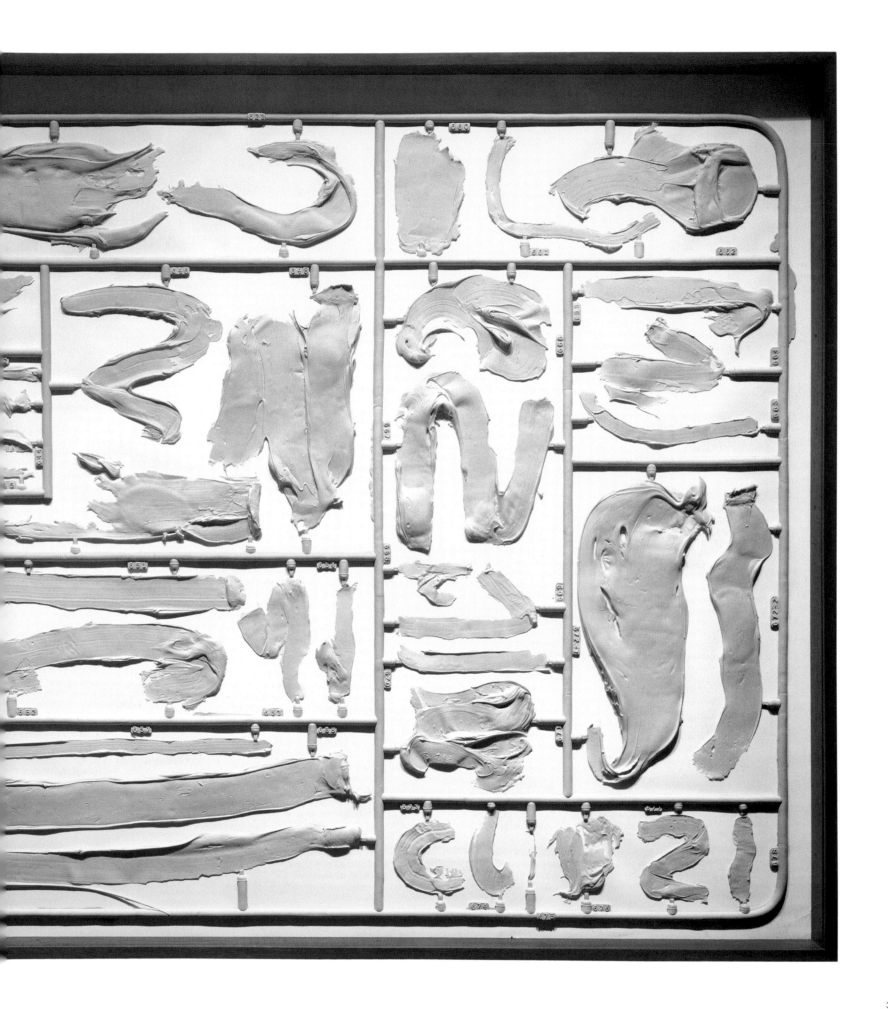

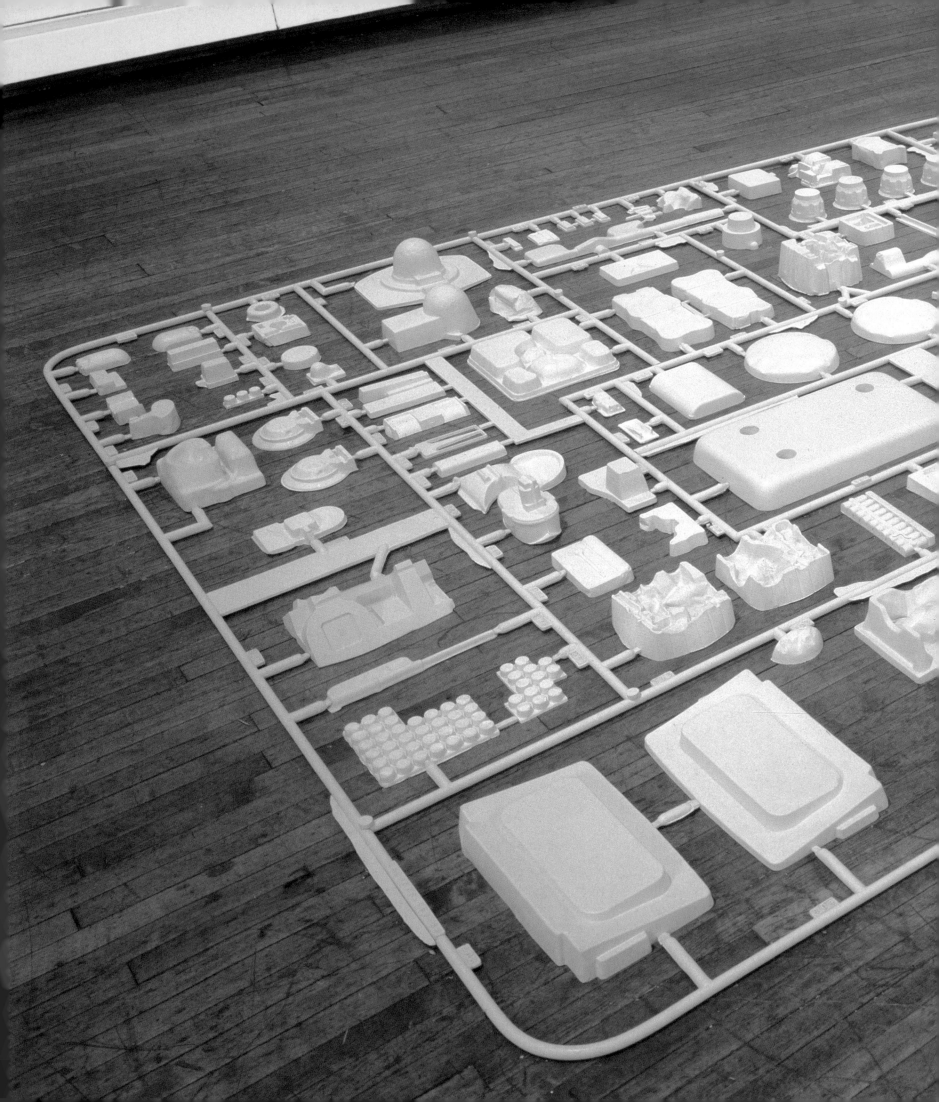

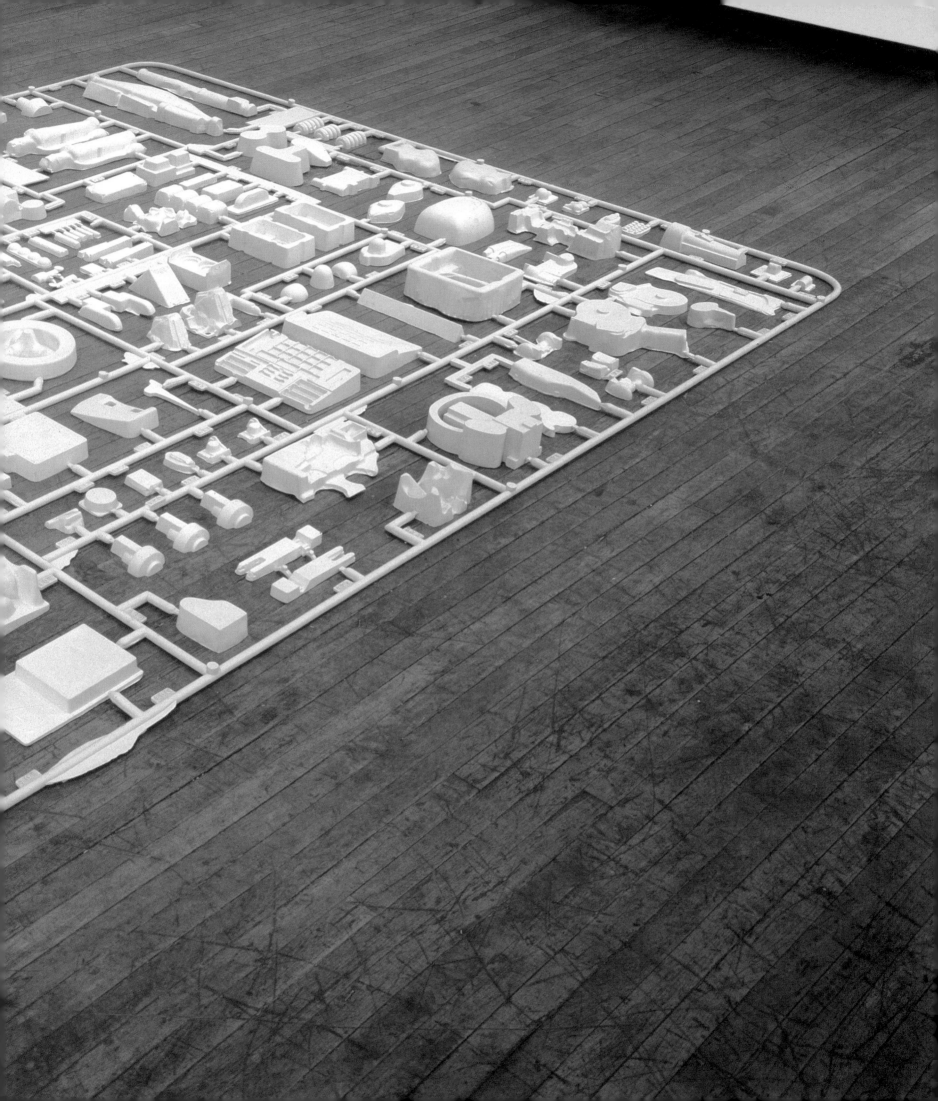

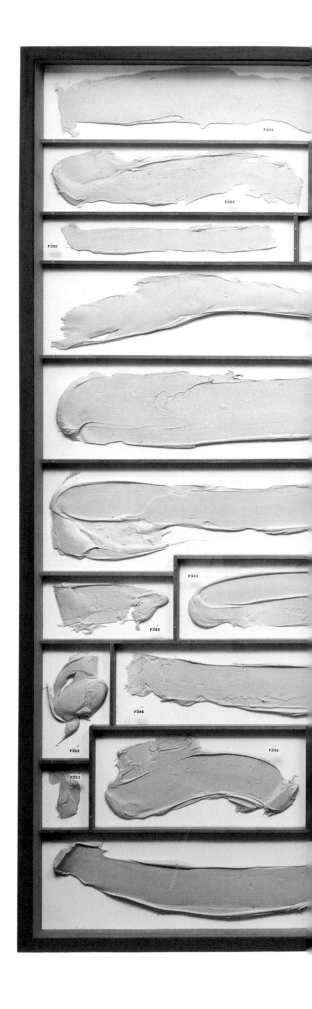

Pigeon Holes, 1997

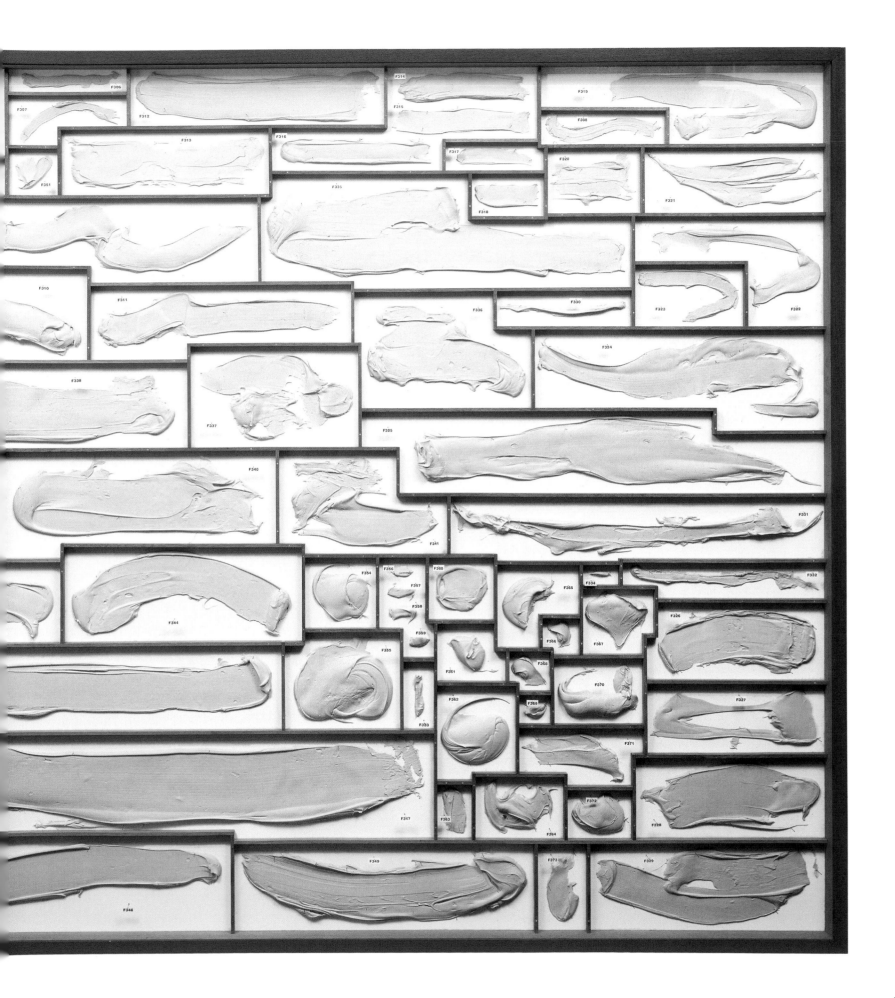

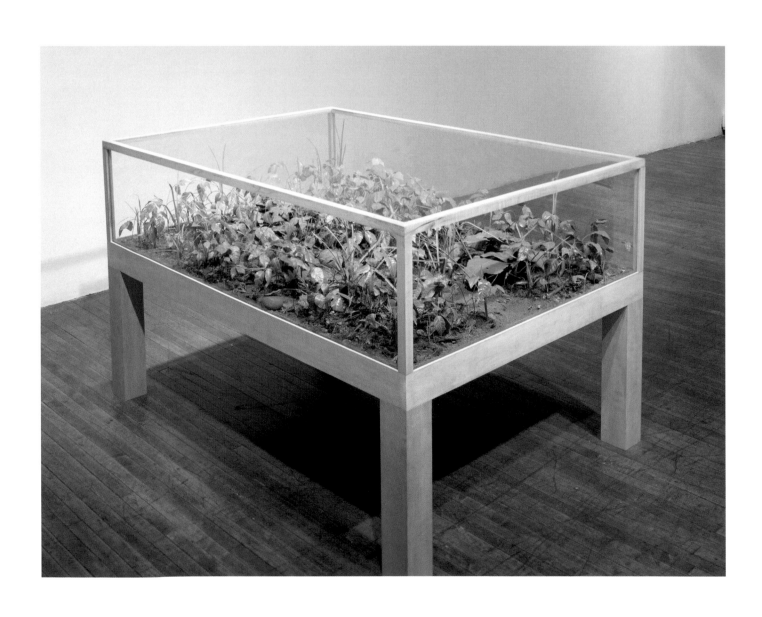

Pages 40–43: **Poison Ivy Field,** 1997

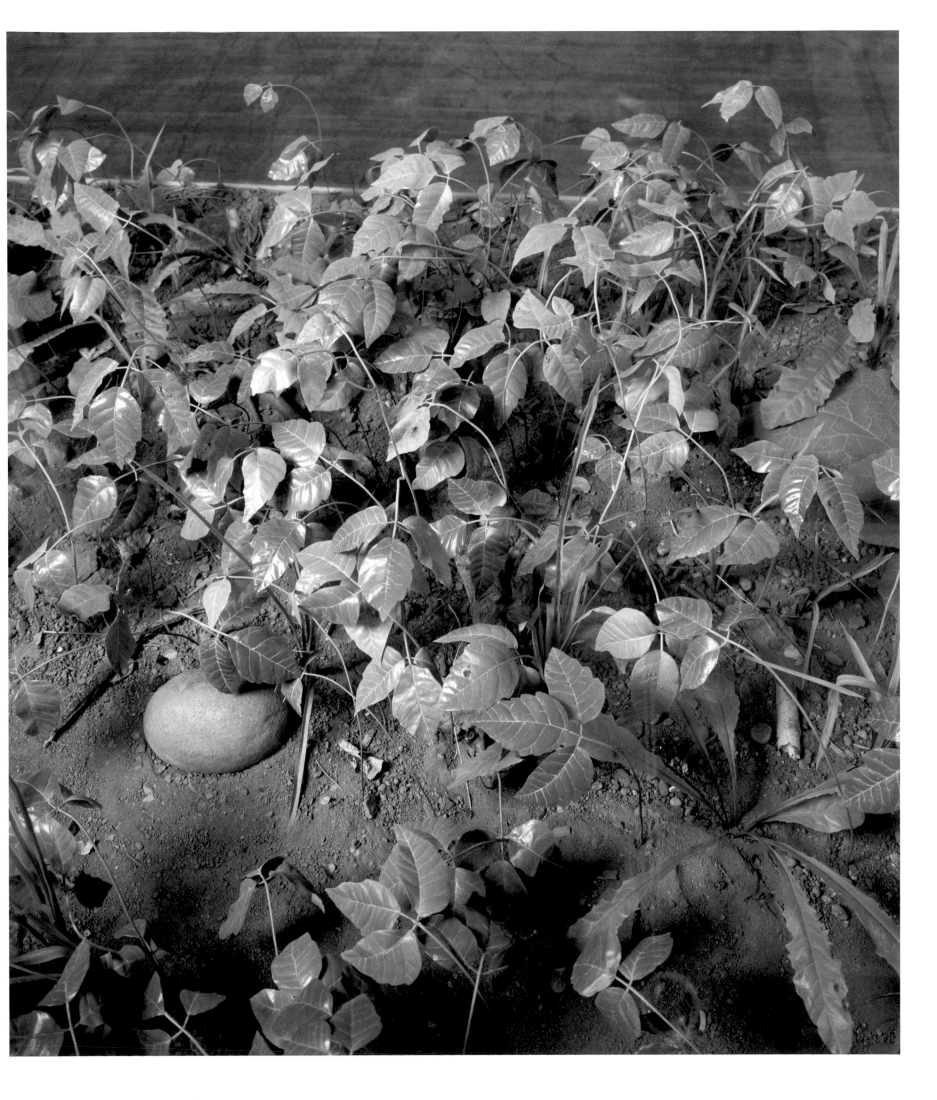

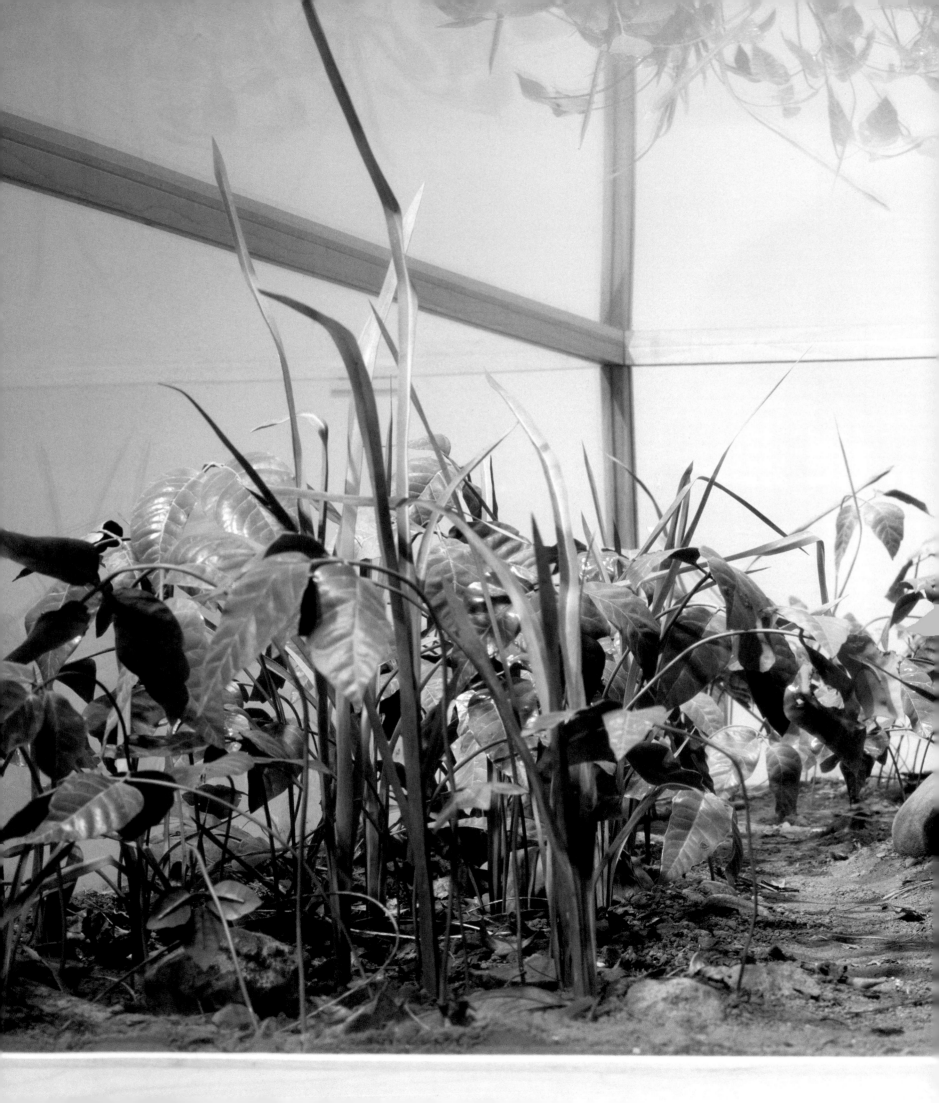

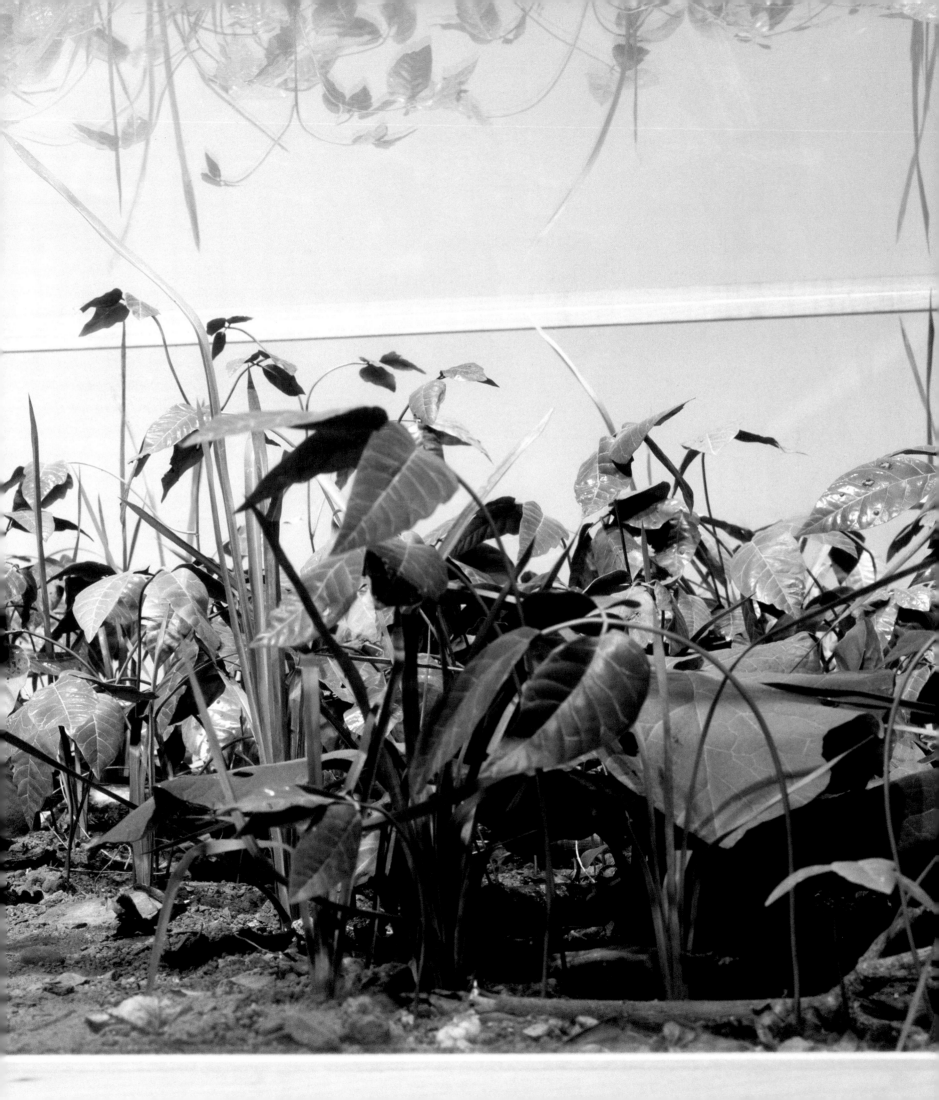

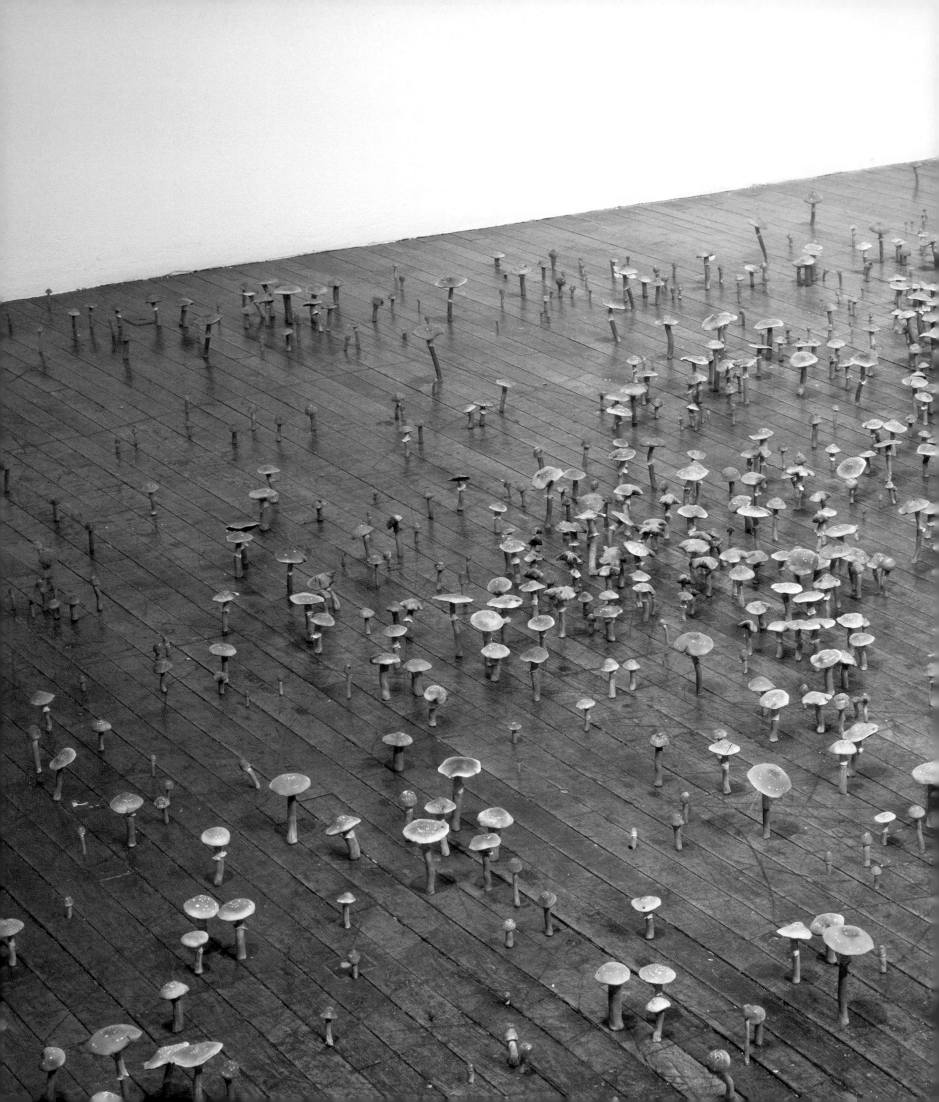

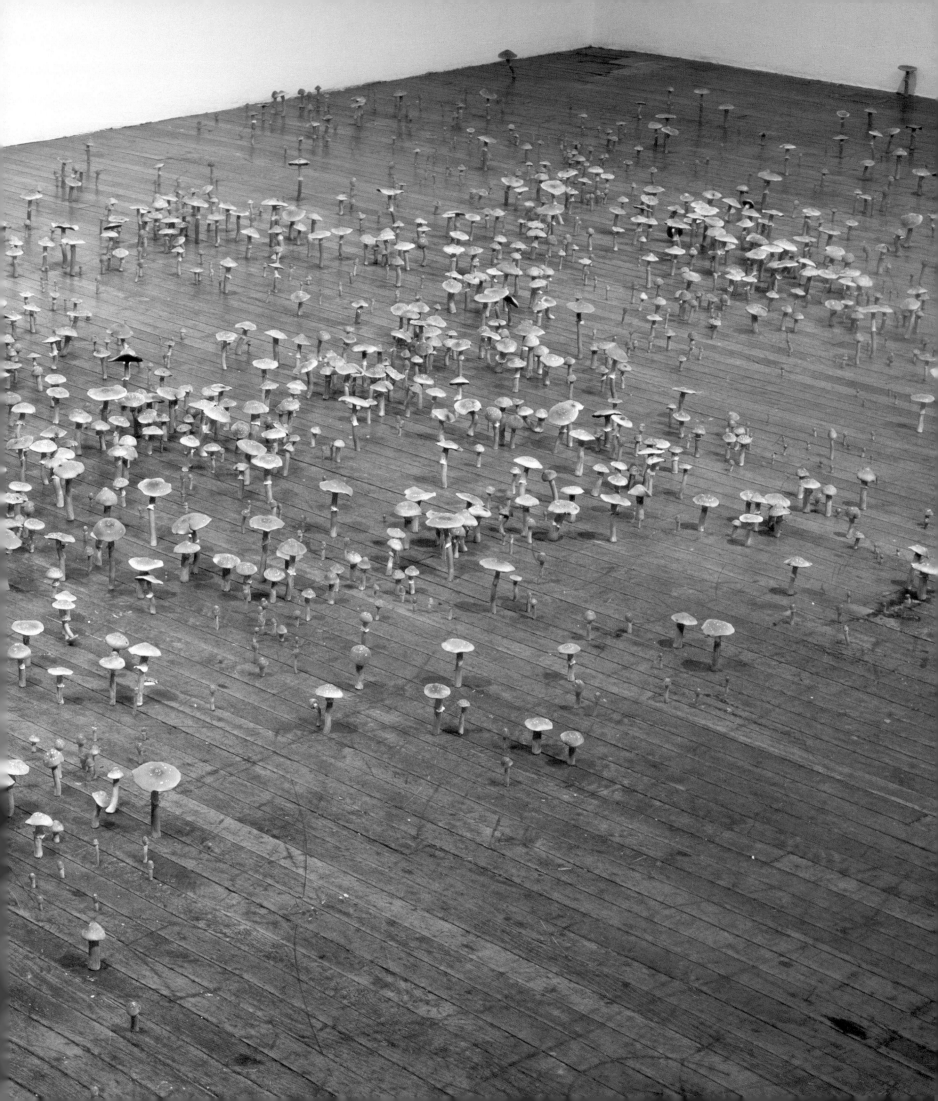

Pages 44–45 and 47: **Psilocybe Cubensis Field,** 1997

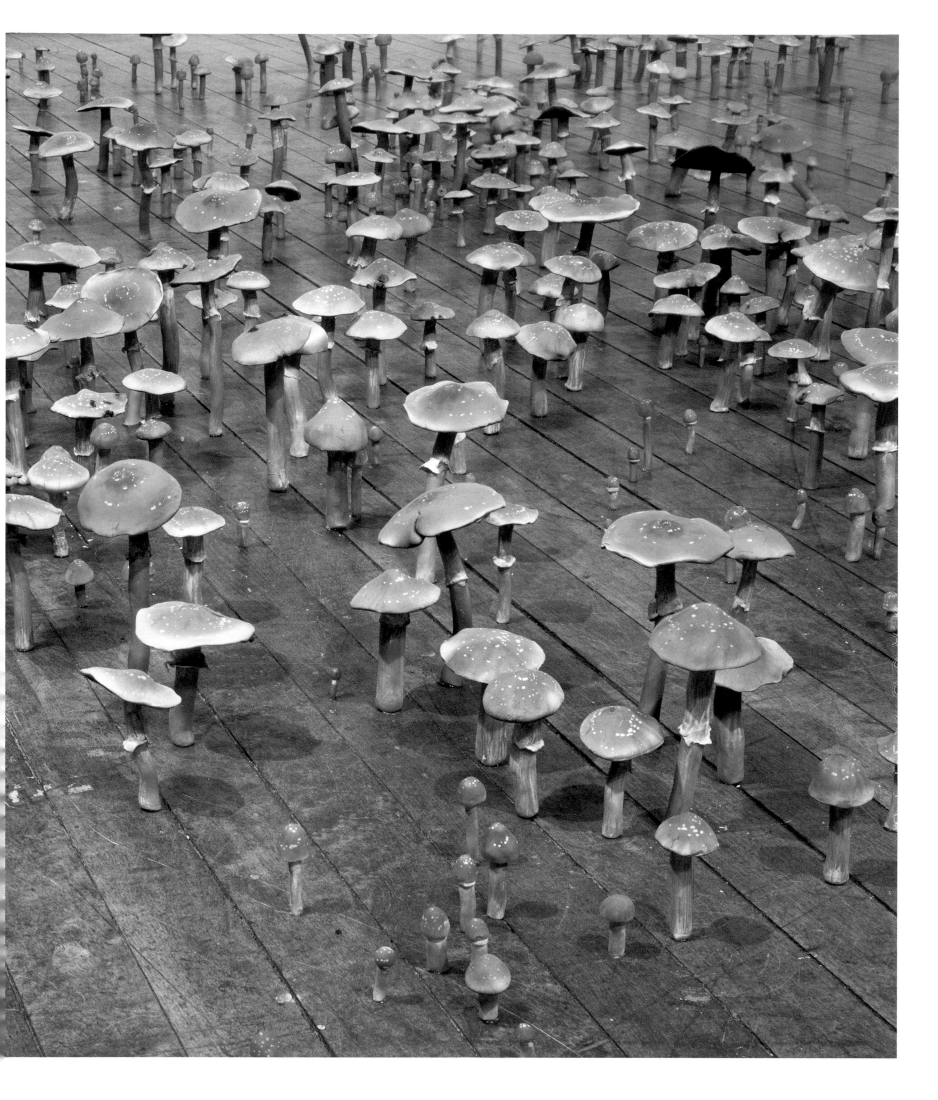

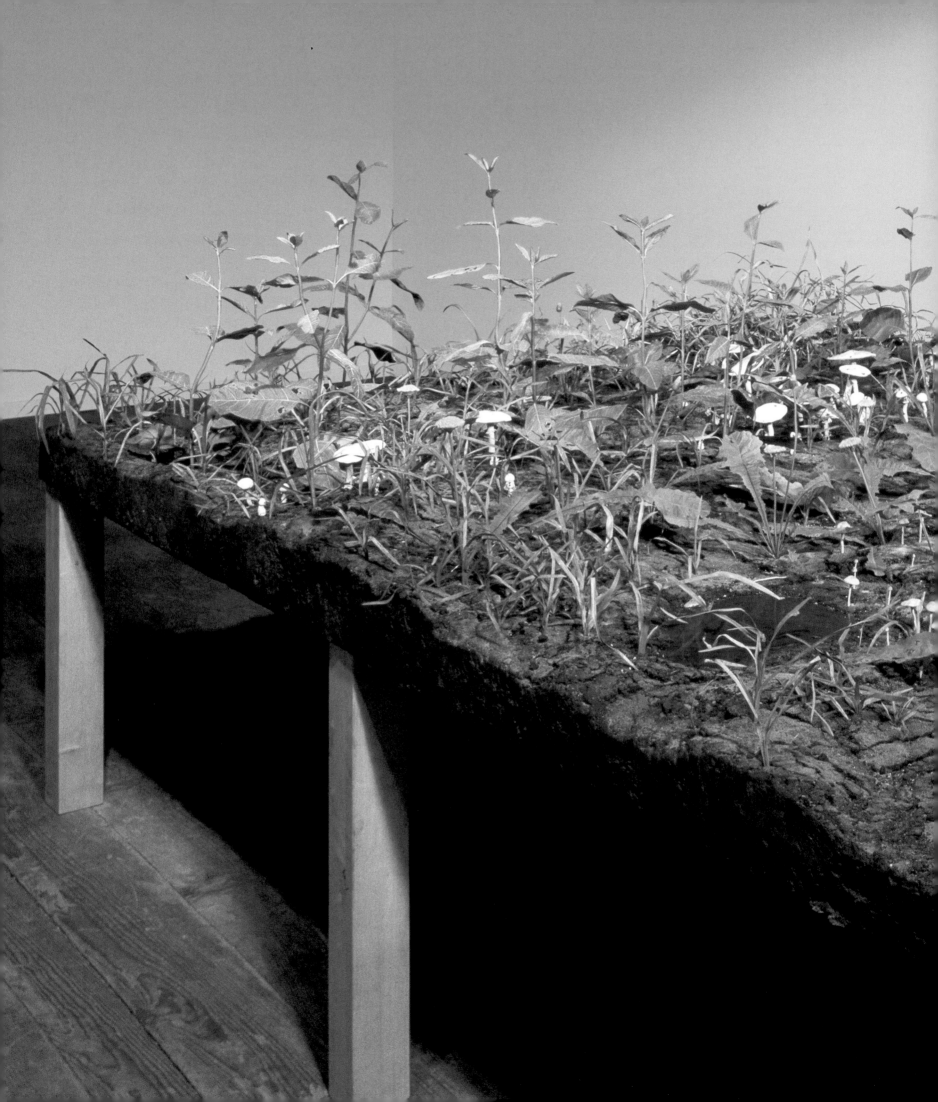

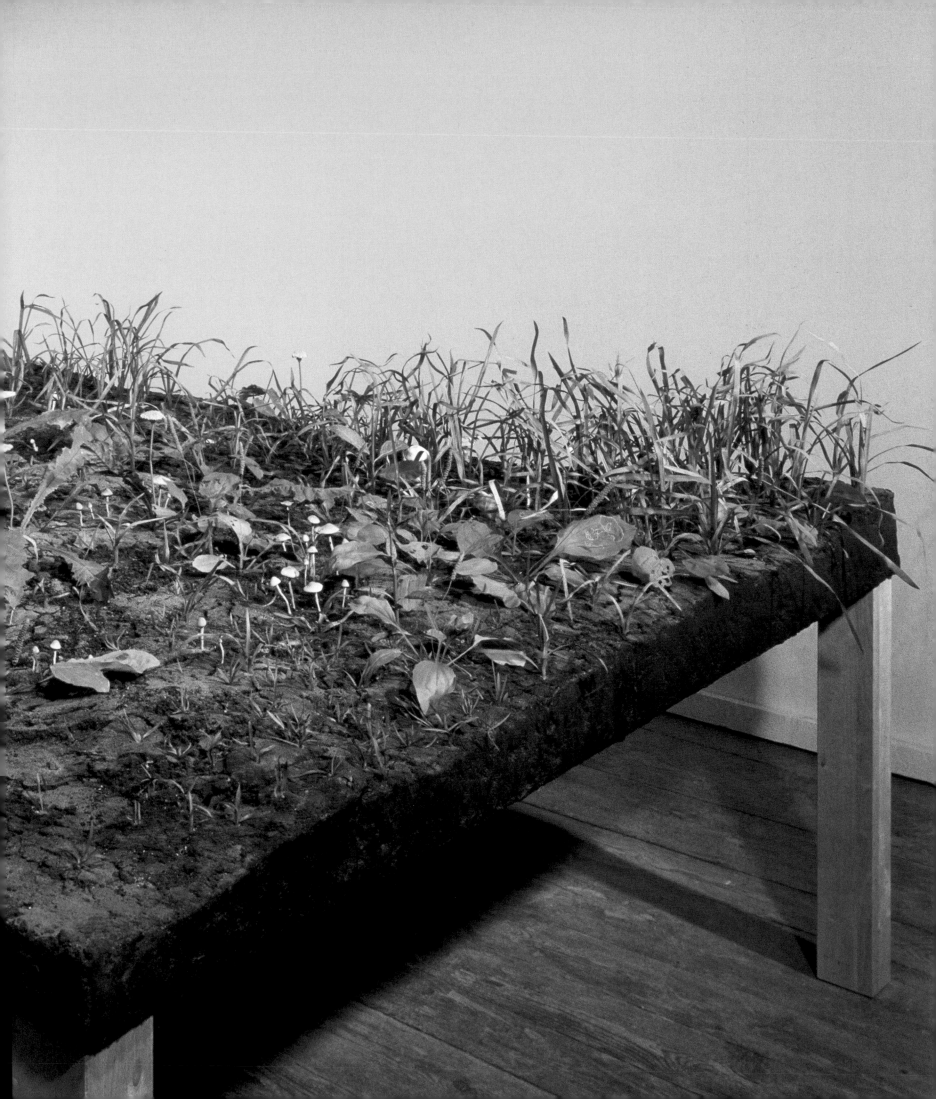

Pages 48–49 and 51: **Bad Lawn**, 1998

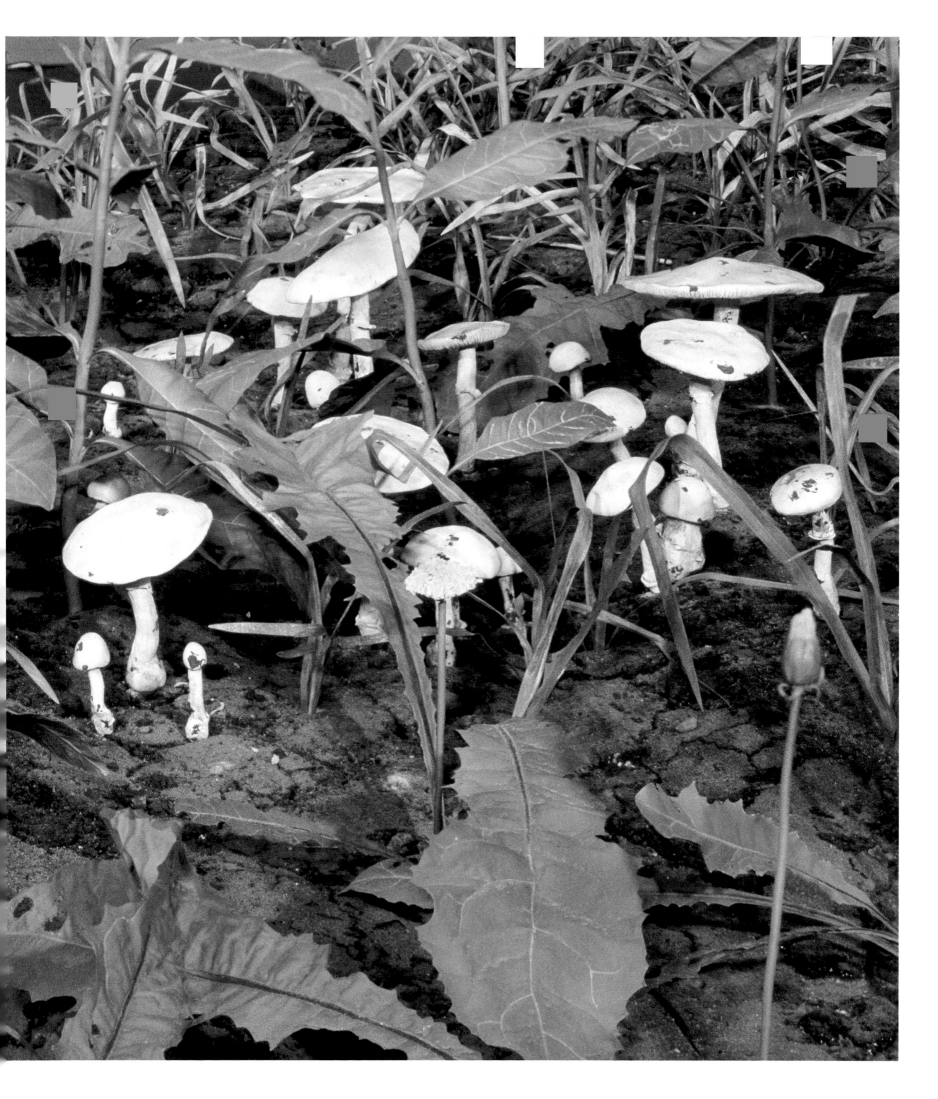

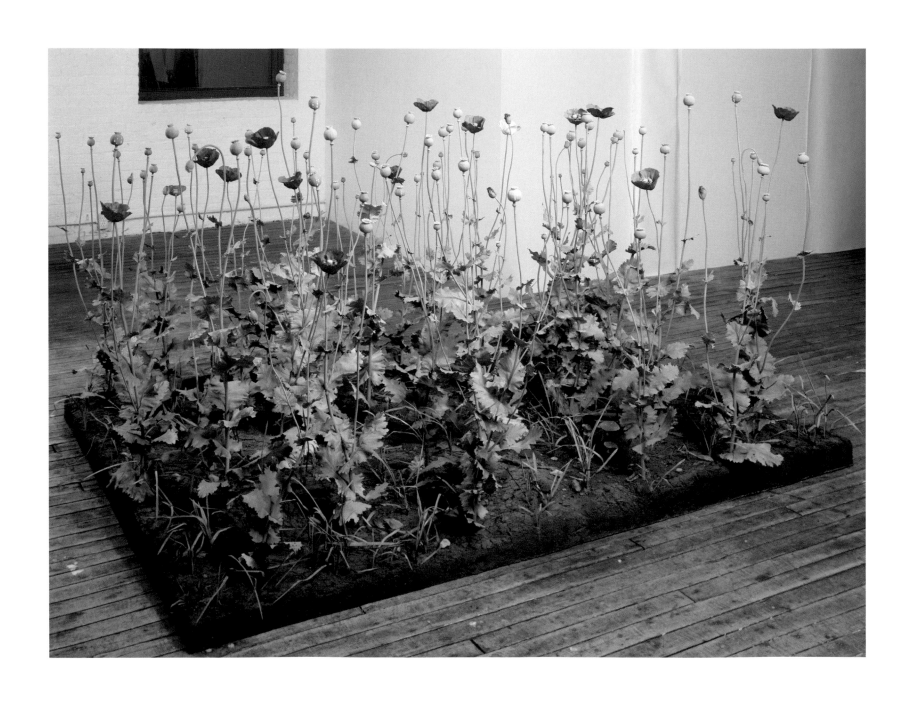

Crop, 1997–98

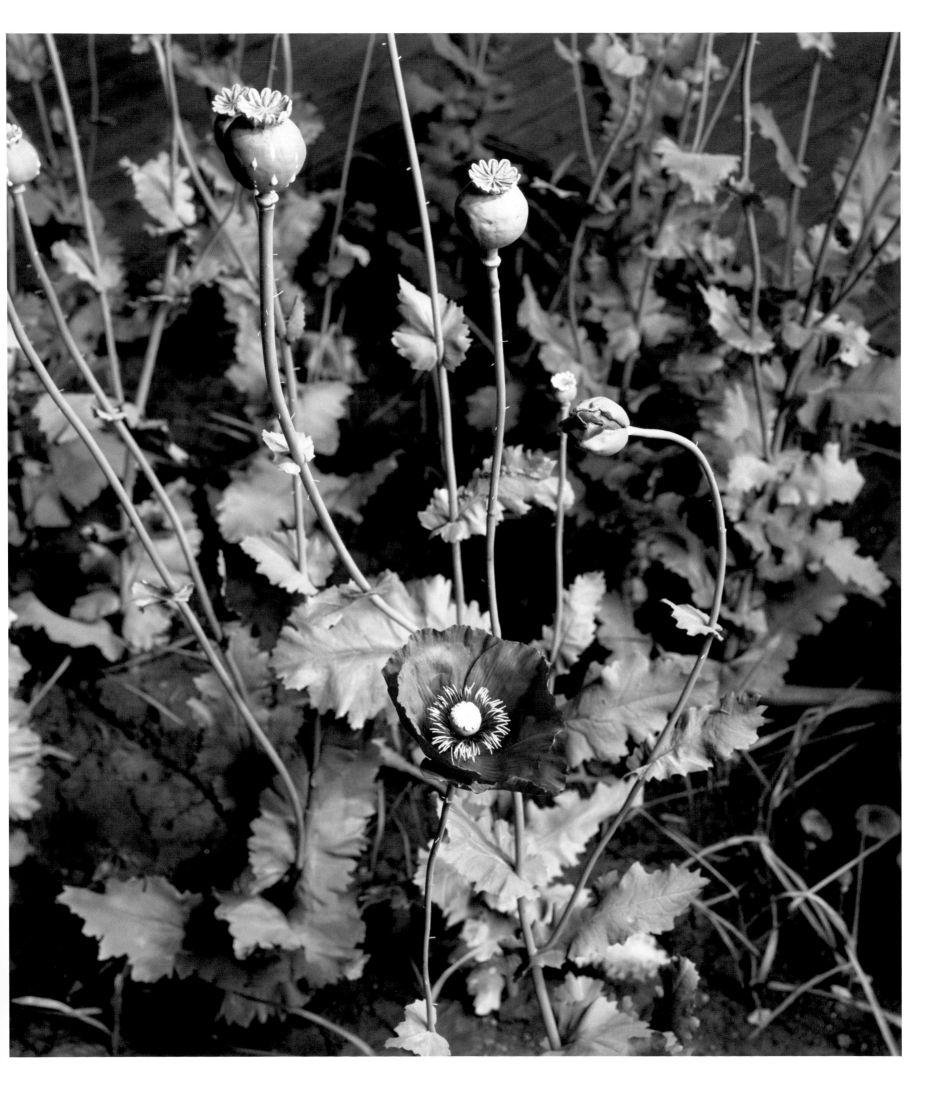

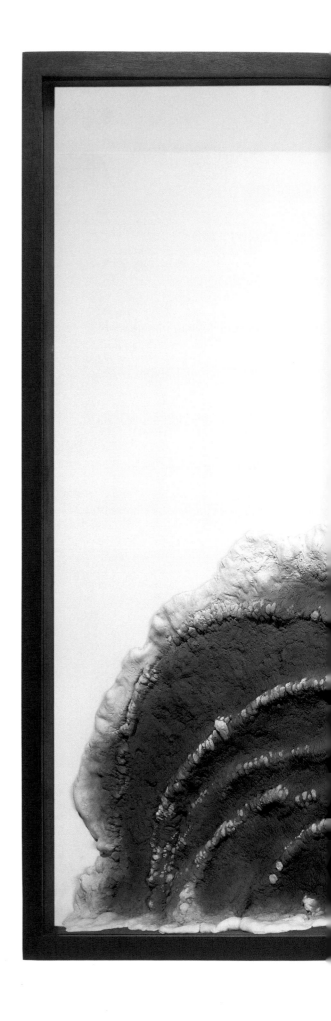

54 **Dry Rot,** 1998

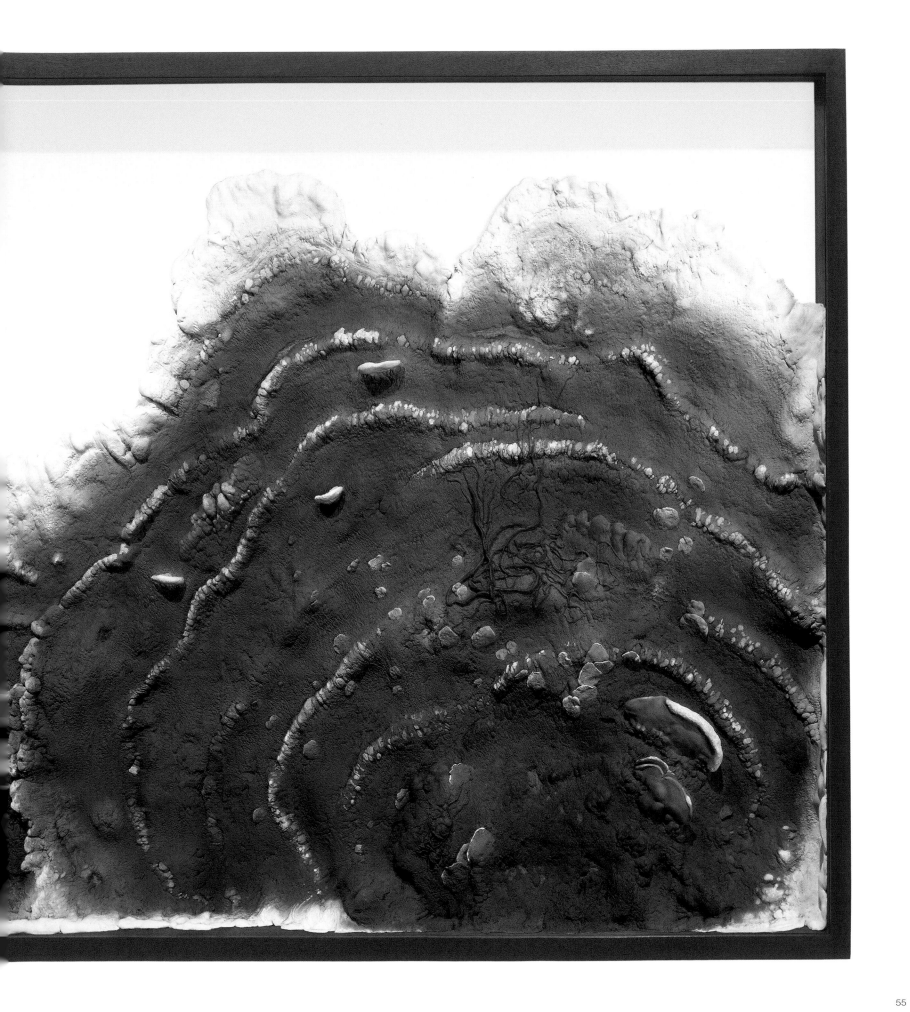

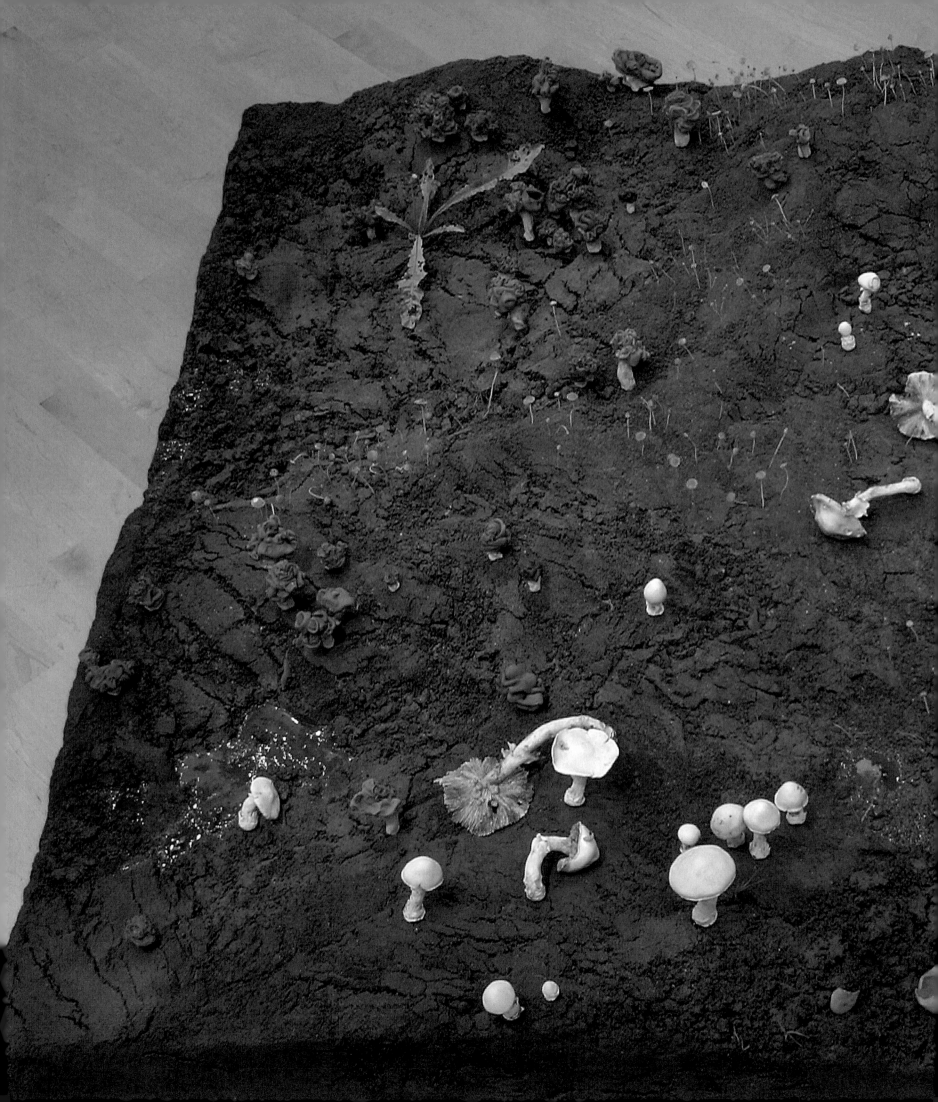

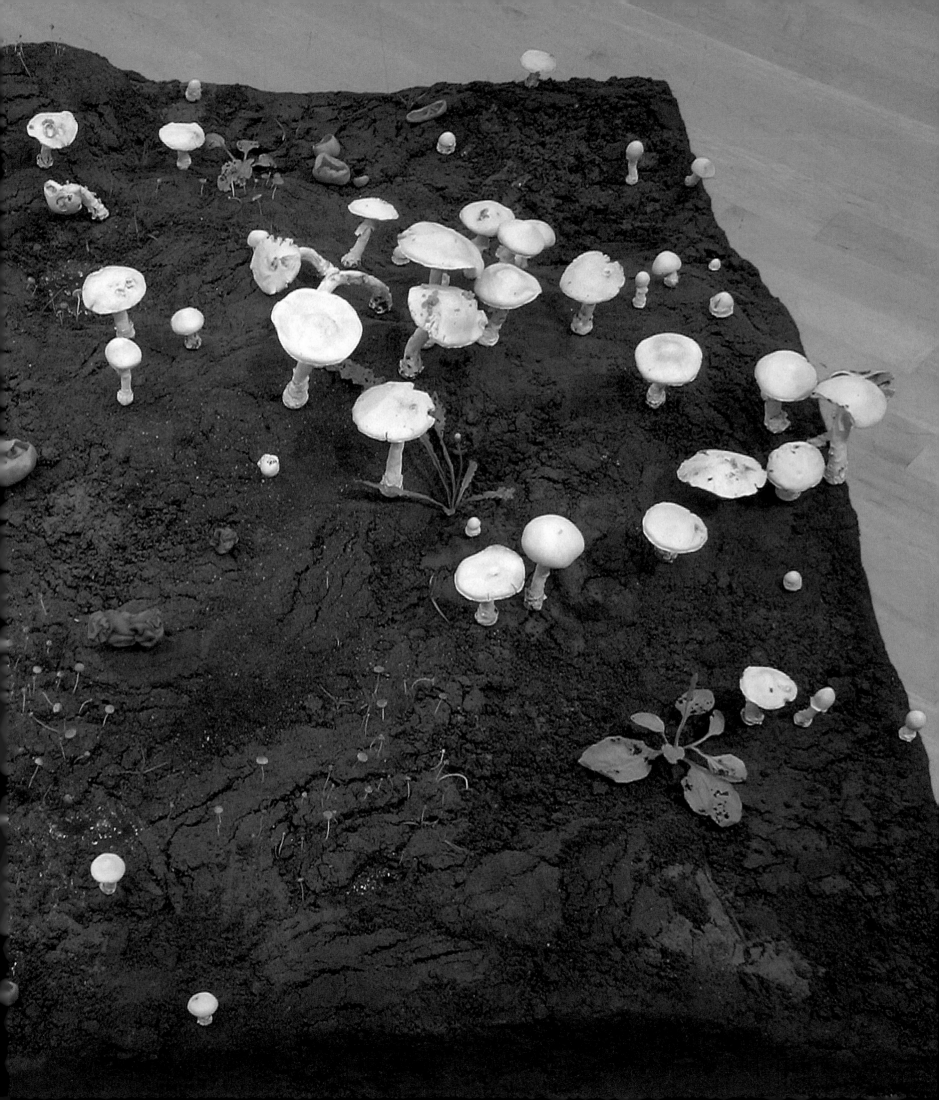

Pages 56–57 and 59: **New Fungus Crop,** 1999

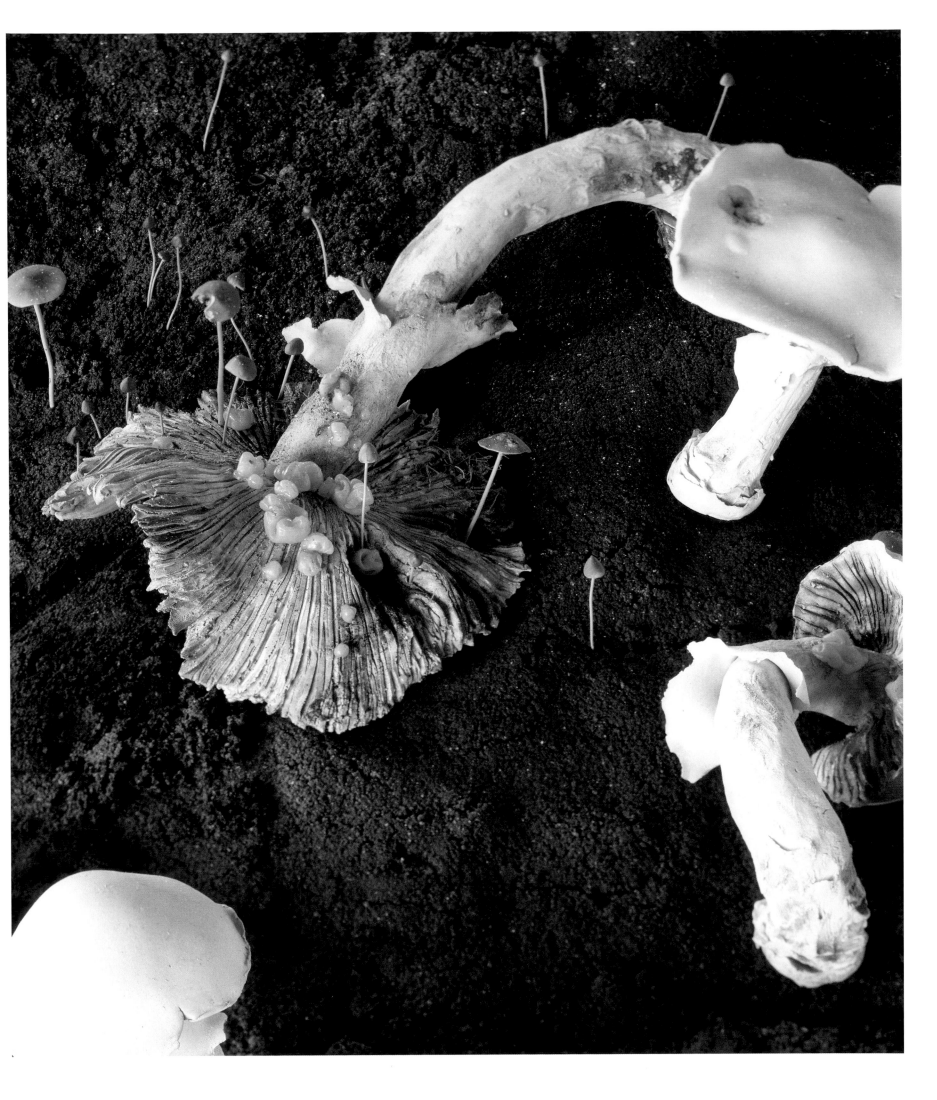

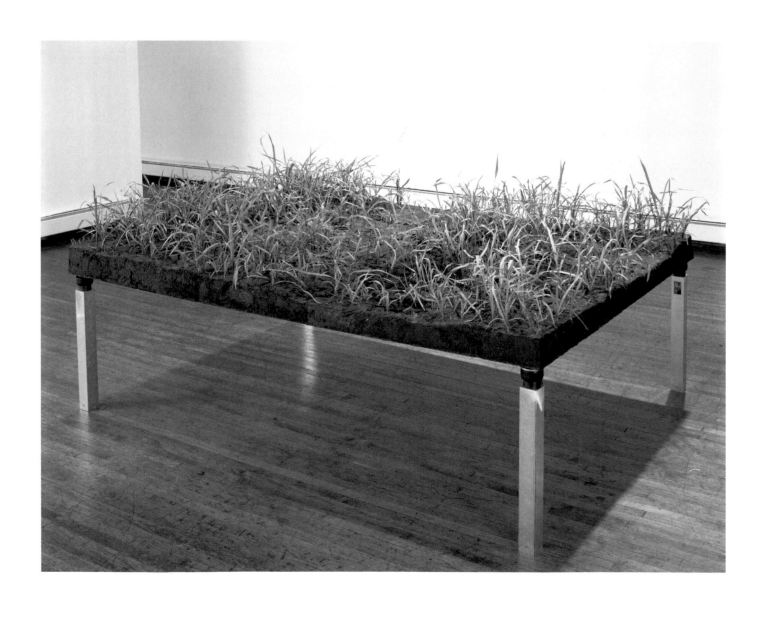

Vibrating Field, 1998

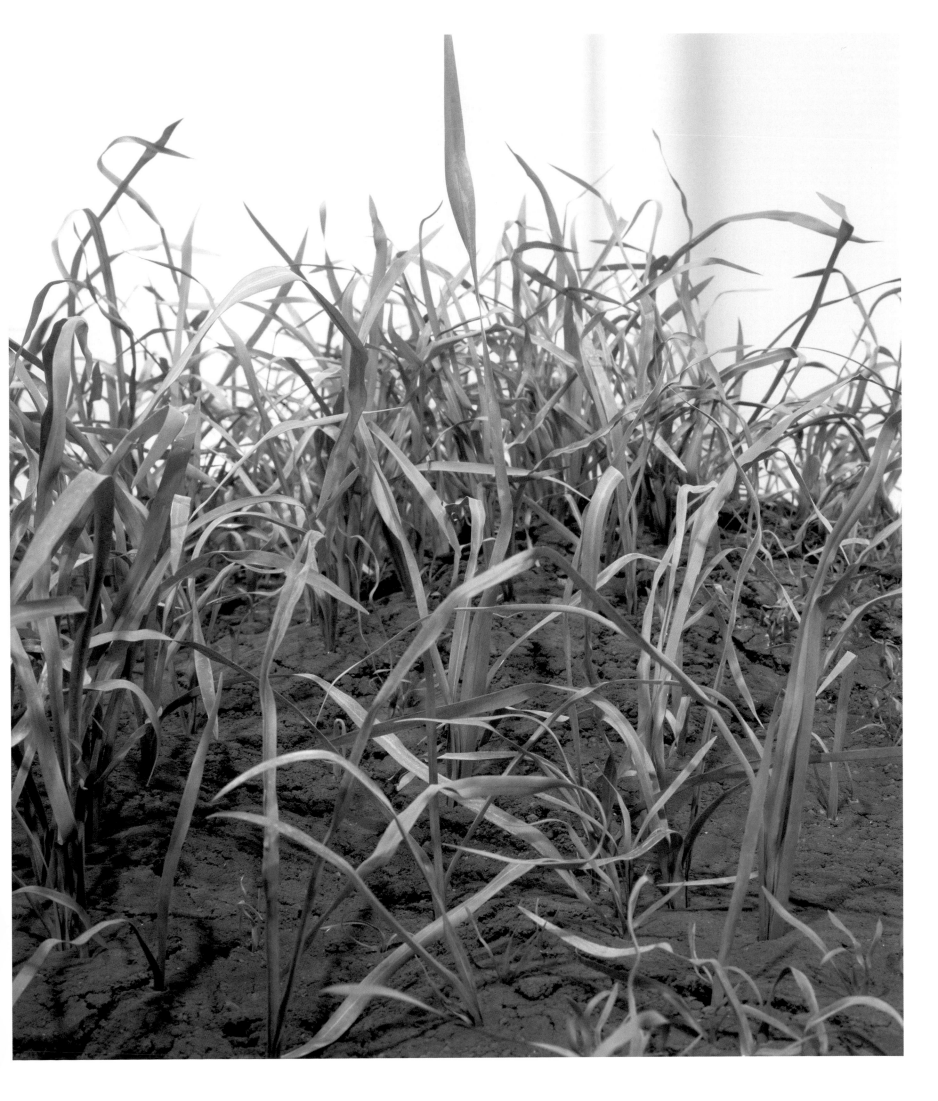

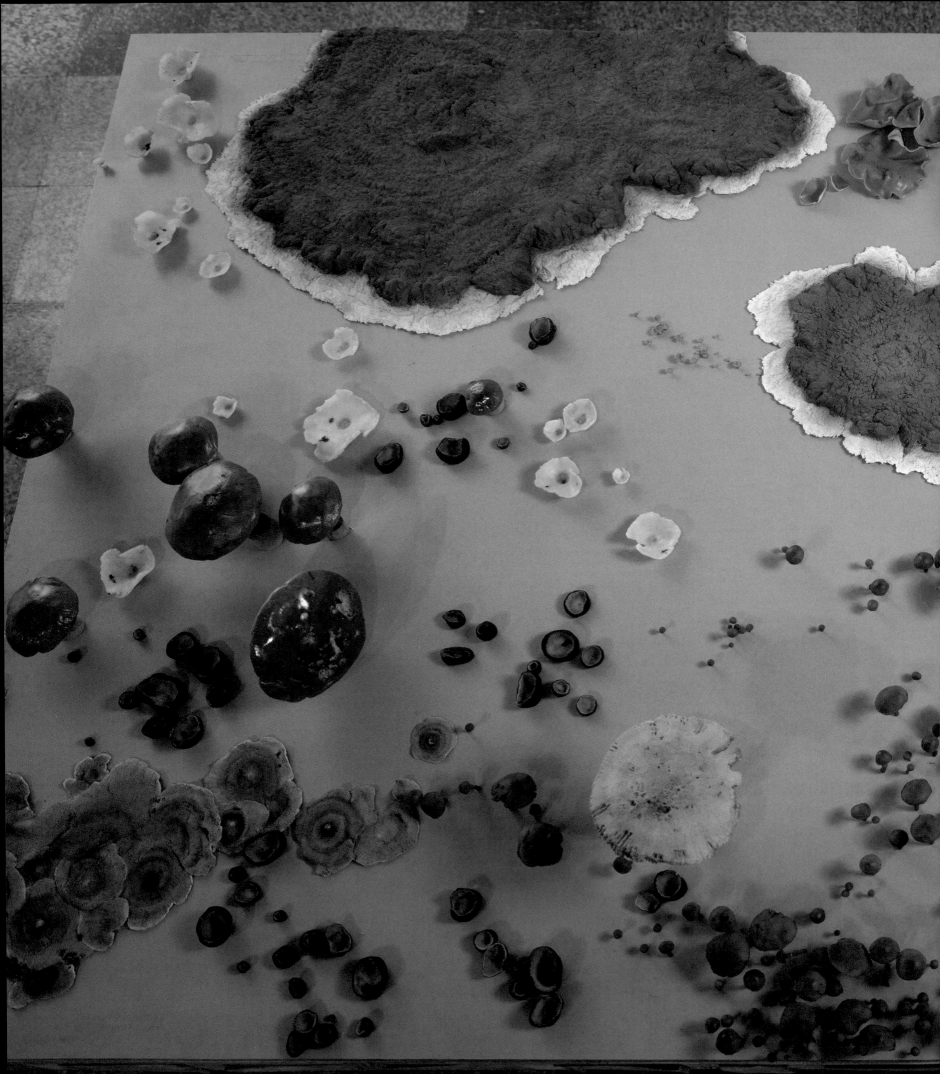

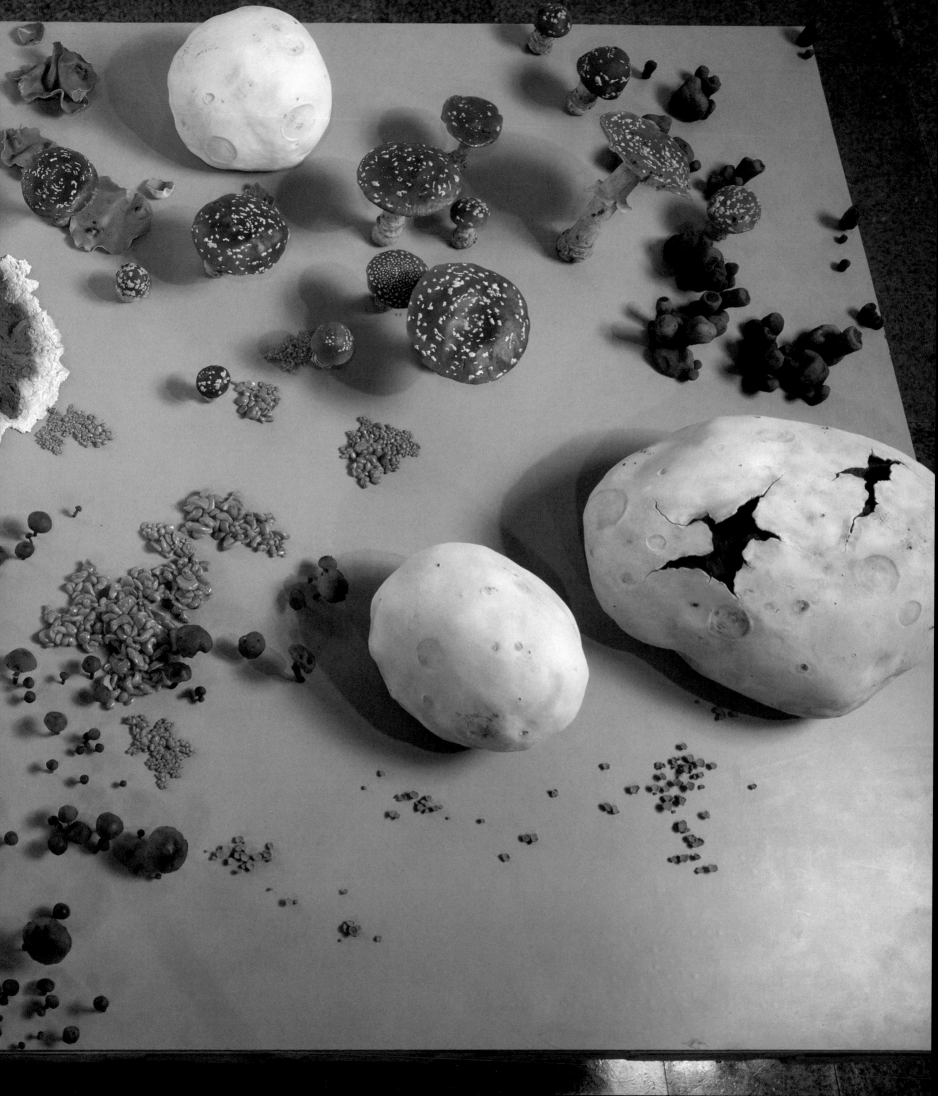

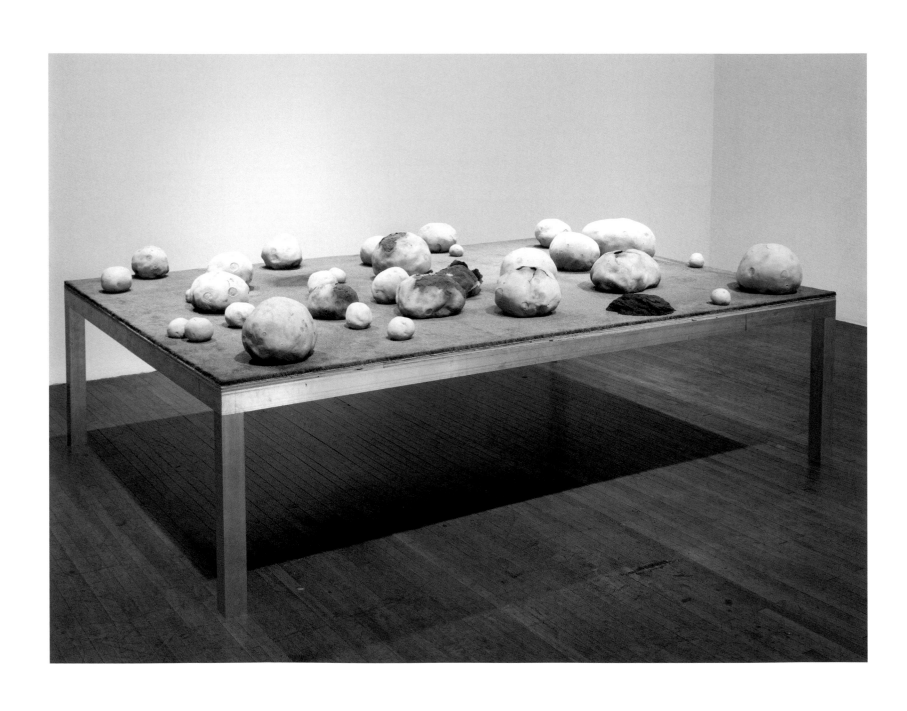

Puff Ball Field, 1998; pages 62–63: **Fungus Formica Field**, 1998

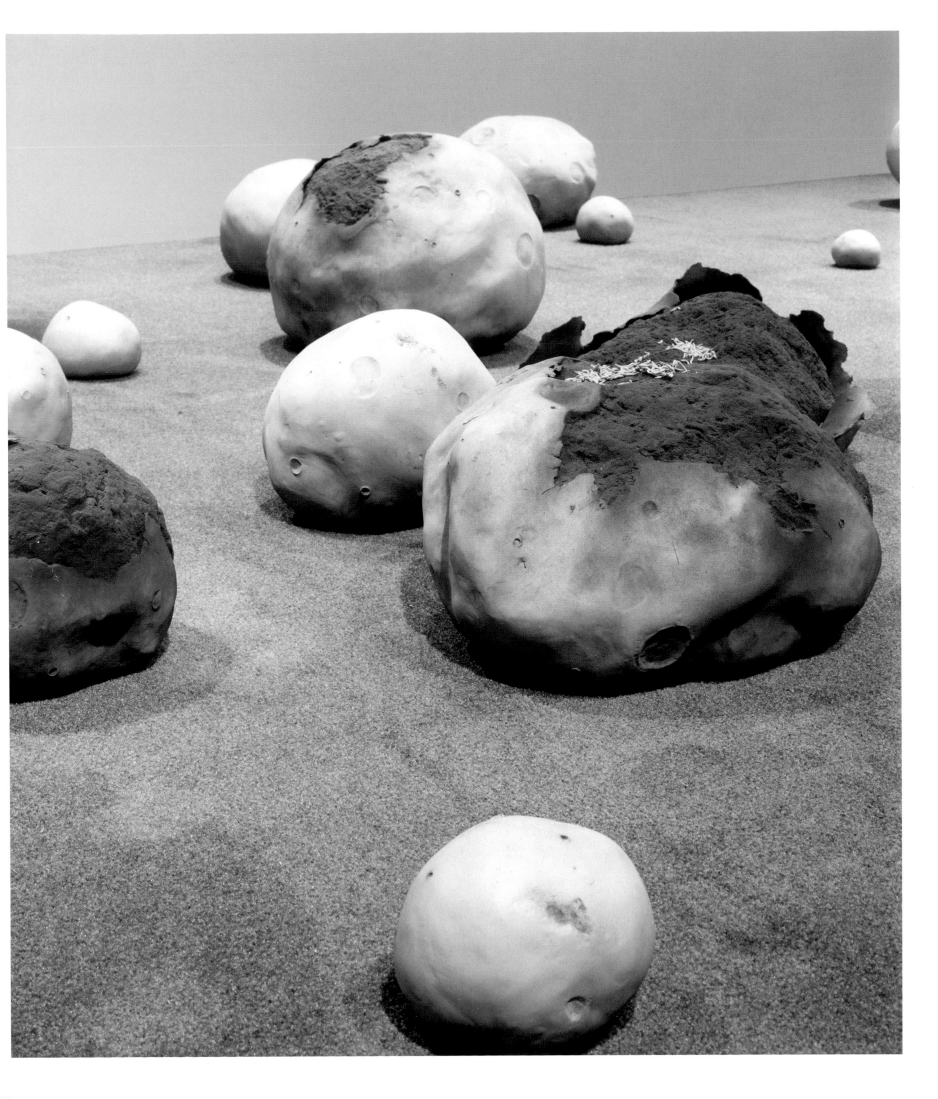

Competing Crusts, 1999

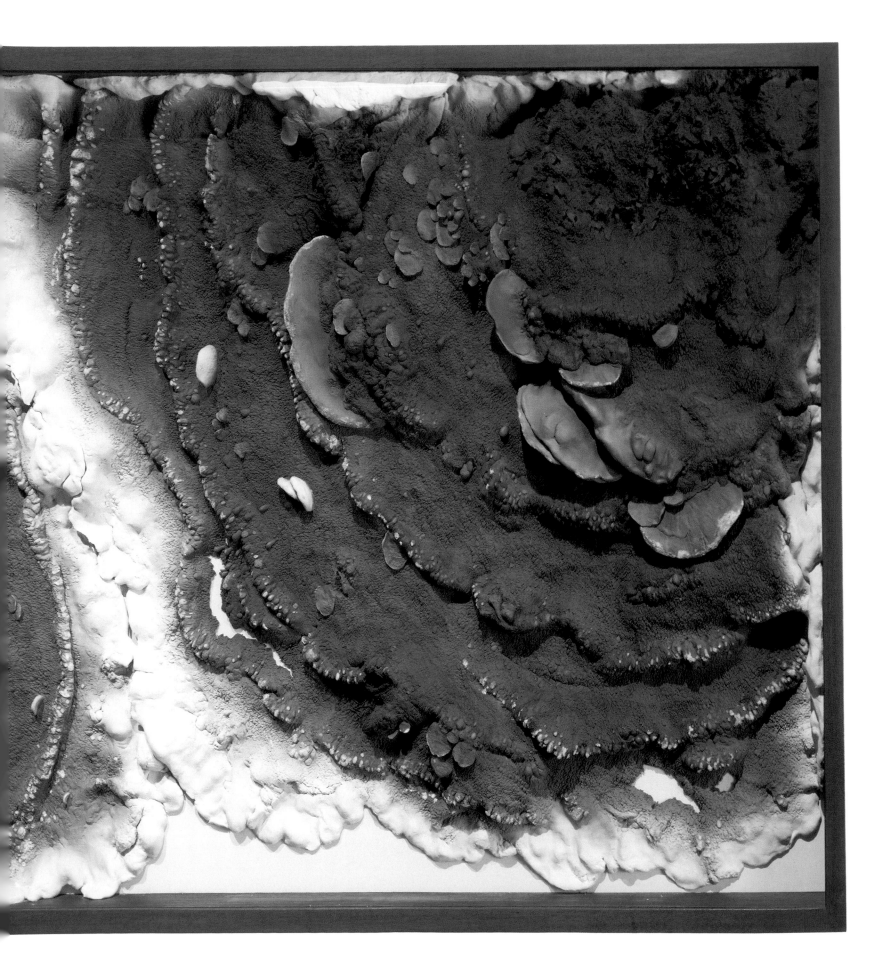

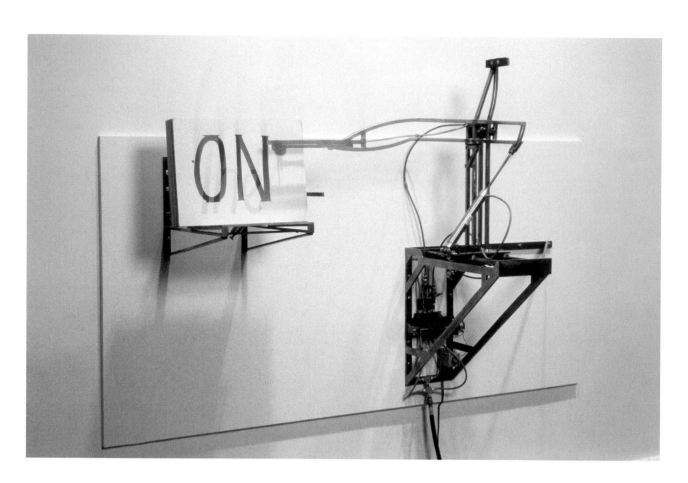

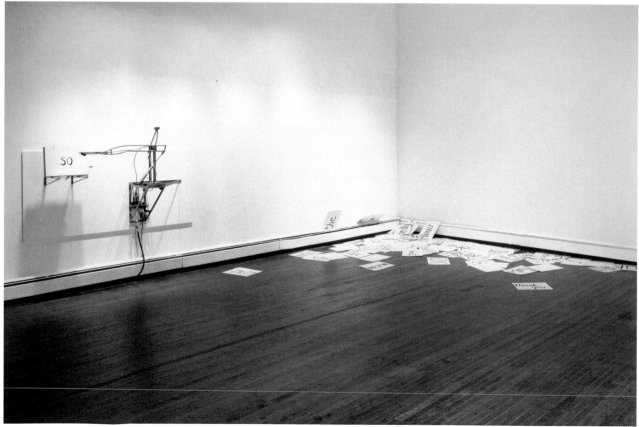

Placard Flinger, 1995

SYSTEMS AND PATTERNS: LANGUAGE AS METAPHOR

In 1996 Paine created a work titled **Model Painting** (pp. 36–37). Consisting of a rectangular arrangement of fifty-eight neutral-colored, thick polymer brushstrokes attached to thin rods and displayed in a mahogany case, it recalled the presentation of parts found in model airplane kits. Like much of Paine's work, **Model Painting** was slyly humorous. Its factory look deliberately undercut the vaunted spontaneity of Abstract Expressionism by suggesting that such paintings could be assembled from manufactured plastic parts. The limited inventory of the forms made by the "strokes" (they ranged from small dots and thin zig-zags to broad gestural swaths) also undermined Abstract Expressionism's mythology of originality.

Although **Model Painting** appeared very much in keeping with the postmodern critique of originality and artistic authenticity, Paine was actually much more interested in another aspect of the work. As a dissection of an abstract painting into its constituent parts, **Model Painting** points to a recurring tendency in the artist's thinking: the reduction of complex organisms and processes into discrete parts that then may be recombined within the parameters of a given system. Meanwhile the notion of a painting's component parts arrayed like scientific specimens suggested the commingling of the supposedly antithetical fields of art and science (later versions of this work include small letter codes under each element, cataloguing it according to an arcane classification system exhibited with the work).

A related 1997 work, **Model for an Abstract Sculpture** (pp. 34–35), is a model-kit display of objects, cast from the plastic used in blister packaging, which notionally could be used to assemble a non-representational sculpture. Like the model-kit works, Paine's vegetal works rely on a dissection of species into constituent parts. These parts are then recombined to create forms that are at once singular and easily recognized as members of that group. Paine uses the metaphor of language to describe this process: "[I]t's learning the language of the species that I'm dealing with so well that I can improvise freely, using the elements and rules to create new entities. The systems that I create to make the individual plants are all based on that ability to manipulate, to alter, to create hundreds of unique entities using the system and language of that species."[8]

The idea of language systems serving as a model for our understanding of the visible world was a tenet of the Conceptual Art movement of the 1960s and remains an important undercurrent in contemporary art. Extending Minimalism's attack on the fetishization of aesthetic form, which had come to dominate art discourse under the influence of critic Clement Greenberg, artists began to attack the whole idea of the art object. Such artists as Joseph Kosuth and Lawrence Weiner, who represented the most stringent branch of Conceptual Art,

[8] Jan Garden Castro, "Collisions: A Conversation with Roxy Paine," *Sculpture Magazine* (May 2006): 42.

suggested that art was really nothing more than a set of analytical propositions. Among Kosuth's best-known works of the 1960s is his "One in Three" series, which presents ordinary objects, such as a chair or clock, in three versions. The actual object, a photo of the object, and its dictionary definition are displayed side-by-side. The implication is that all three states of "chairness" or "clockness" are equivalent. Working along similar lines, Lawrence Weiner created artworks that were simply verbal descriptions painted on the wall.

Other conceptualists were less iconoclastic. Sol LeWitt, whose 1967 article "Paragraphs on Conceptual Art" is one of the earliest manifestos of the movement, remained committed to the object. He was interested in the idea of an artwork as a set of logically comprehensible permutations of a basic mathematical equation. LeWitt set rules for himself, which he strictly followed, to create works that presented every possible variation of the cube with one or more of its edges removed. He elaborated on this systemic process by creating wall drawings determined by sets of instructions about the placement of various lines in relation to each other. These drawings were intended to be completed by others, and as long as the rules were followed, they were to be considered genuine LeWitts.

Some conceptual artists used self-contained systems to investigate political issues. One of the most influential of these is Hans Haacke, whose early works involved the creation of closed environmental systems in which changes in temperature, light, or humidity affected the whole. Later, he applied this idea to the social world, producing art works that focused on the fluid interaction between the systems of art, economics, and politics.

Unlike conceptual purists like Kosuth and Weiner, Paine does not invoke language in order to render objects superfluous. In a manner more in keeping with the ideas of LeWitt and Haacke, he identifies with Conceptual Art's focus on the creation of objects or installations generated by rule-based systems. However, he departs from the closed and self-referential nature of much Conceptual work. Paine is fascinated by the impurities within systems that allow for new and unexpected variations. He is also interested in seeing what happens when one language is translated into another. He points out that the language of fungi, for instance, involves patterns of growth, decay, and rot that can be brought to bear to create an almost infinite number of new versions of any species.

A fascination with language and systems is something Paine shares with biological, physical, and computer scientists. In linguistic, genetic, or binary computer code systems, a simple generative grammar yields highly sophisticated formulations. A potential for change is written into the rules of such structures—in fact, without unexpected variations, growth and change would not be possible. Languages evolve when alien words, phrases, or syntactical rules are introduced, which is one reason why English, one of the Latin-based languages most accepting of outside influences, continues to be such a vital and flexible instrument. In a similar way, Darwin's theory of evolution depends on mutations which, carried through successive generations, allow the species to adapt to its changing environments. More recently a branch of physics known as complexity theory has created models that demonstrate how tiny perturbations in a system can lead to enormous transformations over time.

Similarly, the focus of Paine's art is not the unique object, but the larger system of dynamic relationships in which it exists. The language metaphor has allowed him to introduce variation and change into structures that might otherwise seem static. His faux-natural organisms and his mechanically created objects are all generated by the interaction of pre-established rules and random operations of chance. Their individuality is ensured by small modifications within systems. The reliance on rules and variations allows Paine to establish the parameters for the variable forms of his erosion patterns, the distinctiveness of each specimen in his fields of mushrooms, and the unique shapes of the paintings and sculptures produced by his computer-programmed machines. A similar preoccupation informs his interest in nature and technology, because from his perspective both can be seen as manifestations of inner logic and both can evolve and change through the introduction of unplanned or unexpected variations. In words that echo the principles of complexity theory, Paine has remarked: "I tend not to use the word chaos. I think of it more as situations too complex to predict. It stems, I think, from being a control freak, but understanding that control without its opposite is uninteresting."[9]

Paine's demonstrations of the illogic that lies at the heart of any dynamic system echo some of Sol Lewitt's pronouncements on Conceptual Art. LeWitt declared, somewhat counterintuitively, in his 1967 manifesto: "Conceptual artists are mystics rather than rationalists. They leap to conclusions that logic cannot reach." Elaborating on this idea, he might very well be describing Paine's strategy: "Conceptual art is not necessarily logical. The logic of a piece or series of pieces is a device that is used at times, only to be ruined. Logic may be used to camouflage the real intent of the artist, to lull the viewer into the belief that he understands the work, or to infer a paradoxical situation (such as logic vs. illogic)."[10]

Probably no contemporary artist pursued the idea of systemic illogic as far as John Cage. In his music and performances, Cage was a fervent advocate of chance and indeterminacy, which in his hands became a way to undermine and distort rules that had traditionally governed the composition of music and art. To perform his most famous musical composition, 4:33, a pianist just sits at a piano for the time period specified by the title, so that the audience may become aware of ambient sounds. Other compositions were more proactive, such as one in which Cage instructed musicians to pour water from pots, blow whistles under water, and play a radio. However, despite the evident lightheartedness of his approach, Cage rejected the notion that he was treating music simply as a game. Instead, he insisted that the core of his work was his subversion of the kind of systems that make games possible: "What interests me isn't the rules, but the fact that those rules change. That's why I don't believe that my art is a game. I try to change the rules or eliminate them each time. A game, on the contrary, depends on following those rules."[11]

One of Paine's most overt subversions of the logic of systems is his 1995 **Placard Flinger** (p. 68). A transcript of a fifty-minute session with his psychotherapist yielded 1,892 words, each of which

[9] Herbert, interview, 25.

[10] Sol LeWitt, "Paragraphs on Conceptual Art," *Artforum* (summer 1967).

Untitled (Drawing for
Placard Flinger), 1994

was written onto a placard. Every few minutes, when the work is exhibited, a pneumatic arm picks up a placard and hurls it violently across the room. The amount of time between "hurls" may be adjusted so that by the end of the exhibition, all of the words are flung. At any time, the viewer may see just one word of a stack in the correct order, or may view many words in the disordered mass accumulating on the floor. As a result, the session is rendered incoherent—an apt metaphor, perhaps, for the often jumbled workings of the unconscious which therapy attempts to order. **Placard Flinger,** Paine notes, is in part a reflection of the frustrating slowness of the therapeutic process, as well as a graphic illustration of the difficulties of translating thoughts into words. But it also exhibits a Cagean irreverence toward the notion of rules and order.

Cage was inspired in part by his study of Zen and its emphasis on the suppression of the ego and the mind. But it can be argued that his interest in chance was also stimulated by his study of mushrooms, which provides an intriguing connection to Paine's work with fungi. In a 1954 article cheekily titled "The Music Lover's Field Companion," Cage remarked, "I have come to the conclusion that much can be learned about music by devoting oneself to the mushroom."[12]

An amateur mycologist, Cage was fascinated by the role that fungi play as agents of decomposition in the ecosystem. By breaking down plant material, fungi ensure that important elements such as carbon and nitrogen are released back to the environment to foster future growth. There are parallels between the mushroom's breakdown of organic matter and Cage's breakdown of musical systems. The introduction of chance into a system is not unlike the role played by a fungus in the forest. The shelf fungi that attach themselves to trees will eventually weaken and kill the tree. For the tree they are alien invaders, but for the forest they are necessary agents in the constant process by which organic matter is broken down to release the nutrients for new life.

This process is a persistent theme in Paine's stainless-steel Dendroids. While early examples focused more on the visual contradictions between the living trees and their leafless metal counterparts, more recent Dendroids have been characterized by the eruption of shelf fungi. This element first appears in **Bluff** (2002), which still might be interpreted as a representation of a living tree in its winter state. The shelf fungus becomes the defining feature of the 2004 sculpture **Defunct** (pp. 190–95), many of whose limbs and branches end in jagged breaks, indicating a tree that is dead, not merely dormant. This series seemed to evolve from a preoccupation with a kind of masquerade—the first Dendroid is named **Impostor** (1999; pp. 139–41) while others have names such as **Transplant** (2001; pp. 142–45) and **Substitute** (2003; pp. 217, 219)—to a consideration of the natural cycles of life and death. One of the lessons of mycol-ogy is that in nature may not reflect the values of the human world. Death is not the dreaded end of life but—with the aid of fungi as agents of destruction and disintegration—a stage in the continuation of life.

Cage liked to relate a story that illustrated this idea. He reported that he met a woman at a dinner party who asked him, "Have you an explanation of the symbolism involved in

[11] John Cage, *For the Birds: John Cage in Conversation with Daniel Charles* (Boston and London: Marion Boyars, 1981), 210.

[12] John Cage, "Music Lovers' Field Companion" (1954), reprinted in *Silence: Lectures and Writings by John Cage* (Middletown, Conn.: Wesleyan University Press, 1973), 274.

John Cage picking mushrooms in the woods, 1967.
Photo: William Gedney
© William Gedney Collection, Duke University Rare Book, Manuscript, and Special Collections Library

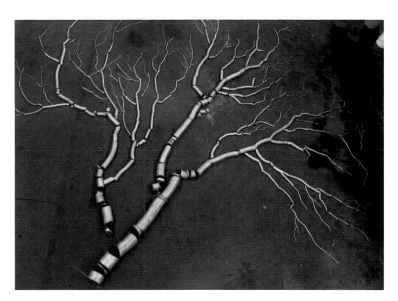

Branch layout for **Bluff**, 2001

the death of the Buddha by eating a mushroom?" "I explained," said Cage, "that I'd never been interested in symbolism, that I preferred just taking things as themselves, not as standing for other things. But then a few days later, while rambling in the woods, I got to thinking. I recalled the Indian concept of the relation of life and the seasons. Spring is Creation. Summer is Preservation. Fall is Destruction. Winter is Quiescence. Mushrooms grow most vigorously in the fall, the period of destruction, and the function of many of them is to bring about the final decay of rotting material. In fact, as I read somewhere, the world would be an impassible heap of old rubbish were it not for mushrooms and their capacity to get rid of it. So I wrote to the lady in Philadelphia. I said, 'The function of mushrooms is to rid the world of old rubbish. The Buddha died a natural death.'"[13]

In their apparently infinite variety, mushrooms also offer a textbook example of the diversity found in any dynamic organic system. Cage himself noted the challenge of identifying and collecting mushrooms. "It's useless to pretend to know mushrooms," he said. "They escape your erudition ... The more you know them, the less sure you feel about identifying them."[14]

Anyone who has gone mushroom hunting will understand this. The illustrations in guidebooks offer specific examples, while mushrooms in the field are so diversified that they seem to depart in dramatic ways from the illustrations. Making a positive identification is an almost unconscious process. One must recognize certain acceptable variations while also being aware of the hallmarks that may indicate a dangerous species. This idea is beautifully illustrated by Paine's **Psilocybe Cubensis Field** (1997; pp. 44–45, 47), which consists of more than two thousand handcrafted polymer representations of the hallucinatory "magic" mushrooms popularized in the 1960s by counterculture figures like Timothy Leary. "Sprouting" directly from the gallery floor, each mushroom is unique, with often minute variations in the size and thickness of the stem, the width, angle, flare, and curve of the cap, and the size of the veil. Scattered across the floor, the undulating heights and uneven concentrations of the mushrooms illustrate the tension between the individual manifestation and the standardized model. The work also underscores the fact that the visible mushroom is simply the fruiting body of the much more extensive underground network of mycelia, a branching threadlike web that is the real organism of the fungus. Understood in this way, it becomes clear that Paine's psilocybes are not meant to be perceived as renderings of unique subjects in the manner of traditional representational painting and sculpture. Rather they are the collective portrait of a species, and their multiplicity illustrates the rules and variations possible within a given system.

Paine's interest in the language of organic form takes on different permutations in other series. He has explained that at times his process of improvisation allows him to go beyond

[13] John Cage, Edgard Varèse, "Nutida Musik" (1958), reprinted in *Silence*, 85.

[14] Cage, *For the Birds*, 188.

merely exploring variations of existing species. He notes, "At times I create new species. The trees are not based on any single species of tree."[15]

Thus, while a work like **Psilocybe Cubensis Field** derives from an existing species, Paine's Dendroids are really more about the idea of tree-ness, which involves the way branches radiate from a central trunk, and about the way that the language of organic growth translates into the language of industry. Paine has said, "I was interested initially in the idea of the tree as a language. . . . Each tree is a new story, a compelling entity, told with that language. The whole project is about permutations with that language. And of course, as I become familiar with the language, other things become interesting, like decay and death in the more recent trees, and looking for new ways to use the language."[16]

The Dendroids have evolved in other ways as well. With **Breach** (2003; pp. 187, 189), Paine began to introduce broken limbs. In **Fallen Tree** (2006; pp. 232–33, 235) the broken ends and individually cut shards of pipe begin to suggest interrupted networks. The Dendroids also have taken on more and more industrial features, with welded joints increasingly visible, and trunks and branches more obviously fashioned from sections of industrial pipe and rods. While the trunk of the first Dendroid, **Impostor**, was created by wrapping steel "bark" around an inner armature, subsequent Dendroids have been constructed solely with steel pipes and rods of different diameters. The forms of the Dendroids are conditioned by the constraints of their material, which include the hardness, the weight, and the standardized dimensions of the stainless-steel pipes with which he works. Thus the Dendroids increasingly reveal a dissonance between the rules of organic growth and those of industrial fabrication. Paine recalls that for **Bluff** he used pipe and rod of twenty-eight different diameters, and created the effect of tapering by connecting, for example, a 4-inch pipe to a 3 ½-inch one, and the 3 ½-inch one to a 2 ½-inch one, and so on.

The trees have also begun to defy natural laws. The interwoven branches of **Conjoined** (2007; pp. 236–41) seem to have grown toward each other rather than toward the light. **Inversion** (2008; pp. 244–46) grows upside-down. Such creative manipulation and re-ordering is even more forcefully evident in **Maelstrom**, in which the pattern of the entangled branches begins to suggest an energy field, or perhaps a diagram of the intermingling of synapses in the brain. Thus botany, biochemistry, neuroscience, and physics seem to merge in these most recent Dendroids, creating new hybrid forms.

Paine's machines present a third way to think about how systems work. Once again these are designed to demonstrate that the manipulation of a system's elements and rules can generate an unlimited number of new forms. Generally, the machines mix the languages of statistics, industrial production, or even poetry with that of art to create a visual object. In the case of the **Erosion Machine**, for example, the types of data are quite diverse, including weather statistics, stock market figures, and school test results. Digitized transcriptions of such data control a robotic arm that moves over a block of sandstone and slowly erodes it with blasts of air and silicon carbide grit. The stones upon which the machine operates add a new set of variables, reflecting the fact that they were created by sand deposits compressed over millions

[15] Castro, "Collisions," 42.

[16] Castro, "Collisions," 41.

of years. The density and thickness of each sandstone layer reflect the different temperature and climate conditions of the time they were created and provide different degrees of resistance to the erosion apparatus. The ultimate form of each Erosion sculpture is determined by such conditions. As a result, these works, which strikingly resemble the fantastic land formations found in parts of the American Southwest, owe their forms to a commingling of sets of prosaic statistics with the natural qualities of the materials out of which they are formed. One kind of information interacts with another, as the data we associate with dry statistical reports are transformed into magically evocative miniature landscapes.

Paine has stated that his machines employ three different levels of language. The first is the overall operating program that is analogous to the body's nervous system and operates the motors, valves, heaters, and other elements. In the case of the SCUMAK, for instance, this would correlate to the machine's hardware, including the series of levers that are activated to release the liquid plastic. The second is the computer code that determines the individual form of the objects created—varying this code ensures that each Scumak sculpture, Erosion work, or dipped painting will be unique. Again, in the case of the SCUMAK, this involves setting the opening and closing of the levers for a period of between 0 and 29 minutes. The third level of language addresses the way in which these two languages interact with various external and environmental systems, for instance, the nature of the materials, gravity, or climate conditions.

In each case the final product is a function of all these intersecting languages. The machines are designed with a certain degree of transparency. One can see the activity of the motors and apparatus that move to guide or shape the material at hand, whether it is paint, sandstone, liquid polyethylene, or ink sprayed on paper. One can also view the laptop that runs the programs guiding the machine's manipulation of these materials. But all this transparency and systemic logic cannot erase the element of chance that determines the final shape of the object. The appearance of the Scumak sculptures is due not only to the different colors of polyethylene used (each series is distinguished by an electric hue of red, green, pink, or blue) but also to different settings for heat, duration of dispersal, and cooling time, all of which affect the way the successive layers of the material take form. Their appearance is also affected by environmental conditions—humidity, external temperature, and the like. The resulting sculptures are surprisingly evocative. Some suggest melted wax, others overly frosted confections, while still others allude to sagging body parts and cavities or elaborately wrapped bundles. The viewer may even imagine cloaked figures or mysterious lava caverns. This diversity of form demonstrates Paine's larger point: despite the care with which he programs his machines, the resulting art works inevitably take form through variables too complex for the artist to control. This is true whether they erode sandstone, make ink drawings, or create thick monochrome paintings. The process is automated, but not standardized, and as with language itself, they suggest that no complex system is completely within human control.

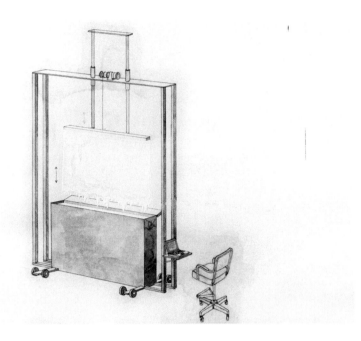

Paint Dipper creates paintings by repeatedly dipping a raw canvas into a vat filled with eighty gallons of specially formulated acrylic paint. A computer controls an orchestrated sequence of actions necessary to complete each "dip." First, a motor opens the lid that covers the paint (to keep it from drying out). Next, a motor lowers the painting to an exactly programmed position within the vat, which varies with each dip. The time that it remains in the vat affects the strength of the resulting line. Next the painting is raised up and when most of the excess paint has dripped into the empty vat, the lid is closed and the machine goes into "dry mode," allowing the paint film to dry so that subsequent layers will adhere properly. Drying time varies from one and one-half to five hours. Each painting is dipped from 50 to 180 times. Each dip is recorded on the painting's surface in sequence, as a horizontal line, so that the resulting painting exhibits a clear history of its own making. —R. P.

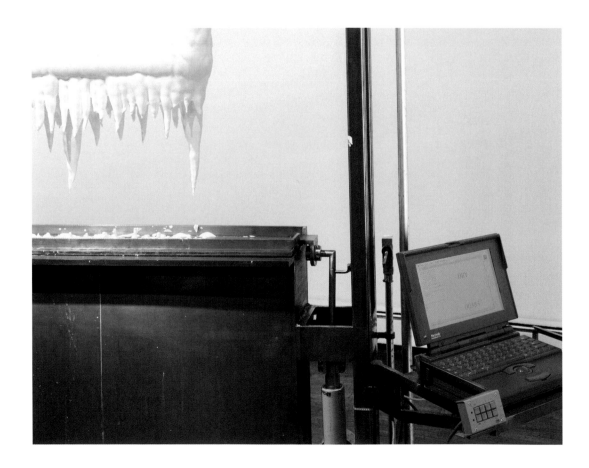

Top: Drawing for **Paint Dipper**, 1996; bottom and opposite: **Paint Dipper**, 1997

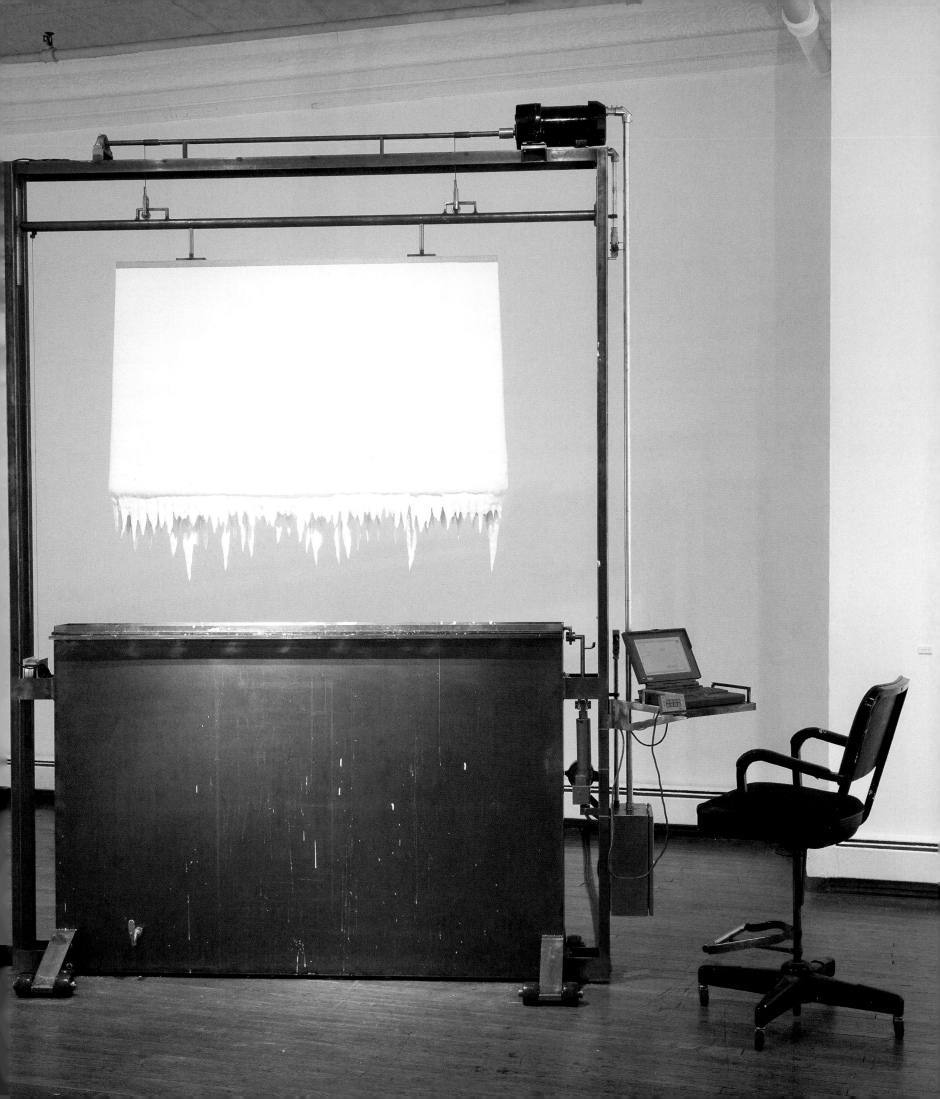

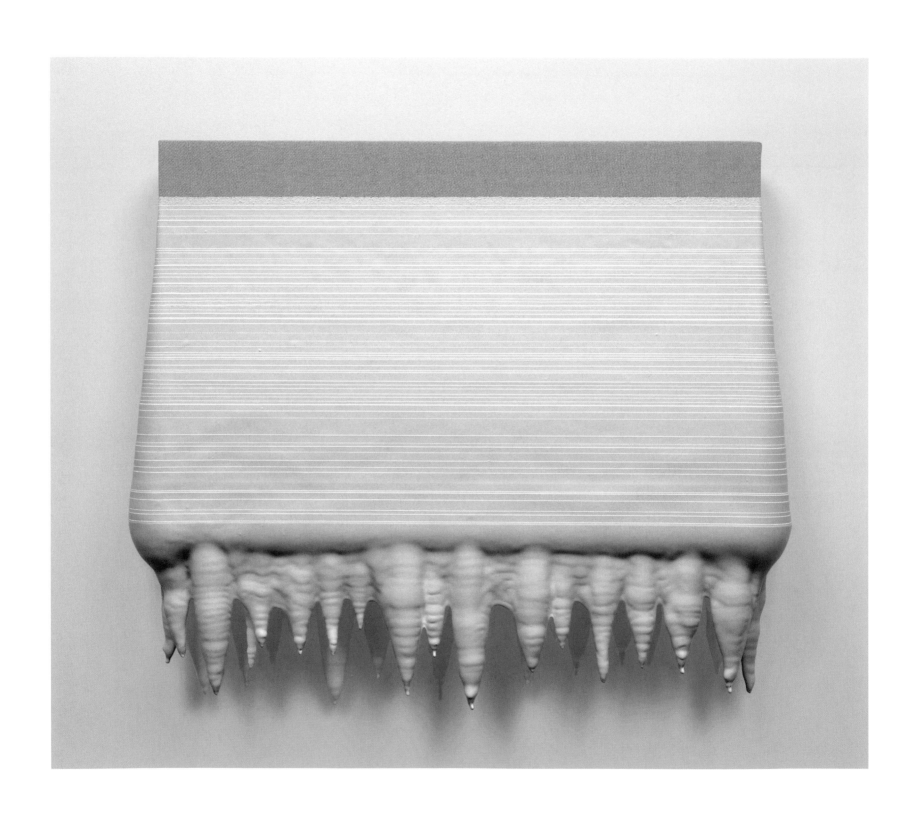

9405282002A, 2002; opposite, clockwise from top left: **17499112002A**, **17499112002B**, **17499112002C**, **17499112002D**, all 2002

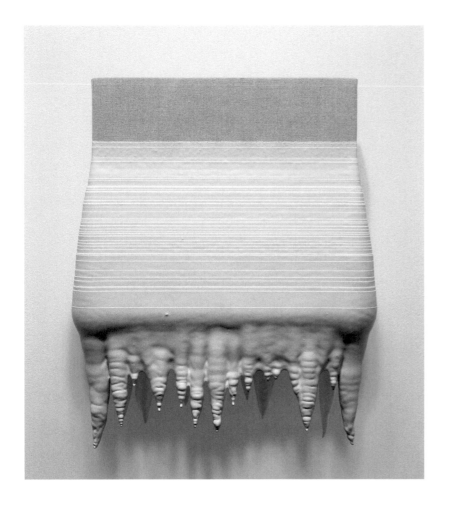
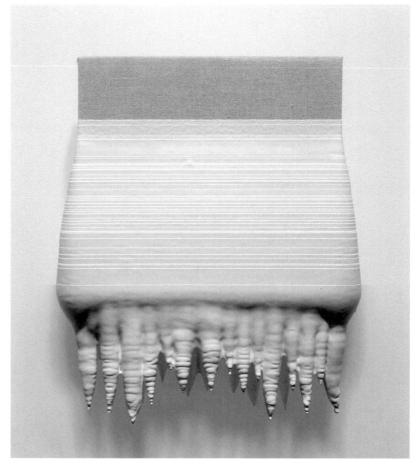
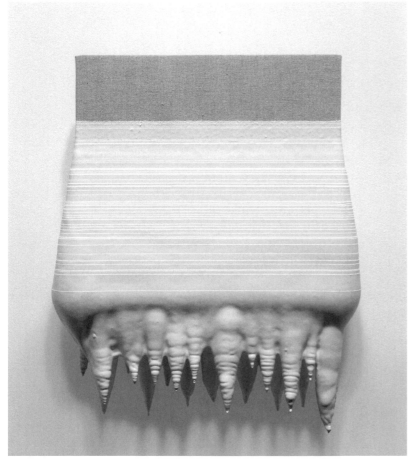
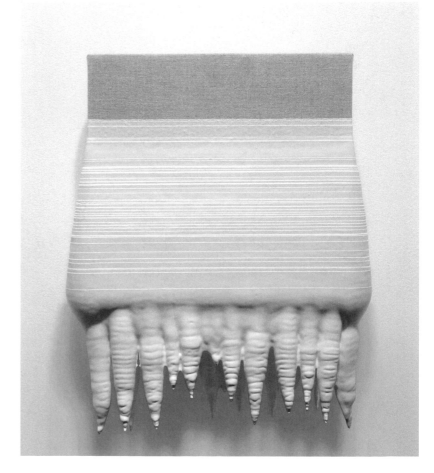

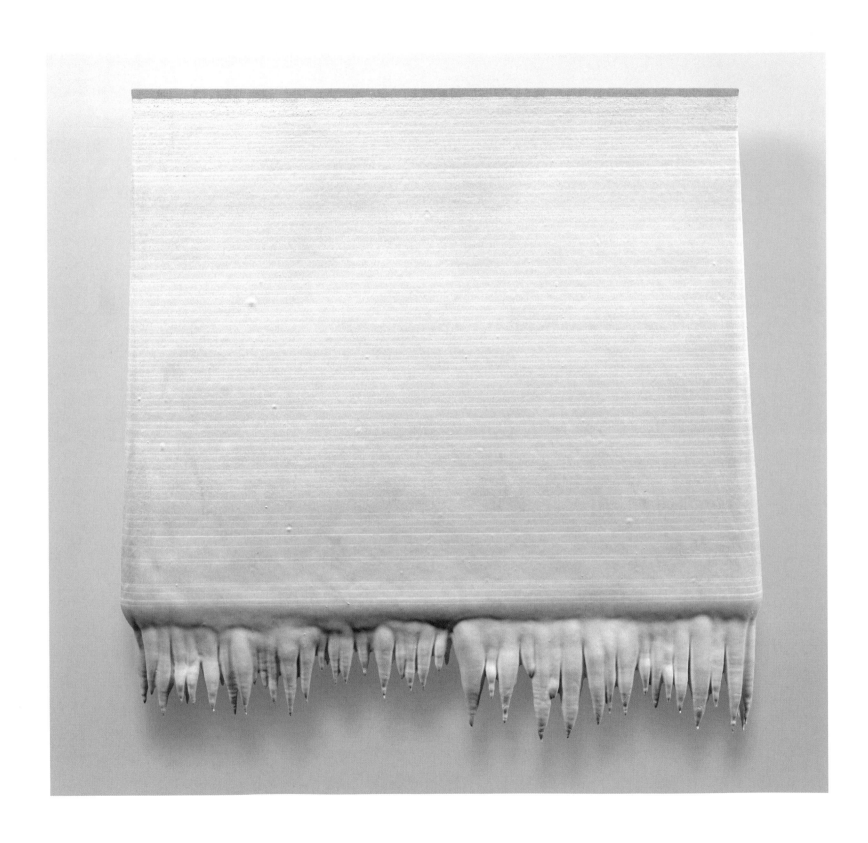

15127101997B, 1997

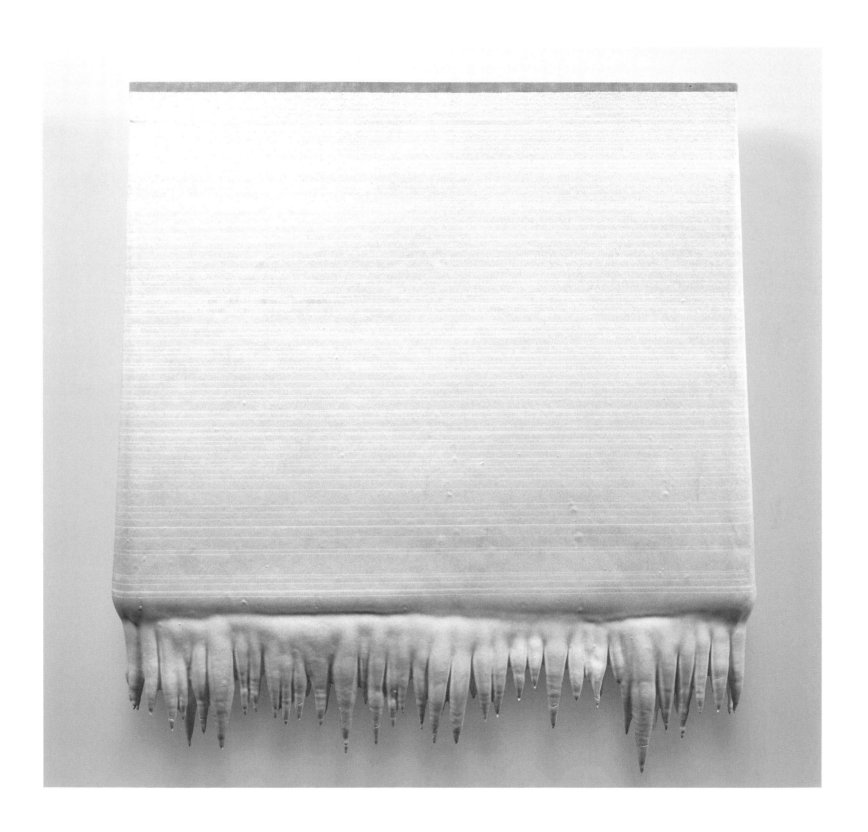

15127101997A, 1997 81

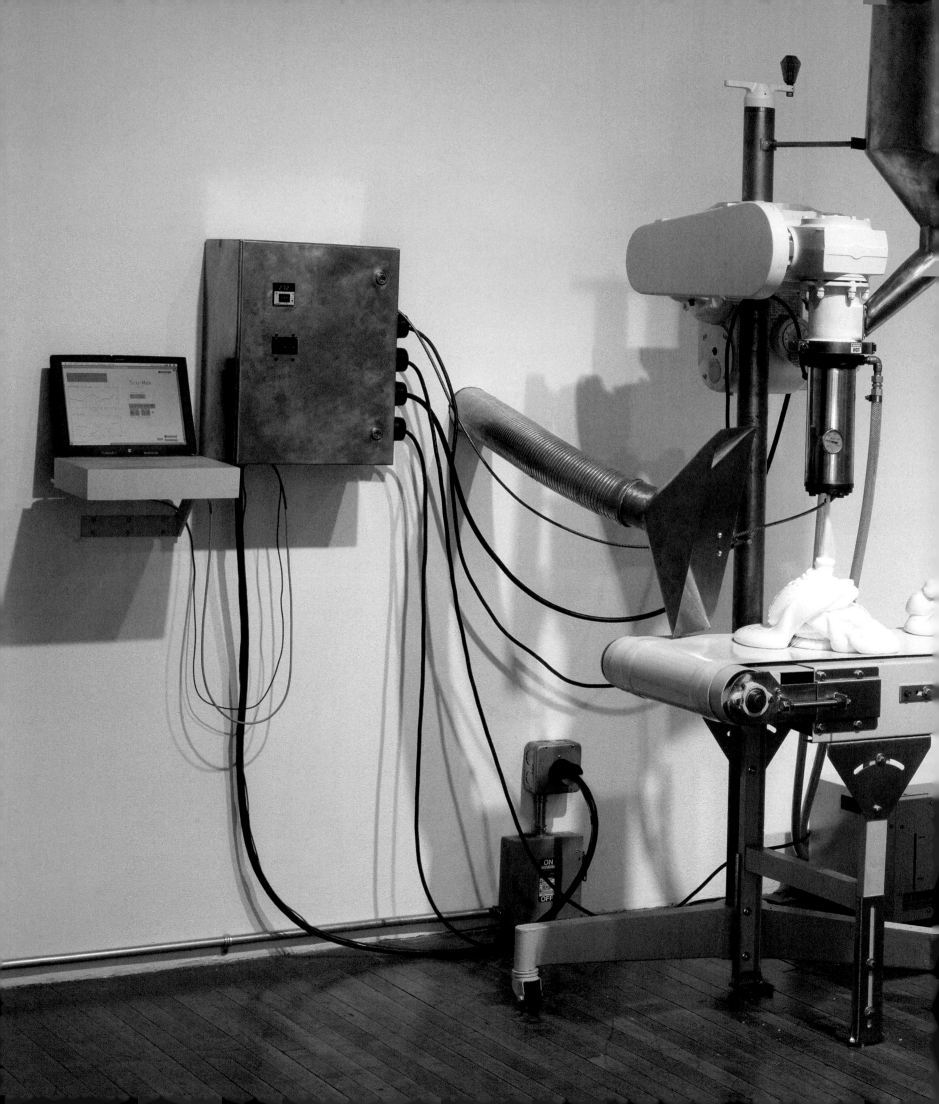

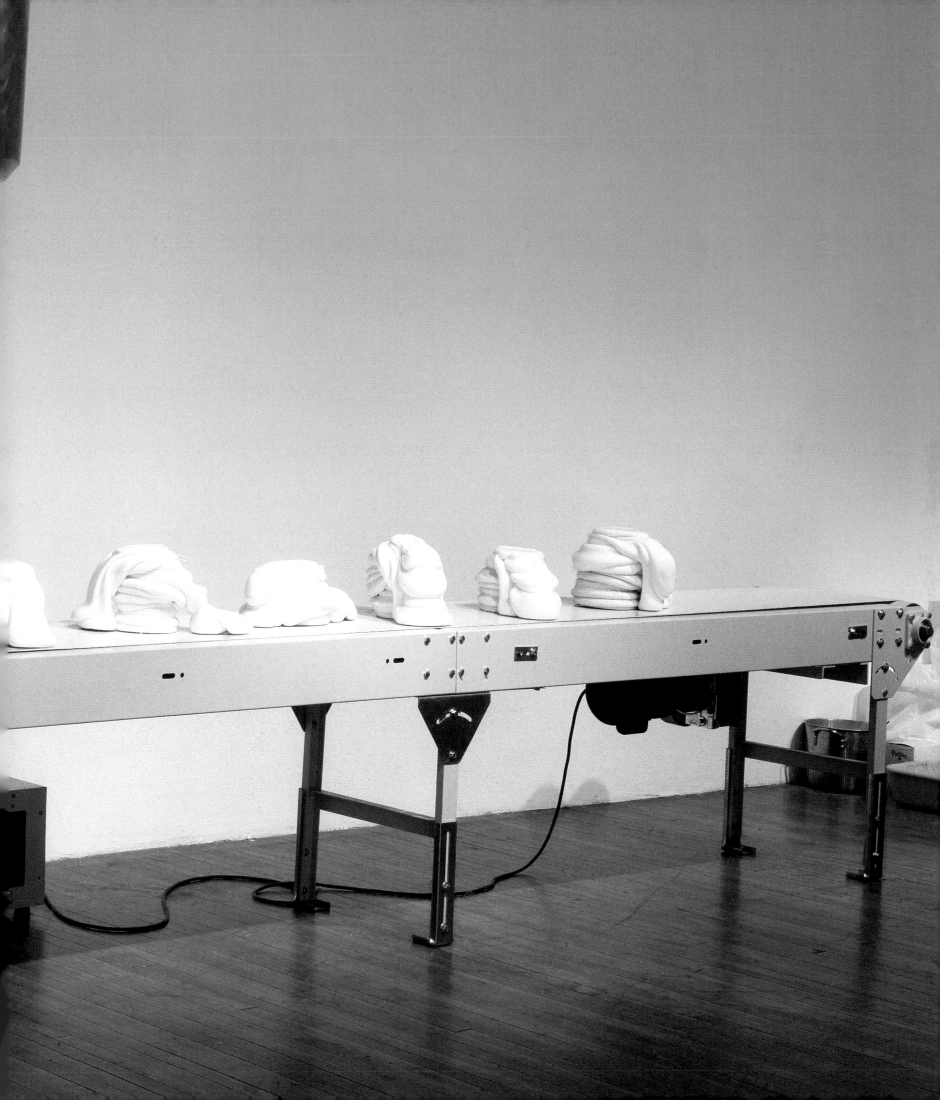

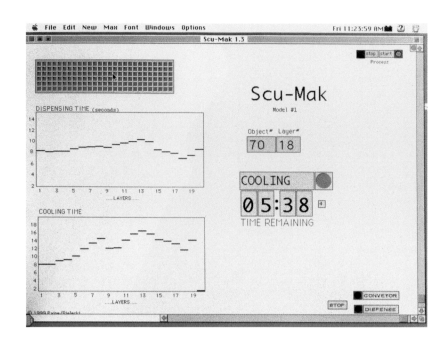

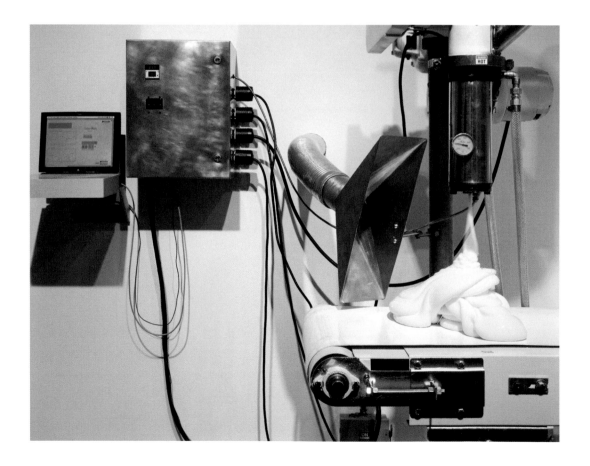

Pages 82–83 and 84, bottom: **SCUMAK (Auto Sculpture Maker)**, 1998; top: program controlling sculpture-making process

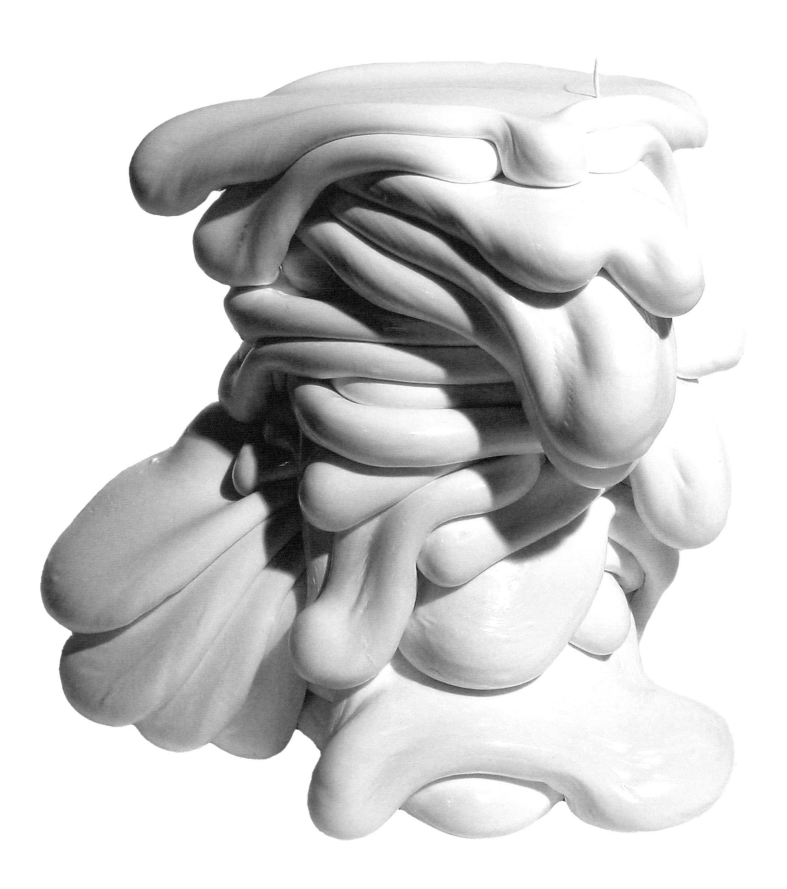

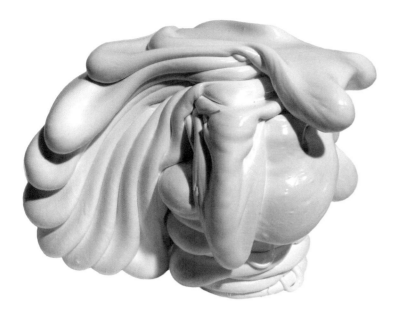
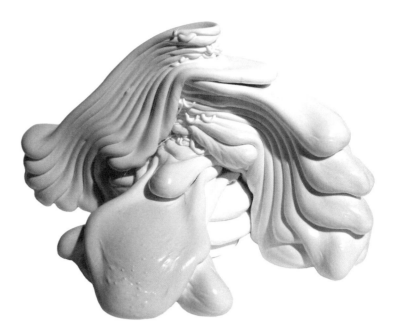
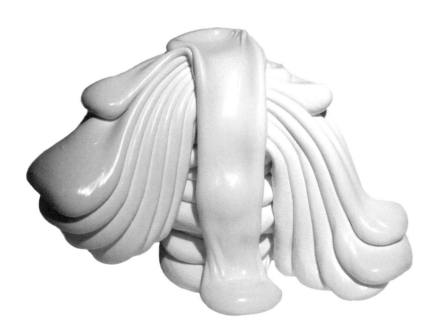
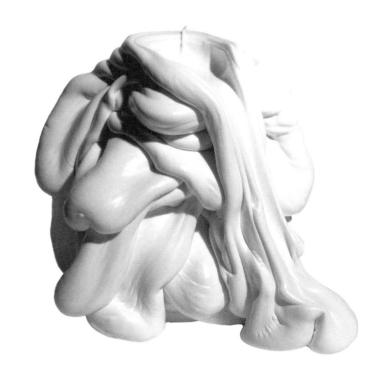

Clockwise from top left: **S1-P2-W1**, **S1-P2-W2**, **S1-P2-W30**, **S1-P2-W4**, all 2000

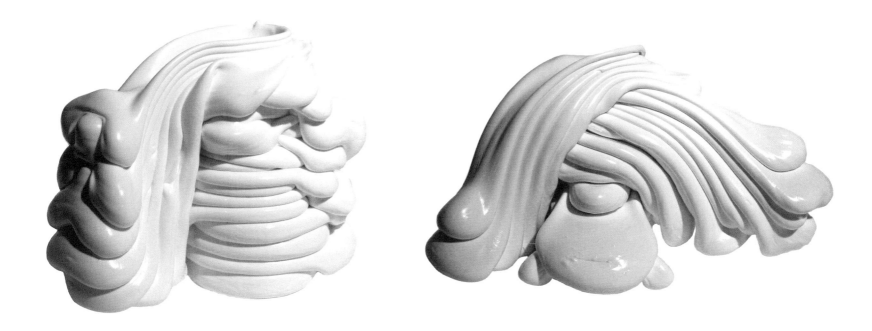

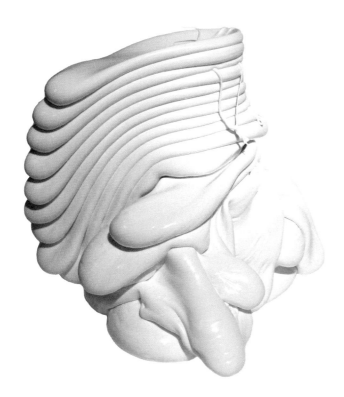

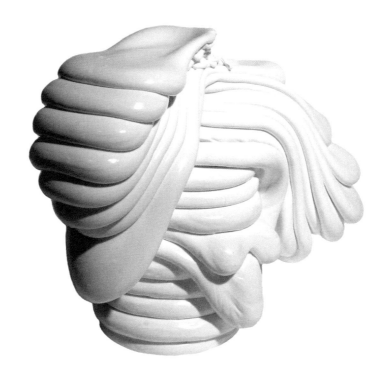

Clockwise from top left: **S1-P2-W6, S1-P2-W8, S1-P2-W33, S1-P2-W14,** all 2000 87

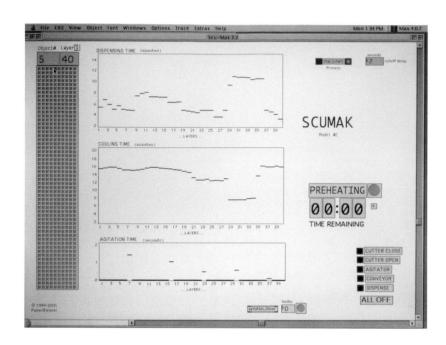

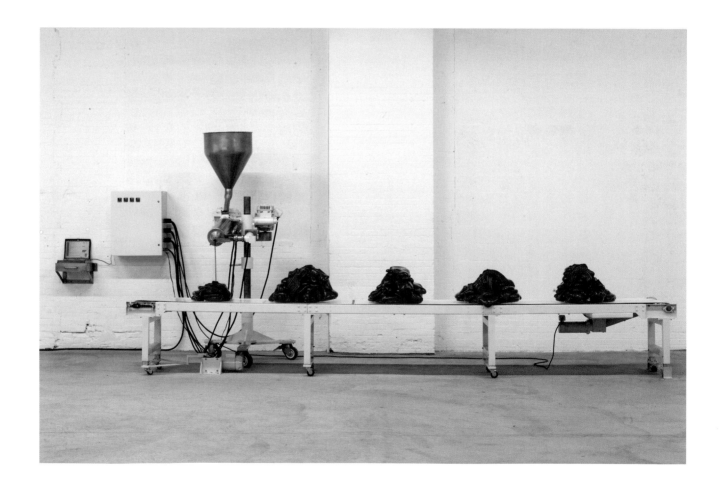

SCUMAK No. 2, 2001; above: program controlling sculpture-making process

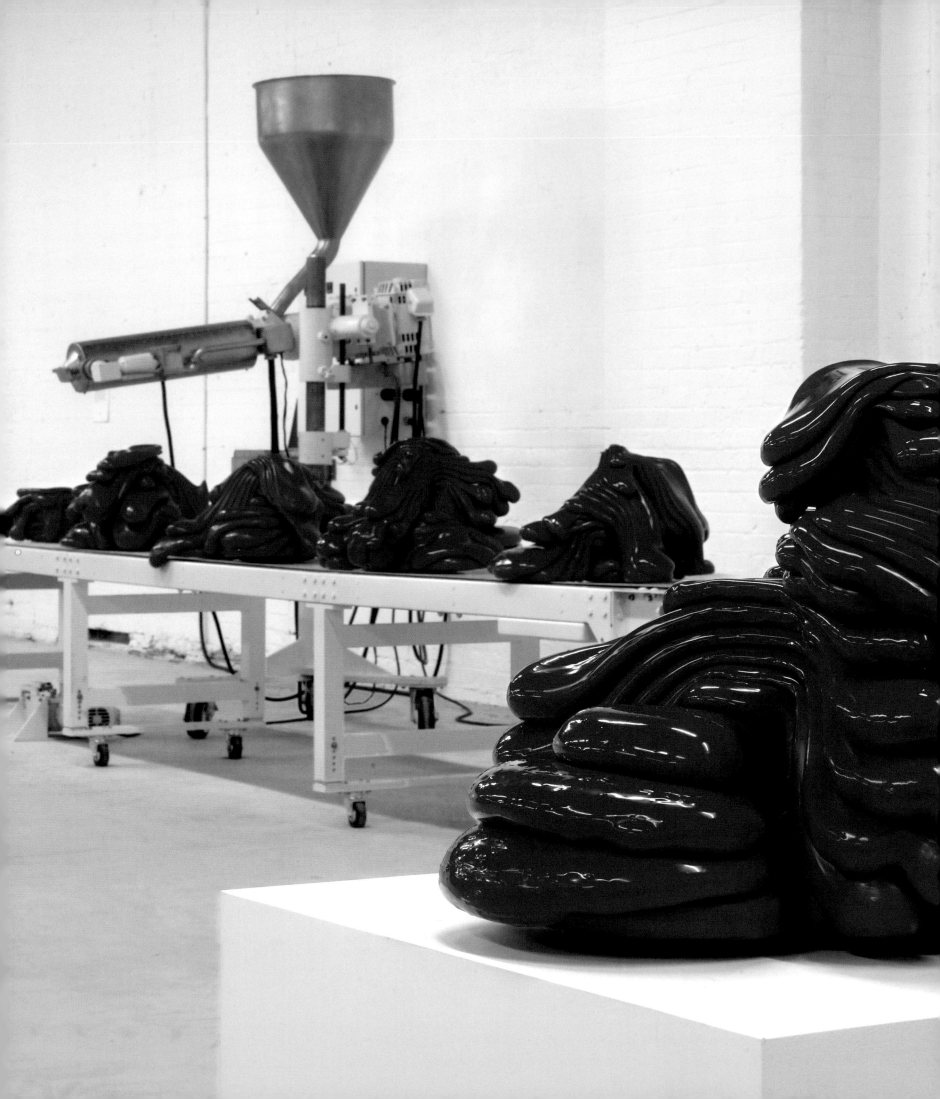

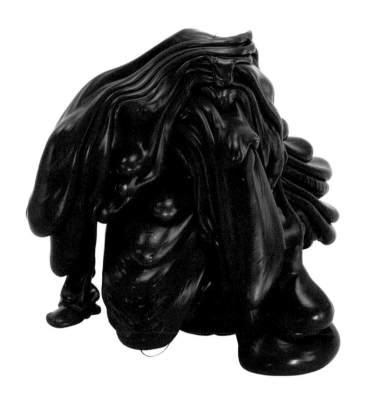
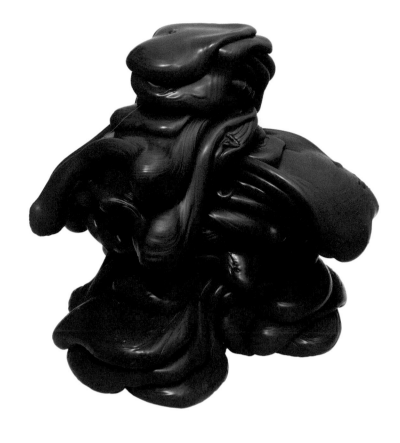
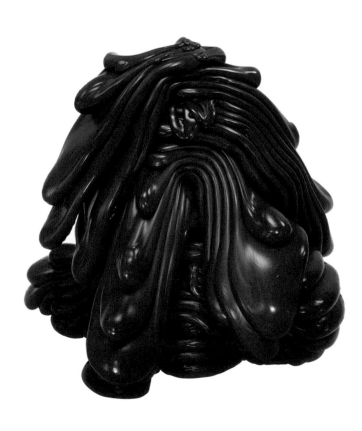
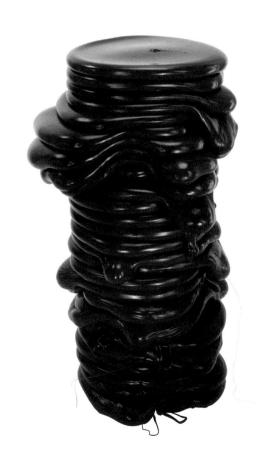

90 Clockwise from top left: **S2-P2-M19**, **S2-P2-024**, **S2-P2-M30**, **S2-P2-M6**, all 2003

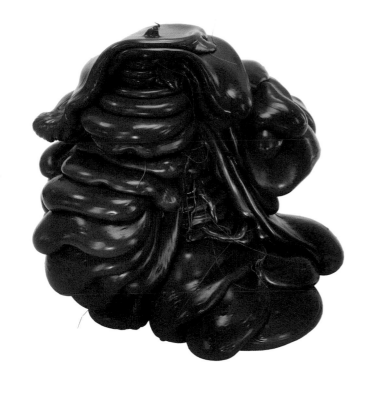

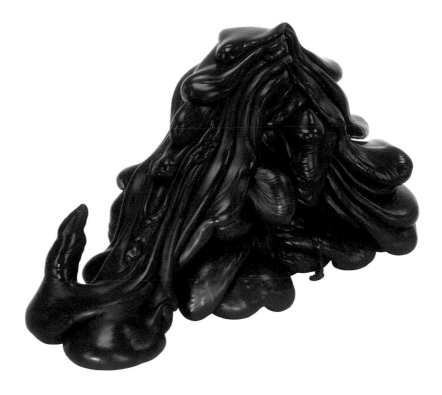

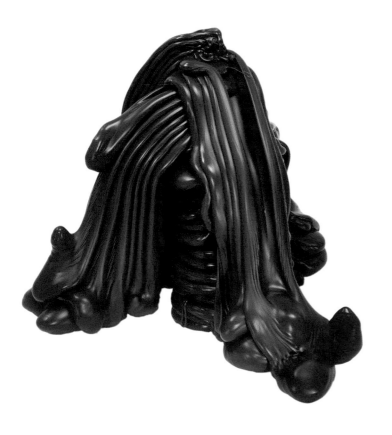

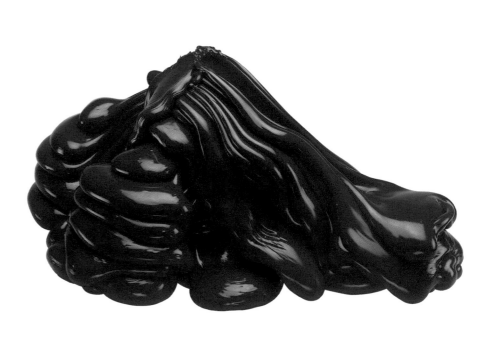

Clockwise from top left: **S2-P2-M19**, 2003; **S2-P2-M10**, 2003; **S2-P2-M28**, 2003; **S2-P2-CR20**, 2007 91

DM No. 9A, 2003

DM No. 7A, 2003

Damn A, 2002

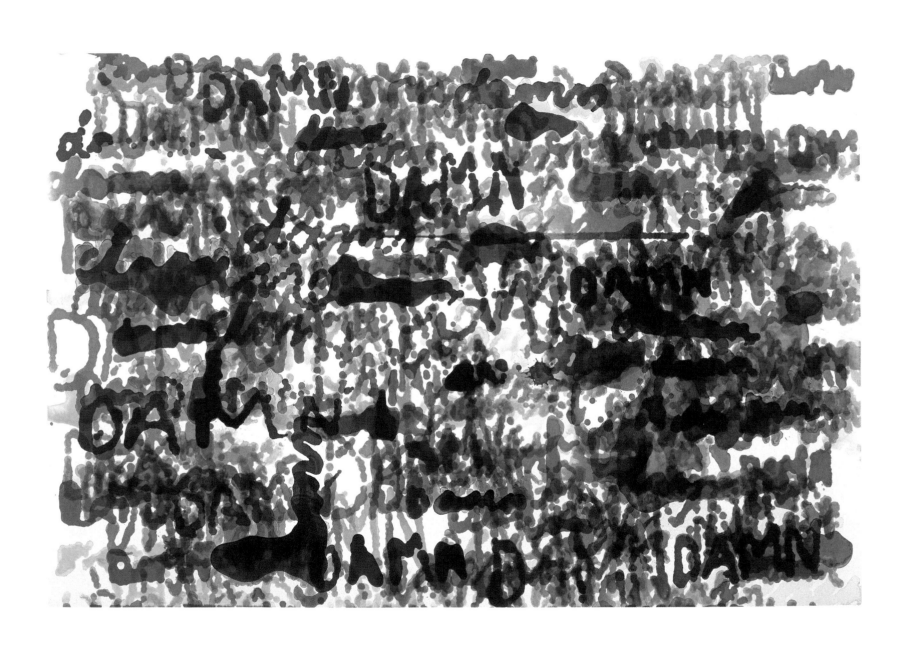

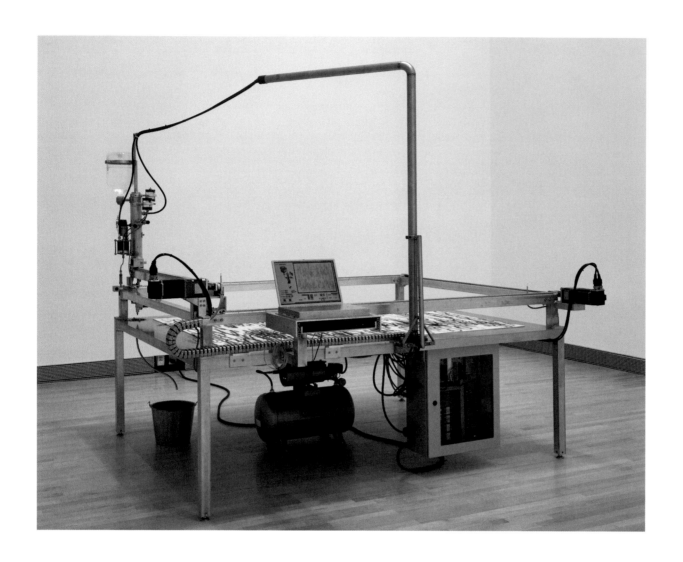

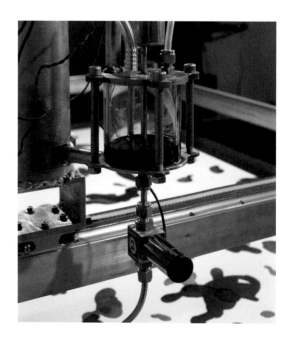

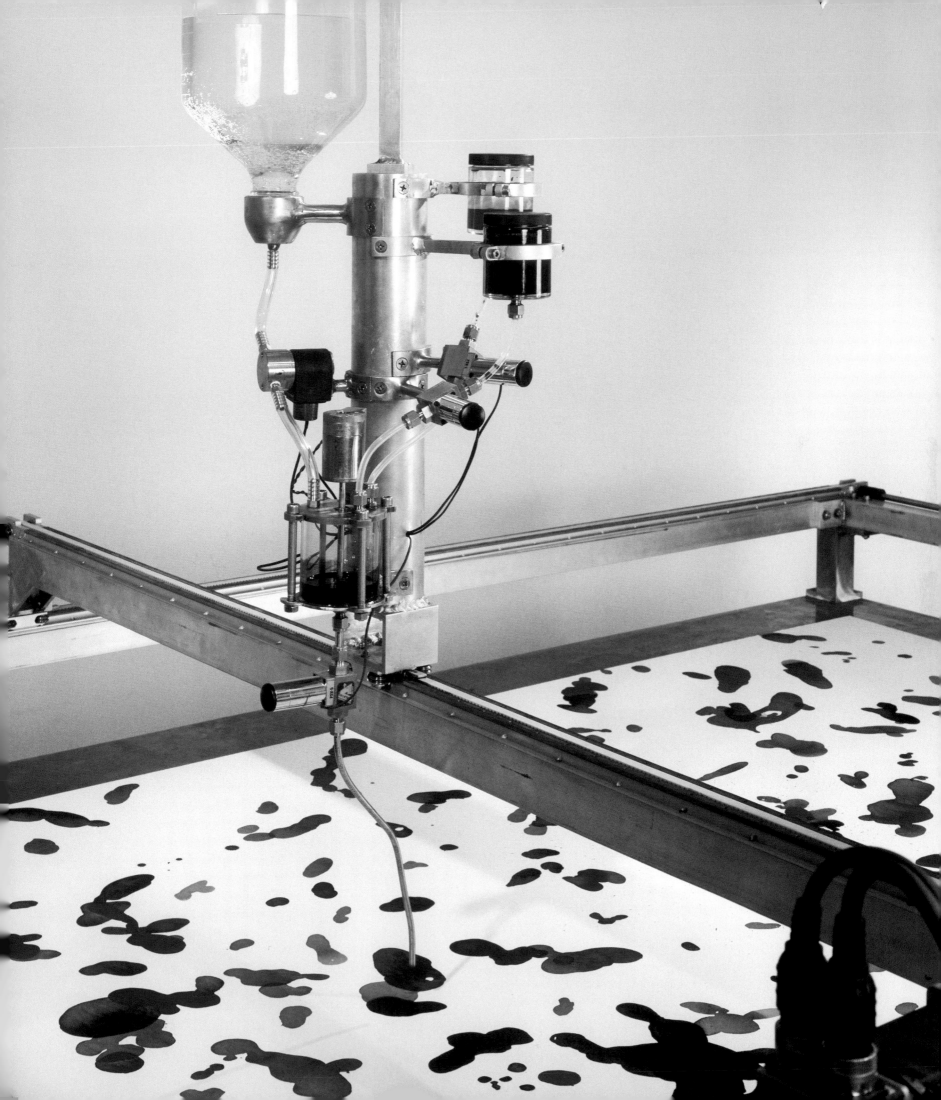

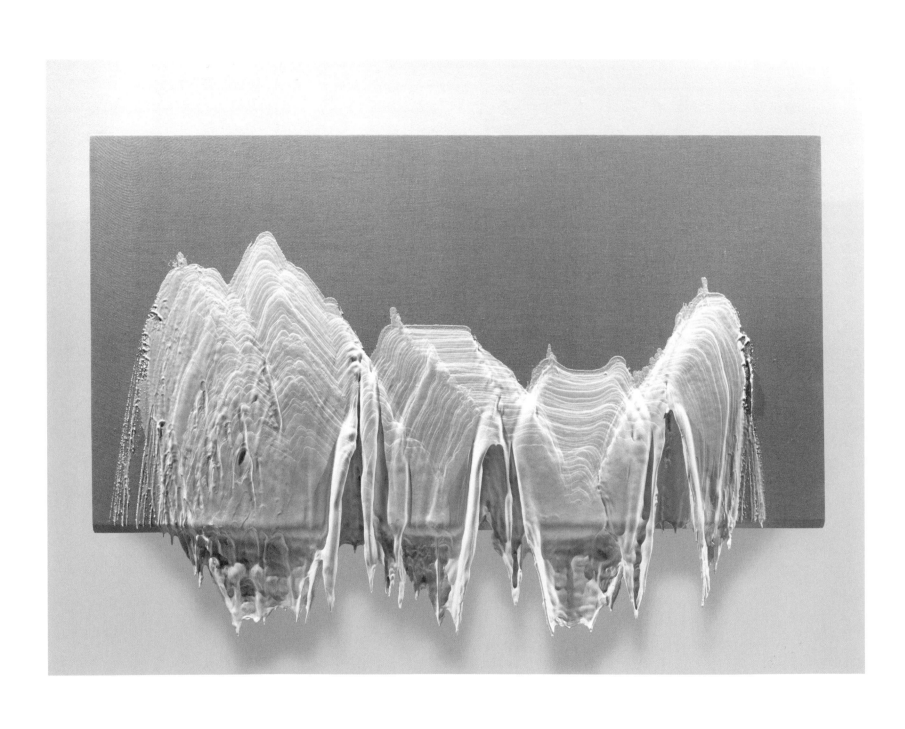

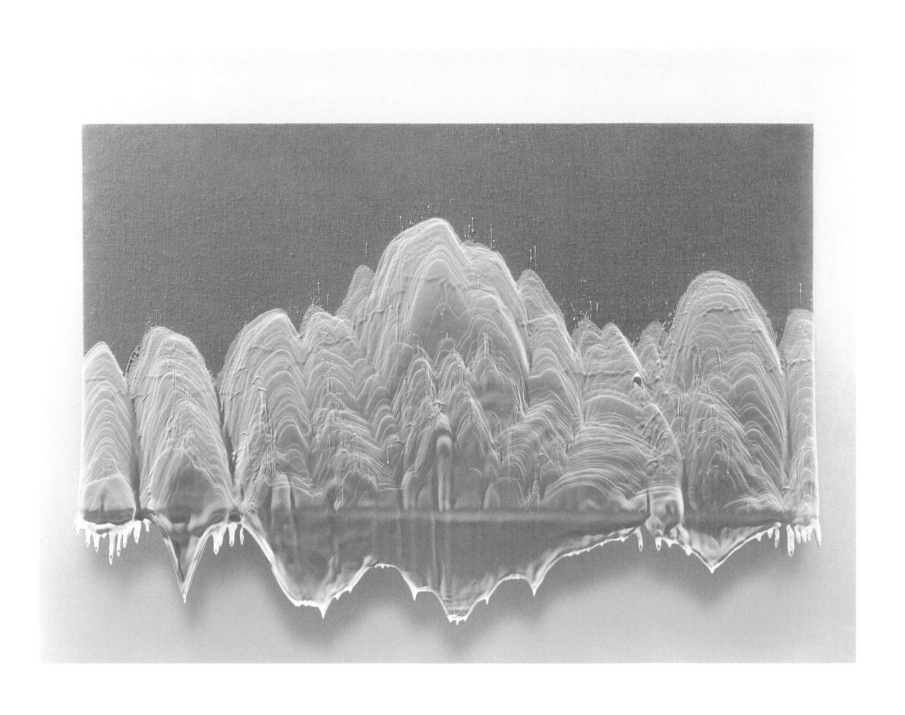

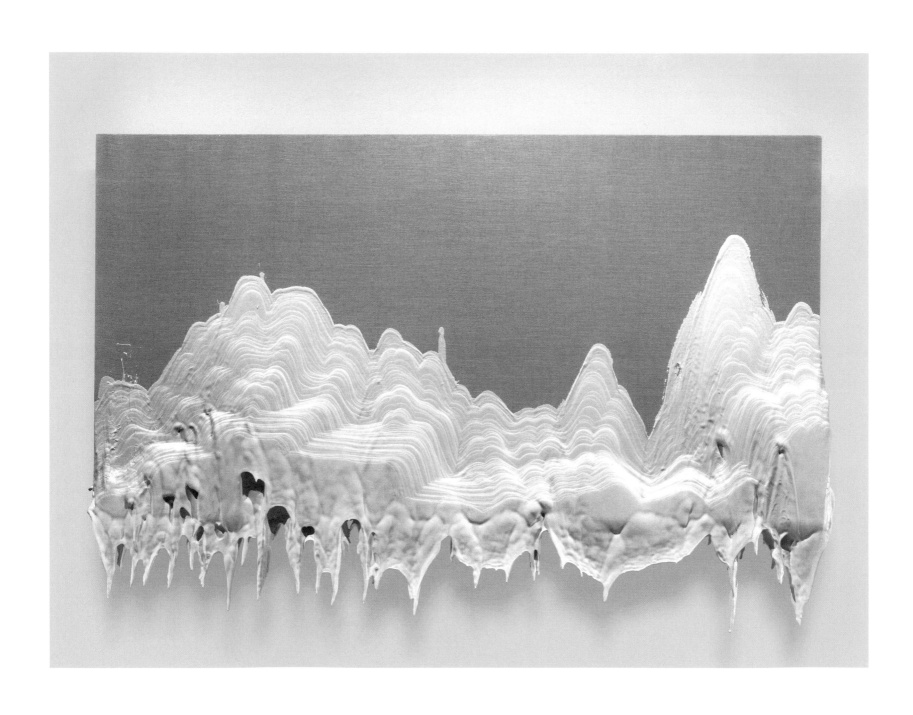

PMU No. 27, 2006

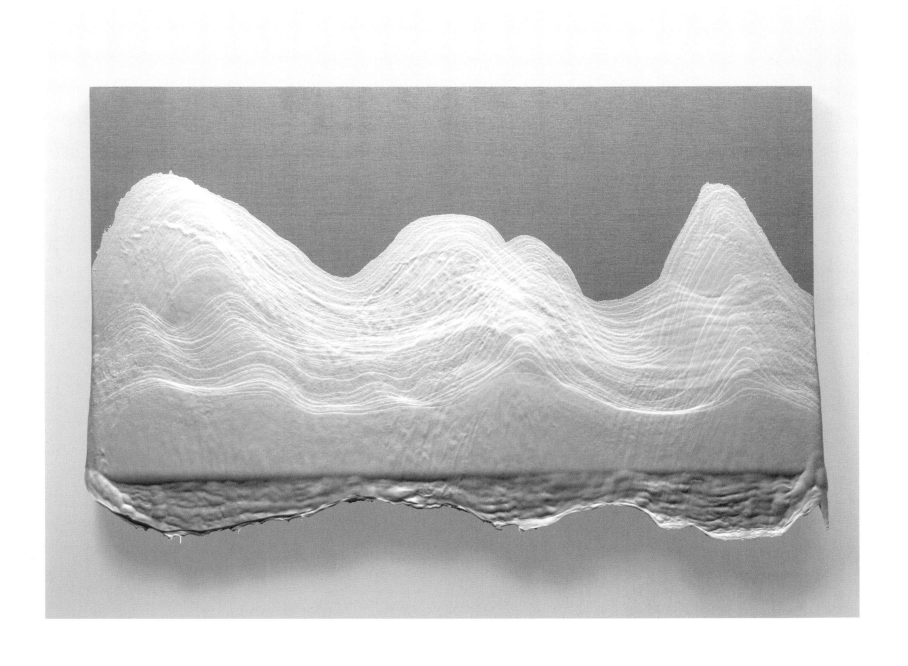

PMU No. 8, 2002; pages 104–5: PMUs with screen shots of the data used to generate the paintings. Page 104, top: **PMU No. 10**, 2002; middle: **PMU No. 20**, 2005; bottom: **PMU No. 6**, 2001. Page 105, top: **PMU No. 31**, 2007; middle: **PMU No. 12**, 2003; bottom: **PMU No. 28**, 2006

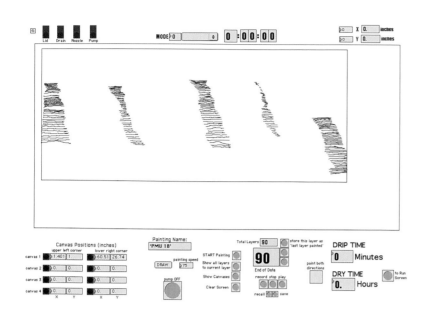
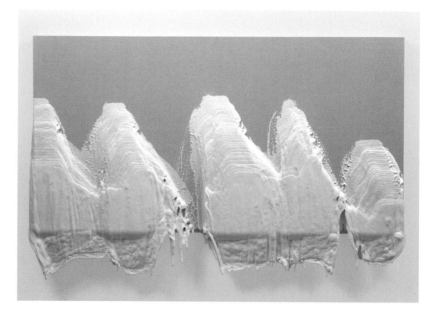

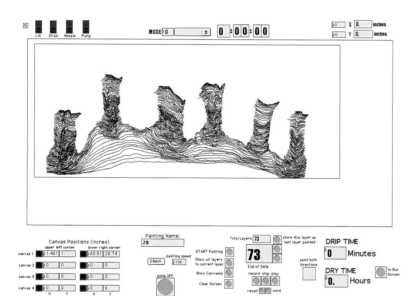
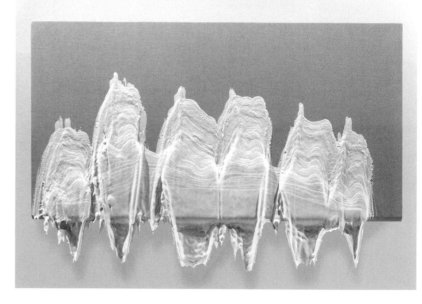

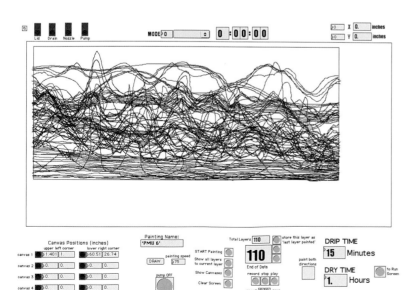
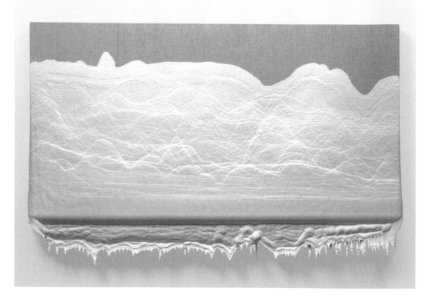

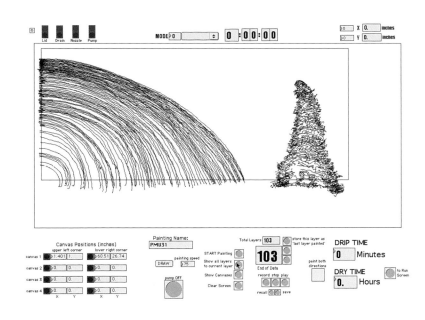
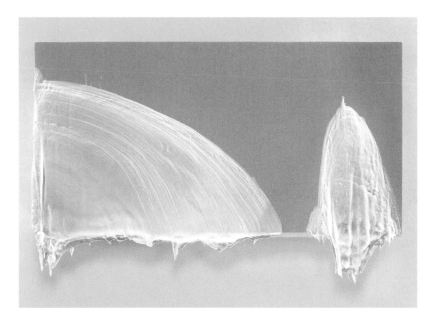
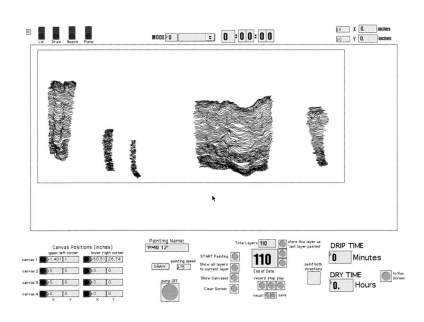
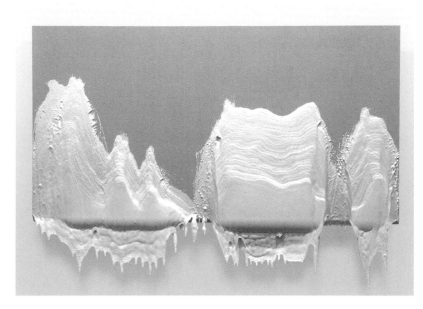
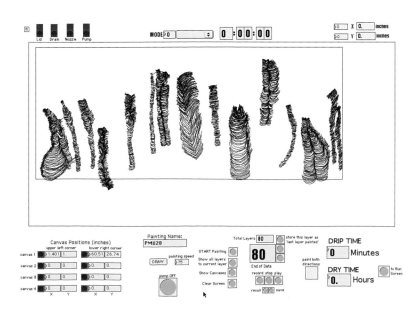
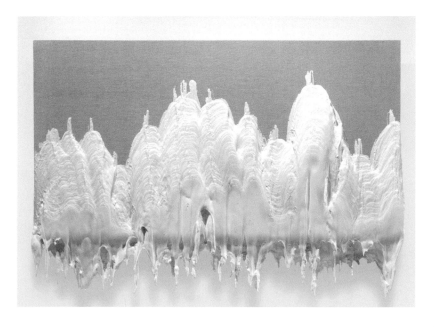

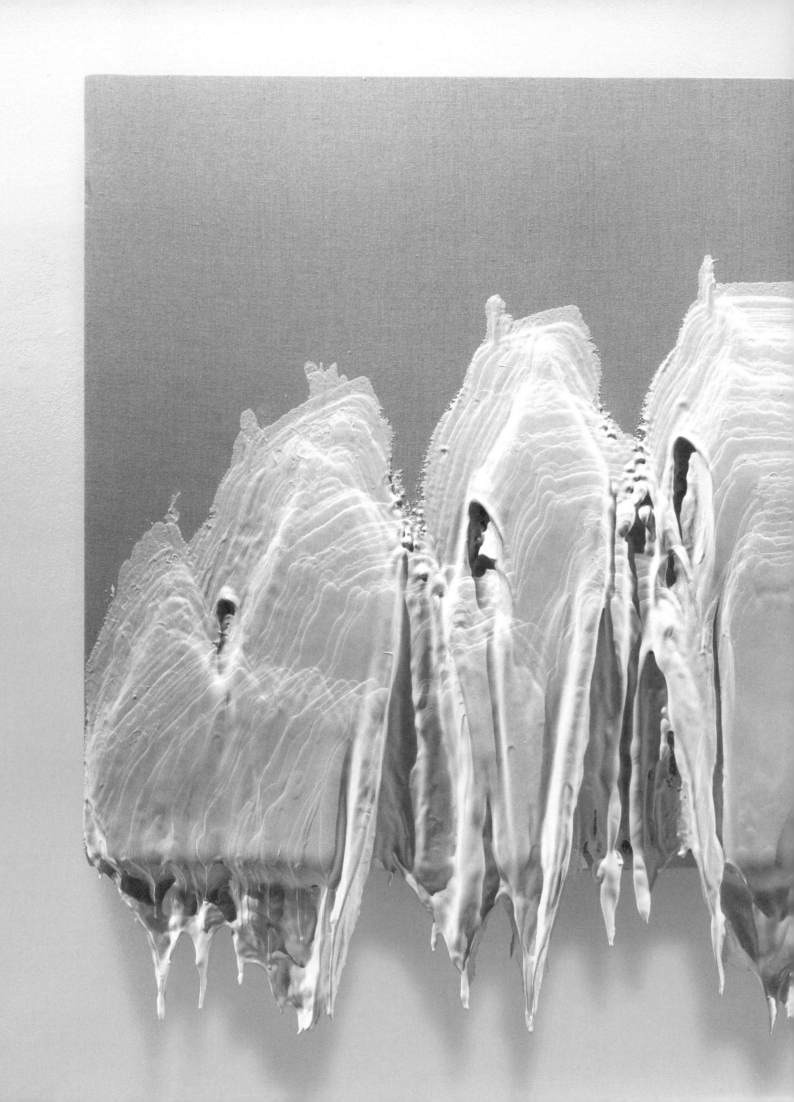

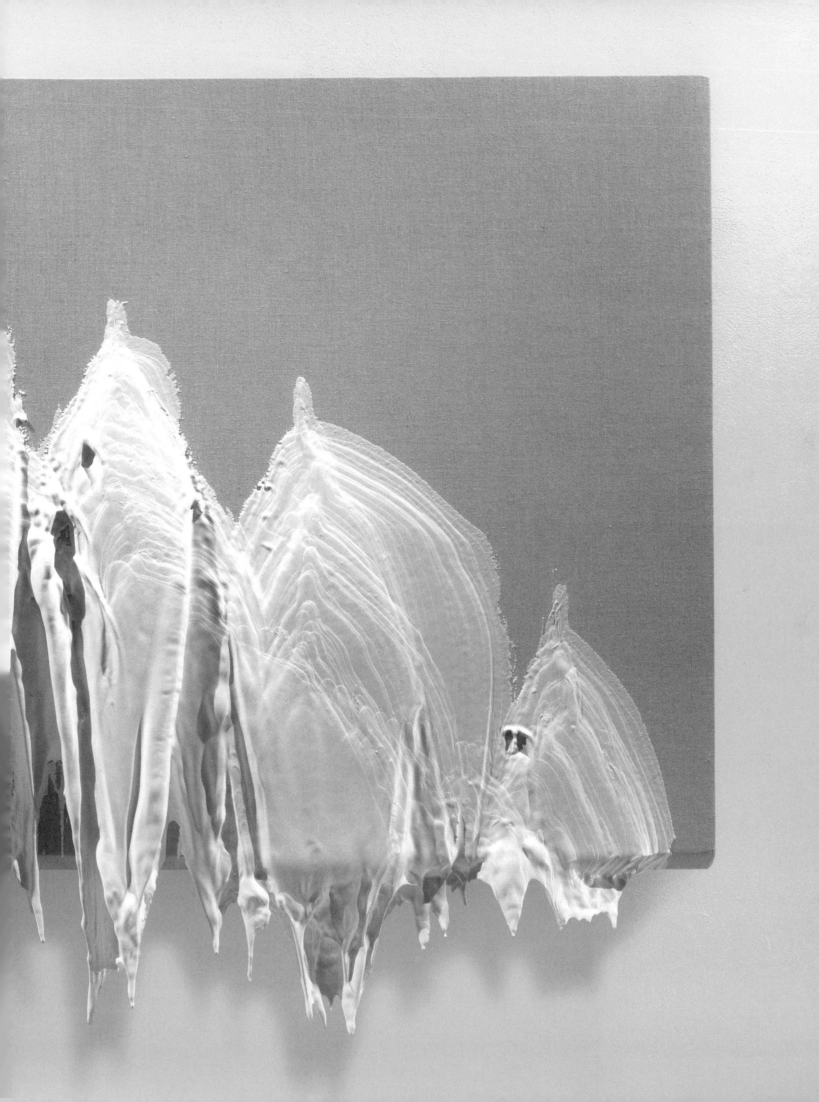

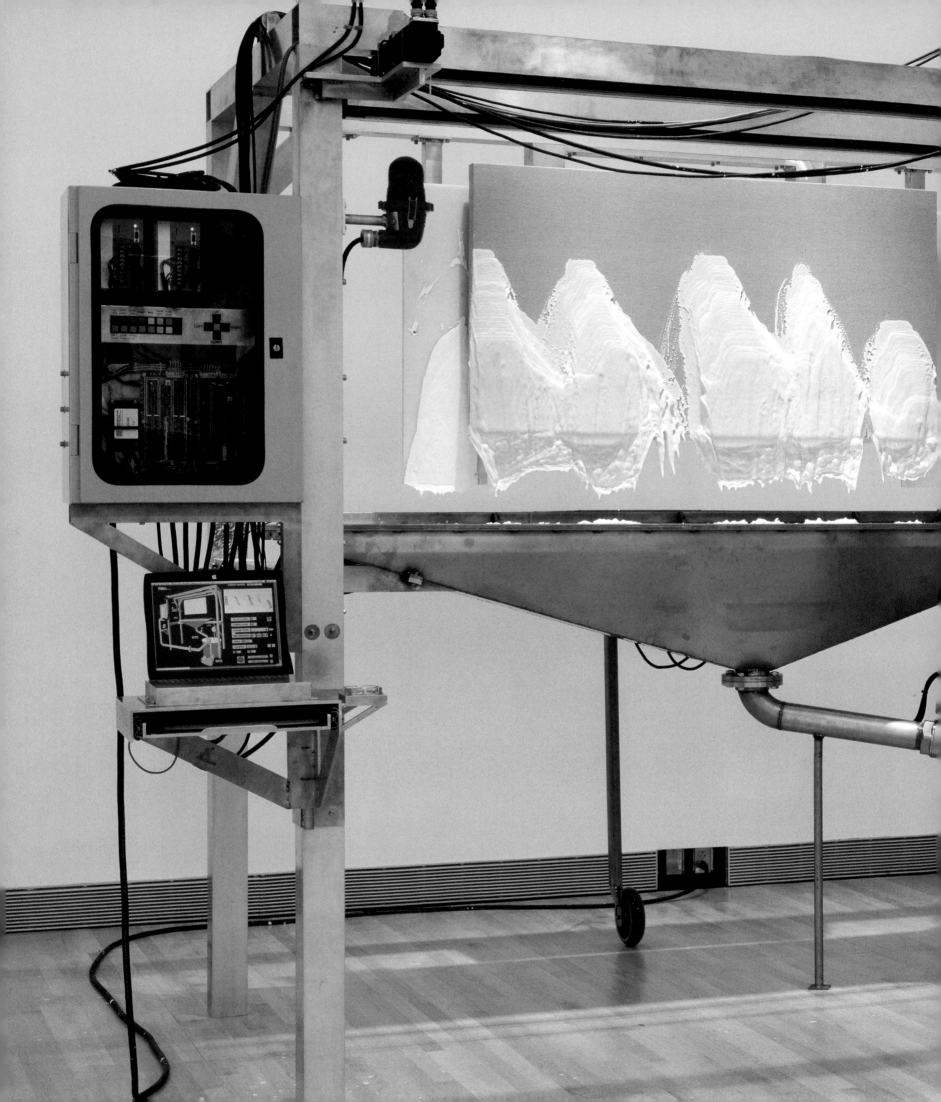

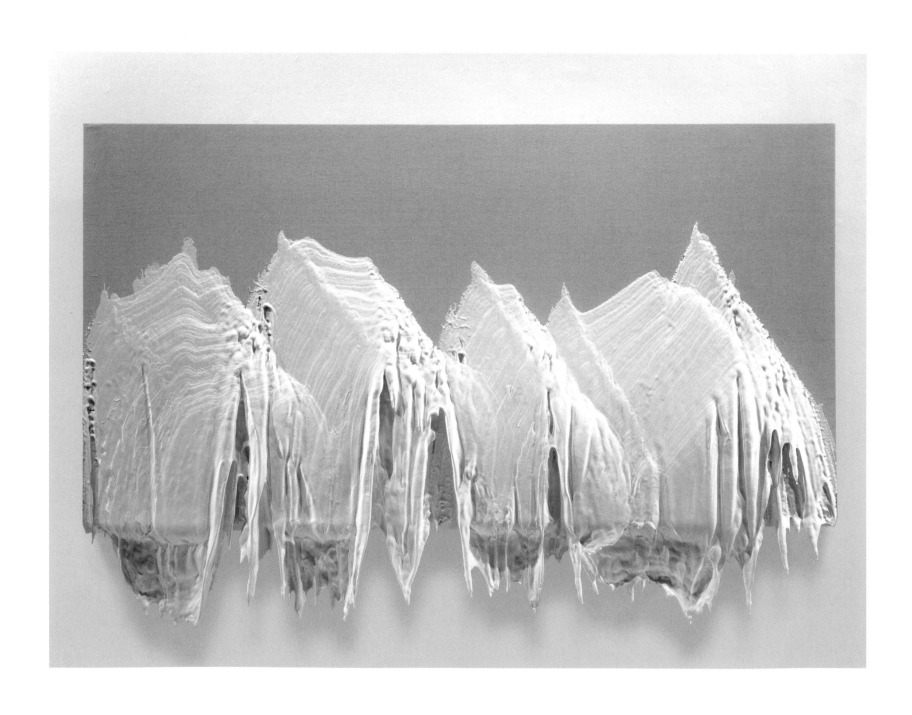

PMU No. 18, 2005; pages 106–7: PMU No. 17, 2005; pages 108–9: Painting Manufacture Unit, 1999–2000

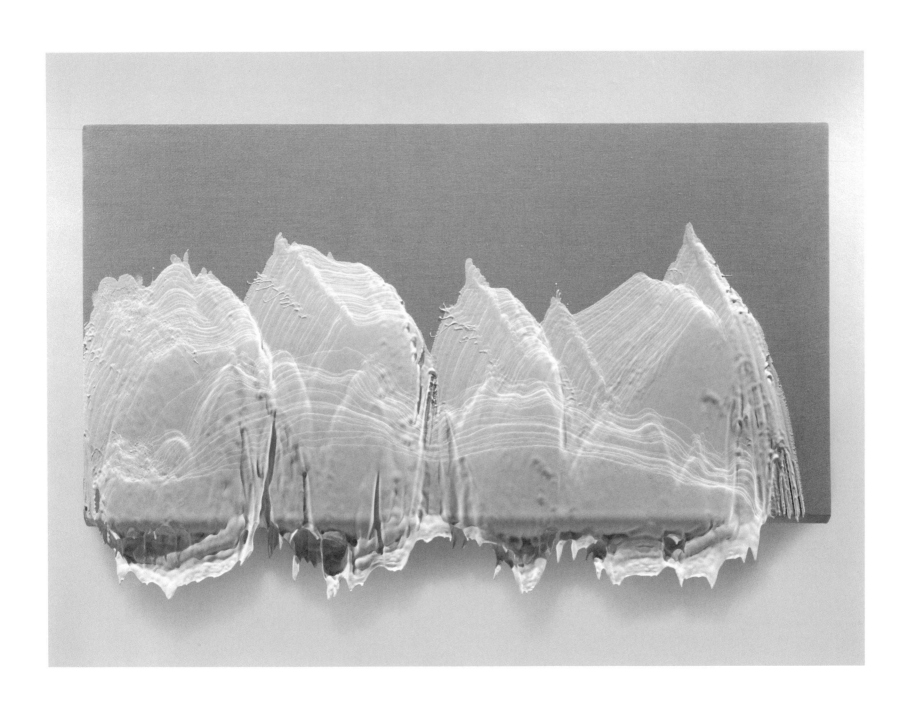

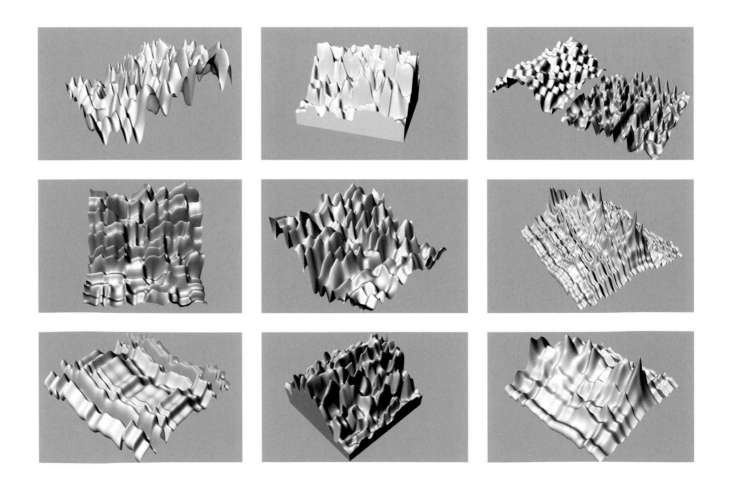

112 Top: Studies for **Erosion Machine**, 2004; bottom: renderings for **Erosion Machine**; opposite and pages 114–15 and 116–17: **Erosion Machine**, 2005

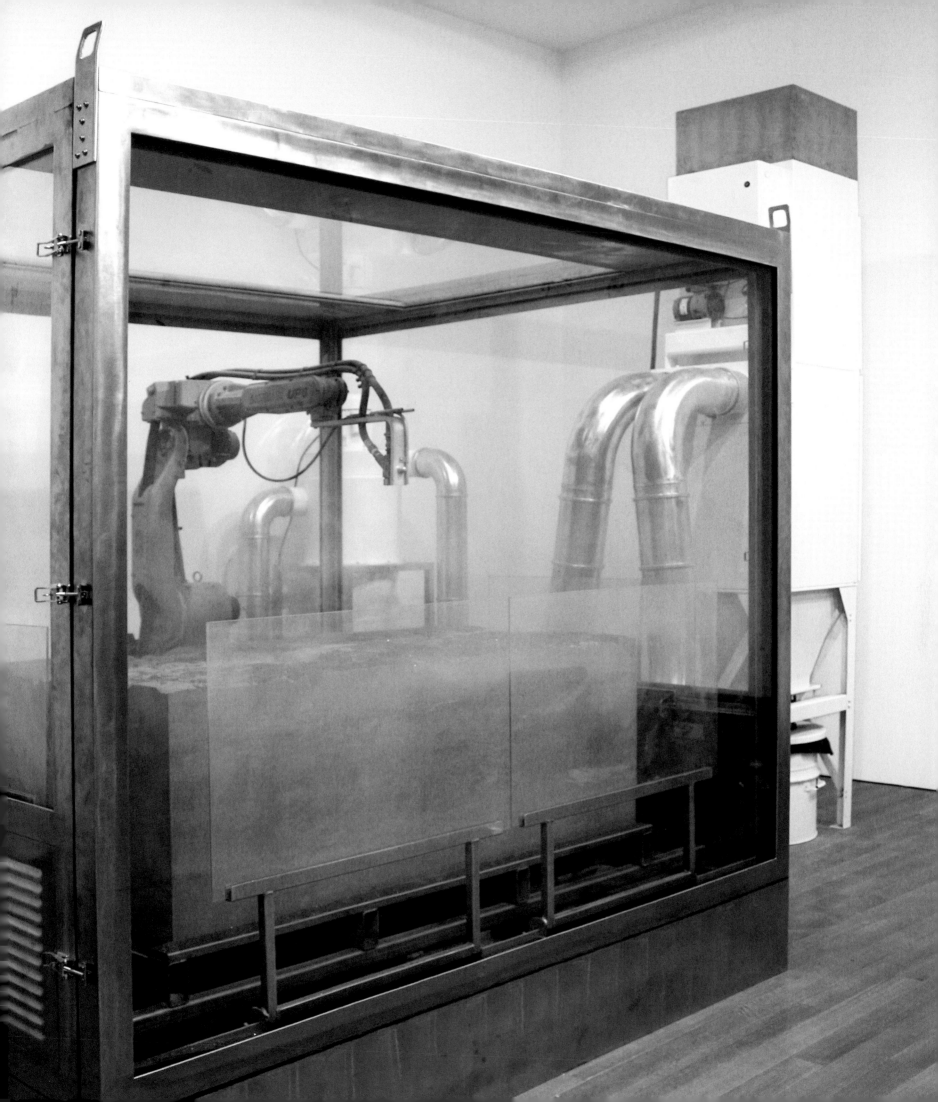

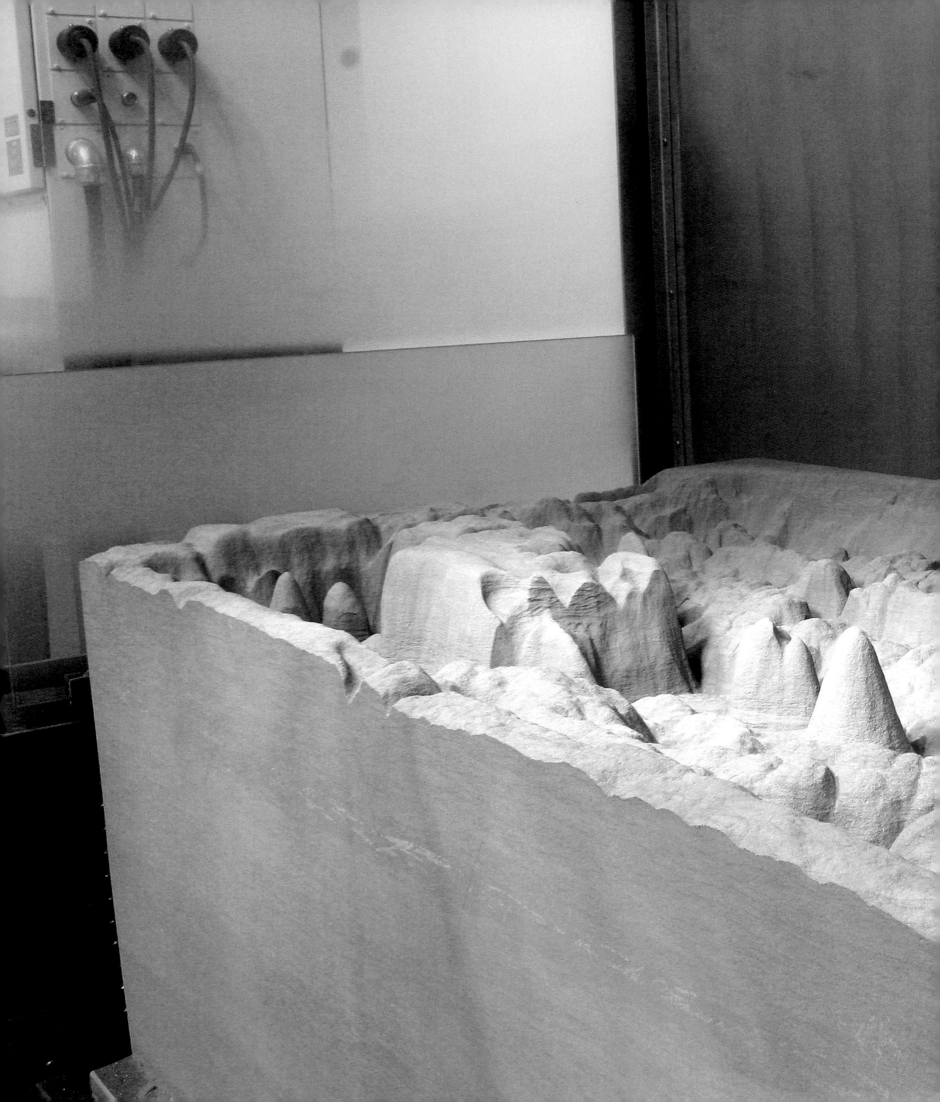

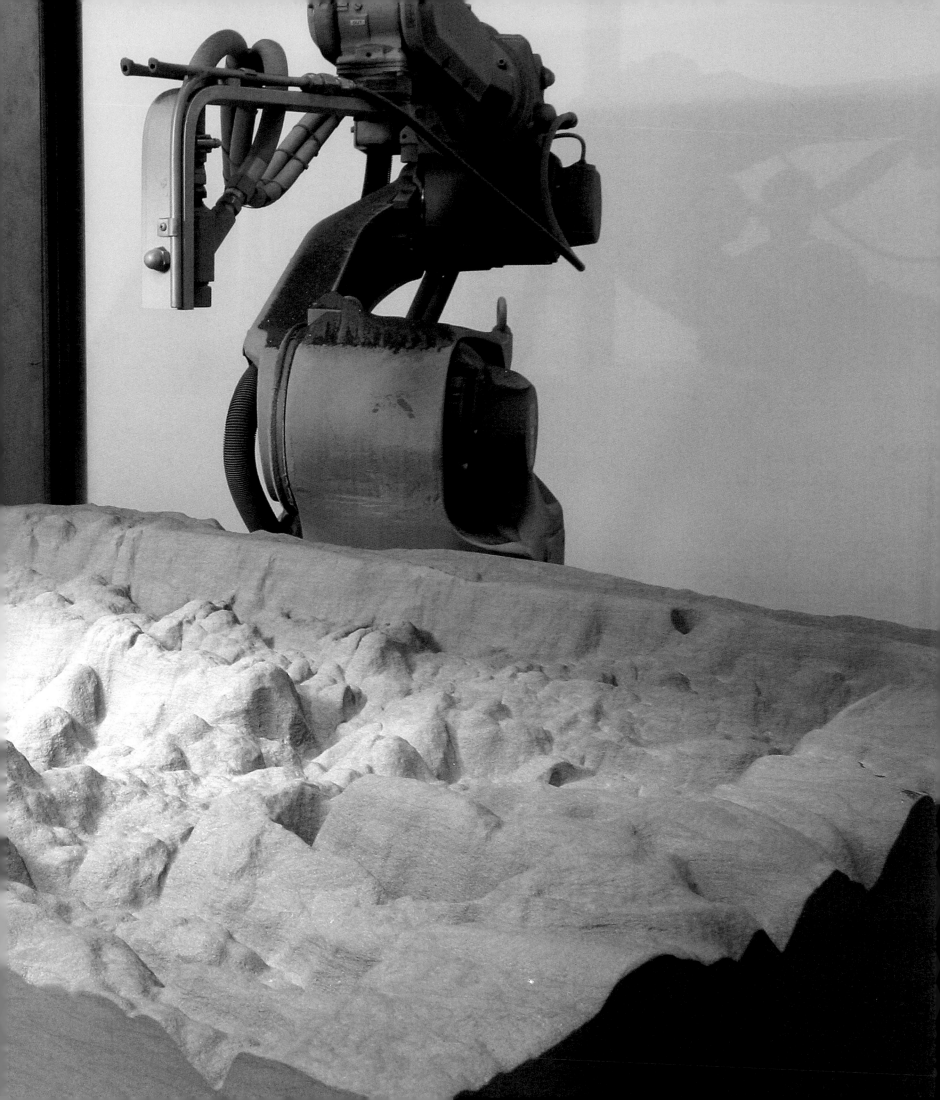

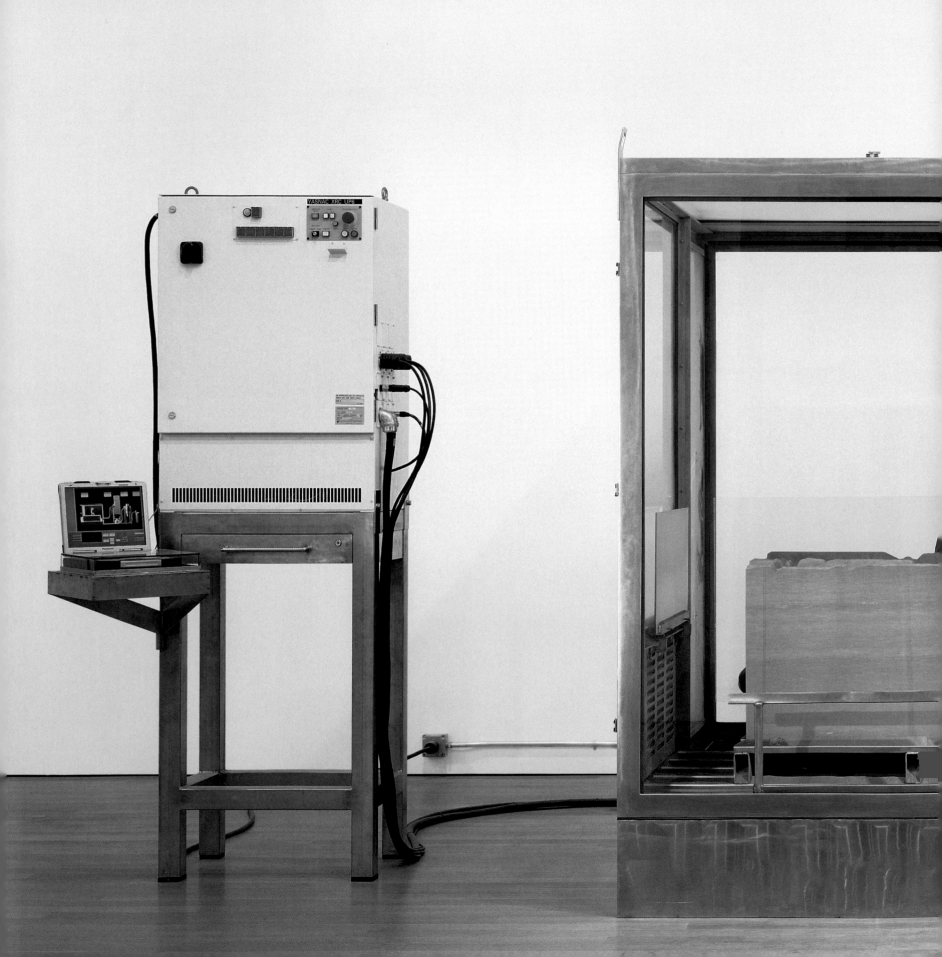

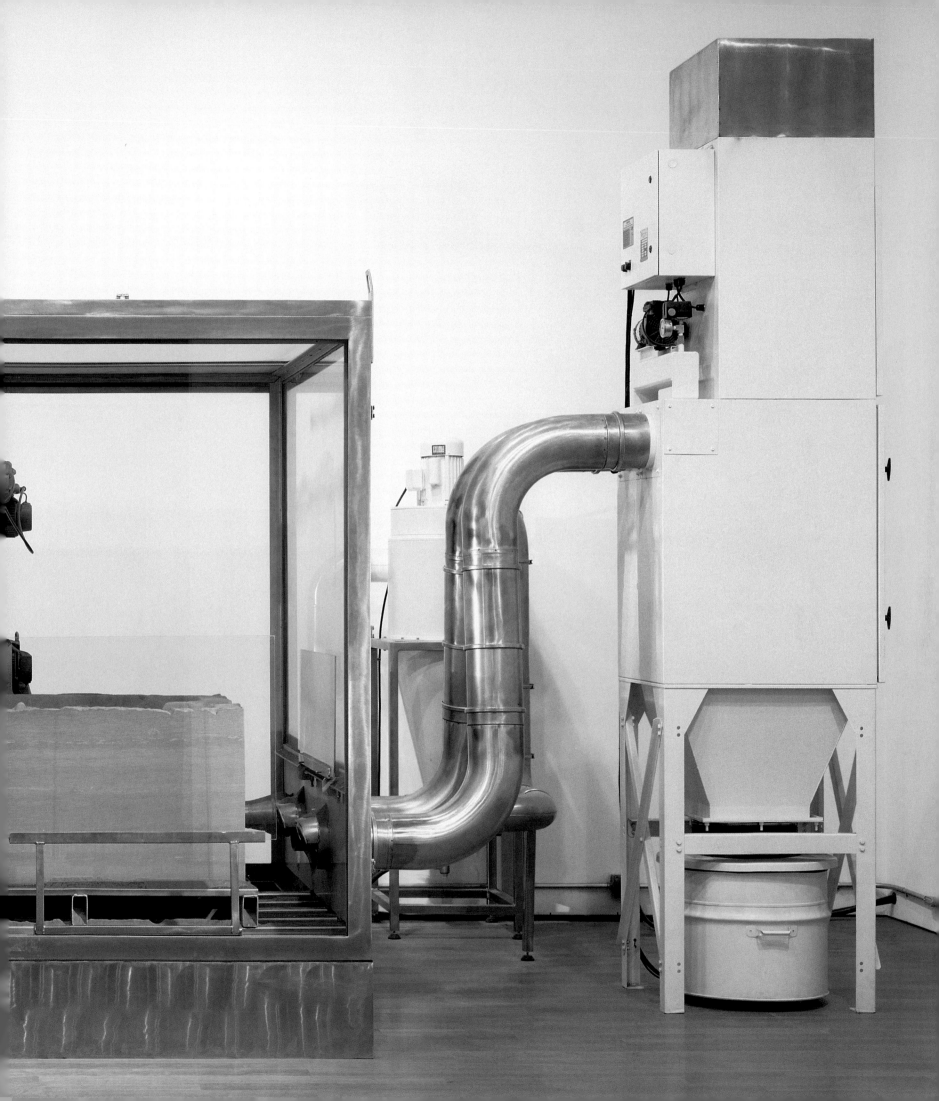

With silicon carbide particles directed by a high velocity stream of compressed air, **Erosion Machine** shapes a block of sandstone in patterns determined in part by data sets from diverse sources. For instance, one stone was eroded using stock market data from 1998 to 2002, another using crime statistics from Ohio. A forklift places a 60 x 36 x 24–inch, 4,500-pound block of sandstone into the glass-enclosed chamber of the machine. A robot arm moves over the stone, its movements controlled by a data set unique to each stone. The stone is slowly eroded over a six- to twelve-week period. Patterns in the data as well as inherent variations in the stone contribute to the final form of the eroded stone. Other factors, such as the dynamics of aeolian currents and turbulence, substantially influence the outcome and move the process out of the realm of control commonly associated with robotic manufacturing. A reclaiming unit gathers the silicon carbide particles from the bottom of the machine to be re-used; the "dust hog" cleans the air that reenters the room around the machine; and the computer and control box direct the robot arm as well as the series of orchestrated events necessary to sustain the erosion. The robot is also responsible for cleaning the inside of the glass so that the process continues to be visible from the outside. —R.P.

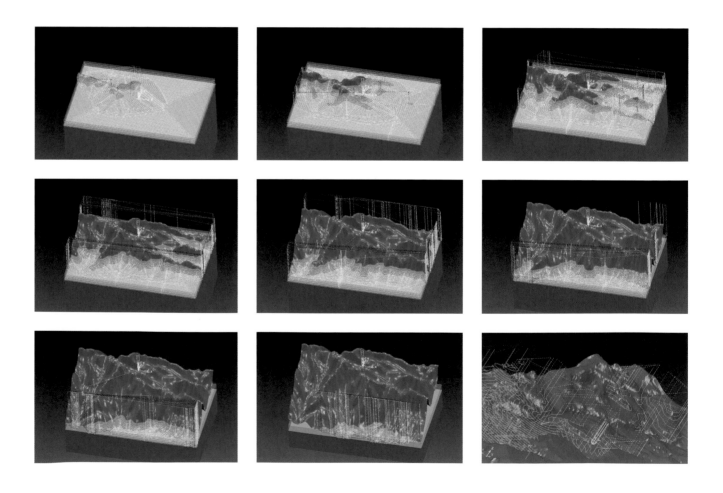

Renderings for **Erosion Machine**; opposite and pages 120–21: **Erosion Machine Stone No. 2**, 2006; pages 122–23: **Erosion Machine Stone No. 3 (Crime Data)**, 2006

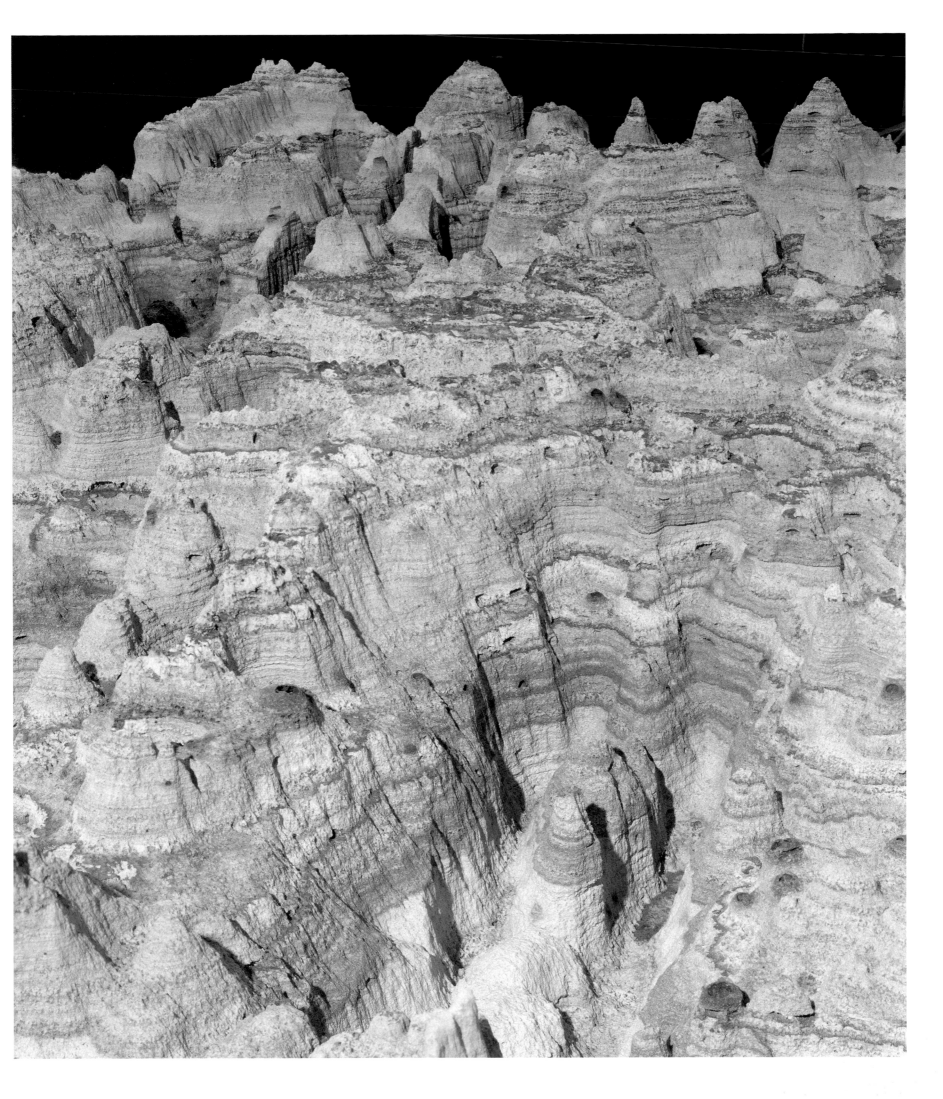

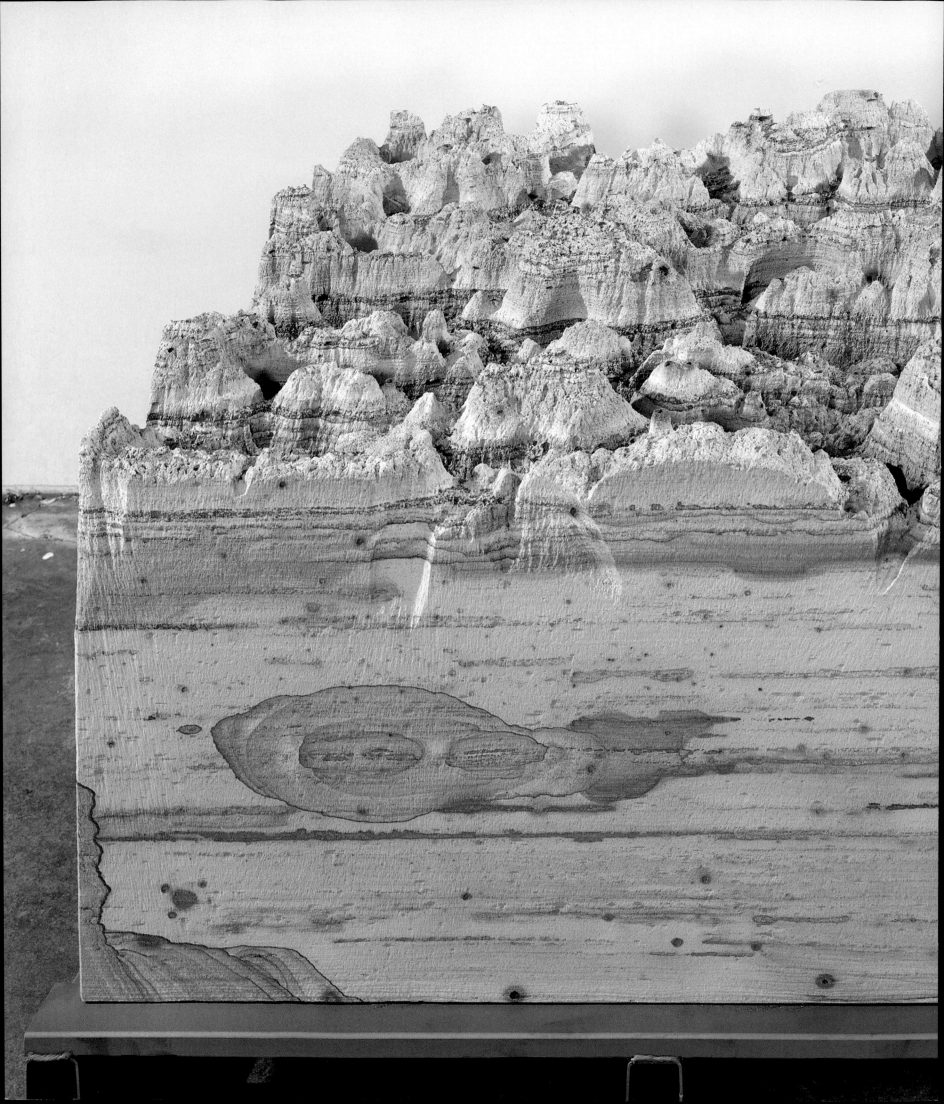

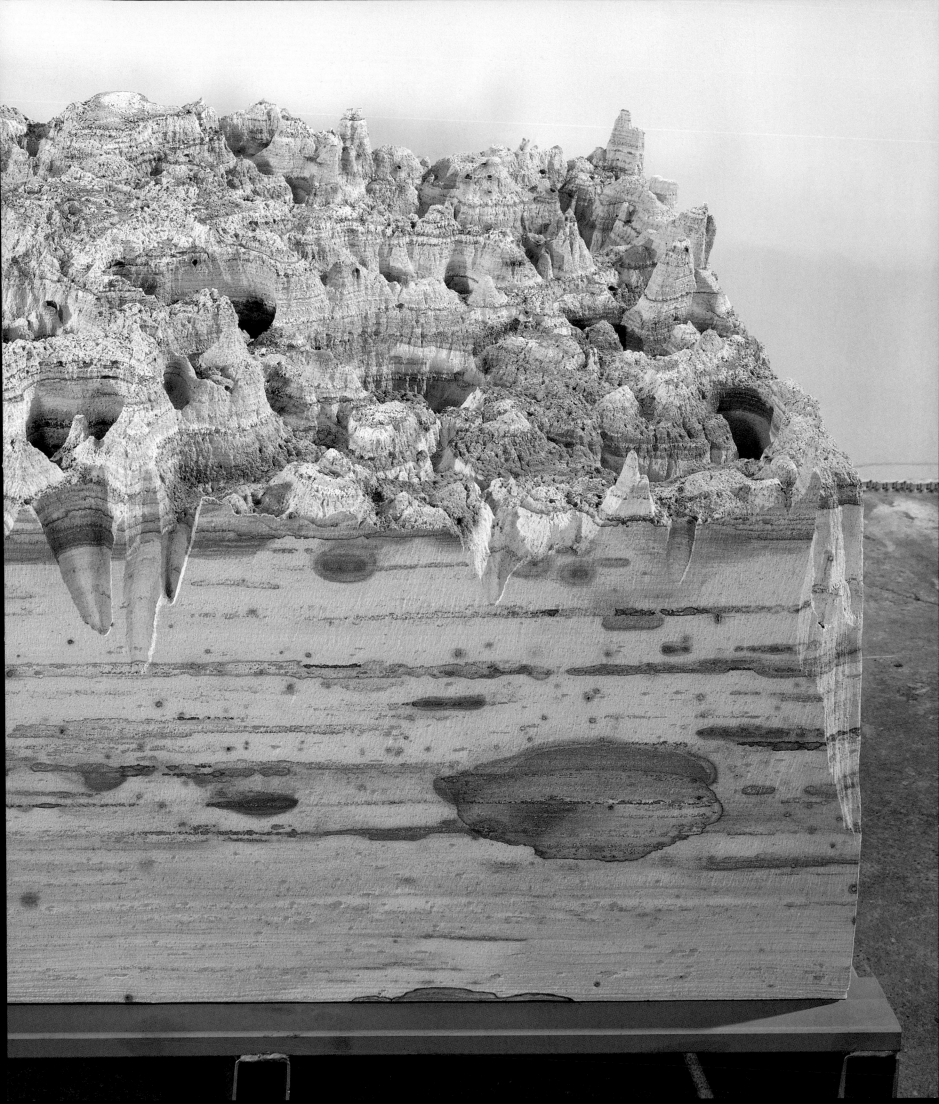

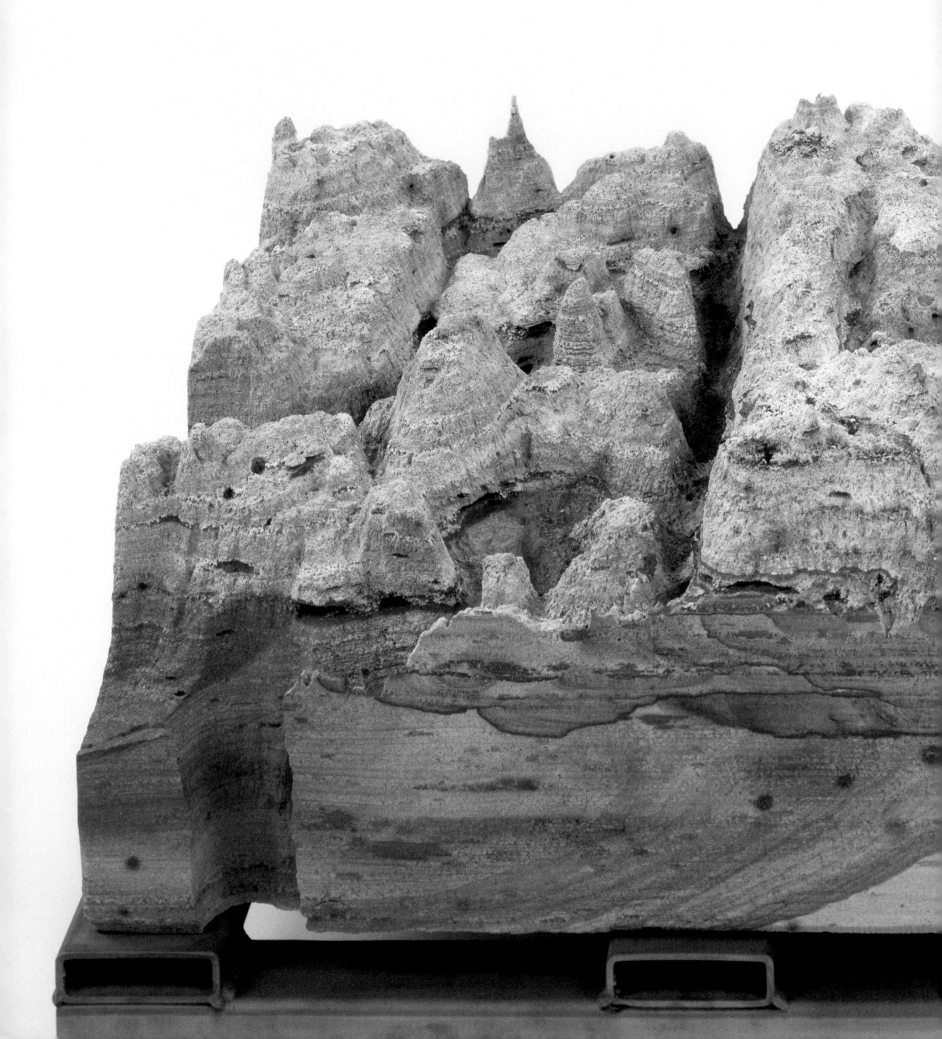

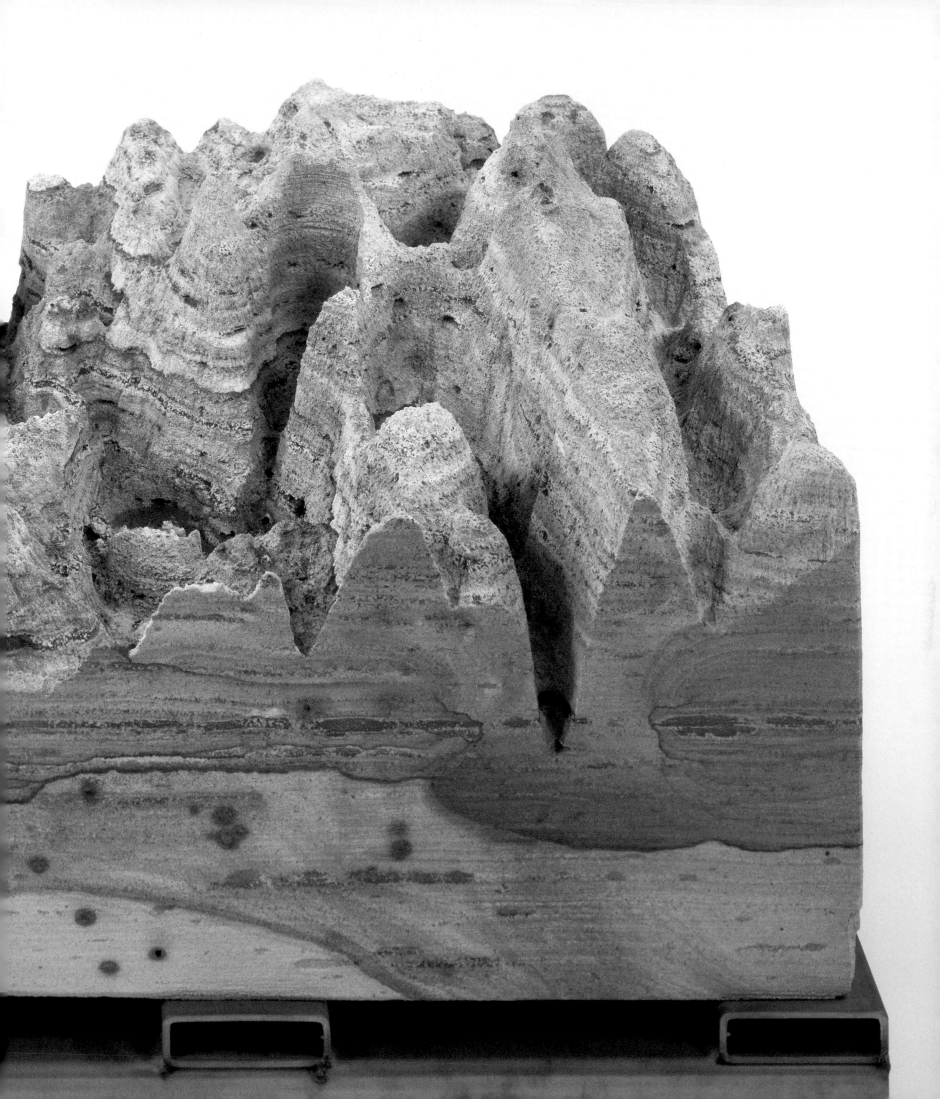

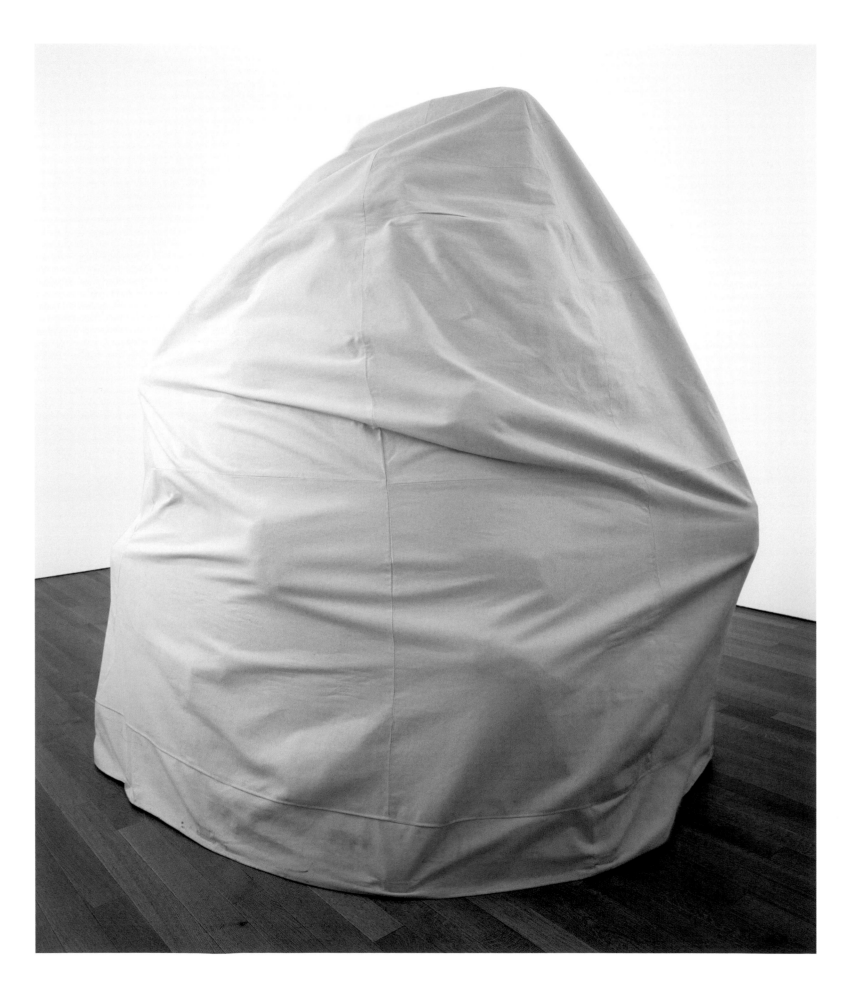

Unexplained Object, 2005

OUT OF CONTROL: BLACK HUMOR AND ENTROPIC HALLUCINATIONS

The unexpected consequences of human efforts to control nature form a third, and often quite humorous, leitmotif in Paine's work. A self-confessed control freak, Paine has invented a world that is rife with hidden dangers, unanticipated mutations, and unfortunate outcomes. Two somewhat anomalous works epitomize this tendency. The very aptly titled **Unexplained Object** (2005; pp. 124, 212–15) is a canvas-covered sculpture that resembles a large boulder that constantly undulates. There is in fact an explanation: inside the apparatus is an arrangement of thirty pneumatic cylinders set in motion when an attached Geiger counter registers local radiation. Because it responds to the random emission of subatomic particles, the configuration of the sculpture is constantly changing and never the same. The effect is at once mysterious and unsettling. The irregular thrusts bring to mind the struggles of an imprisoned creature, while the actual source of the movements serves as a reminder that we are always subject to minute doses of environmental radiation.

Bad Planet (2005; pp. 226–29) offers an equally sardonic addition to our environmental nightmares. This work consists of a brown globe, five feet in diameter, erupting with grotesque pox-like globules. It's not clear whether this malformed orb represents an alternate world or a future projection of our own world, whether the repellant surface is its natural state or the result of pollution or some catastrophic event. Whatever its origin, this planet is devoid of life and undeniably horrible.

Both of these works bring to mind pop-cultural speculation about the dire effects of our efforts to dominate and control nature. Science fiction films such as Andrew Niccol's *Gattaca* (1997), the Wachowski Brothers' *Matrix* trilogy (1999–2003), and Steven Spielberg's *A.I.* (2001) offer equally unsettling visions of the sinister underside of science and technology. The granddaddy of all such fables is, of course, Mary Shelley's 1818 masterpiece *Frankenstein*, in which a brilliant scientist's successful effort to create a perfect human leads to the destruction of everything he holds dear. Conceived at the dawn of the industrial age, *Frankenstein* remains a dark myth hovering over our efforts to engineer nature and has been applied as a warning to everything from genetic modification of vegetables and domestic animals (which are sometimes referred to as "Franken-foods" and "Franken-animals") to cloning, the manipulation of the human genetic code, and the creation of robotic aids.

In discussing **Bluff** in an interview with the artist Allan McCollum about the Dendroids, Paine expressed concerns that seem evident in all his work: "[Bluff] mimics how we increasingly experience nature—cows are 'grown'; crops are optimized genetically for particular characteristics. Everything is treated like an element in a machine. I'm interested in this con-

stant desire to control nature, to make it fit into processes, factory processes. The perfect chicken is the one that is all white meat breasts and each chicken is genetically almost the same."[17]

Commentaries on our Frankenstein complex tend to be moralistic warnings against the hubris of playing God. However, Paine approaches the subject with a bemused humor, at once accepting and mocking modern man's obsession with controlling nature. This attitude underlies his sterile, non-functioning Dendroids, his absurd machines, and his meticulous fabrication of "anti-social" species of weeds and fungi. In referring to the latter as "Replicants," he recalls Frankenstein's latter-day descendents, the rebellious robots called Replicants in Ridley Scott's 1982 classic film *Blade Runner*. The name Dendroids, which comes from the Greek word for tree, also recalls "android," the name for such humanoid robots.

Paine undermines the notion of control in various ways. His repeated fabrication of psychedelic mushrooms, along with such works as **Drug Ziggurat** and his poppy diorama **Crop**, suggest an openness to the pharmaceutical alteration of consciousness. Such works present a challenge to conventional concepts of restraint and self-discipline. Along with his psilocybin field, Paine also has fabricated numerous representations of Amanita muscaria, the colorful red-and-white spotted mushroom that was favored by the Siberians and ancient Scandinavians (as well by the drug-friendly counterculture of the Sixties) for its hallucinogenic qualities. The Amanita muscaria's close kin is the Amanita virosa, another species memorialized by Paine, and one of the most beautiful as well as one of the most deadly forest mushrooms. That this genus can both expand consciousness and cause a rather gruesome death points to the two-sidedness of nature and its failure to be subservient to human expectations.

In part, Paine's interest in hallucinogenic substances derives from his own history of drug experimentation. However, the persistence of this interest seems to point to a reaction against the Puritan culture's obsession with self- and social control, a stance that also seems apparent in Paine's subversion of suburban conformity. The futility of our efforts to control our natural environment is the theme not only of **Bad Lawn**, but also the equally satirical **Weed-Choked Garden** (1998–2006; pp. 127, 148–51). Here Paine represents nature's revenge against the hapless gardener's efforts to create order. Ranging over an elevated slab of cracked earth are sorry-looking polymer tomatoes that are under attack by thirteen varieties of fabricated weeds. Although a pattern of furrows has been imposed on this patch of ground, the effort to control it seems quite futile.

"The **Weed-Choked Garden** is someone's attempt at a garden, but it is completely overgrown. The weeds are doing the best—although they are also being eaten. In a way," Paine continues, "there's this same sort of conflict in my work, between this human desire to create a perfect, manageable thing—like a grid or a row or the garden—and nature's other structures, which have their own logic but can't be contained. So there are these other organic structures in there, with these interconnections, with these different species coexisting."[18]

This theme is also explored in Paine's **Poison Ivy Field** (1997; pp. 40–43). Inspired by a childhood memory of an unfortunate encounter with poison ivy, the work involves another

[17] "Conversation/Roxy Paine and Allan McCollum," in Ann Wehr, ed., *Roxy Paine/Bluff* (New York: Public Art Fund, 2002), 15.

[18] Ribas, "AI Interview."

common species that suburbanites attempt to eradicate. Paine has further indicated the disdain with which this plant is held by presenting it along with weeds and bits of rubbish, including a syringe and cigarette butts. The poison ivy plants, along with other unwelcome visitors, such as skunk cabbage and dandelions, have been placed like precious objects or scientific specimens in a beautifully crafted vitrine, underscoring the work's absurdity. It resembles a poorly maintained museum diorama, except that the main event is not stuffed animals or figures of primitive man. In other works, like **Group No. 5** (2004), similar vitrines hold mangy-looking specimens of Amanita muscaria and Amanita virosa, presented in their various stages of growth, or beginning to flop over as they return to the earth. Removed from nature, the specimens appear forlorn and vulnerable, and quite distant from pastoral fantasies about the beauties of nature.

Suburban desires for the domestication of nature are further undermined by works that present the natural world as the site of the proverbial struggle of all against all. For instance, Paine has suggested that the theme of **New Fungus Crop** (1999; pp. 56–57, 59) is nature as a battlefield. Here orange jelly fungus creeps over decaying specimens of Amanita virosa, while false morels and orange capped bonnets stake their claim nearby, revealing the competition for space in a stretch of forest floor. Similarly, **A versus B** (2005; p. 181) deals with the skirmishes between bacteria and fungus, a clash that, as Paine notes, has benefited humanity: "That's a conflict we've used to our advantage. Look at penicillin, which is the product of that battle, a fungus that creates an antibiotic, literally, an antibacterial. It's a poison that a fungus produces in order to kill the competition for food and resources. Interesting things come out of that conflict."[19]

Vibrating Field (1998; pp. 60–61), kin perhaps to the **Unexplained Object**, takes the argument in another direction. This piece consists of the replication of a field of grass, made to vibrate slightly by an unseen motor. The hidden mechanism points to a familiar theme in Paine's work, the interconnectedness of the forces of nature and mechanization. The modern era is marked by contradictory attitudes toward those two forces. Early critics of the industrial revolution, like William Morris and John Ruskin, decried the aesthetic and human costs of mass production which, they believed, led to the dehumanization of labor and the deterioration of craft. Thinkers like Walter Benjamin saw a potential for human liberation by embracing the machine. In his famous 1936 essay "The Work of Art in the Age of Mechanical Reproduction," he hailed the democratizing effect of new modes of mechanical reproduction, notably photography and film, arguing that new technology would strip the art object of its precious "aura" of uniqueness and return it to the mass audience. Elements of both those attitudes can be detected in the work of Marcel Duchamp. His "readymades" posited an equivalence between

[19] Castro, "Collisions," 43.

Drawing for **Weed Choked Garden**, 1998

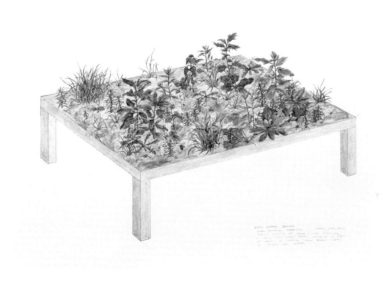

artworks, such as paintings and sculptures, and mass-produced objects, such as bottle racks, snow shovels, and urinals. By placing such items in a gallery or museum setting, Duchamp seemed both to elevate manufactured objects to the level of high art, echoing Benjamin, and demolish the aesthete's separation of art from ordinary life, in a confirmation of the worst fears of Ruskin and Morris.

Since Duchamp, the art world has oscillated between two very different attitudes toward production that run through modern and contemporary art. At one extreme is Andy Warhol's "assembly-line" style of producing paintings—which Warhol justified by declaring "I want to be a machine"[20]—and the Minimalist practice of making artworks that look industrially fabricated and are often made with industrial materials. At the other extreme is the Abstract Expressionists' fetishization of human touch and the recent resurgence of craftsmanship, which can be seen in the works of such contemporary sculptors as Robert Gober, Charles LeDray, and Liza Lou.

[20] Kynaston McShine et al., *Andy Warhol: A Retrospective*. (New York: Museum of Modern Art, 1989), 18.

Like Duchamp, Paine responds to the conundrum of machine versus art by denying their separation. His hand-fabricated Replicants use industrial materials, including wire, thermoset plastic, various polymers, lacquer, epoxy, acrylic paint, and fake dirt, while his machines are programmed to transform oil paint, sandstone blocks, and liquid polyethylene into unique objects that inhabit the realm of high art. The paradoxical relation of machine and art is particularly evident in Paine's Dendroids. Fashioned out of hand-cut and welded lengths of standard stainless-steel pipes, these works mix craftsmanship and industrial fabrication. Paine buys industrial pipes and rods in bulk and stacks them in his studio according to diameter and length. Shaped into irregular curves with a hydraulic pipe bender, they become the "raw materials" Paine employs as he seeks to replicate a maquette. As a result, the Dendroids exist between art and industry, combining characteristics of each.

They are hybrid in other ways as well. There are hints of bioengineering in Paine's tendency to combine the characteristics of different species of trees in a single work. Like many infertile vegetal and animal hybrids created through genetic manipulation, these stainless-steel trees are both literally and metaphorically barren—their metal construction and leafless state attest to their sterility. Some of the Dendroids are designed to further emphasize their unnaturalness. For instance, Transplant (2001), Paine's second tree, was placed in semi-arid soil in Spain, an environment where no such actual tree could grow. The tree Inversion (2008) "grows" upside-down, anchored to the ground by its smallest branches while its roots above ground appear to cling to air. Recent Dendroids, including Conjoined (2007) and Maelstrom (2009), begin to resemble synaptic networks and computer circuitry, taking the mechanical metaphor one step further. Here we seem to return to Frankenstein territory, where even brain functions may be simulated mechanically.

While the Dendroids consist of manipulated industrial elements that resemble organic life forms, Paine's machines move beyond references to industrial production to actually mimic industrial processes. They employ techniques of assembly-line production, but, through use of highly variable programmed instructions, subvert the normal factory goal of creating

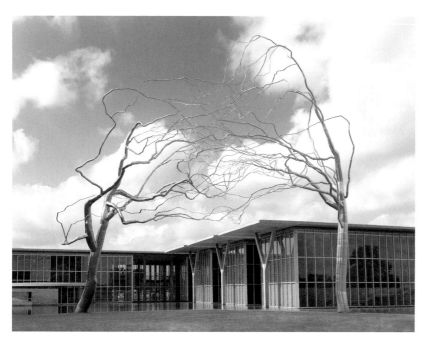

Conjoined, 2007, (at Modern Art Museum of Fort Worth)

[21] Helen Molesworth, "Work Avoidance: The Everyday Life of Duchamp's Readymades," *Art Journal* 57, no. 4 (winter 1998): 58.

standardized products. Hence they invoke the process of mechanical production while rejecting the usual result. Here again there are parallels with Duchamp's approach to the machine. Art historian Helen Molesworth argues that Duchamp's readymades represented an attack on mass production as well as the mechanized habits of work and leisure these new processes were designed to instill in the population. Referring to Frederick Winslow Taylor, inventor of the science of industrial management, she argues, "The readymades are thus an anti-Taylorist gesture... Their antifunctionality is not solely about their stymied use and exchange value as commodities but has a more literal component. They are antifunctional as in antiwork: they resist their intended, mandated, standardized use."[21]

Just as Duchamp's readymades undermined his objects' original functions, Paine's machines, busily producing "useless" works of art, can also be considered antifunctional. By using industrial processes to create objects with no practical purpose, Paine's machines directly challenge industry's rationale of utilitarianism. At the same time, by alluding to factory production, Paine's mechanically created paintings, drawings, and sculptures also undermine Modernism's claim that art by definition exists outside the worlds of labor and mass production.

From another perspective, however, Paine's machines reflect a postmodern notion of the artist as producer and the artwork as product. Once conceptual artists began to conceive of art as an idea rather than an object, the physical product and the means of execution became more or less irrelevant. It hardly mattered whether the instructions to create a sculpture were handed over to assistants, as was the practice of Sol LeWitt, or whether the artwork remained merely a verbal concept or set of words, as for Lawrence Weiner. In the case of Paine's machines, there is to the question whether the "art" is the end result—blobs of polyethylene or canvases coated with thick layers of paint—or if it is those products, actual and potential, together with the apparatus that produces them. Paine tends to argue for the latter. He intends the paintings and sculptures to stand on their own, but he also sees the machines as artworks and presents them at work in his exhibitions. Thus he departs from artists who employ machines to fabricate their work but keep the machinery out of sight. Instead, Paine elevates the machine to a status equal to its products.

This is not strictly a new idea, and in fact after the Second World War, a number of American and European artists took up the idea of "machine art." One of the most prominent was the Swiss sculptor Jean Tinguely, who in 1959 created motor-driven drawing machines with which the viewer could create abstract drawings. These were shown in New York in 1967 under the auspices of Experiments in Art and Technology (also known as

E.A.T.), a non-profit organization, founded by artists Robert Rauschenberg and Robert Whitman and engineers Billy Klüver and Fred Waldhauer, that served as the catalyst for collaborations between hundreds of artists and engineers. More recently the German artist Rebecca Horn has engineered kinetic sculptures that snap, flail, and pound away like malevolent spirits, sometimes flinging pigment against the wall or scattering ashes on the floor. The sculptor Tim Hawkinson presents elaborate mechanisms that often yield mundane products, such as numerous copies of the artist's signature, or create equally mundane effects, such as the playing of the Olympic theme song. These differ from Paine's mechanically created works in that the "product" has little interest when separated from its originating apparatus.

While Paine's machines create objects that can be viewed, and aesthetically appreciated apart from the mechanism that created them, they nevertheless retain the hallmarks of the processes that brought them into existence. Take, for instance, Paine's first art-making machine, the 1996 **Paint Dipper**. This is an apparatus designed to dip a canvas periodically into a trough of white acrylic paint. The canvas is lowered and raised numerous times according to a computer program that determines how long the canvas will remain in the trough and how long it will dry between submersions. The final product is a thickly crusted, striated white canvas whose bottom features an irregular edge of hardened drips. Each canvas is unique, with different patterns of striation and hardened drips that vary in size and length. When displayed in a gallery, **Paint Dipper** is presented with an empty chair pulled up to the laptop that regulates the dipping process, a kind of ghost of the absent artist.

Paine's **PMU (Painting Manufacture Unit)** (1999–2000) refines his mechanized painting technique. Here, instead of echoing the flat monochrome canvases of artists like Ellsworth Kelly and Robert Ryman, as with the earlier painting machine, he evokes the gestural brushstrokes of expressionist painting. The onset of painting is signaled by a red light and siren, at which point the nozzle of a hose, attached to a pipe leading to a vat of paint, rises up, and paint spews onto a canvas from three jets, which then retreat to begin the process again. The variables, controlled by a computer program designed to insure the uniqueness of each painting, include the number of layers (which can reach into the hundreds), location on the canvas, duration of paint application, and drying time. As in **Paint Dipper**, the excess paint slides down to the bottom of the canvas, leaving a pattern of petrified drips on its way back to the vat. The resulting paintings are even more diverse than those created in **Paint Dipper**, suggesting everything from mountain landscapes, icebergs, and gentle sweeping horizons to ruffled wave patterns. The upper areas of raw canvas suggest a region of sky, which contrasts with the white paint's more rugged land or ice formations.

Marcel Duchamp, **The Bride Stripped Bare by Her Bachelors, Even (The Large Glass)**, 1915–23. Oil, varnish, lead foil, lead wire, and dust on two glass panels, 9 feet 1 1/4 inches x 69 1/4 inches. Philadelphia Museum of Art, bequest of Katherine S. Dreier, 1952. © 2009 Artists Rights Society (ARS), New York / ADAGP, Paris / Succession Marcel Duchamp

The 2001 **Drawing Machine** also alludes to the gestural mark. Here a nozzle attached to ink bottles moves horizontally across the surface of a large sheet of paper set on a flatbed. More delicate than the **PMU**, it pools variable amounts of ink on the paper according to computerized instructions, which may be based on a single word repeated many times or on more abstract patterns of marks. The ink sinks into the paper, creating abstract drawings that resemble Asian brush paintings.

The sculptures created by **SCUMAK No. 1 (Auto Sculpture Maker)**, from 1998, are termed **Scumaks**. This machine is programmed by a computer to pour pigmented polyethylene plastic (the same thermoplastic used for shopping bags) to create mounds, which form gradually on a conveyor belt and then are moved down the line. The sculptures are built up, layer by layer (twenty layers for the first **SCUMAK** machine and forty layers for **SCUMAK No. 2**). The final form is determined by certain variables; some of these, such as the number of layers, cooling times between layers, and amount of material extruded, are programmed into the computer, while others, including local atmospheric conditions, are beyond the artist's control. The results are extremely varied, and the shapes, after they harden, retain a remarkably fluid appearance. **Erosion Machine**, described above, rounds out Paine's machines. The products it makes are both remarkably varied and evocative—like miniature eroded desert landscapes.

Paine's machines point to the longstanding dream of creating a machine capable of replicating some aspect of human intelligence. Daniel Dennett, one of the leading thinkers of the A.I. (artificial intelligence) movement, refers to machines as externalized intelligence. Some commentators have linked Paine to this movement, suggesting that his machines offer a substitute for human creativity. Critic Jonathan T. D. Neil argues that "Paine's machines may not be granted the status of rational, thinking agents, equivalent in every ascertainable respect to real minds, but within the circumscribed field of artistic production, they certainly achieve those results in every way indistinguishable from those that have been, and are, produced and presented by real artists. Paine's machines, it turns out, might have minds after all."[22]

22 Jonathan T. D. Neil, "Do Androids Dream of Making Art?" *ArtReview* (August 2006): 52.

In this context Duchamp once again seems significant, particularly his 1915–23 *The Bride Stripped Bare by Her Bachelors, Even (The Large Glass)* (opposite). This work, which consists of a rendering in oil, varnish, lead foil, lead wire (and, later, dust), sandwiched between two layers of glass, depicts the encounter between the "Bride" and her nine "Bachelors," all of whom are envisioned as various kinds of mechanical apparatuses. The work is extremely diagrammatic. The bride is rendered as a skeletal rectangular form from which is projected an inverted funnel, while the bachelors hang below as if on a clothesline and are connected by a pole to a "chocolate grinder" composed of drum-like shapes on tiny legs. The work is generally interpreted as a sardonic comment on the mechanical nature of sexual desire and frustration, with the bride separated physically from the bachelors, who endlessly and without satisfaction churn the chocolate machine.

There is an echo in Paine's work of Duchamp's comic equation of human sexual function and mechanization, and in fact the machine itself, with its arrangements of pipes, vats,

and rods, bears an odd resemblance to Duchamp's chocolate maker. Belgian artist Wim Delvoye's humorously absurd *Cloaca* (2000) offers a more recent example of this approach. The elaborate mechanical apparatus manufactures feces by processing a daily meal through a unit that simulates human digestion. Paine's **SCUMAKs**, which preceded *Cloaca*, share an excretory quality.

Paine observes that he is less concerned with the simulation of human creativity or the miming of human mental or physical processes than with harnessing the machine to create objects that are interesting in their own right. Again he skates between two apparently irrec-oncilable positions by choosing to regard the machine neither as the simple servant of our needs, nor as a threat to our individuality. Instead, by creating works that combine human and technological intelligence, the machines point to the potential of technology as partner. This is in keeping with Paine's larger vision of humanity as the product of both nature and technology, and underscores the status of his Dendroids and Replicants as hybrid products of these two worlds. Paine takes us beyond the Frankenstein myth and its suspicion of scientific progress and knowledge into a world where we gain effectiveness by ceding a certain degree of control to the larger forces around us, whether natural or manmade.

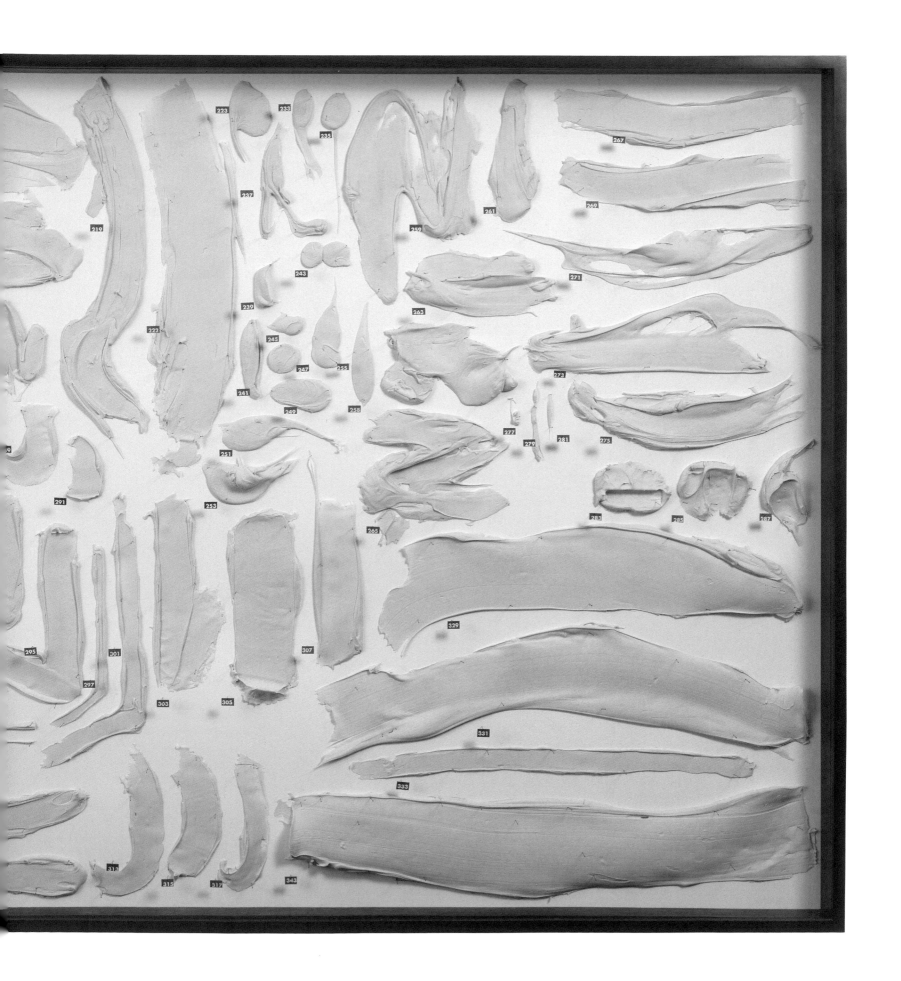

Specimen Case, 1995 133

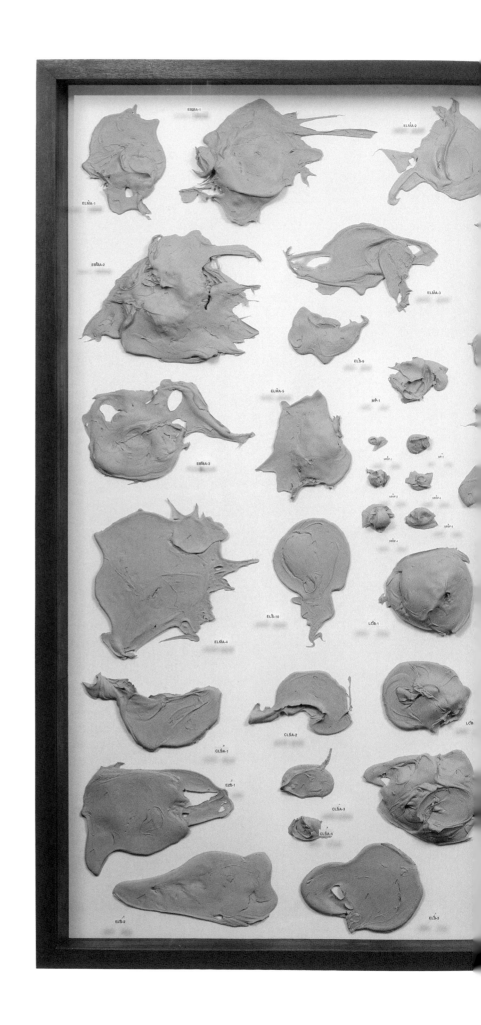

Blob Case (No. 8), 1998

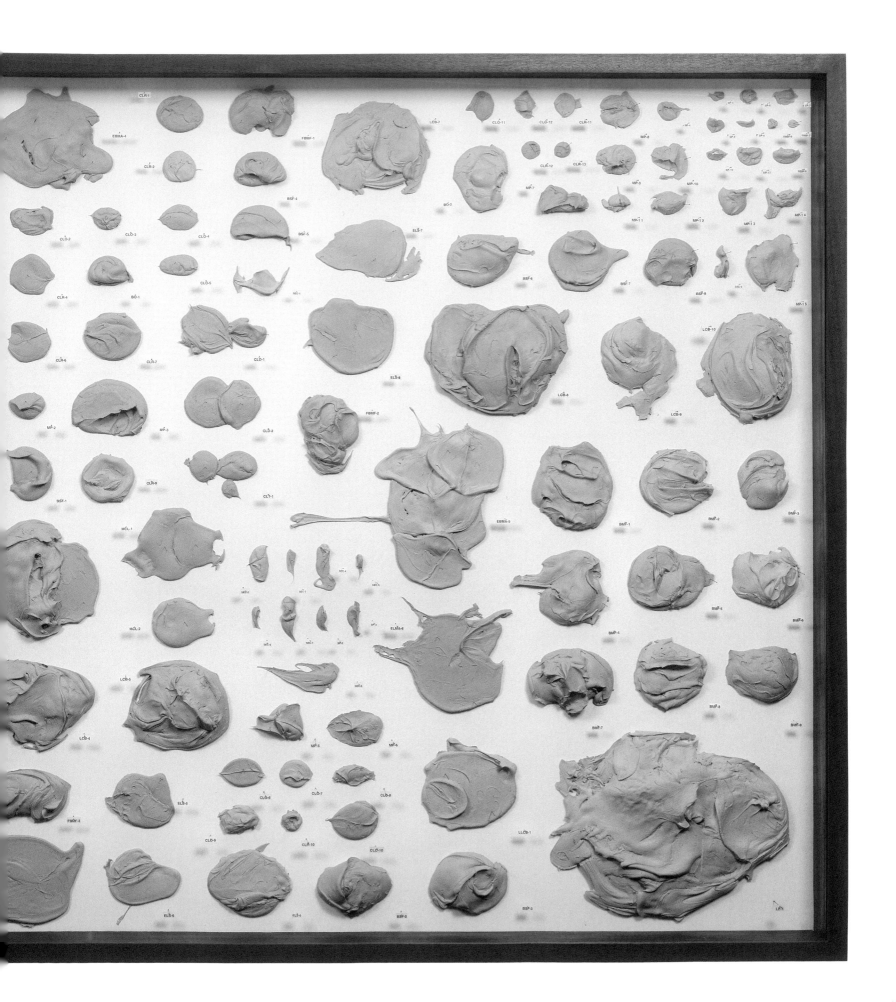

Large Fungus Painting, 1998–99

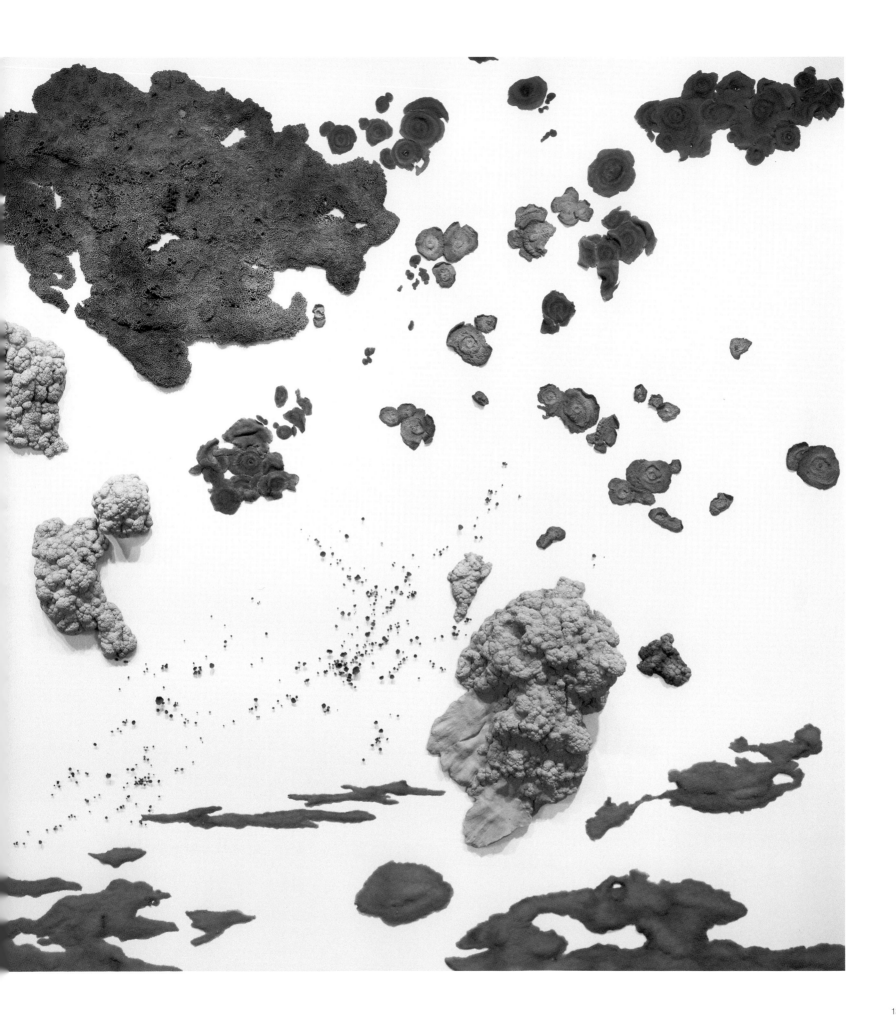

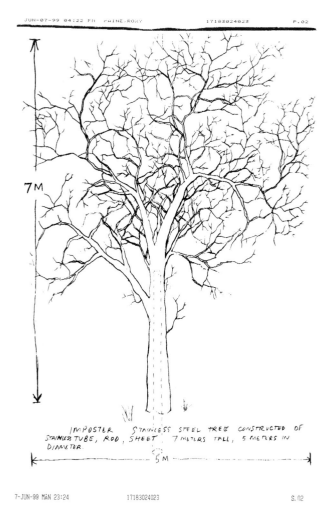

7M

IMPOSTER STAINLESS STEEL TREE CONSTRUCTED OF
STAINLESS TUBE, ROD, SHEET. 7 METERS TALL, 5 METERS IN
DIAMETER.

5M

138 **Impostor,** 1999; above: study for **Impostor,** 1998

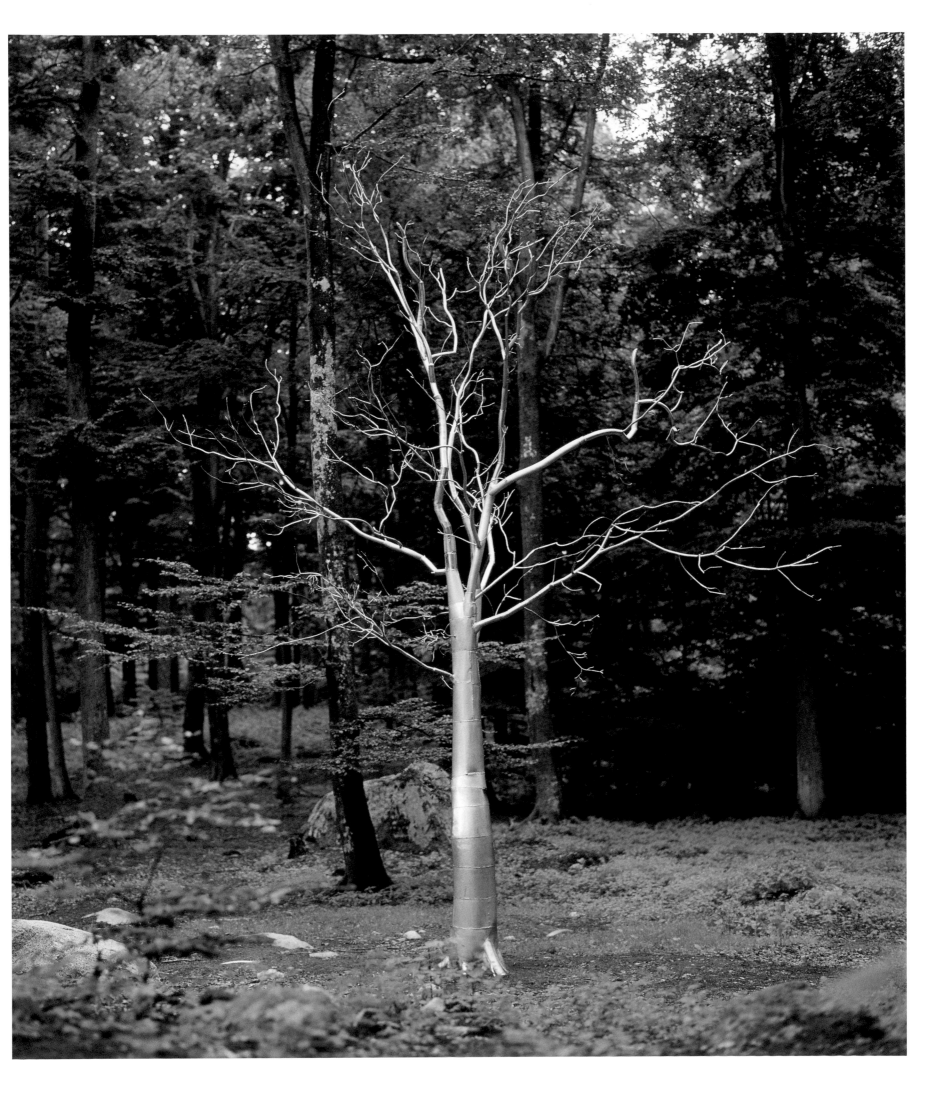

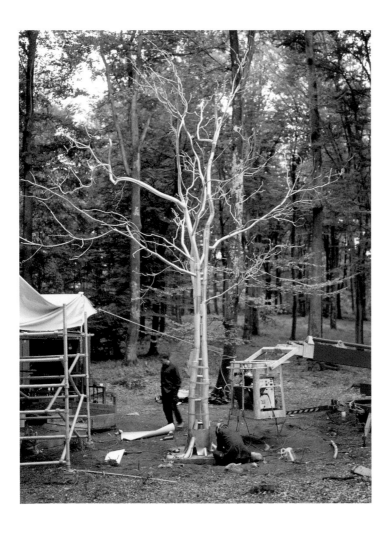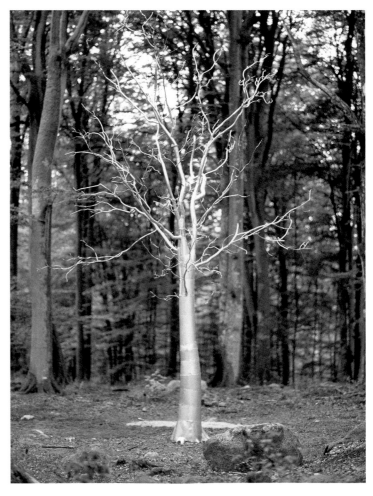

Impostor under construction, 1999, and views of the completed work

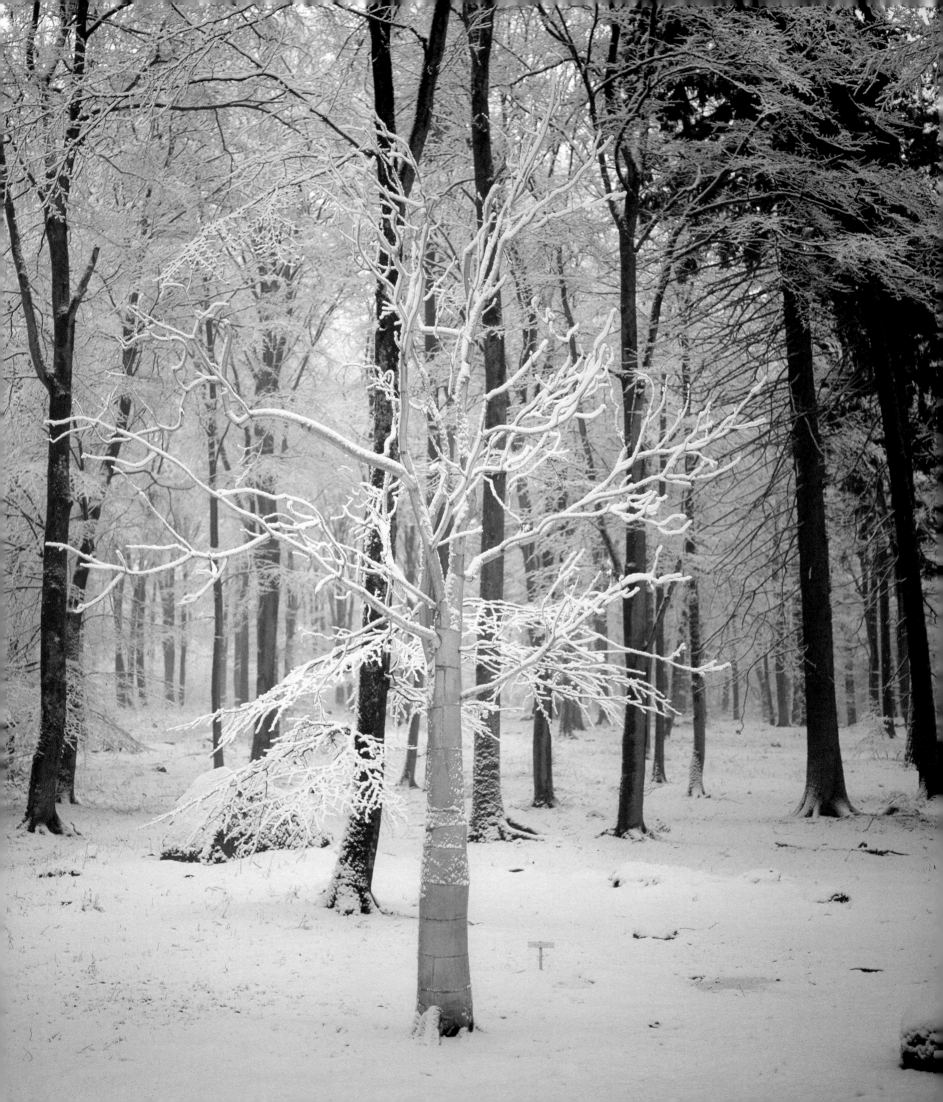

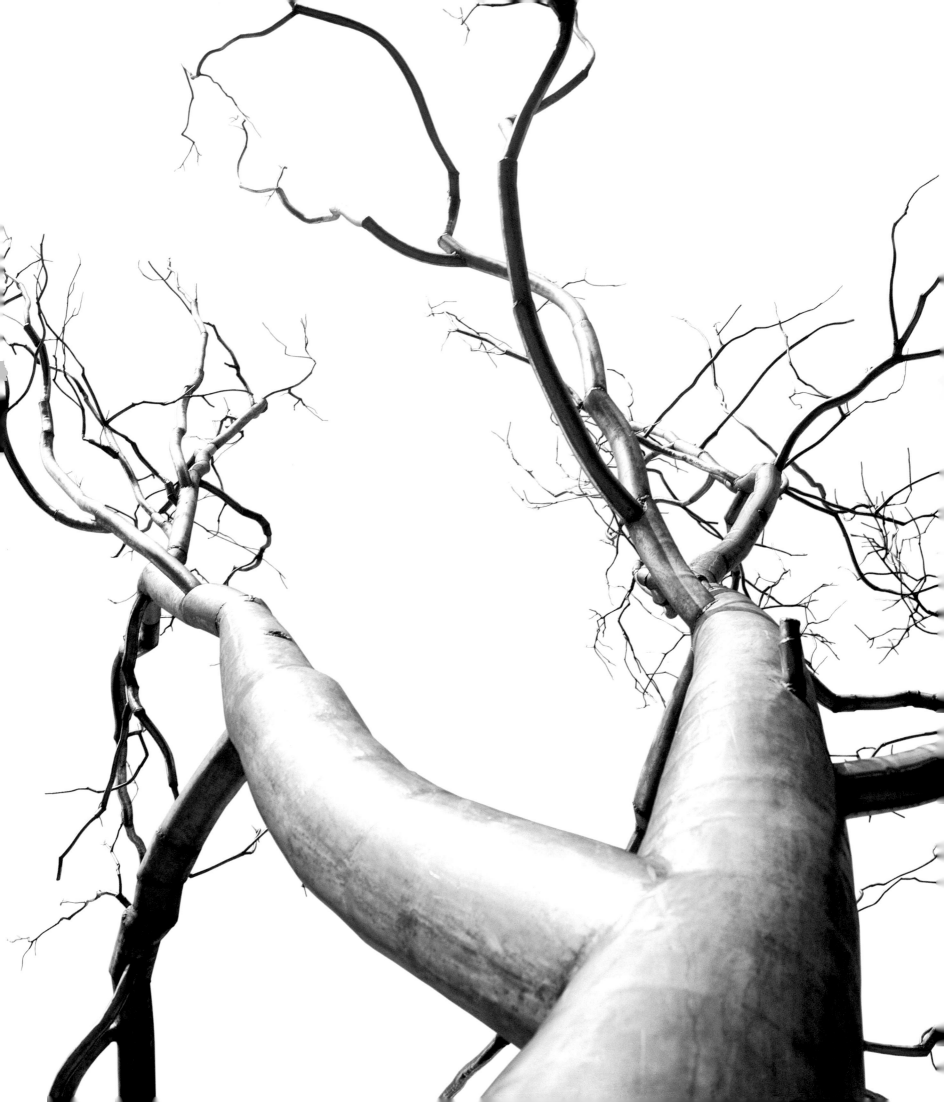

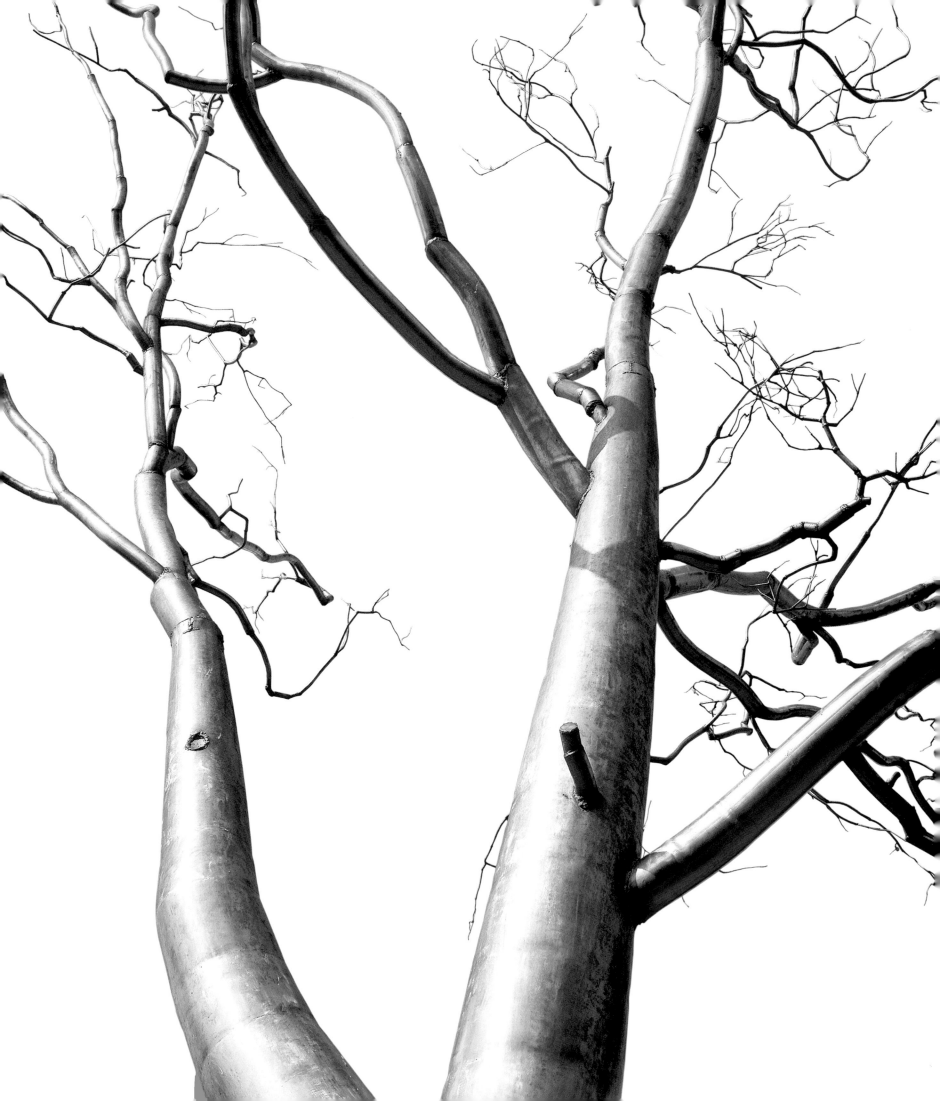

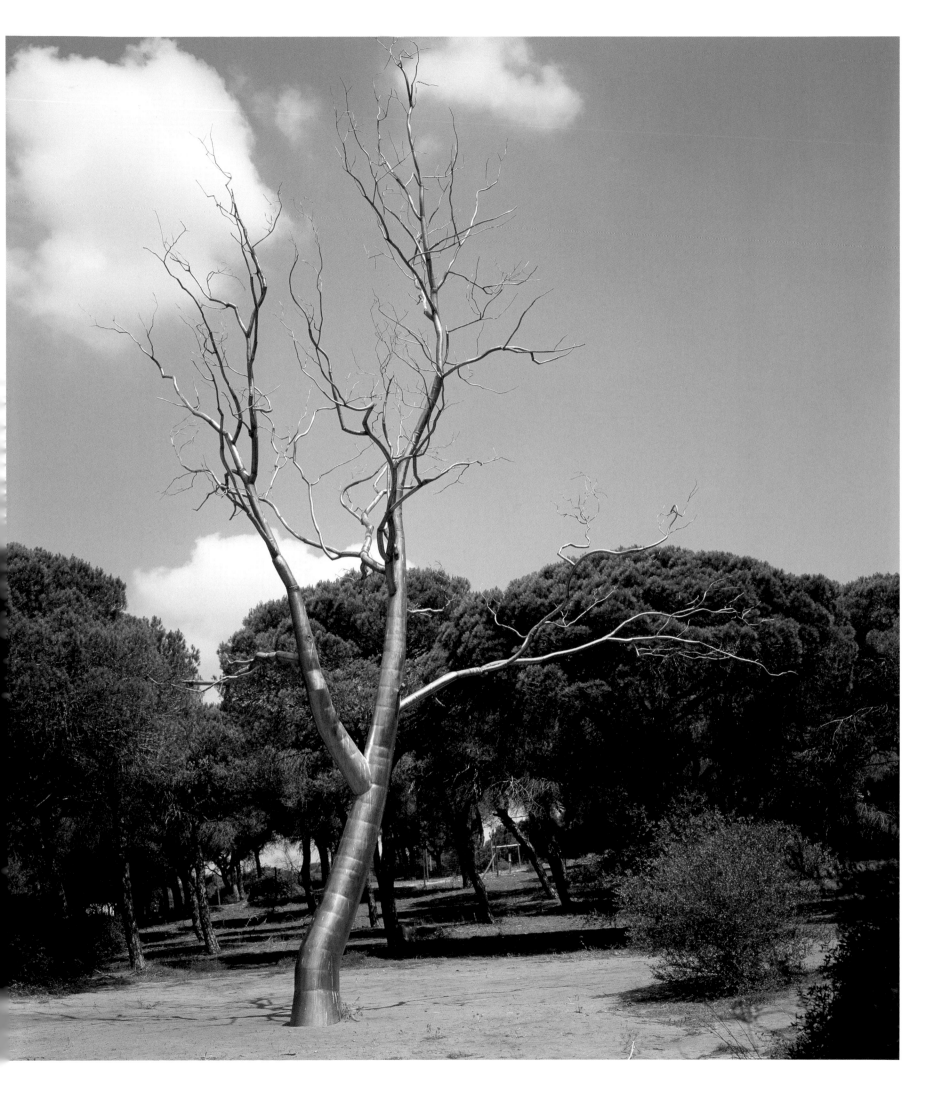

146 **Dry Rot,** 2001

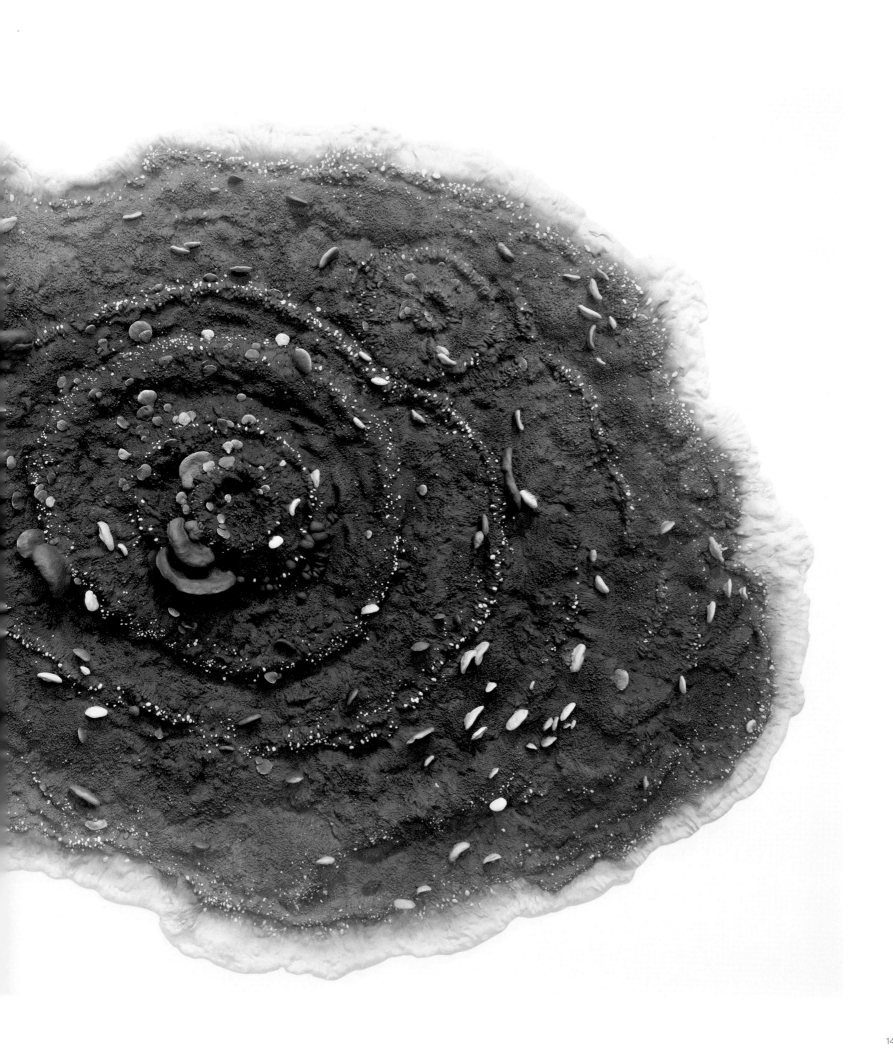

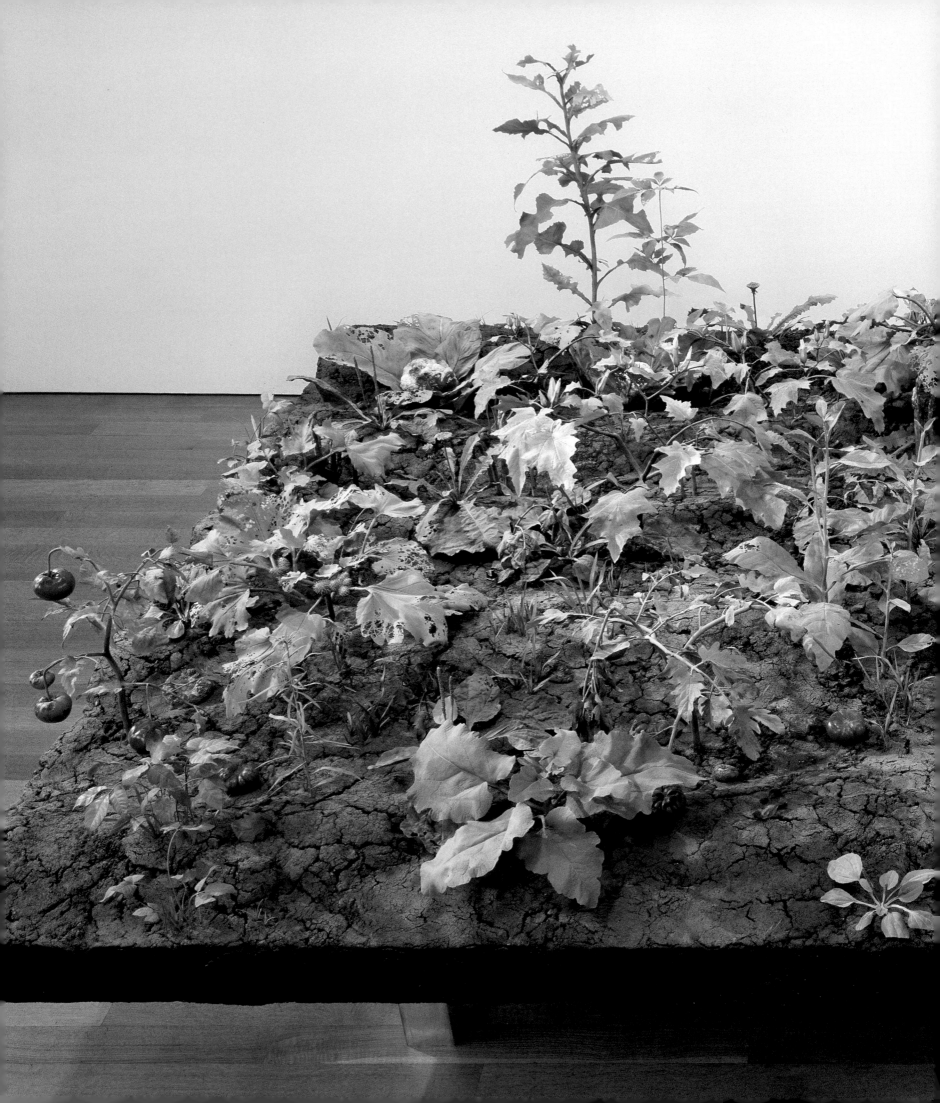

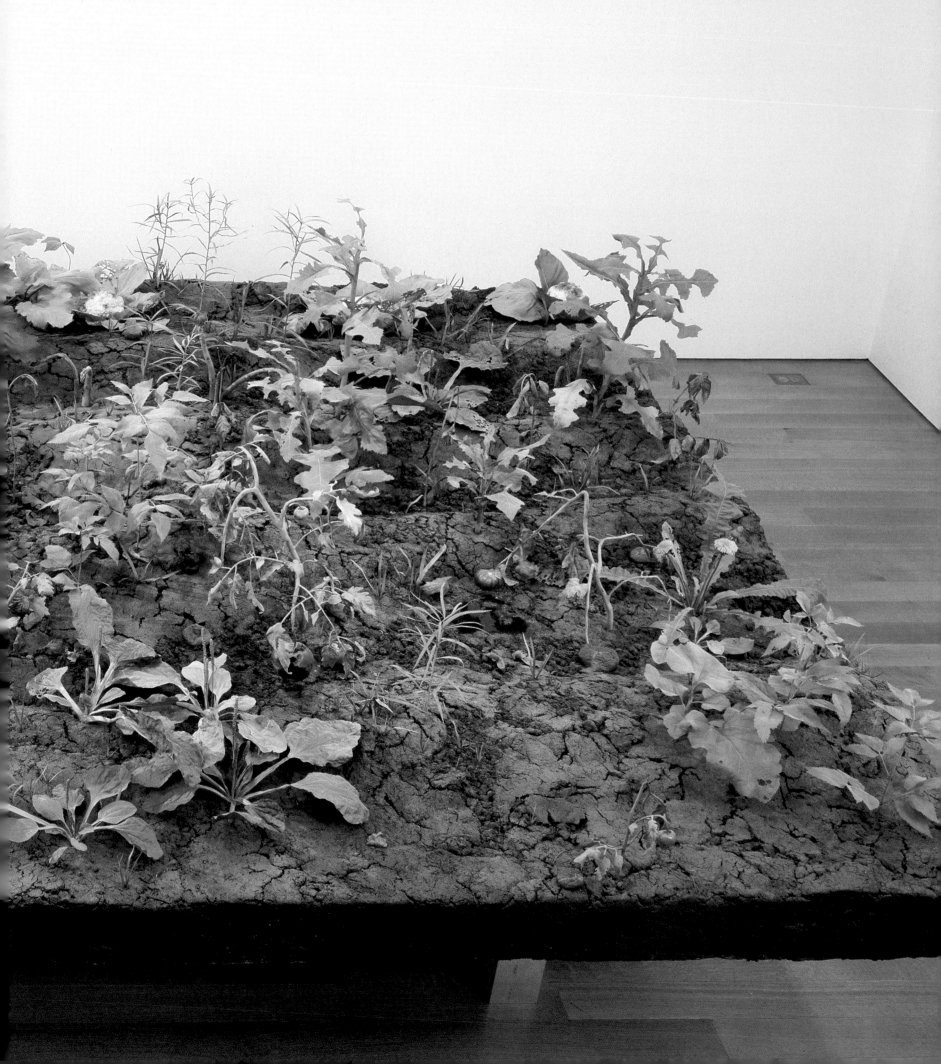

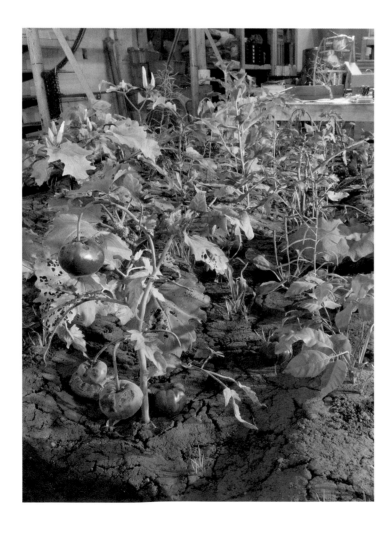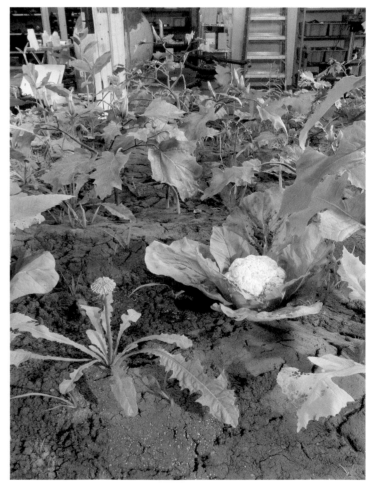

150 Above and pages 148–49 and 151: **Weed Choked Garden**, 1998–2006

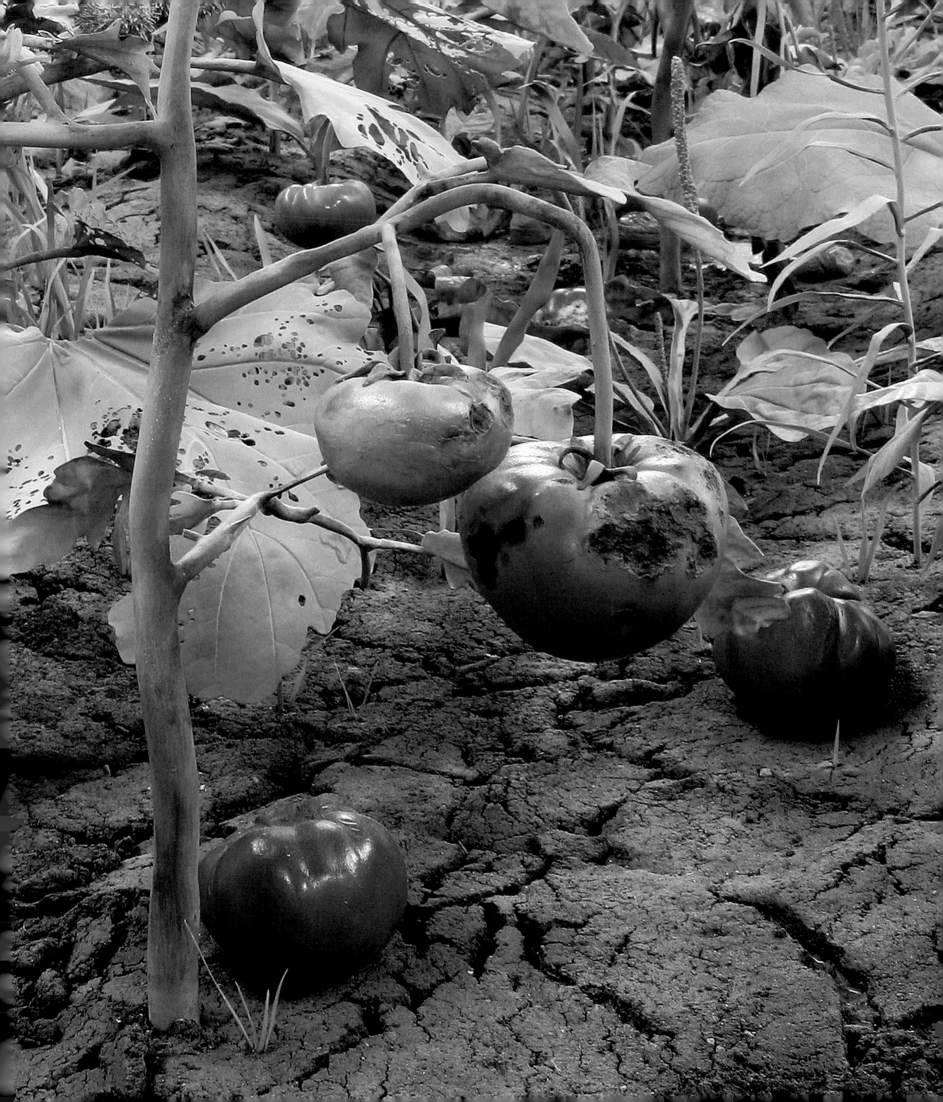

Amanita Muscaria Field, 2000

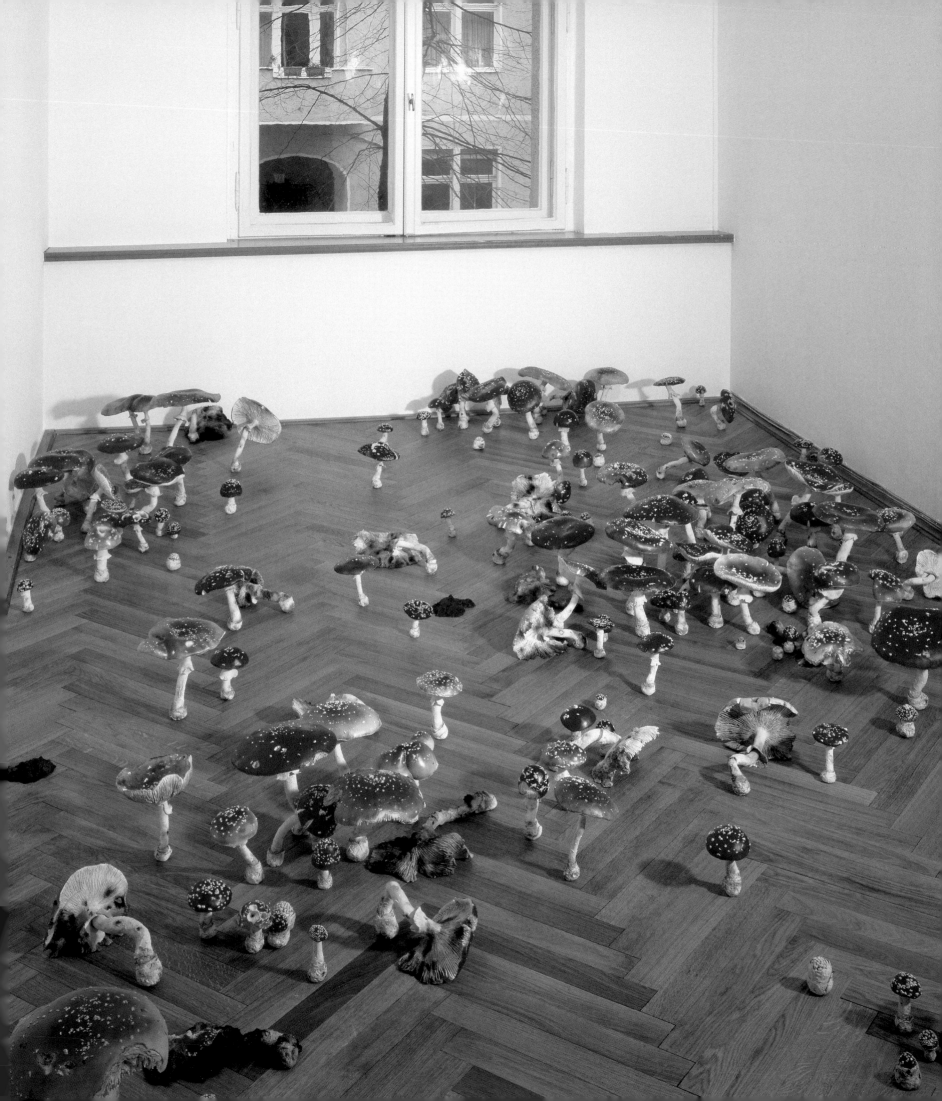

Amanita Muscaria Field, 2000 (detail); pages 156–57: **Amanita Virosa Wall,** 2001

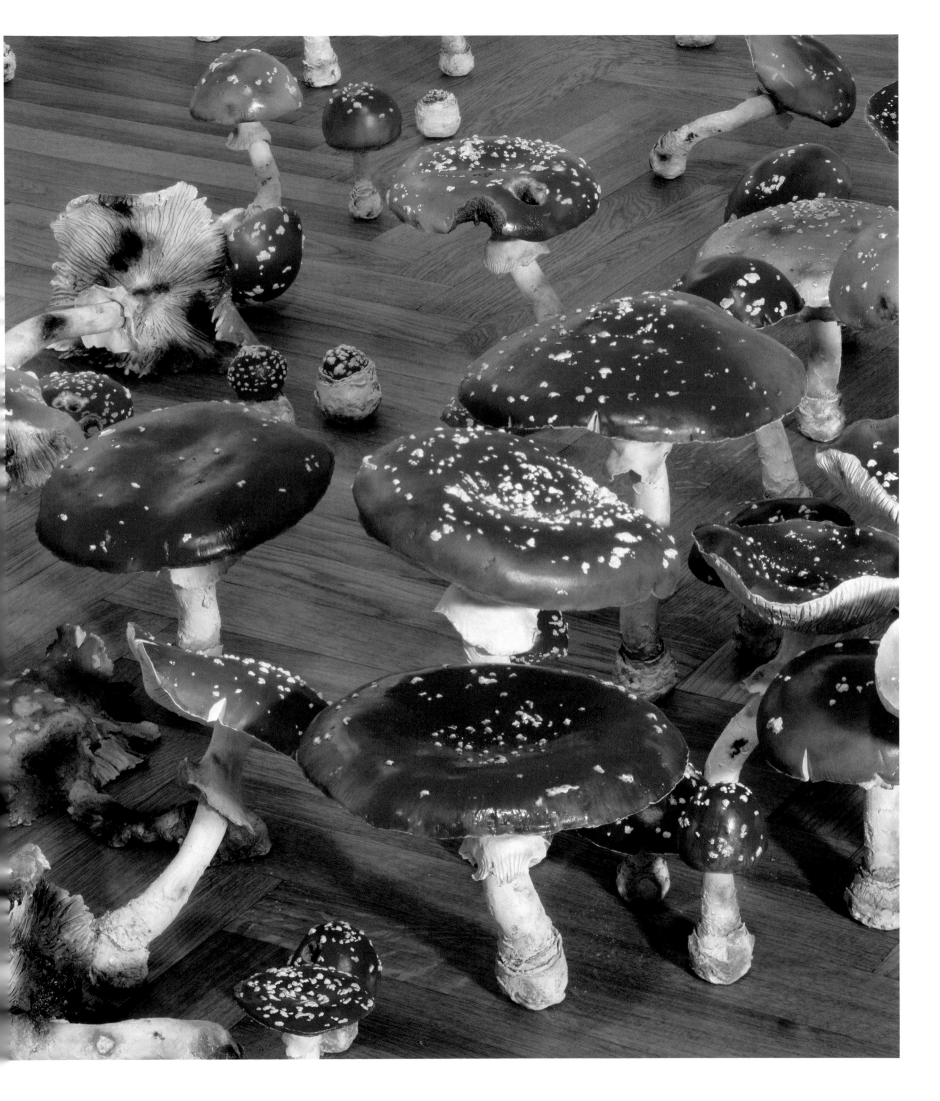

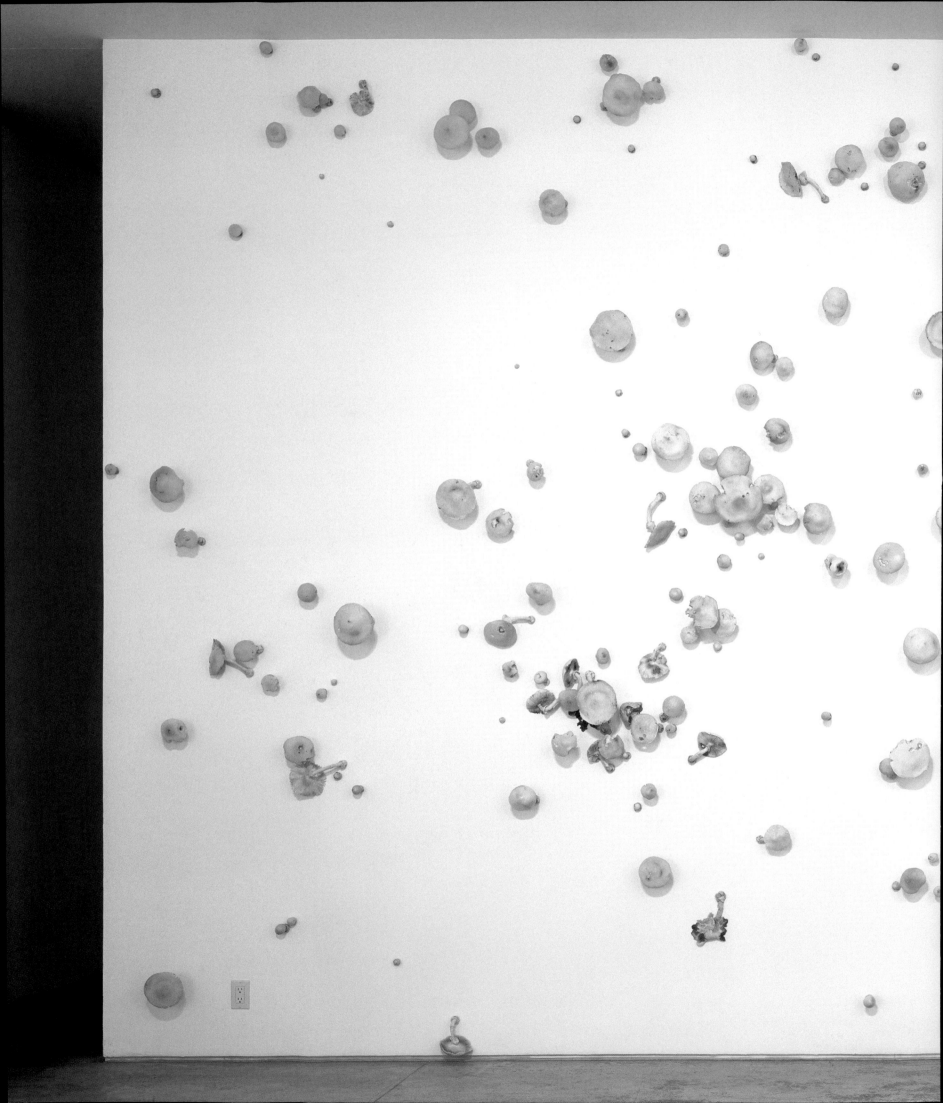

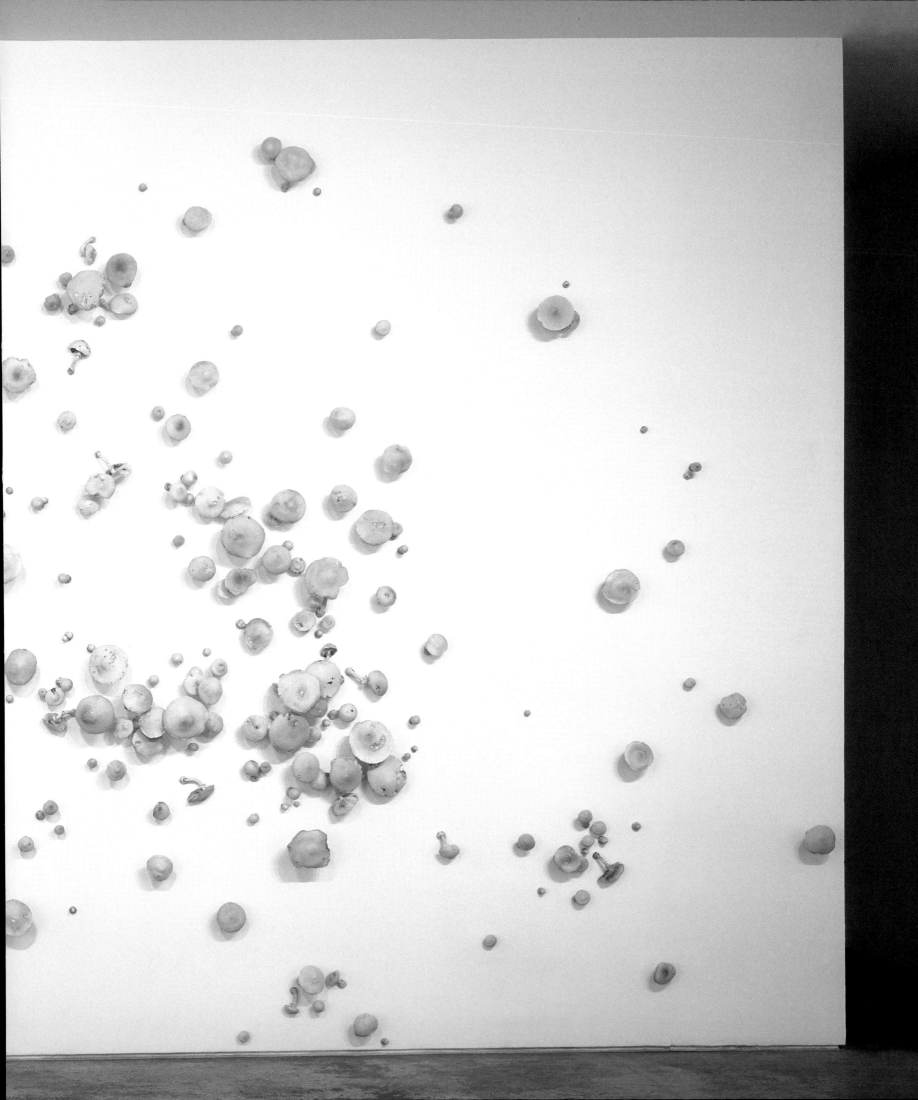

Pages 159 and 160–61: **Sulfur Shelf Wall**, 2001

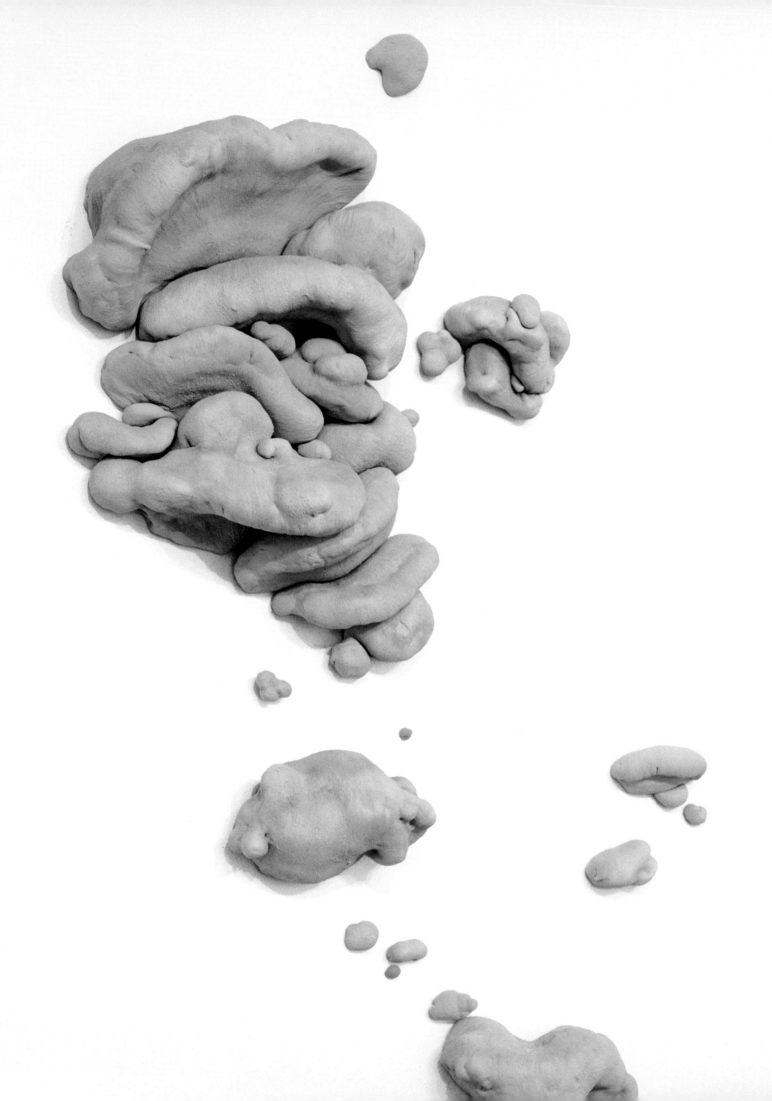

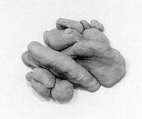

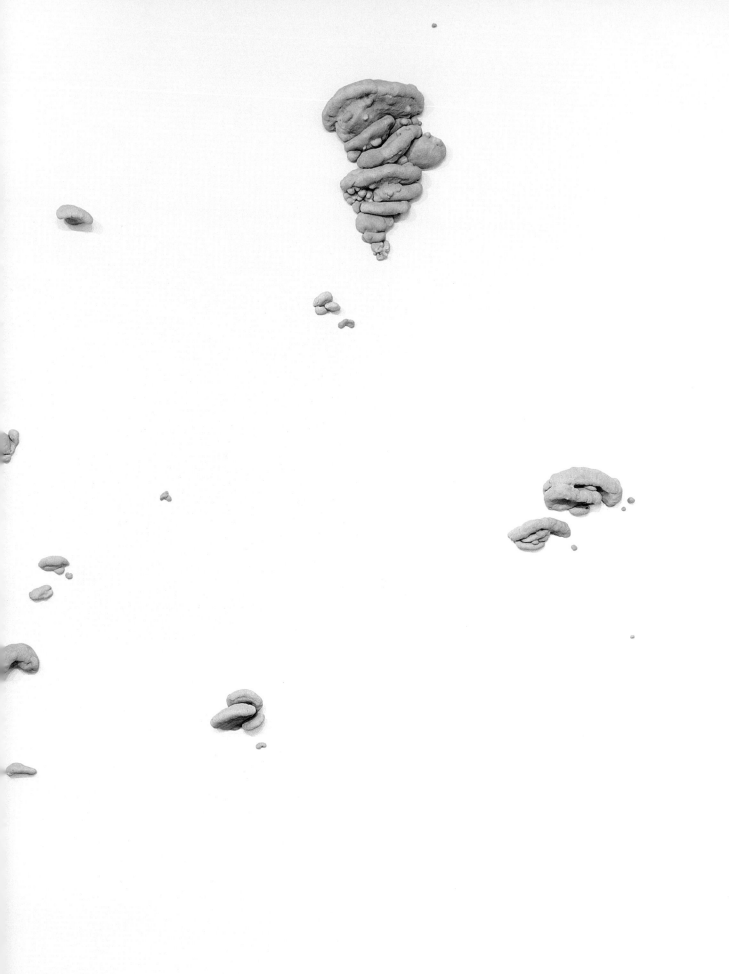

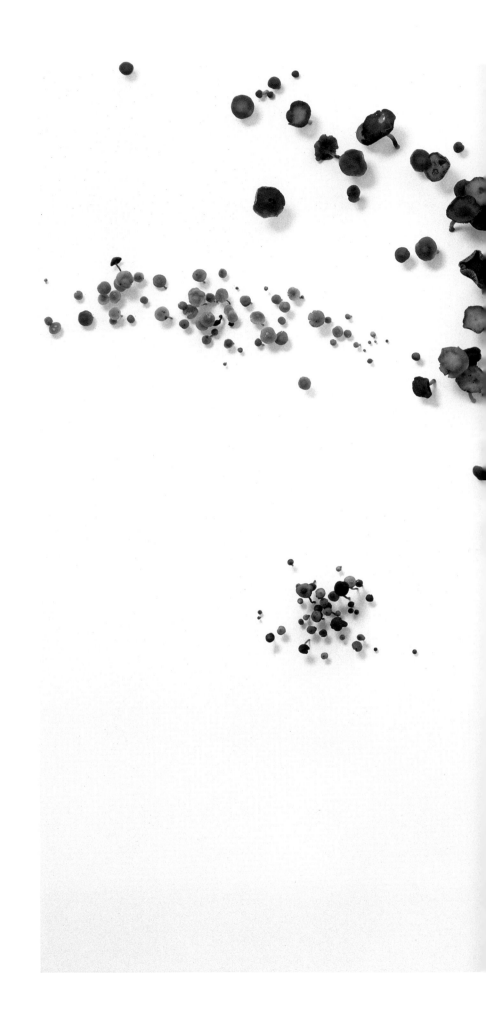

Untitled, 2002

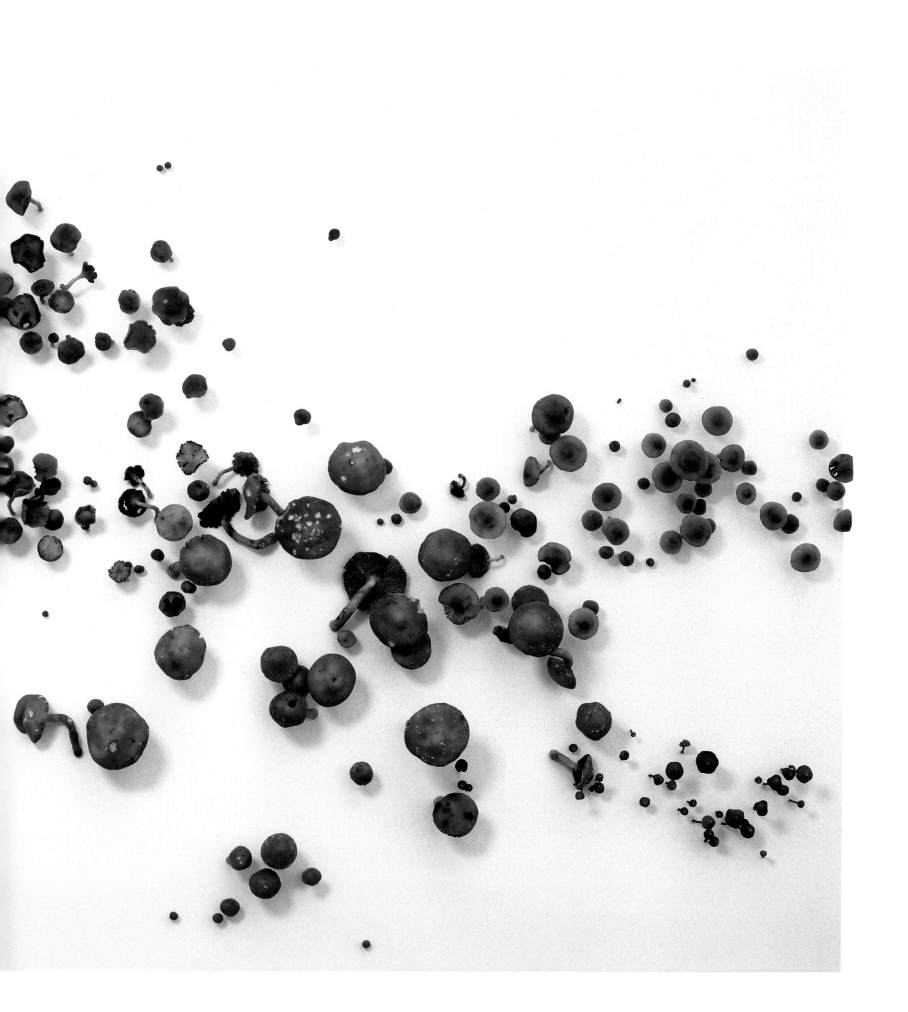

Tapioca Slime Painting, 2001

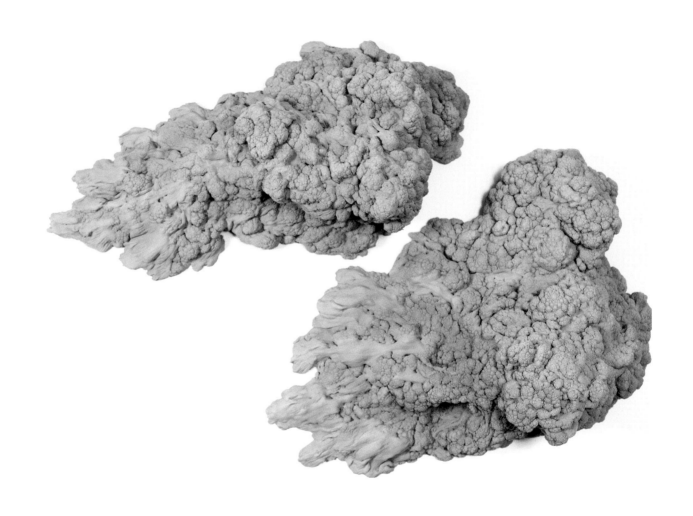

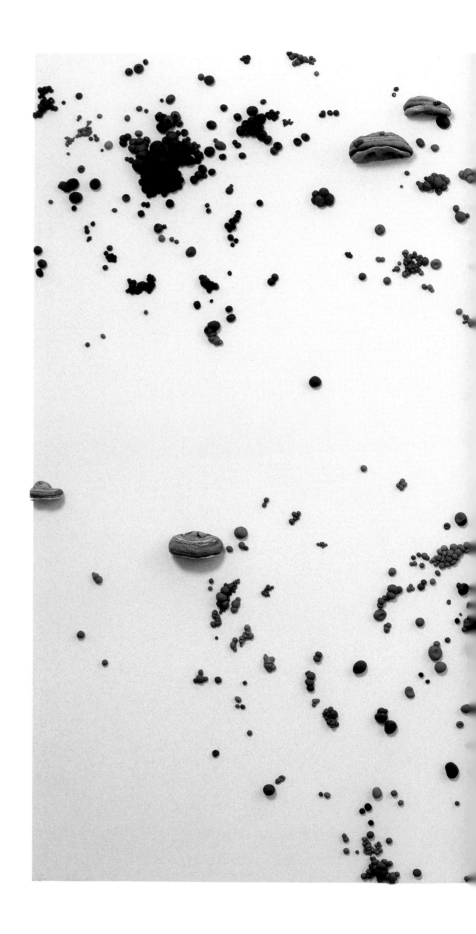

Untitled, 2002

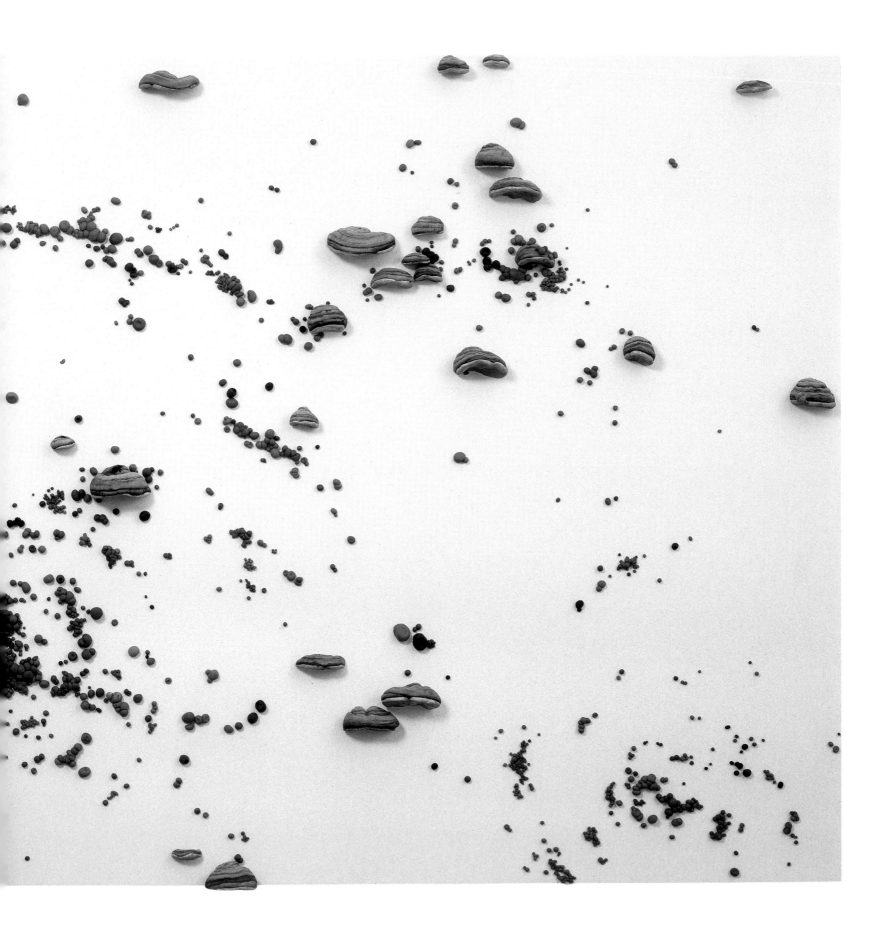

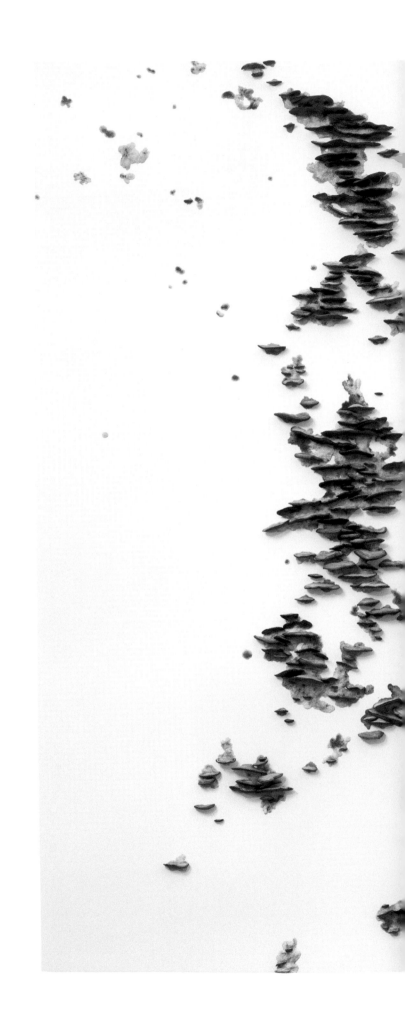

168 Untitled, 2002

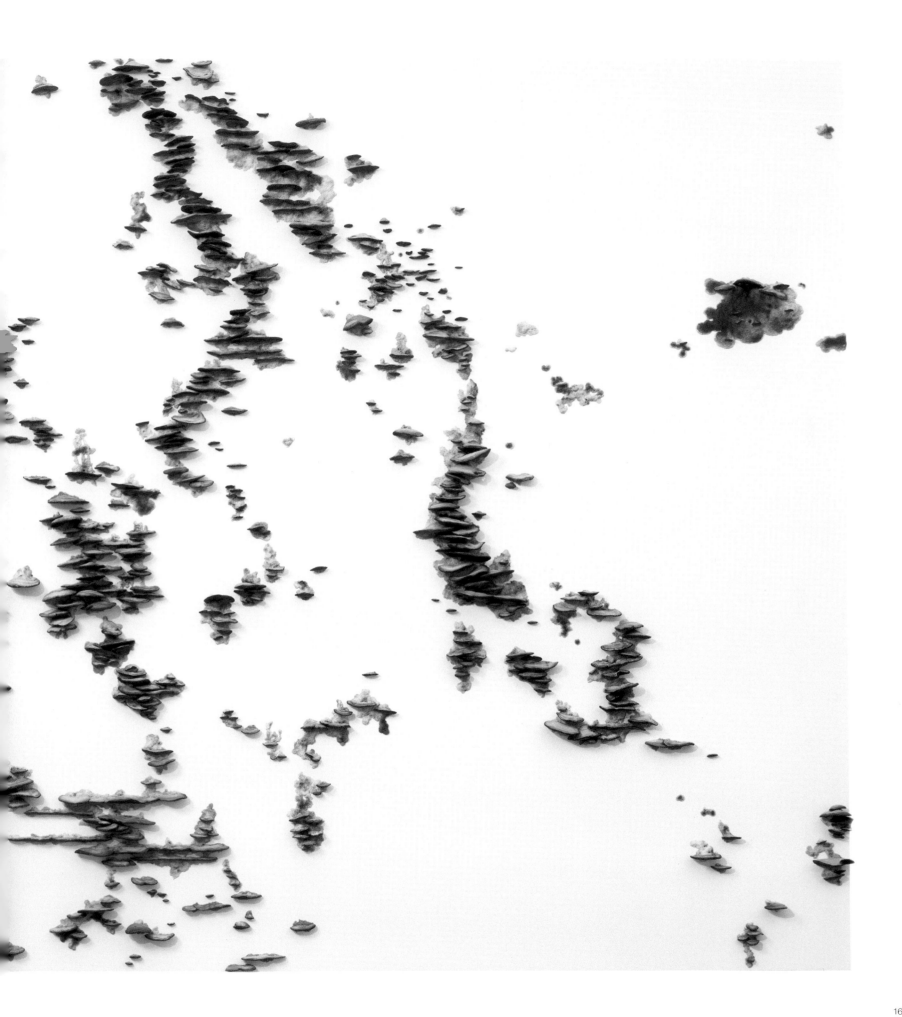

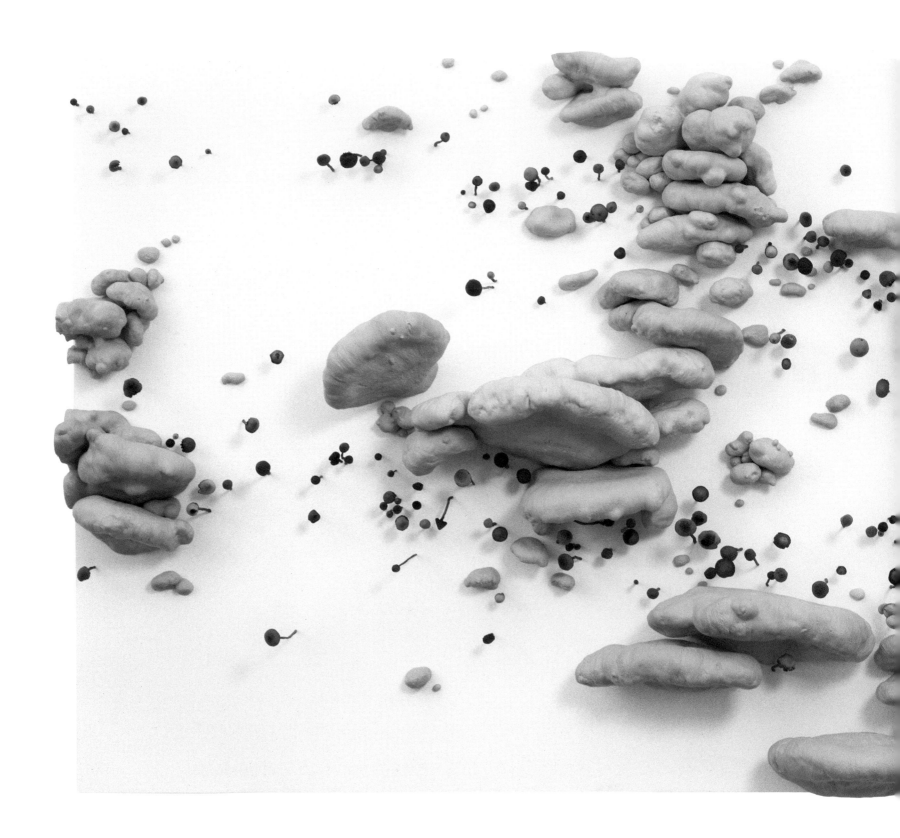

Untitled, 2002

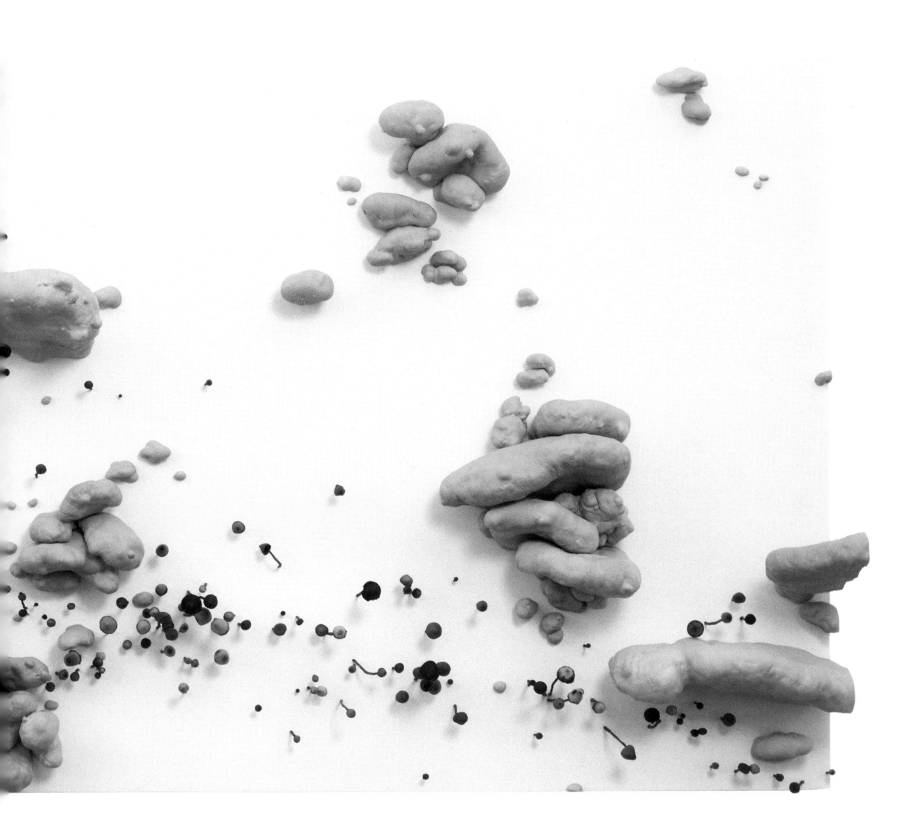

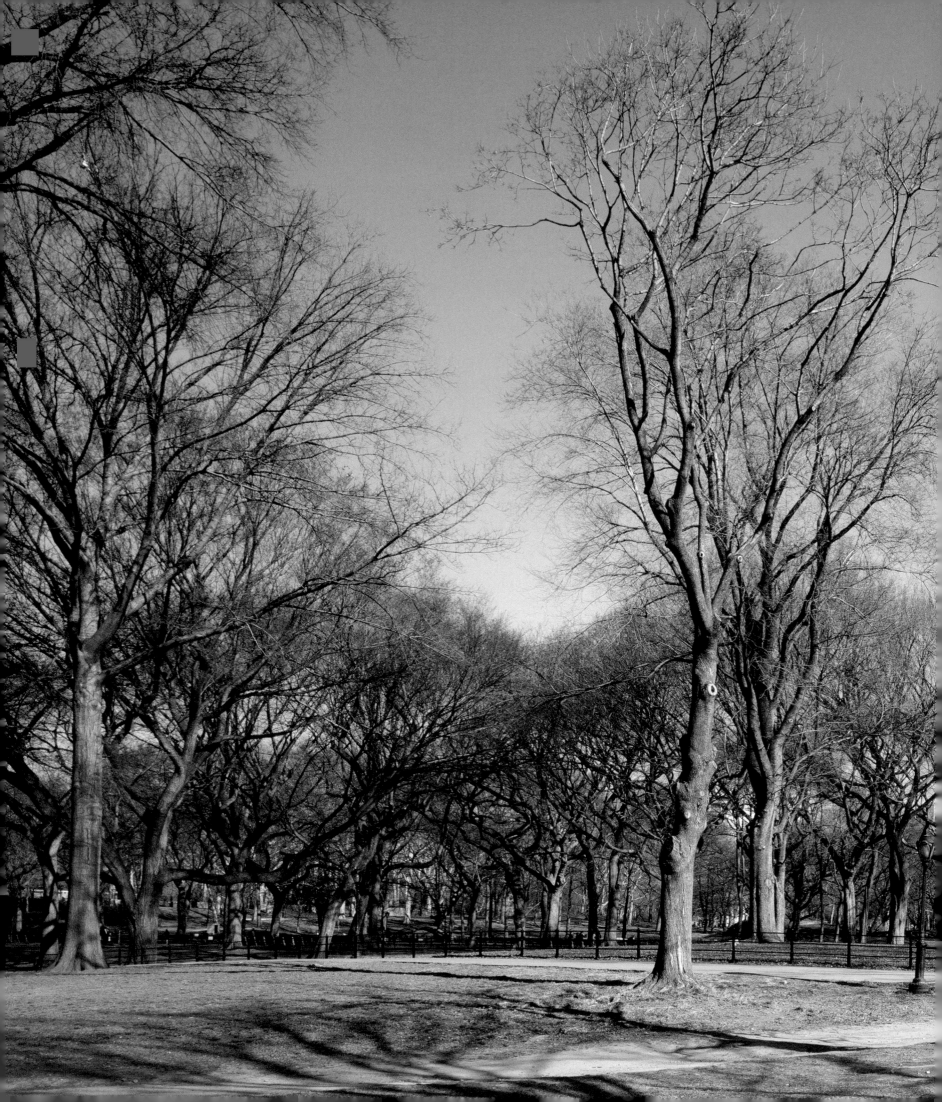

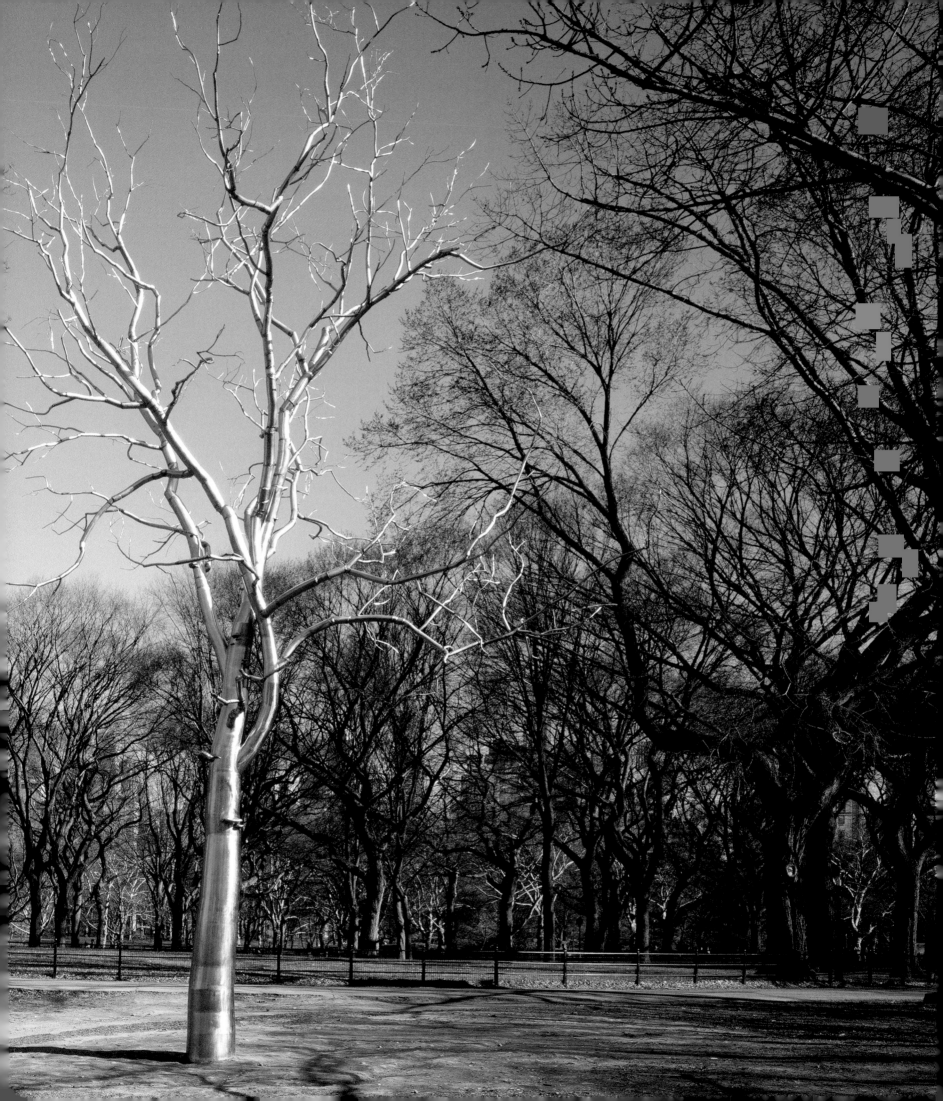

Engineering studies for **Bluff**, 2002; pages 172–73 and 175: **Bluff**, 2002

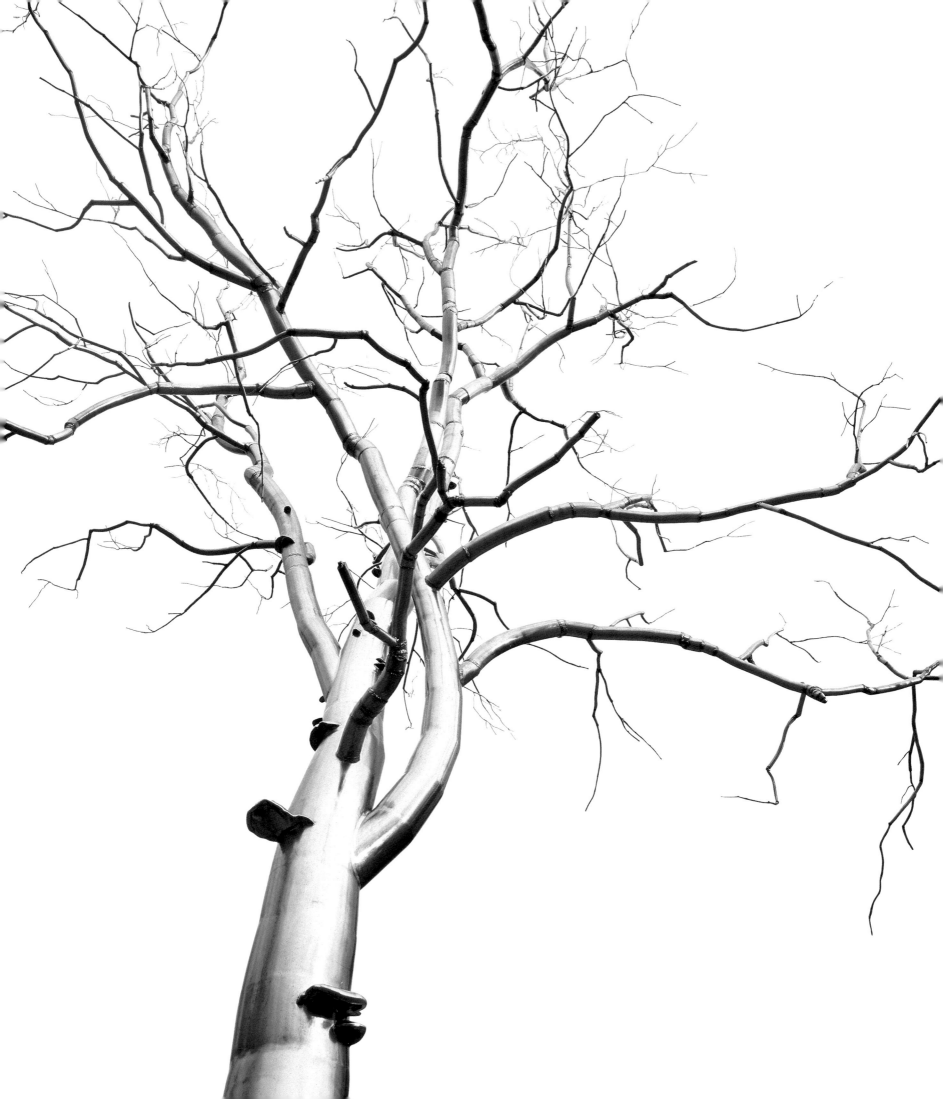

Split, 2003

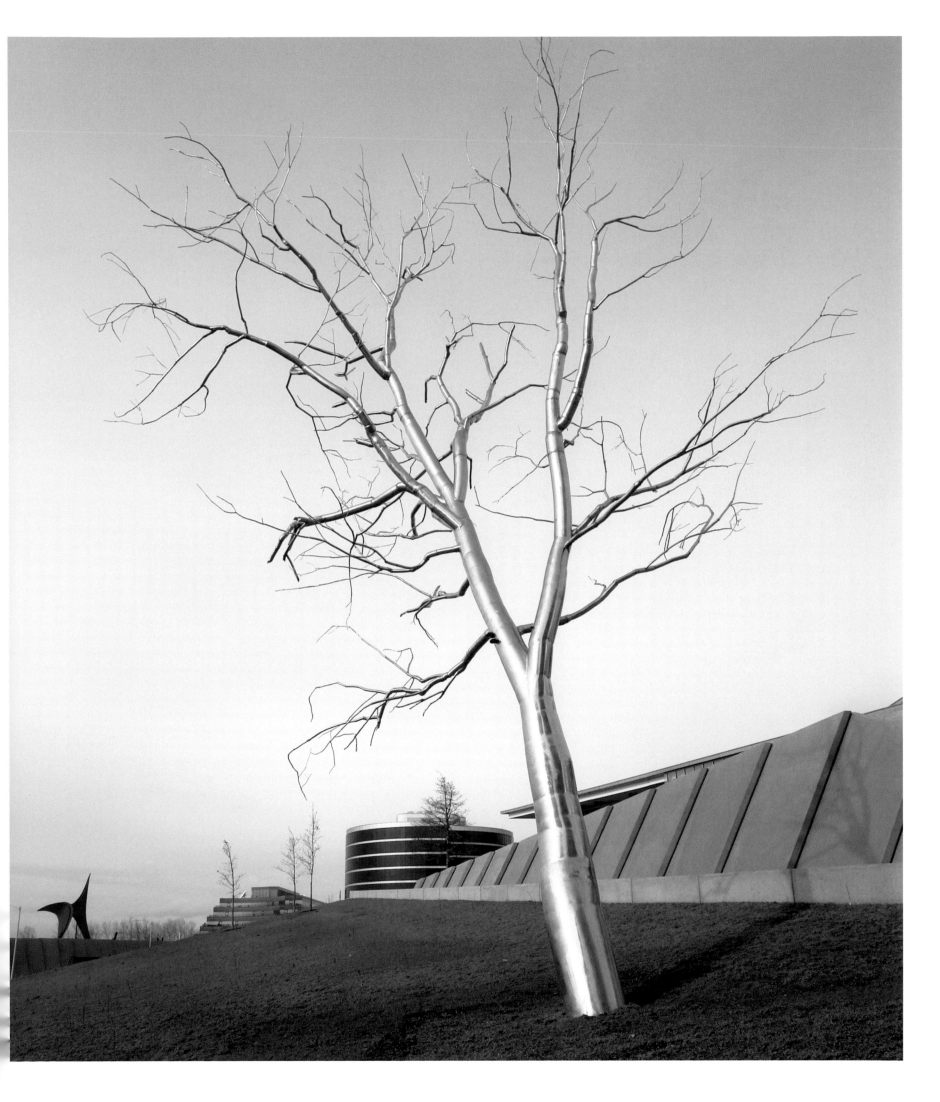

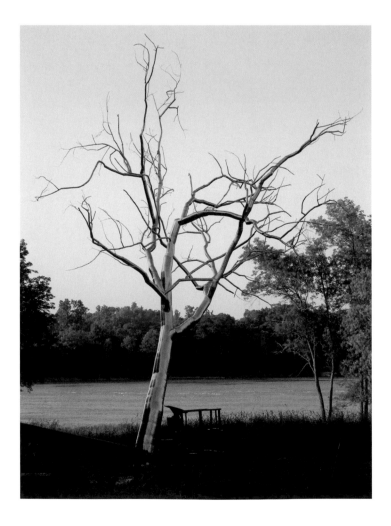
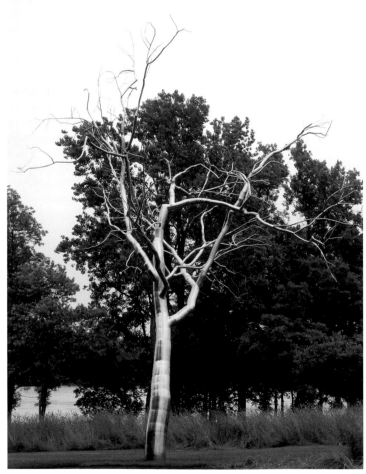

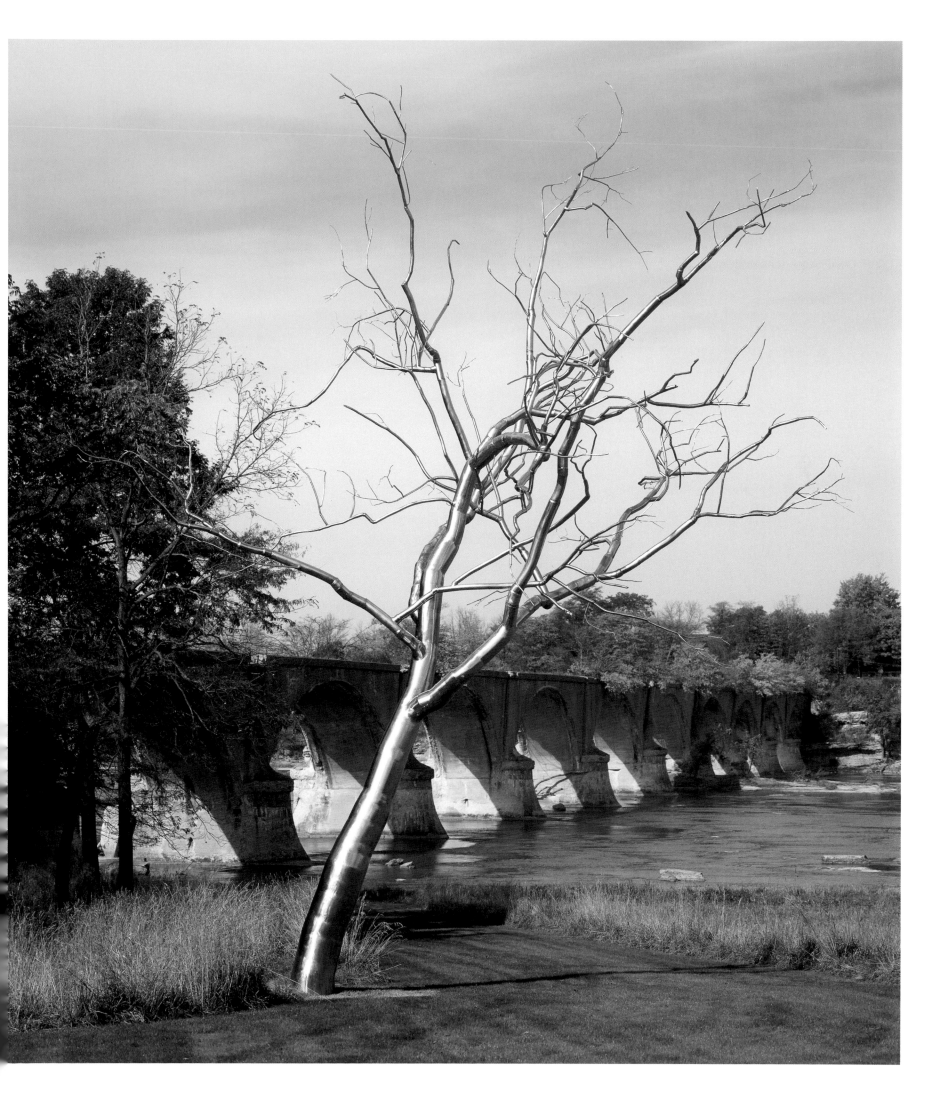

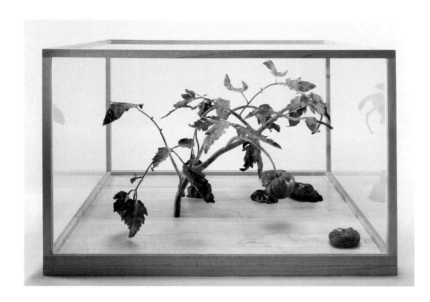

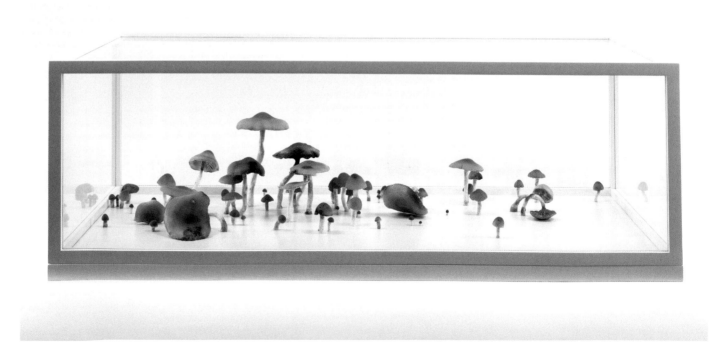

Top: **III Tomato**, 2005; bottom: **Azurescens Case**, 2006

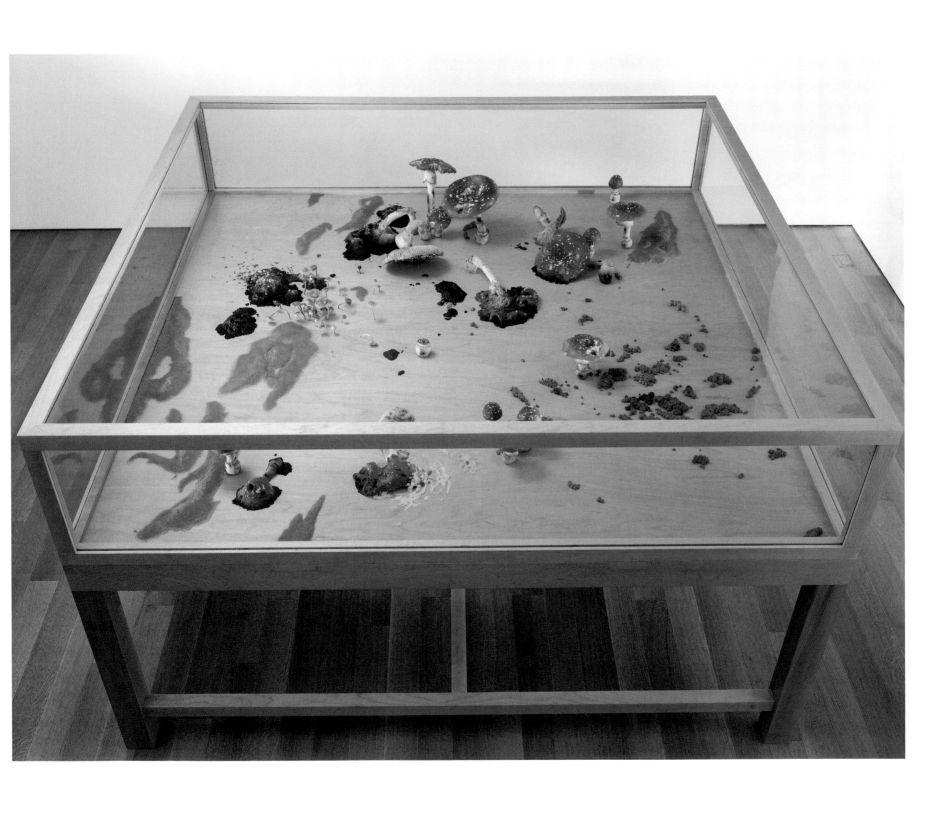

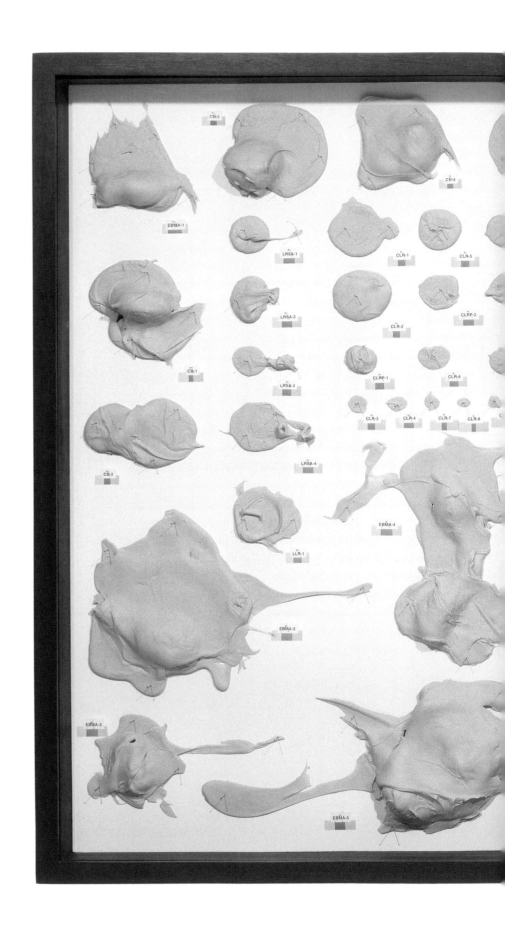

Specimen Case No. 11, 2000 (for key, see p. 256)

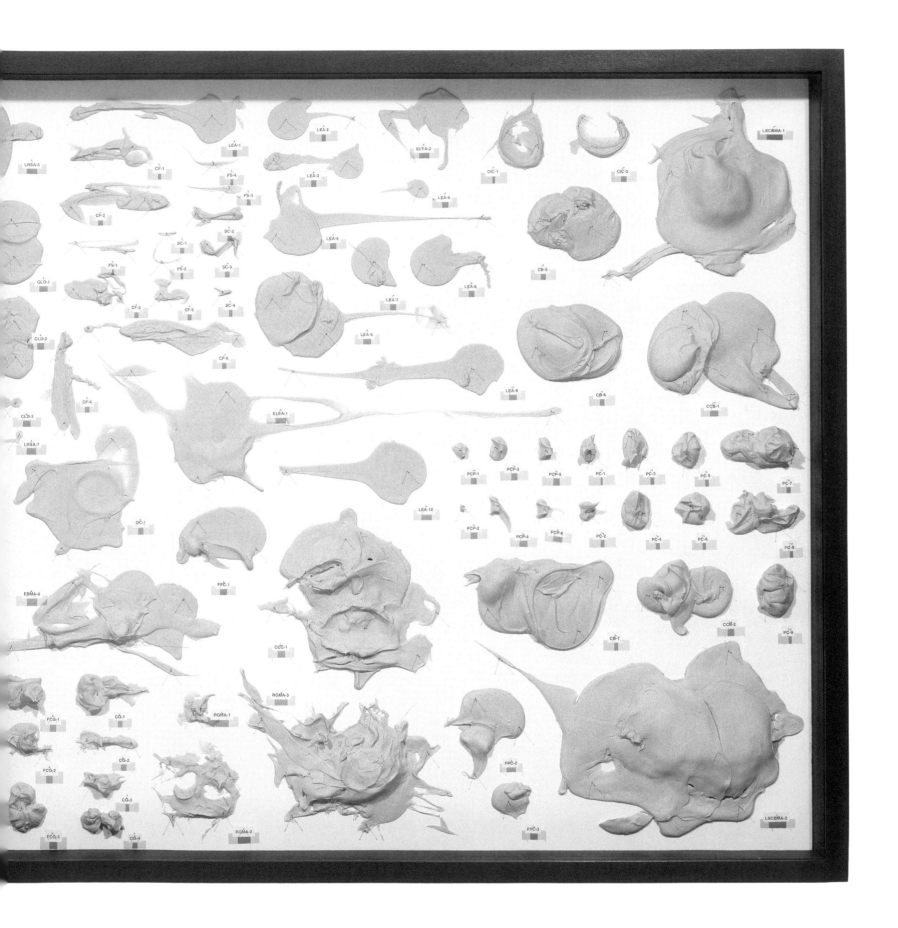

LRSA-5
CF-1
LEA-1
FS-4
LEA-2
ELEA-2
CIC-1
CIC-2
LSCBMA-1

CF-2
FS-3
LEA-3
LEA-6
CB-5

FS-1
SC-1
SC-2
LEA-4
CLD-1
CF-3
FS-2
SC-3
CF-5
SC-4
LEA-7
LEA-8

CLD-2
CF-6
LEA-5
CB-6
CCB-1

CF-4
ELEA-1
CLD-3
LRSA-7
PCP-1
PCP-3
PCP-5
PC-1
PC-3
PC-5
PC-7

DC-1
LEA-10
PCP-2
PCP-4
PCP-6
PC-2
PC-4
PC-6
PC-8

EBMA-6
FPC-1
CCB-2
PC-9

CCC-1
CB-7

FCG-1
CG-1
RGMA-3
RGMA-1

FCG-2
CG-2
FPC-2

FCG-3
CG-3
CG-4
RGMA-2
FPC-3
LSCBMA-2

183

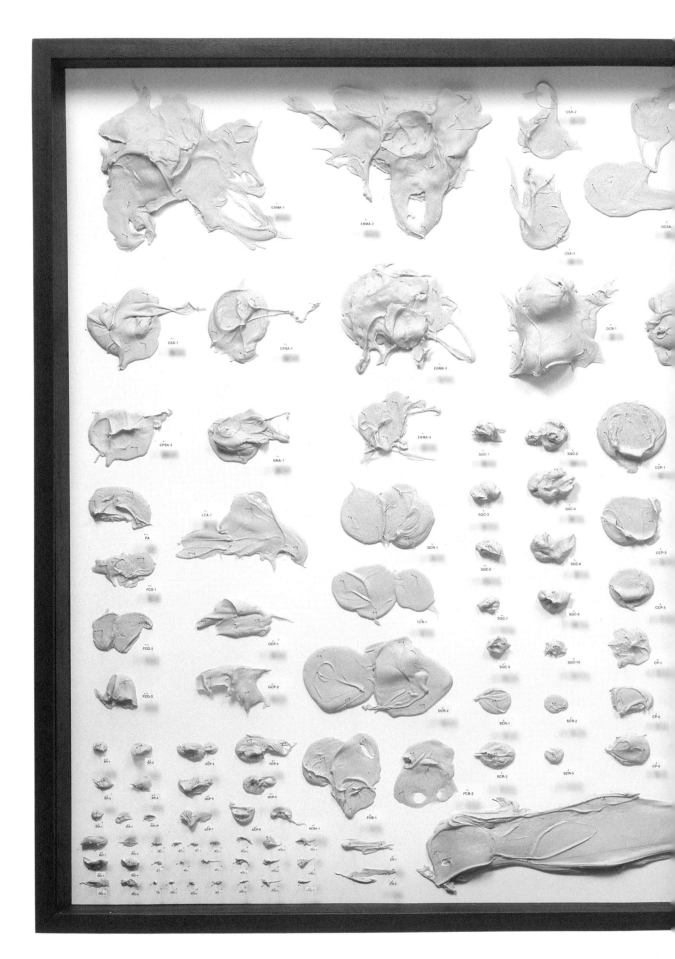

Specimen Case No. 12, 2006 (for key, see p. 256)

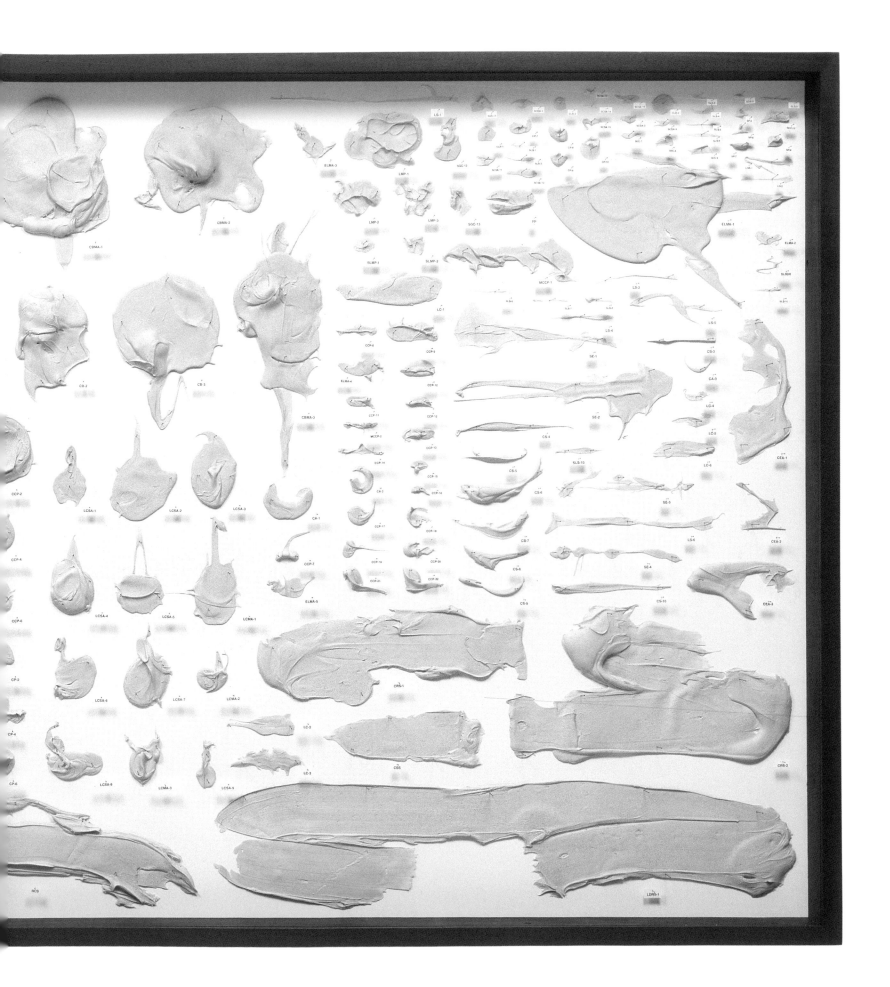

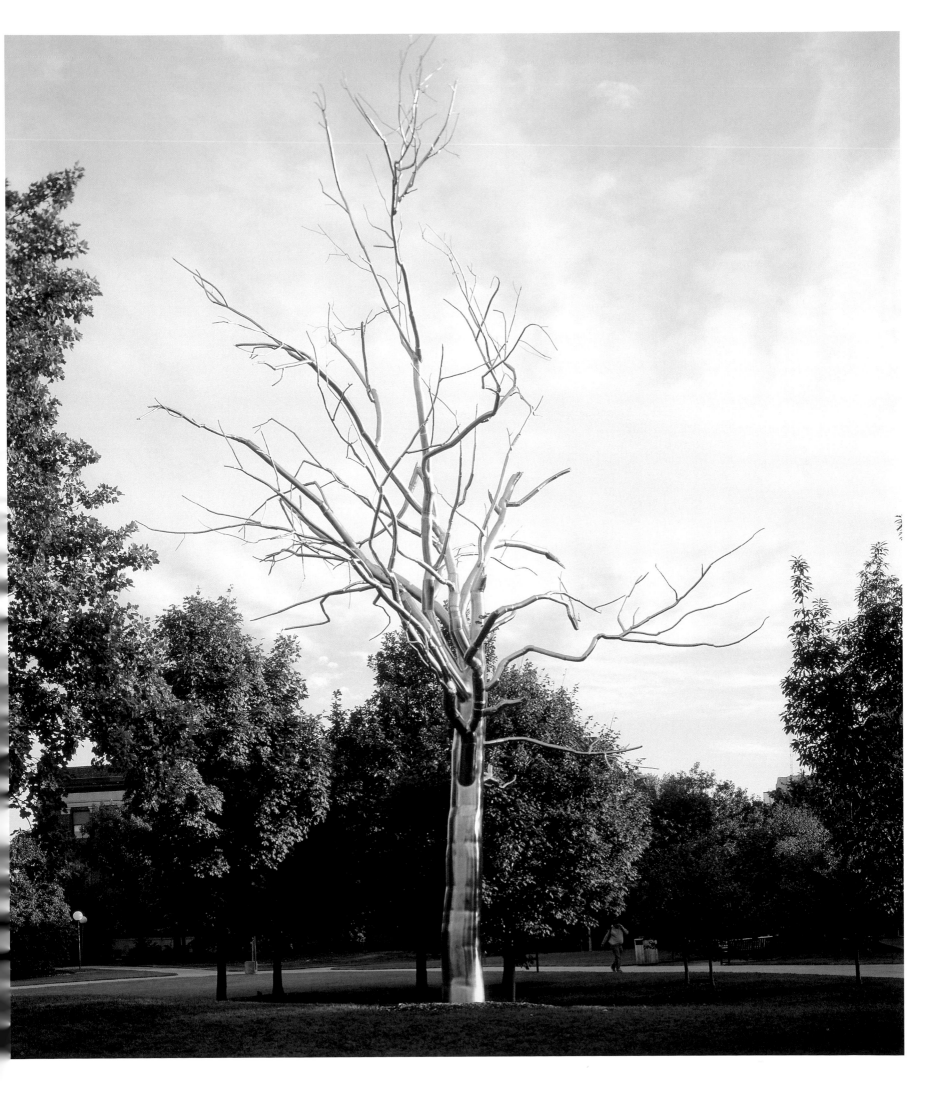

Breach, 2003 (detail)

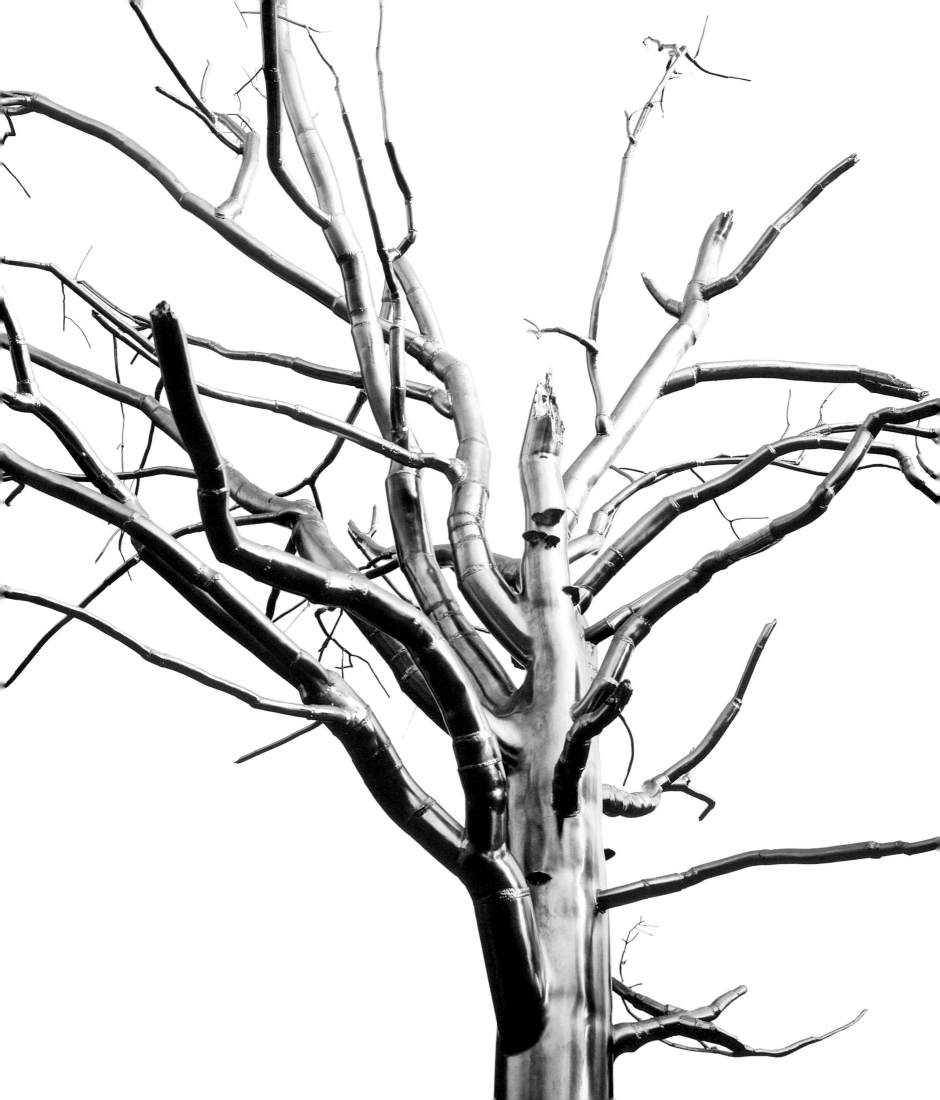

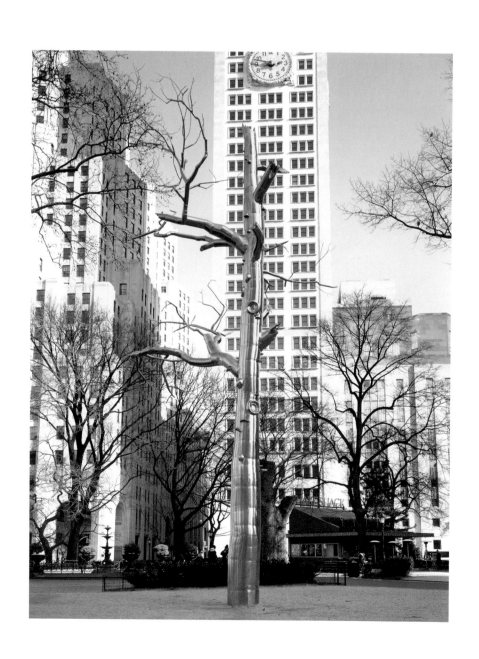

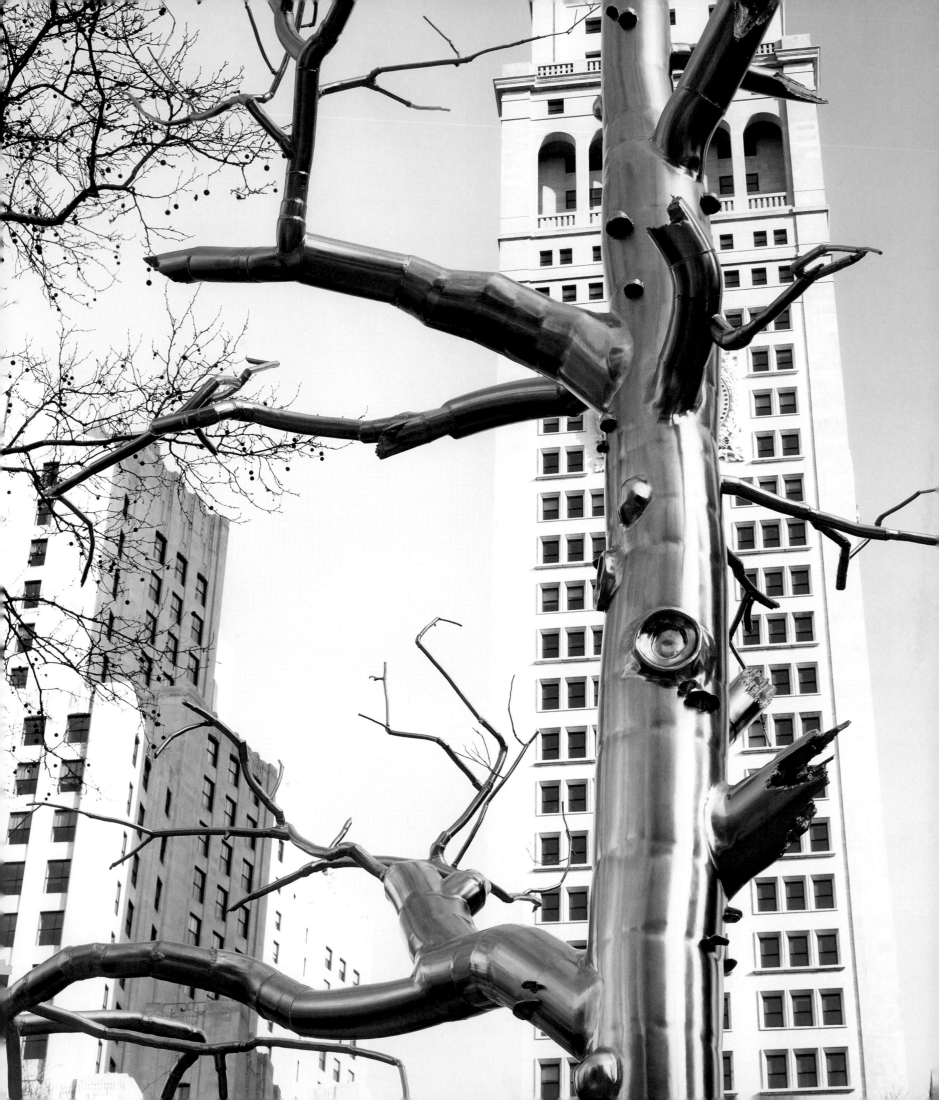

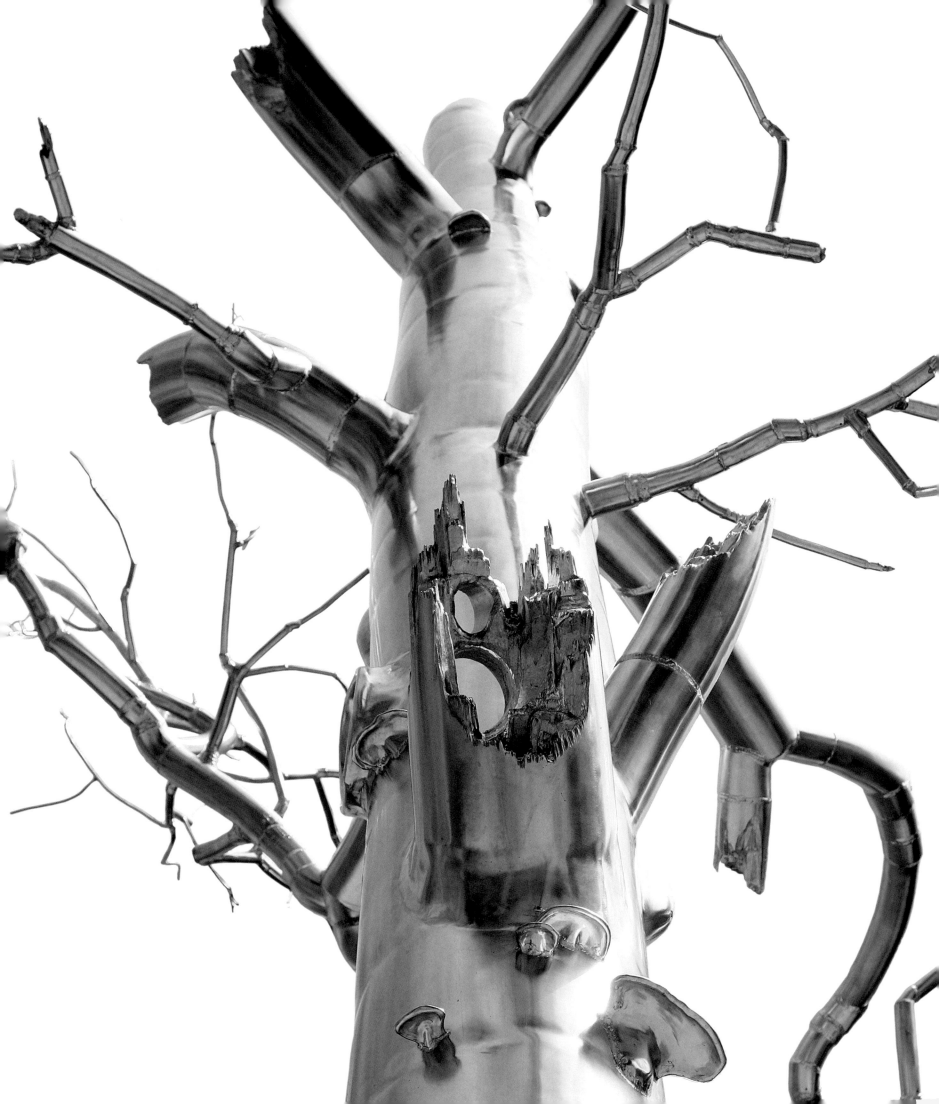

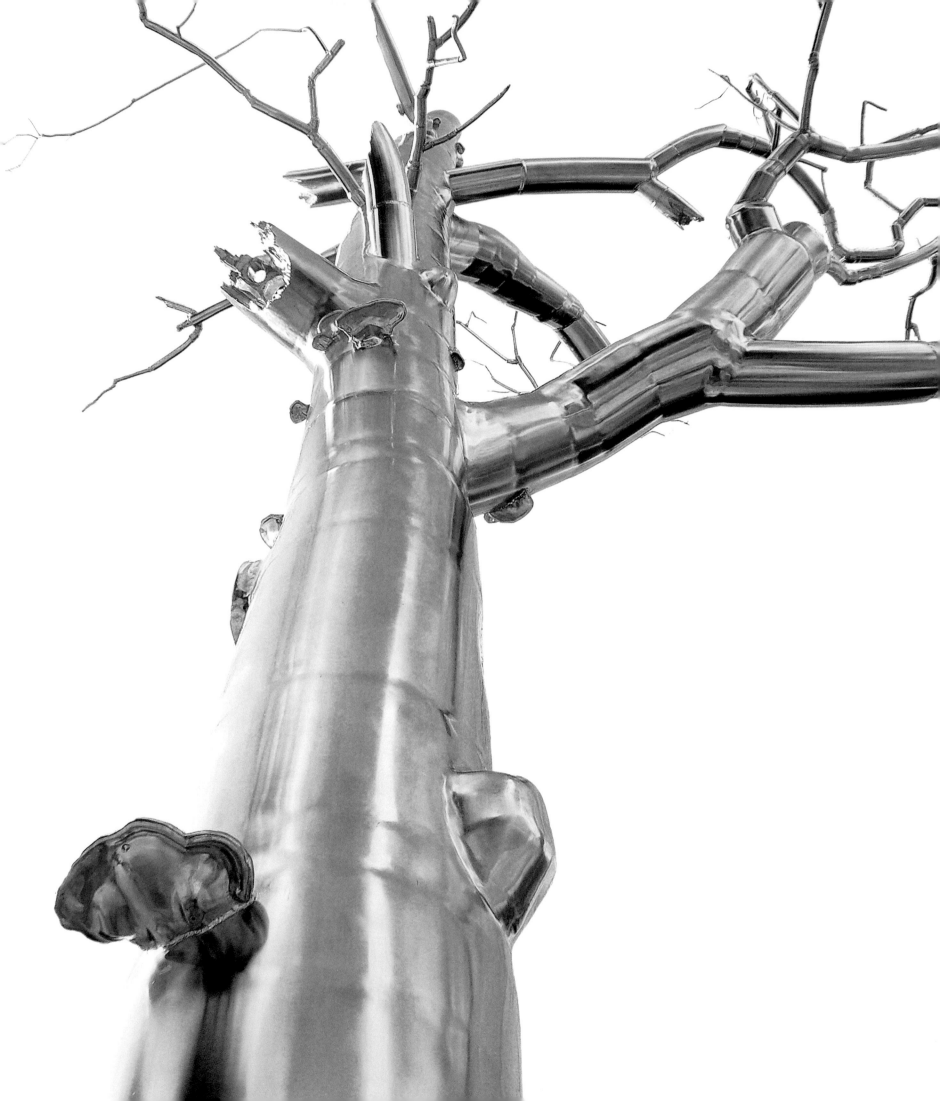

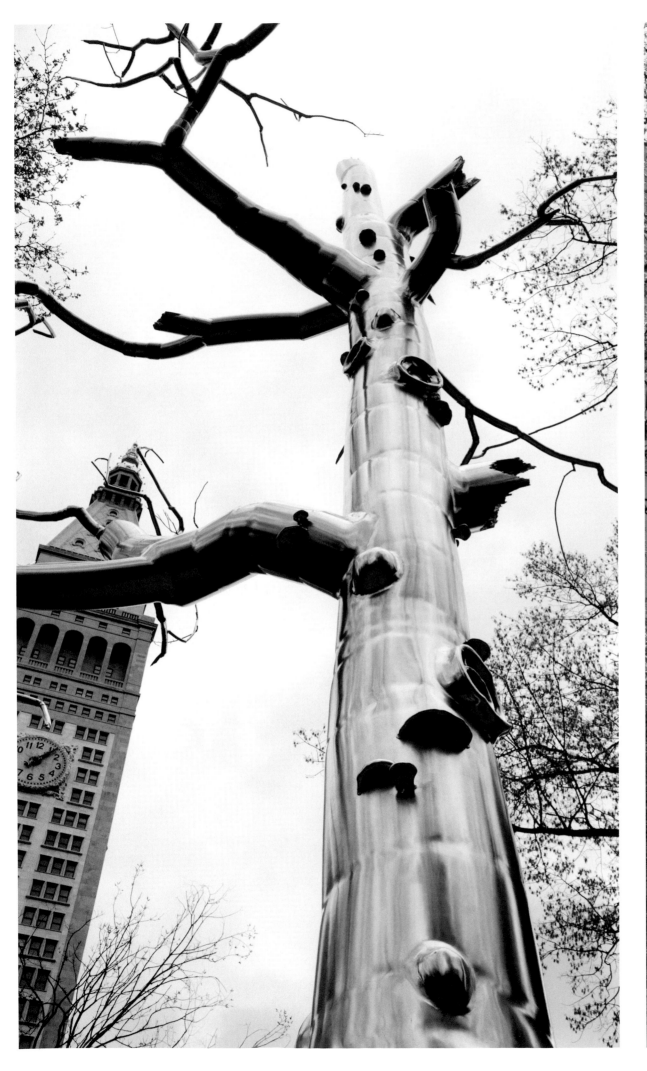

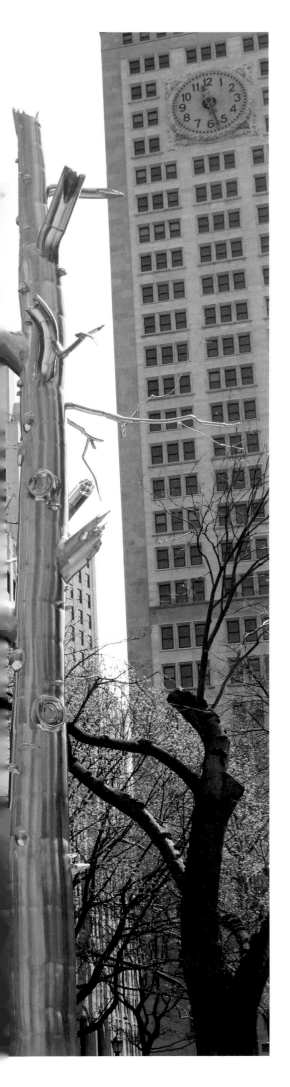
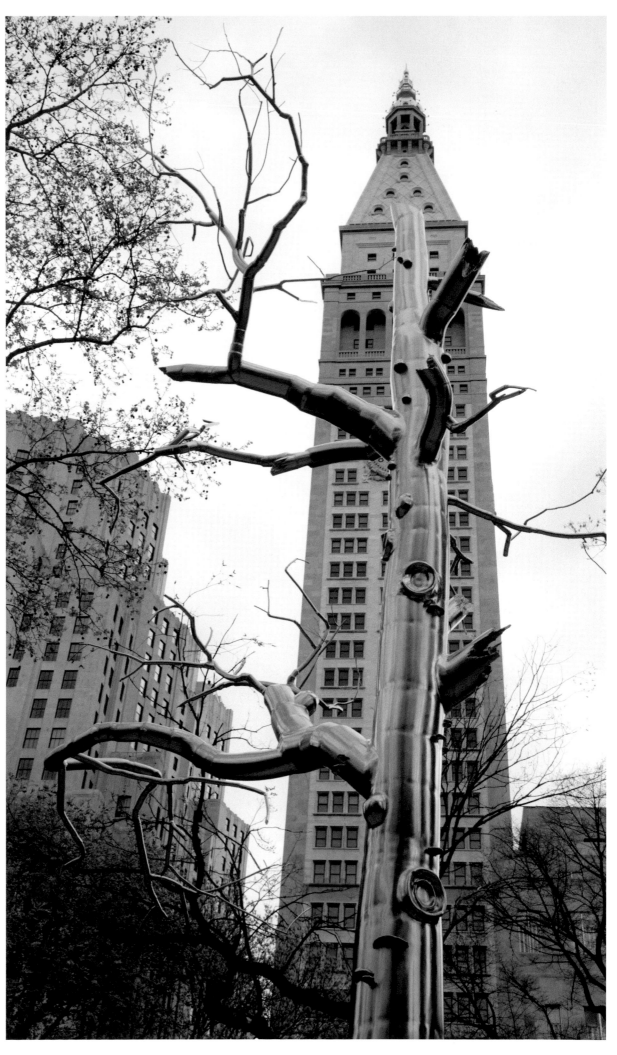

Palimpsest, 2004

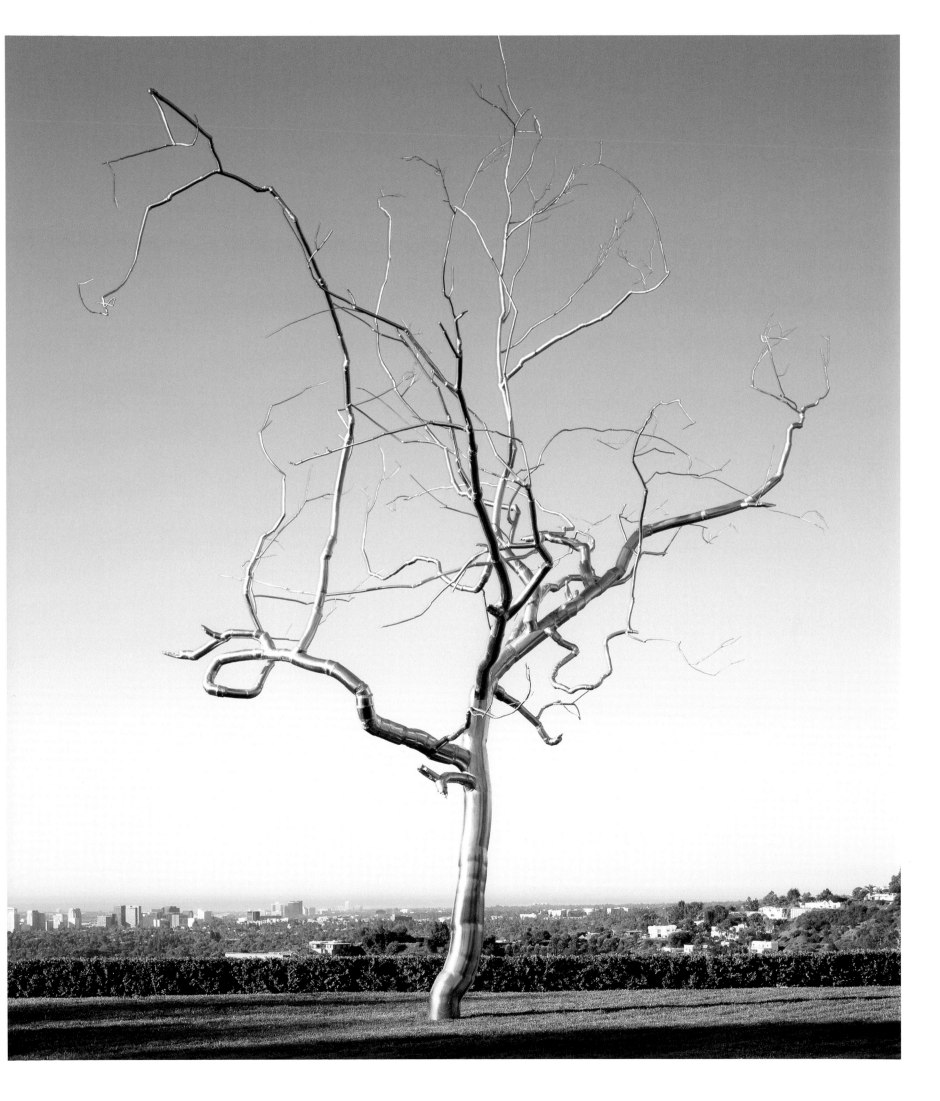

Palimpsest, 2004 (detail)

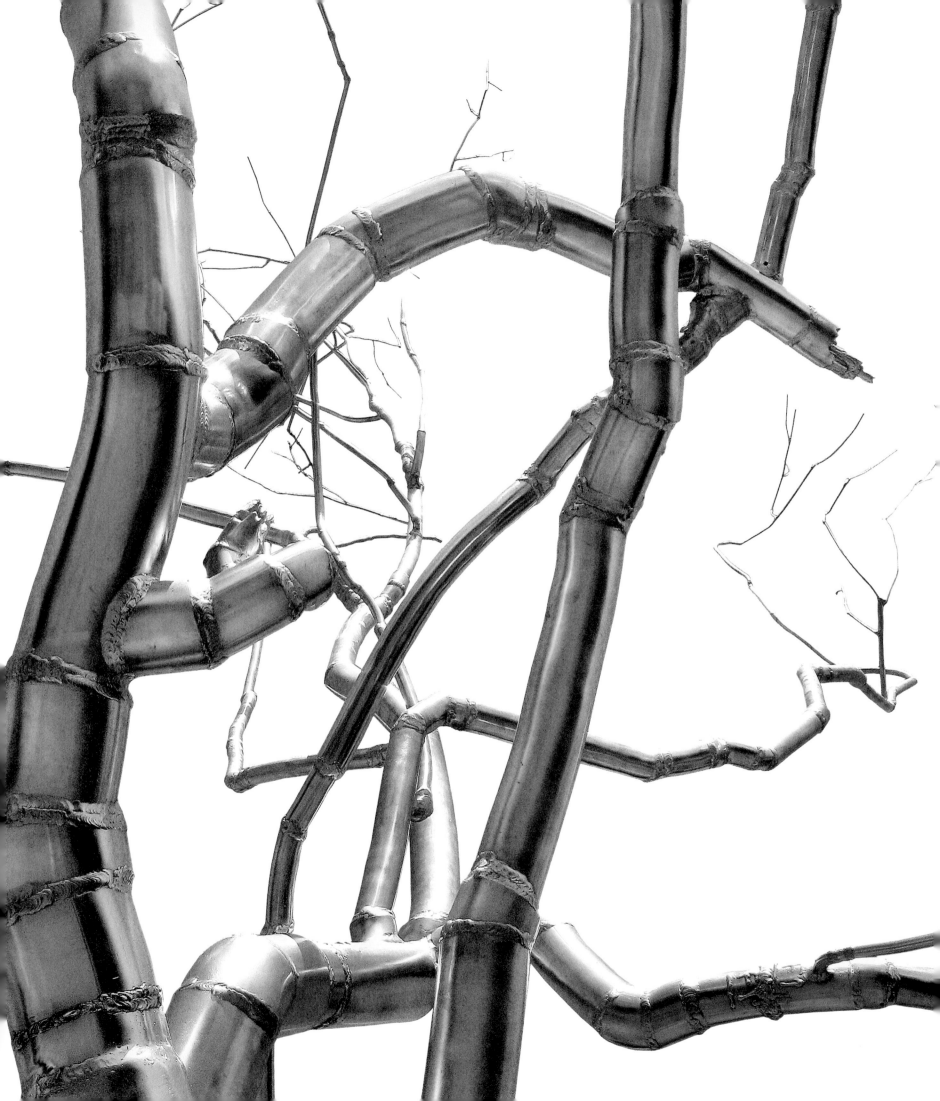

Pages 201, 202 and 203: **Placebo**, 2004

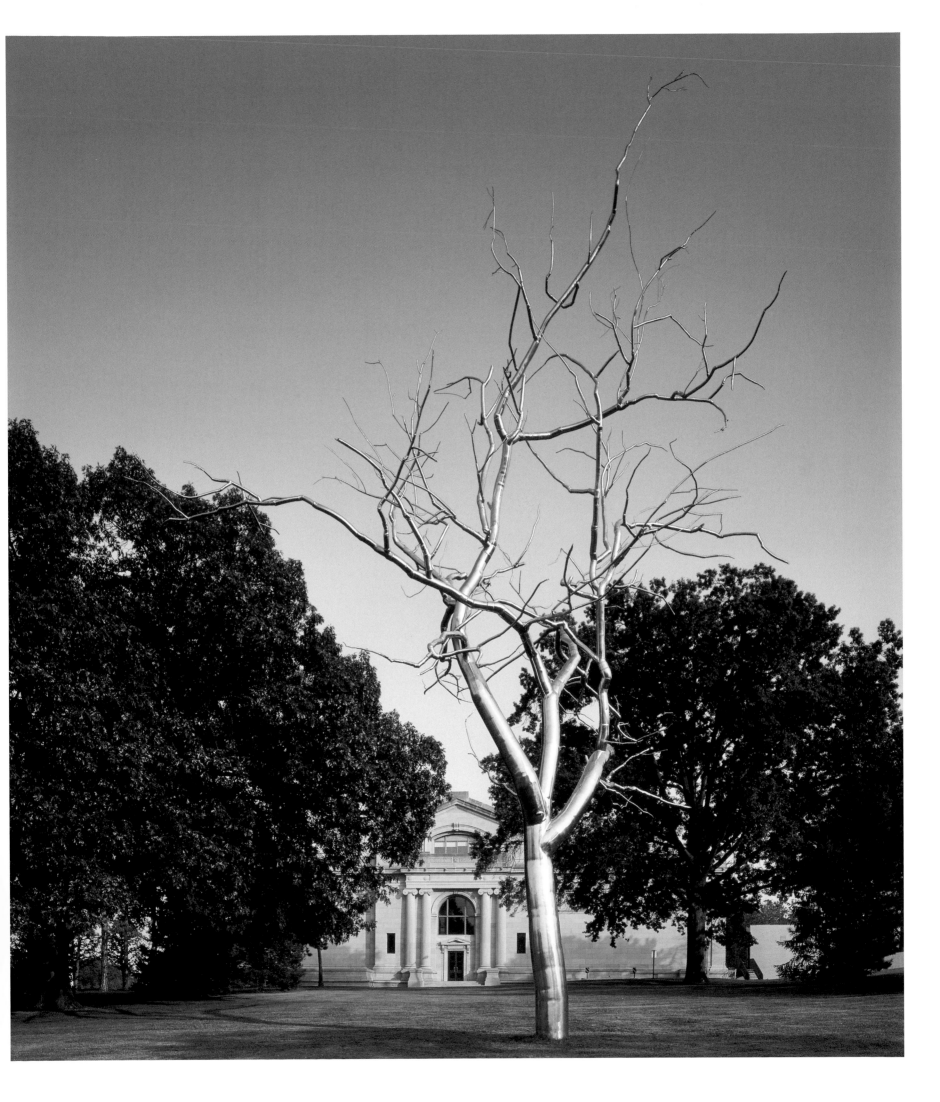

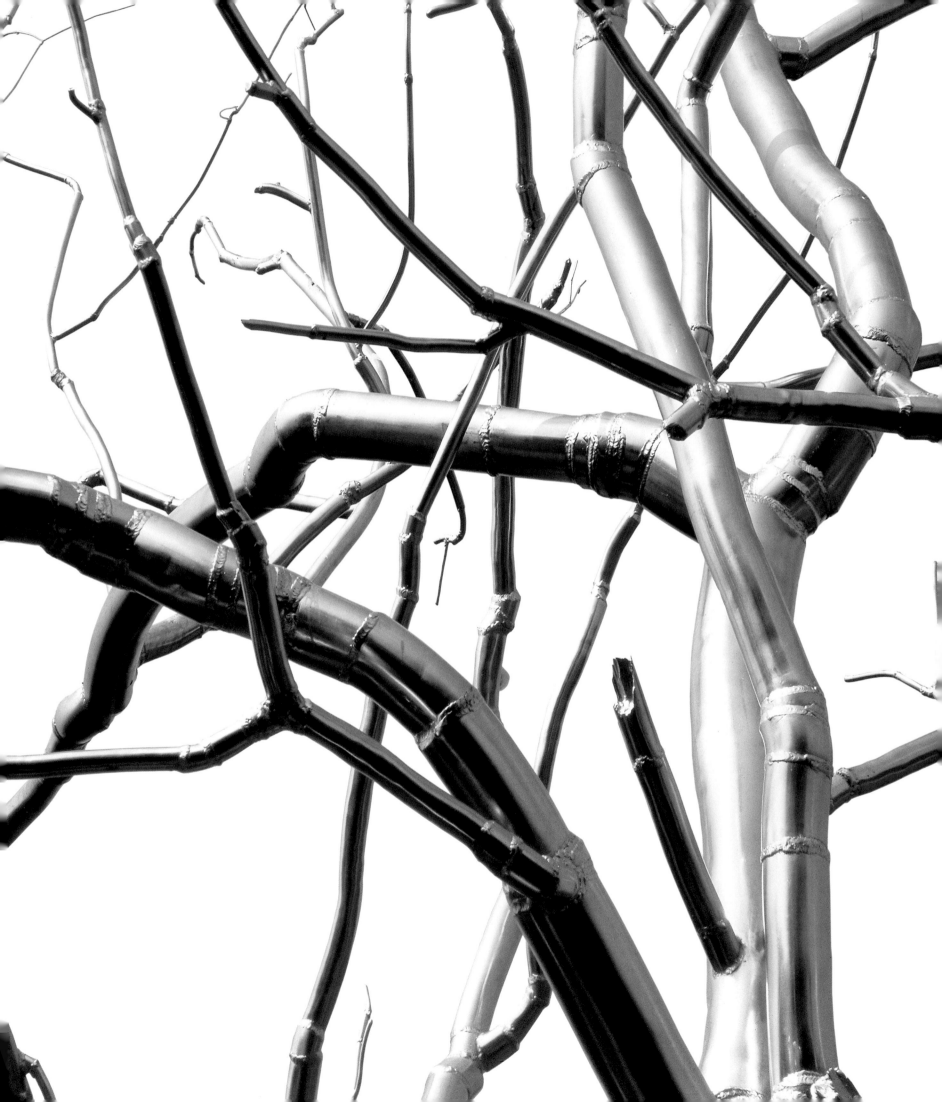

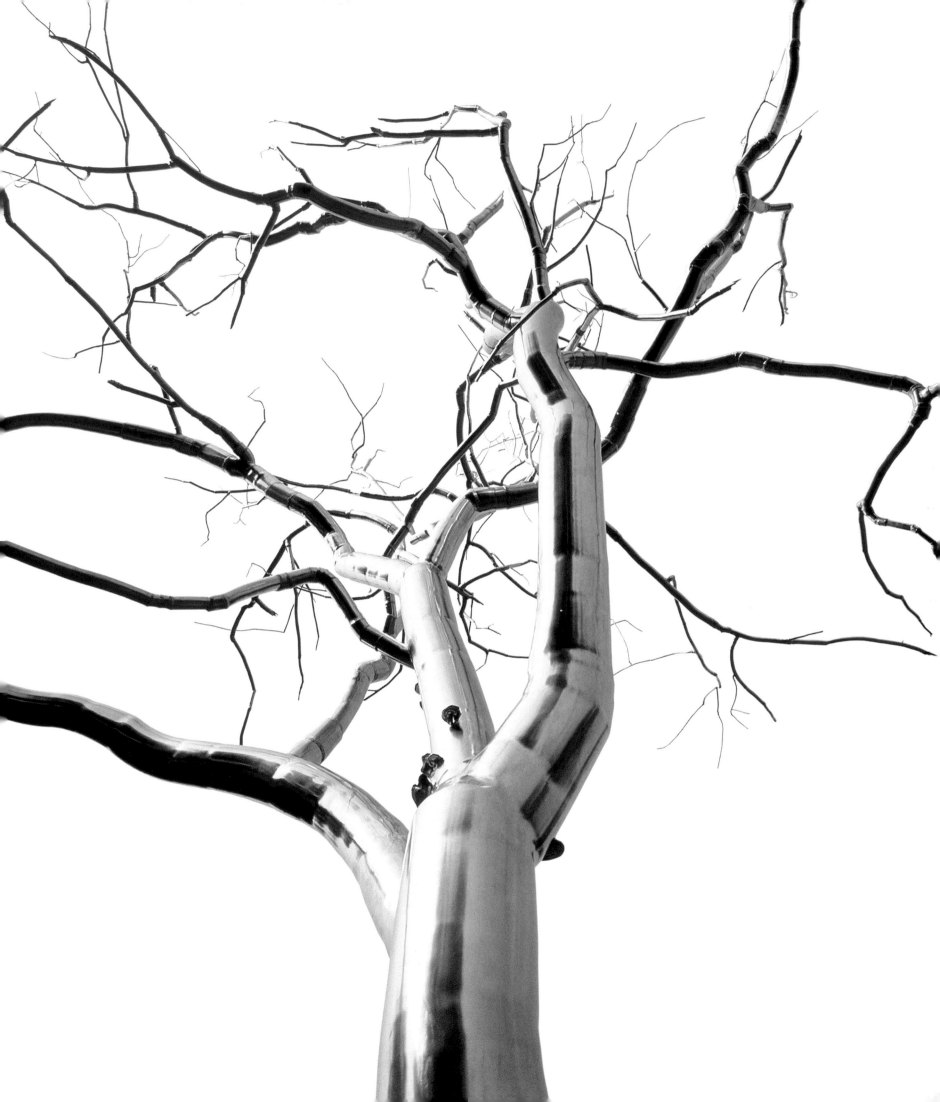

MODERNISM, MATERIALS, AND MYCOLOGY

Although Paine delves promiscuously into disciplines as diverse as robotics, botany, mycology, geology, physics, and neuroscience, he remains deeply committed to his role as an artist, creating works that retain a keen sense of art history and aesthetic theory while also poking fun at the shibboleths and pieties of modernism. This strategy was evident in his early **Large Soap** (1996; pp. 30–31, 204), a grid of commercial soap bars of varying hues. This work both mimics the geometric color-chart paintings of artists such as Ellsworth Kelly and Gerhard Richter and satirizes, by literal example, the purity of modernist abstraction. Action Painting seems the target of Paine's 1990 **Viscous Pult**, a kinetic work that splattered the gallery window with white paint, ketchup, and motor oil. And the do-it-yourself kits that comprised **Model Painting** and **Model for an Abstract Sculpture**, described above, took aim at Modernism's fetishistic attitude towards originality and authenticity in art.

Such works might seem to be merely the insouciant response of a postmodern artist to his precursors. In fact, they represent Paine's engagement in a thoughtful and multifaceted dialogue with modernism and its discontents. Paine makes use of the revolutionary aspects of formalism, Action Painting, Process Art, and Minimalism without feeling required to accept these movements wholesale. As a result, his works provide new ways to think about old "truths."

Paine's attitude to materials forms one of his most important links to art history. In a discussion of the products created by his machines, he remarked: "In a way they're actually portraits of the materials that each machine works with. They get at the core essence of whatever the material is. Like the polyethylene that makes the **Scumaks**: the viscosity, the hardness, the molecular structure . . ."[23] He adds, "That is what causes them to flow, to accumulate, to cool the way they do, so they reveal inherent structural aspects of the materials themselves."

By subjecting plastic, paint, and sandstone to various natural and industrial forces, the machines are designed to bring out the inherent qualities of the materials on which they work. Paine's goal here seems to relate to the philosophy of the once-powerful critic Clement Greenberg, who became the guru of American modernist art during the 1940s and 1950s. In a seminal 1940 essay, the critic outlined the beliefs that came to be understood as Greenbergian formalism. He declared that painting and sculpture should be stripped of all hybrid forms and external references, leaving them "to be hunted back to their mediums" where they would be "isolated, concentrated and defined."[24] Further elucidating, though not necessarily clarifying, his ideas, Greenberg went on to note: "The purely plastic or abstract

[23] Herbert, interview, 21.

[24] Clement Greenberg, "Towards a Newer Laocoon," *Partisan Review* 7, no. 4 (July–Aug. 1940), reprinted in Francis Frascina, ed., *Pollock and After: The Critical Debate* (New York: Harper and Row, 1985), 42.

qualities of the work of art are the only ones that count. Emphasize the medium and its difficulties, and at once the purely plastic, the proper, values of visual art come to the fore."[25]

Greenberg's dictums pointed to a strict aesthetic regime in which paintings were to exist simply as self-contained dispositions of line, color, and shape on flat canvases, and sculptures were to consist of abstract masses of materials in space. However, Greenberg was not a pure materialist—by "medium" he referred not just to the material out of which an artwork was created, but also to its abstract form and its visual impact. It was up to the Minimalists, whom Greenberg despised, to take his ideas to the next logical step. The Minimalists were radical reductionists who removed any remaining vestiges of illusionism and subjectivity from art. Artists such as Donald Judd and Carl Andre are identified with works that consisted of standardized, interchangeable parts fabricated from industrial materials and arranged on the floor or wall with a machine-like consistency.

With his machines, Paine confronts these issues. The products of the **SCUMAK**, **PMU**, **Paint Dipper**, and **Erosion** machines are, first and foremost, evidence of the reaction of the materials to the forces of gravity, heat, compression, and even barometric pressure to which they have been exposed. There is no effort to disguise their essential qualities, as is often the case with industrially produced plastic products, or even in traditional illusionist paintings and sculptures. In this they are very Greenbergian. At the same time, Paine's use of industrial production and repetition point toward Minimalism. As Paine has remarked: "One could look at the machine pieces as a logical extension of Minimalist ideals. The **SCUMAKS** can be seen as revealing the essential nature of this plastic, polyethylene. Also, they are being produced by an industrial process without human intervention. However, other ideas present in the pieces directly contradict Minimalist notions. The pieces would not be interesting to me if those contradictions were not embedded in them."[26]

Among those contradictions are certain aspects that bring these works closer to Process Art or Anti-Form, two names for a school of art in the Sixties that paralleled Minimalism yet sought to soften the severity of its principles. As the name suggests, the process is part of the content of the work. One of the most literal realizations of this idea was a 1961 work by Robert Morris titled *Box with the Sound of Its Own Making,* which consisted of a plain wooden box that contained a three-hour tape recording of the sounds made during its construction. But Process Art was also an exploration of materials that reflected the ideal of open-endedness and transparency. Morris frequently worked with accumulations of felt and other soft materials that spilled across the floor. In a similar spirit, Eva Hesse created floppy latex grids, Richard Serra splashed molten lead on the wall and floor and allowed it to dry in rippling configurations, and Linda Benglis created colored latex "pours," which countered the insistently non-objective quality of much Minimalist work by appearing to be flexible, fleshlike, and also, some argue, feminine.

Paine's **Scumaks** and manufactured paintings are clearly heirs of this approach to art. Speaking to an interviewer about his **PMUs**, Paine echoed Morris: "You can read that into them, [a relationship to the tradition of the monochrome painting] but for me it's more about

[25] Greenberg, "Towards a Newer Laocoon," 44.

[26] McCollum, "Conversation," 26.

27 Herbert, interview, 22.

28 McCollum, "Conversation," 11.

keeping the focus on the process. The thing that is most important to me is that they are a record of their own making."[27] Indeed, the multiple layers that have slowly accumulated to create the forms of the sculptures and paintings can be seen as encapsulations of their process, frozen records of the slow repetitive dipping or spraying that brought them into being.

An even more basic contradiction inherent in these works is the fact that Paine has no interest in purging references to the outside world, in the manner of formalism, Minimalism, and Process Art. Instead, he welcomes such associations. He points to the geologic qualities of the layered landscapes that are created by **Erosion Machine**, relating the walls of their tiny canyons to strata found in Utah's Grand Staircase–Escalante National Monument. He does not shy away from interpretations that link the drips at the bottom of his manufactured paintings to stalactites or icicles. His clearly representational Dendroids and Replicants further betray modernism's strictures against illusionism and representation. It is evident that for Paine there is no essential conflict between formal issues and imaginative ones.

This belief is even more evident when Paine takes on the issues of painting. He initially studied painting in school before turning to sculpture, and he retains an interest in such questions as the relationship between figure and ground and the contradictions of illusionism and abstraction. Oddly enough, though his **Paint Dipper** and **PMU** machines manufacture paintings, it is really with certain types of Replicants that Paine delves most deeply into the meaning and history of painting. Both his fields, which involve groupings of individual Replicants, and the Myco Paintings (derived from "mycology"), which comprise a subset of the fields and involve arrangements of elements on vertical canvases, consciously refer to gestural abstraction.

From one perspective, all of Paine's works are essentially fields, in the sense that they represent interconnected systems of discrete elements bound by certain conventions. As the artist remarked to an interviewer: "I imagine each piece as a field. A field as in a place where the mind can play—a playing field or a court. If we're talking about a basketball court, there are structures in that court—elements and rules, number of players, rules of play, physical boundaries, and time limits. And yet the way that each game progresses is unique and infinitely varied."[28]

However, Paine also uses the term "field" in a narrower sense when he refers to works such as **Psilocybe Cubensis Field**, **Poison Ivy Field**, and **Vibrating Field**. Some of these fields refer to organic ecosystems, as in **Bad Lawn** and **Poison Ivy Field**, while others are fields in the more art-historical sense, indicating a kind of overall composition that does not favor one element over another.

Replicants that present fields in the latter sense deal with formal issues that were of great interest to the modernists. One of these is the distinction between works placed on the wall (which traditionally denoted painting) versus placement on the floor (which denoted sculpture). For Paine, this distinction is not always so important. While the products of

Detail of **Bad Lawn**, 1998

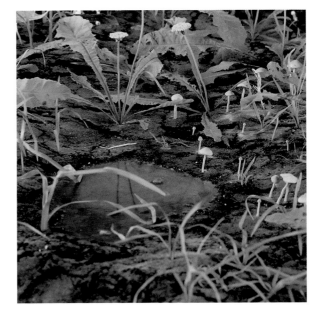

the SCUMAK and PMU take their appropriate place as paintings or sculptures on the wall or floor, the Replicants may colonize either. Amanita Muscaria Field (2000; pp. 153, 155) is a group of red-capped "magic mushrooms," in various stages of emergence and decay, arranged on the floor, while Amanita Virosa Wall (2001; pp. 156–57) is a similar grouping of white "death cap" mushrooms placed, as the title indicates, on the wall. The difference is less one of essence than of perception. The floor works play on our sense of the real, and so we suspend our disbelief and imagine that the fungi are somehow taking root from the polished wood floor of the gallery. Considered from an art-historical perspective, they bring to mind scatter works by Process artists such as Robert Morris and Barry Le Va, who spread materials like ball bearings, shattered glass, felt squares, and powder more or less randomly across the floor. By contrast, we perceive the fungi on the wall more abstractly, seeing in them patterns of movement and density that may relate to painterly models, such as Asian ink drawings or the overall drip paintings of Jackson Pollock.

Another painting issue reflected in the fields and Myco Paintings has to do with the relationship of figure and ground. Particularly apparent in the wall works is Paine's careful attention to formal composition. Sulfur Shelf Wall (2001; pp. 159–61) presents various states of the spongy yellow sulfur shelf fungus that erupts from dead or dying trees. Here the different stages become larger or smaller splotches of color sparely arranged against a massive white wall. Even more reminiscent of abstract painting is the 2002 Untitled (Sulfur Shelf and Liberty Cap). In this work the protruding yellow shapes of the shelf fungus are interspersed with the tiny, linear forms of the liberty caps, which from a distance begin to resemble spatters of black ink or paint against the larger yellow masses of color. These two elements are distributed in clusters against a white ground, creating a visual rhythm of the sort also found in works of gestural abstraction. Needless to say, there is no botanical rationalization for this grouping since sulfur shelves grow on trees and liberty caps are found on the forest floor.

Works such as Untitled (Trichaptum Biformis) (2003) and Untitled (Lycogala Epidendrum + Hoof Fungus) (2002) reduce the palette to muted earth tones set against white grounds, and the swirls and meandering strips of dark mushrooms against the uncolored canvas evoke vortices or the flung ink of traditional Asian ink paintings. Large Fungus Painting (1998; pp. 136–37) suggests a map or topographical study, the different types of fungus, of varying hues and textures, suggesting different kinds of land masses.

Other works allude to Color Field Painting, a development of Abstract Expressionism championed by Greenberg in the 1950s. Here the individual mark or brushstroke was replaced by large flat areas of saturated color. Often, as in the work of Morris Louis, Kenneth Noland, and Helen Frankenthaler, thin layers of paint seeped directly into the raw white canvas, thereby becoming one with the ground.

Paine has created a number of Myco Paintings based on crust fungi that echo this aesthetic. Crust fungus, like the paint in Color-Field Painting, appears to seep like a stain over the bark of trees. Its ecological role is to decompose the dead outer layer of the tree, thereby turning wood into soil. Dry Rot (2001; pp. 146–47), for example, is a large brown-ringed mass

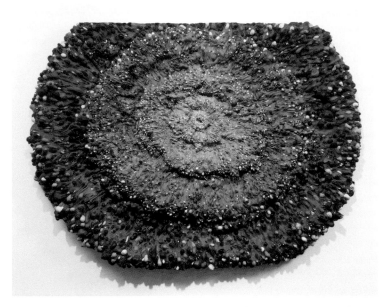

Abstract No. 6, 2000

29 Herbert, interview, 18.

30 Tim Griffin, "At Breakneck Speed," in Ann Wehr, ed., *Roxy Paine/Bluff* (New York: Public Art Fund, 2002), 71.

that seems to be spreading outward from the center of the canvas. Within its rings one sees smaller white and brown shelf fungi, trapped in what appears to be an expanding mass. **Competing Crusts** (1999; pp. 66–67) also plays on the sense of movement and growth. Here two brown crusts, each emanating from opposite ends of the canvas, appear to be moving toward each other like a pair of rippling waves of water. They meet in a white strip that suggests the froth thrown up when waves collide.

Paine acknowledges the reference to Color Field Painting, while also pointing to a different interpretation of these works suggested by the function of fungi as agents of decay. He notes: "As I got into the fungus I started looking at these crusts and immediately thought of paintings. This wonderful spreading quality, and thinking about paint as something that spreads and creeps and grows on a canvas, fouling it forever."[29]

By employing fungal forms to imaginatively recapitulate tendencies in modernist painting, Paine also employs their decompositional role in nature to defile the ideal of purity so dear to Clement Greenberg. Such a strategy becomes even clearer in several anomalous abstract works based on the format of **Dry Rot. Abstract No. 6** (p. 209), for example, is a target-shaped work built up from crusts of fiberglass. Like **Dry Rot**, it moves outward from a central core, but it is more regular in shape than the crust-fungus works and its rosy red color comes from art rather than nature. The high-relief form brings to mind Jay DeFeo's legendary *The Rose* (1958–66), a huge radiating painting built-up over an eight-year period from countless layers of paint, which, following its well received debut in Pasadena and San Francisco in 1969, was hidden for twenty years behind a plaster wall at the San Francisco Art Institute.

Critic Tim Griffin articulates this relationship between such paintings as **Abstract No. 6** and the exhausted theories of modernism. He notes: "Given the quasi-modern title **Abstract No. 6**, the effusive form marries the biological codes implicit in natural phenomena with those visual codes of twentieth-century painting. Painterly abstraction is posited as merely a fungus at the same time that fungus is painterly: the dead tropes of formalism during the past century are, in a sense, recycled (a natural property of all fungi being the processing of dead matter). Drips become the dumb procedures of dry rot and composition the unintelligent—or blind—expansion of organic material through space."[30]

The Dendroids engage Modernism in a different way. If the Replicants seem at times pressed into service as fungal approximations of Color-Field Painting, one might argue that the Dendroids' long fingerlike extensions bring to mind the compressed energy of Action Painting. Their sense of frozen movement and the whiplash configurations of their attenuated branches echo at times the slashing strokes and dancing drips of artists like Franz Kline and Jackson Pollock. The Dendroids allude as well to Minimalism by their industrial materials

and the way their forms are created using uniform, commercially produced pipes and rod. However, the ultimate effect is far from minimal—by evoking trees, these works edge art back toward the realm of illusion and representation. And despite their obvious welded seams, which reveal how they were constructed, the Dendroids do not fit comfortably in the realm of Process Art or Anti-Form.

In seeking the art historical context for the Dendroids, it seems best to return to the notion of fields, in the sense of interactive systems of related elements. Here Paine touches on concerns that underlie the movement toward environmental art. The Dendroids are created for outdoor settings, and much of their meaning is derived from the setting in which they are placed. As such they can be considered site specific, a type of work that is so much a part of today's public and environmental art and is considered inseparable from the setting in which it is shown. For example, Walter De Maria's *Lightning Field* (1977), which consists of four hundred stainless-steel posts arranged in a grid over almost four hundred acres of New Mexico desert, is far more than the sum of its individual elements. It invites viewers, whose presence is strictly regulated to preserve the purity of the experience, an opportunity to surrender to the landscape and experience shifts in light, atmosphere, and weather over a twenty-four hour period. *Lighting Field* gets its name from the poles, which serve as lightning rods during thunderstorms. One of the most famous and dramatic photographs of this work depicts the field beneath a turbulent sky as a filigree of lightning strikes one of the poles.

The Dendroids operate in a similar way, making viewers aware not only of the sculpture in front of them but also of the surrounding landscape. Their treelike forms, at once natural-looking and utterly alien, serve as a foil for the surrounding forest. The stainless-steel trunks and branches become mirrors that reflect the sky, nearby foliage, and changing light patterns, at times blending into the environment and at other times seeming to stand starkly apart from it. In one sense the Dendroids, like De Maria's poles, are conduits between earth and sky. In fact, there is a haunting correspondence between some of the Dendroids and De Maria's site-

Walter De Maria, **Lightning Field** (New Mexico), 1977.
Permanent earth sculpture: 400 stainless steel poles arranged in a grid array measuring one mile by one kilometer, average pole height 20 feet 7 inches, pole tips forming an even plane

specific work. Paine's **Fallen Tree** (2006), for instance, presents a tree whose trunk has cracked, as if it had been struck by lightning, casting the treetop earthward at a sharp angle. **Conjoined** (2007) recalls *Lightning Field* in another way, as the entwined branches of two trees create a jittery linear pattern that looks very similar to that created by lightning bolts that jump around in seeking a low-resistance path to ground.

As site-specific works in the landscape, the Dendroids also engage the dialogue surrounding public art. Here we can stretch the idea of the field to include the viewers who interact with these works. A far more varied constituency than that normally found in galleries and museums, the audience for the Dendroids includes both art-aware and more general audiences who may come upon the works unexpectedly and for

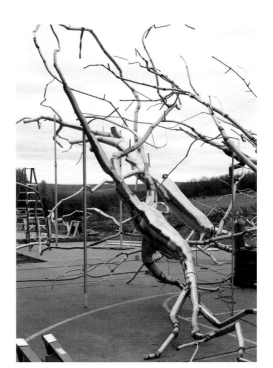

Maelstrom in progress, 2008

whom their evident contradictions serve as food for thought. By placing these works in public settings, Paine expands their reach while relinquishing a certain amount of control over how they will be interpreted.

Maelstrom, Paine's most recent work, offers the most acute articulation yet of the idea of Dendroid as field. Here, it becomes almost impossible to discern exactly how many separate "trees" are involved in this careening, twisting network of stainless steel pipes. They rise from and return to the ground, creating a cloud of densely entwined branches above the viewer's head. As a result, the viewer has the peculiar sensation of being enveloped within a pulsing spray of frozen steel, which, because it is sited out-of-doors, glints and flashes with changes of light. **Maelstrom** thus does more than simply evoke arboreal forms. It suggests various kinds of visible and invisible networks, including neural networks, nervous and circulatory systems, electric fields, computer circuits, and even the complex of fungus mycelia spreading for miles beneath the soil.

With **Maelstrom**, the Dendroid seems to provide a link between our inner and outer realities, reminding us that we are all, in a sense, fields—bundles of relationships and interconnections that define who and what we are. And this may be the ultimate message of Paine's work. Such concepts as body, nature, and industry, growth and decay, interior and exterior states, can't easily be disentangled. Nor can art be enshrined as a unique and exclusively human form of endeavor. For Paine, nature, as represented by fungus, weeds, and trees, and industry, as represented by material-shaping machines, serve as metaphors for art-making. Nature's principles of growth and industry's mechanical systems of operation provide models for the creative process. Similarly art and industry become metaphors for nature, reminding us that there can be no real separation between our roles as products and manipulators of the forces of the natural world.

As Smithson noted, nature is not one-sided. Neither, as Paine demonstrates, is art.

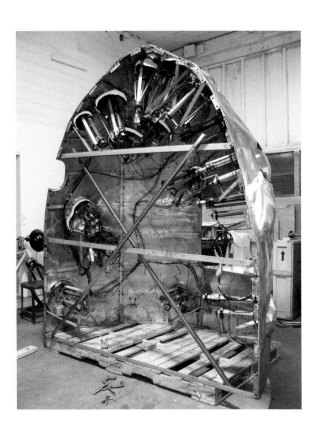

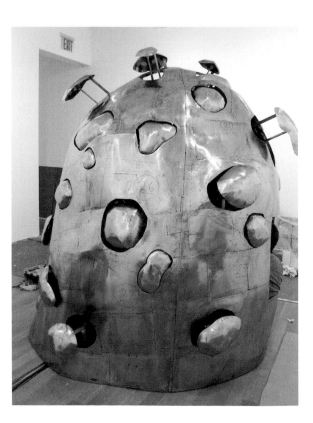

Unexplained Object, 2005. Top: internal valve assembly; bottom left: internal view; bottom right: assembled without cover

Pages 213 and 214–15: various configurations of **Unexplained Object**

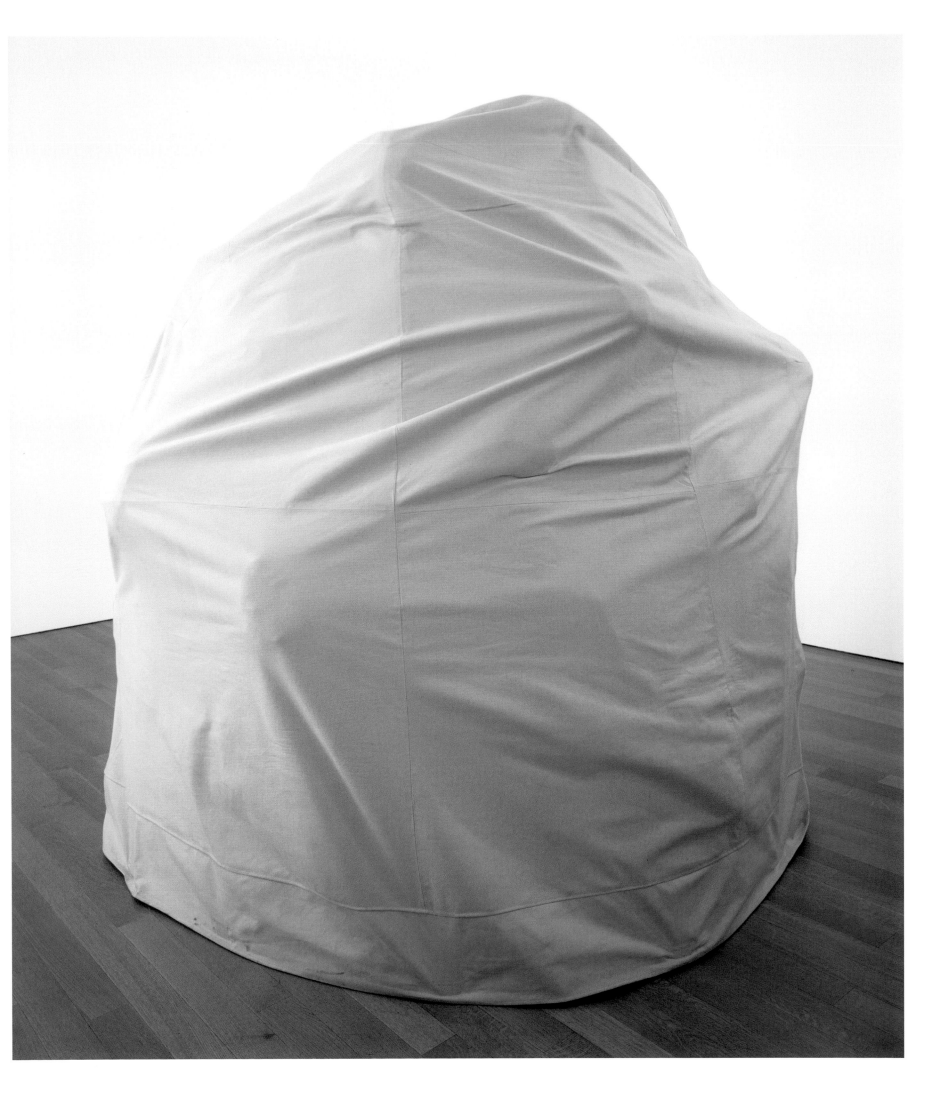

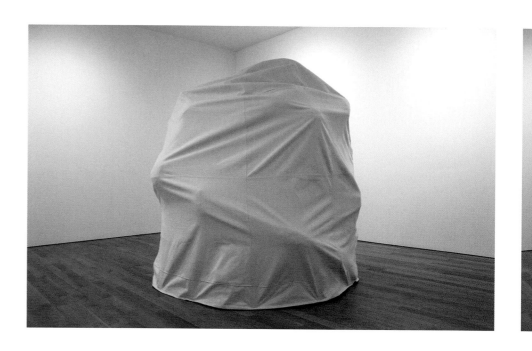

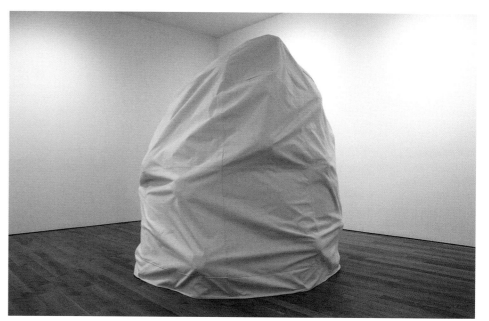

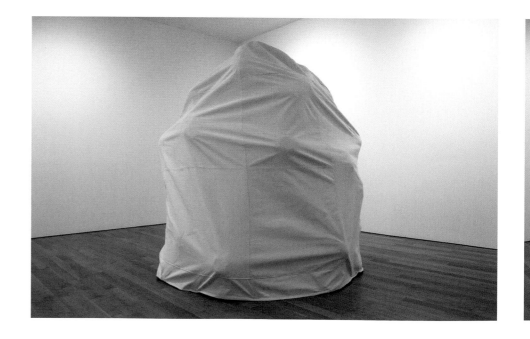

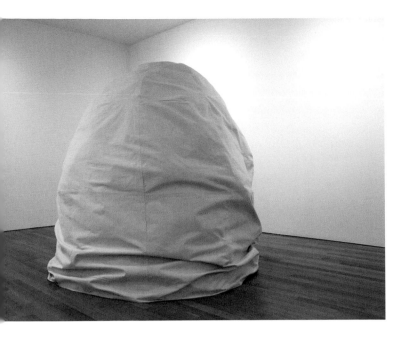
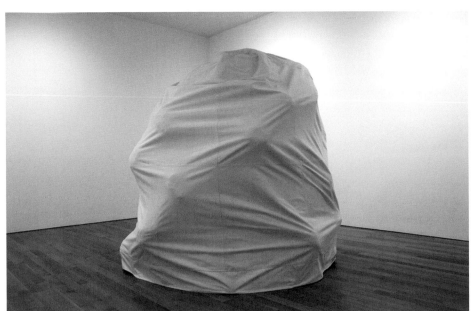
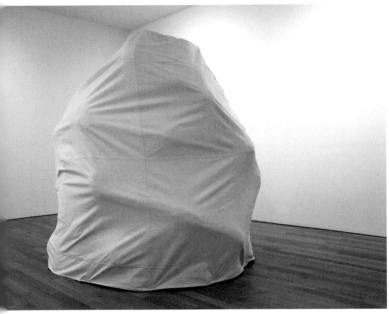
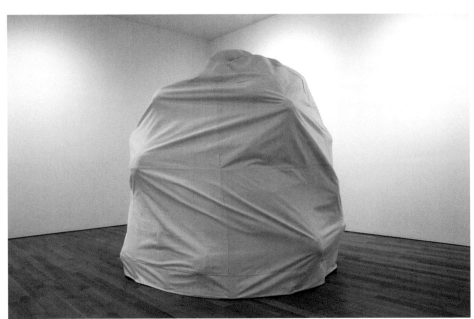
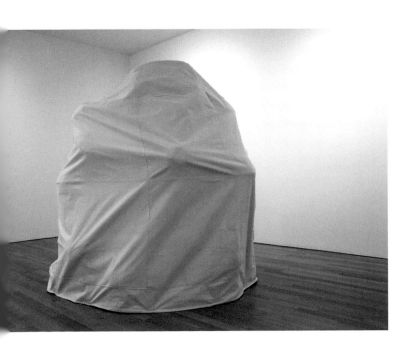
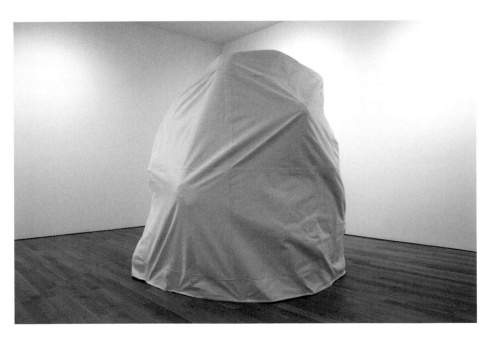

Substitute, 2001

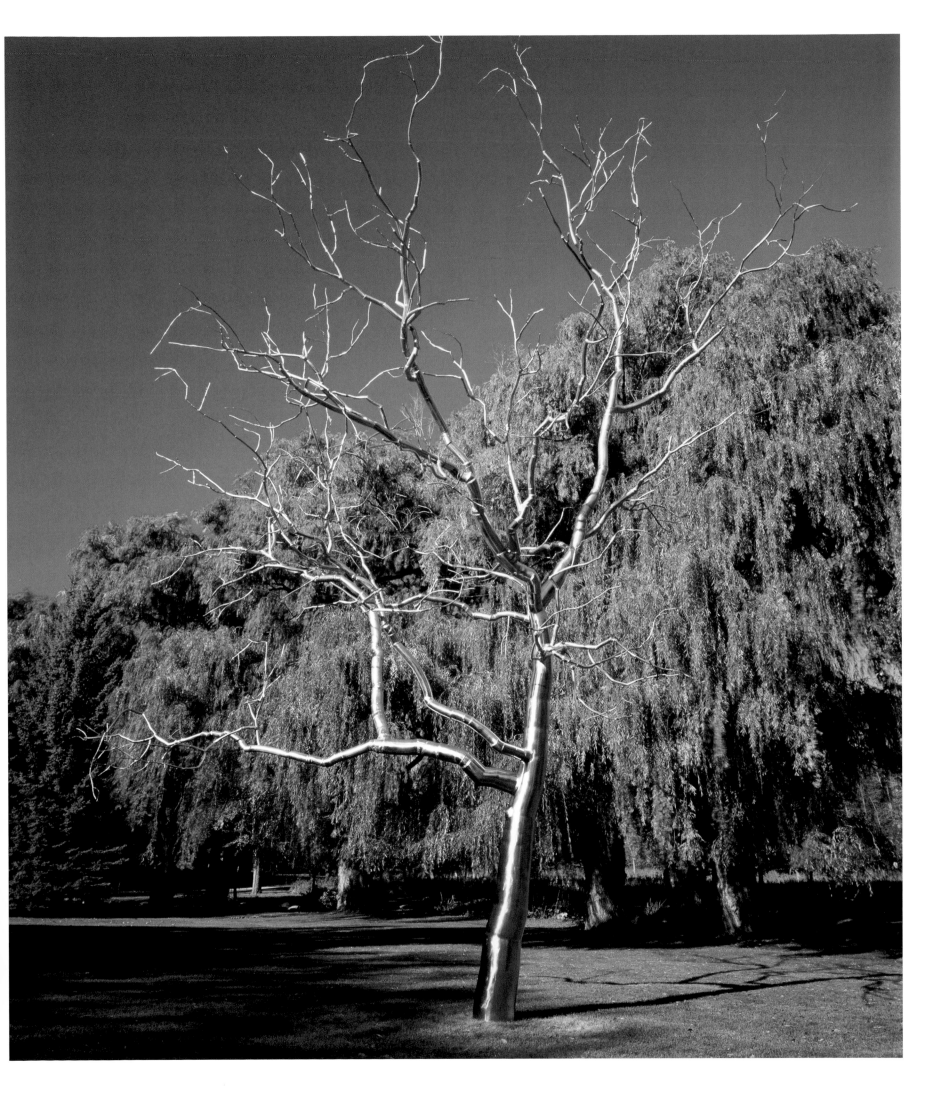

218 **Substitute,** 2001 (detail)

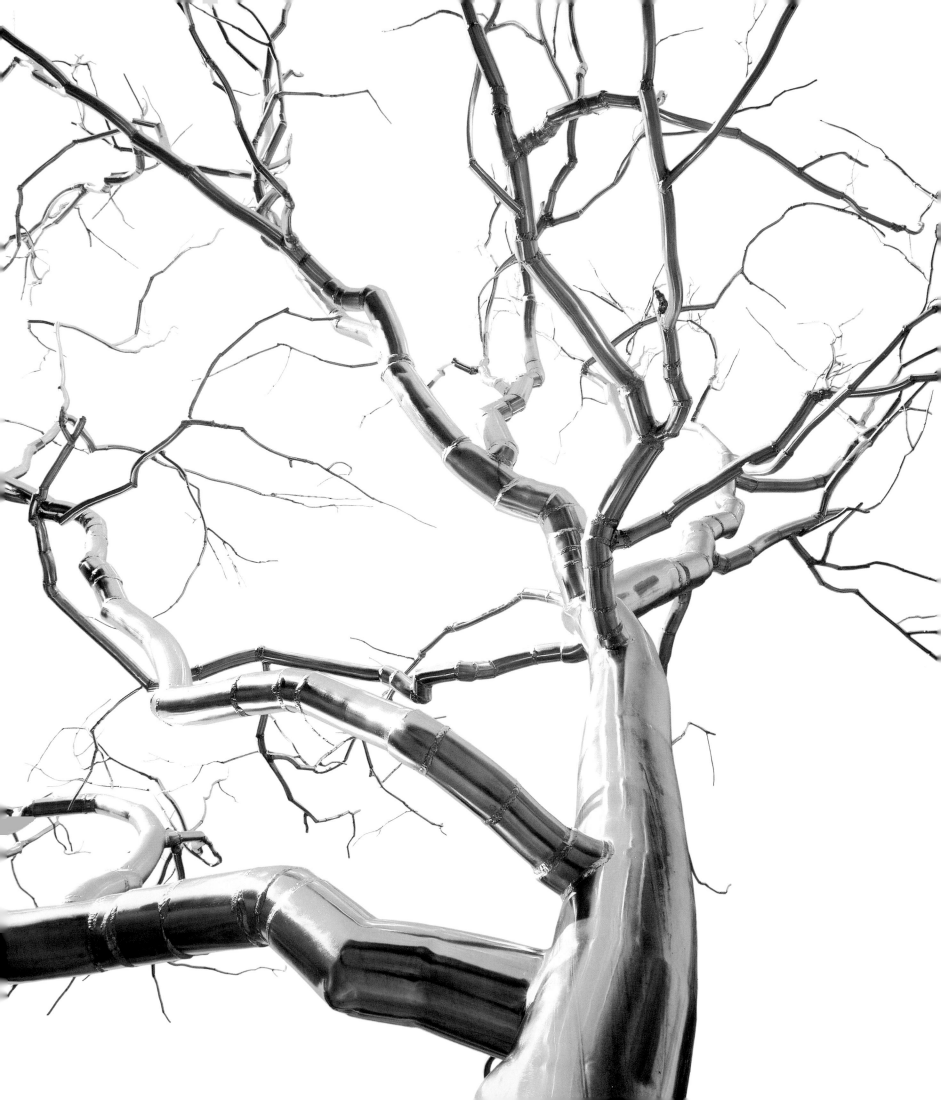

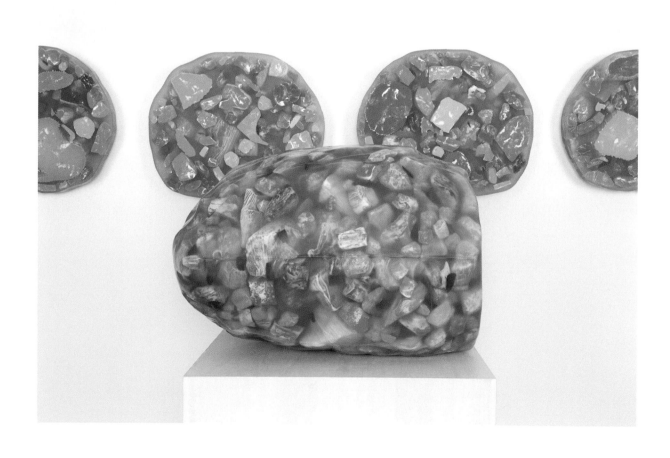

Pages 220 (detail) and 221–23 (selected slices): **Head Cheese, Loaf and 7 Large Slices**, 2004

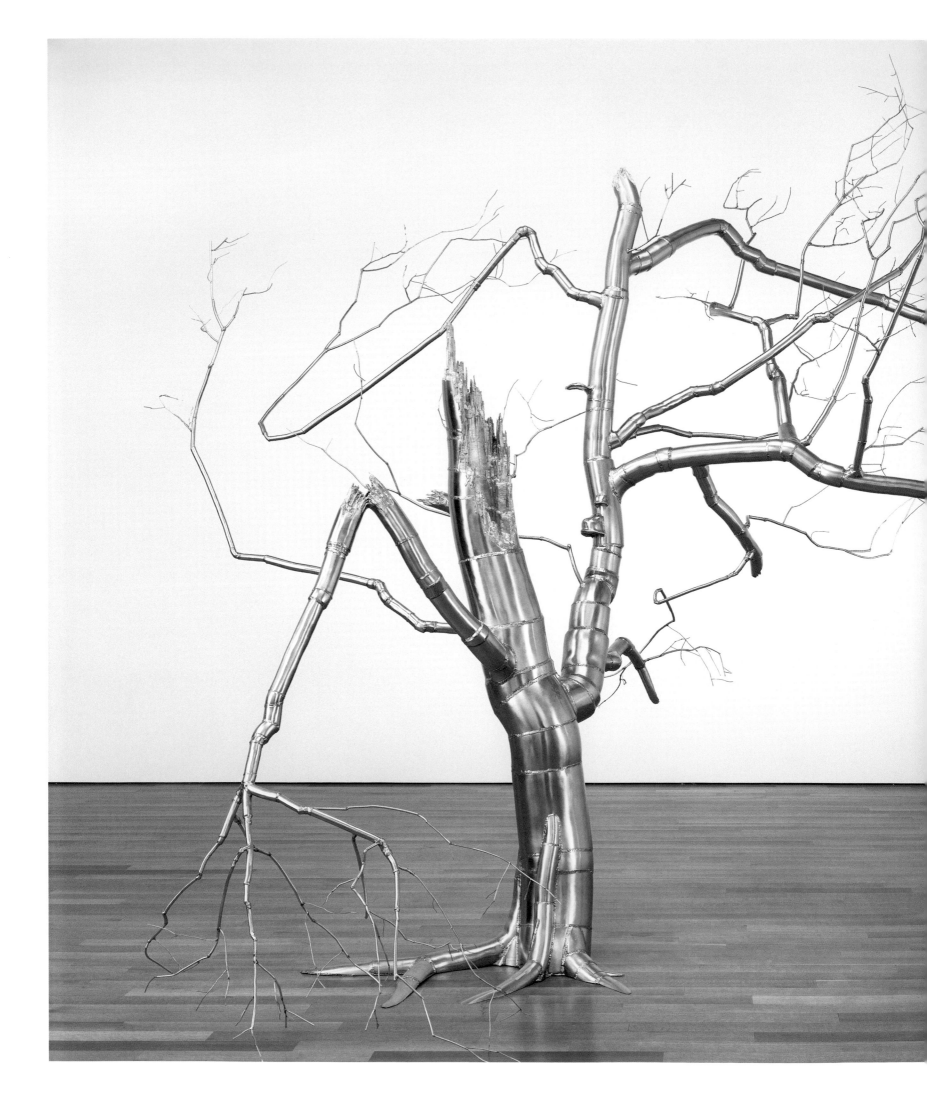

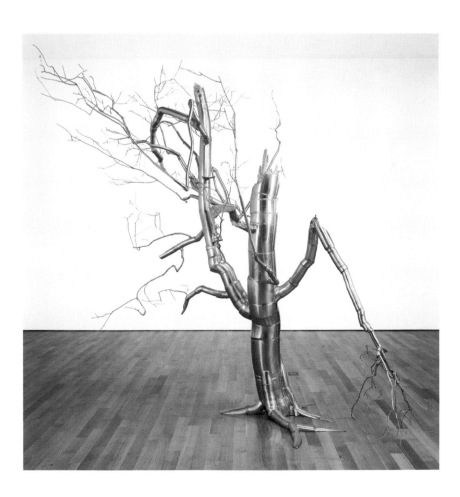

BAD PLANET

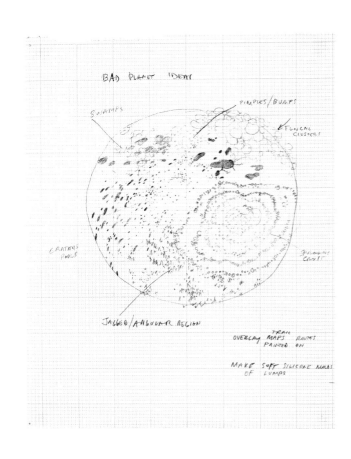

IMPOSSIBLE TERRAIN PITRO JAGGED
WARTY BUMPY CRATERED
BROWN OCEANS
BROWN LANDSCAPE
VOLCANOES
SPIKED PINNACLES

BAD PLANET IDEAS

SWAMPS PIMPLES/BUMPS
 FUNGAL
 CLUSTERS

CRATERS
POOLS

JAGGED/ANGULAR REGION
 TRAIL
 OVERLAY MAPS ROUTES
 PAINTED ON

 MAKE SOFT SILICONE MOLDS
 OF LUMPS

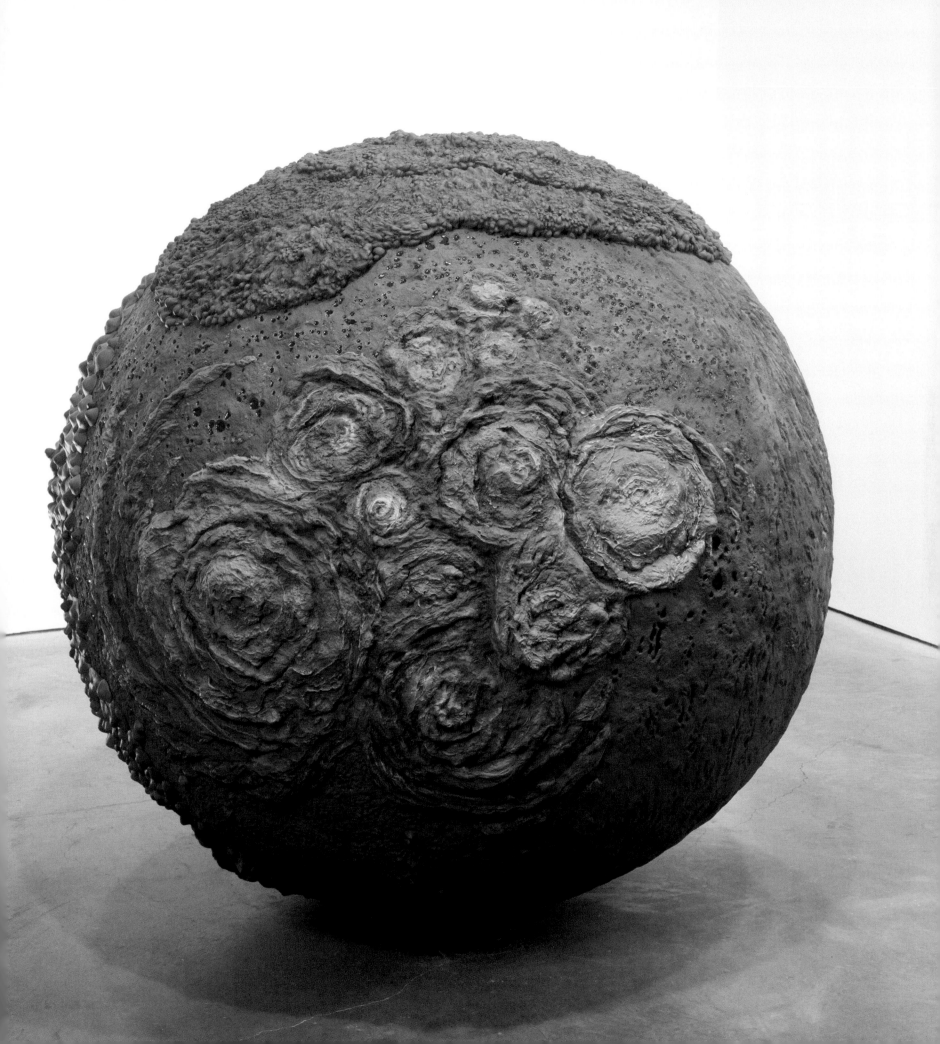

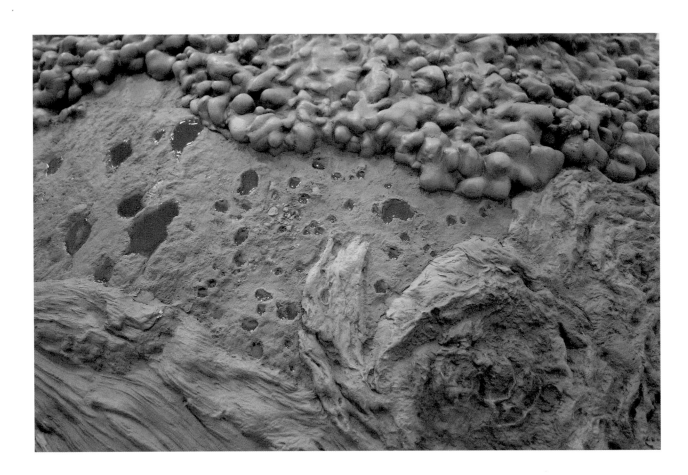

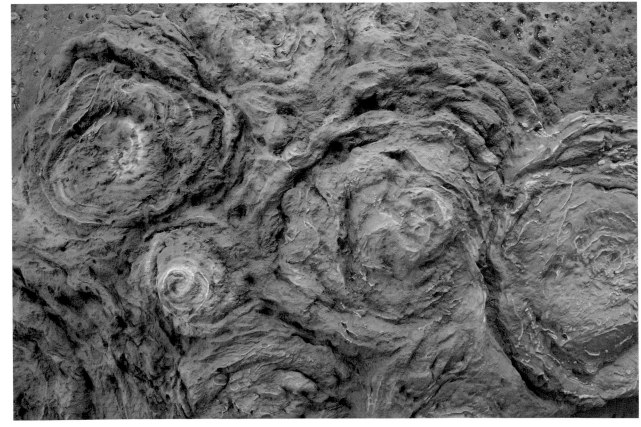

228 **Bad Planet,** 2005 (details)

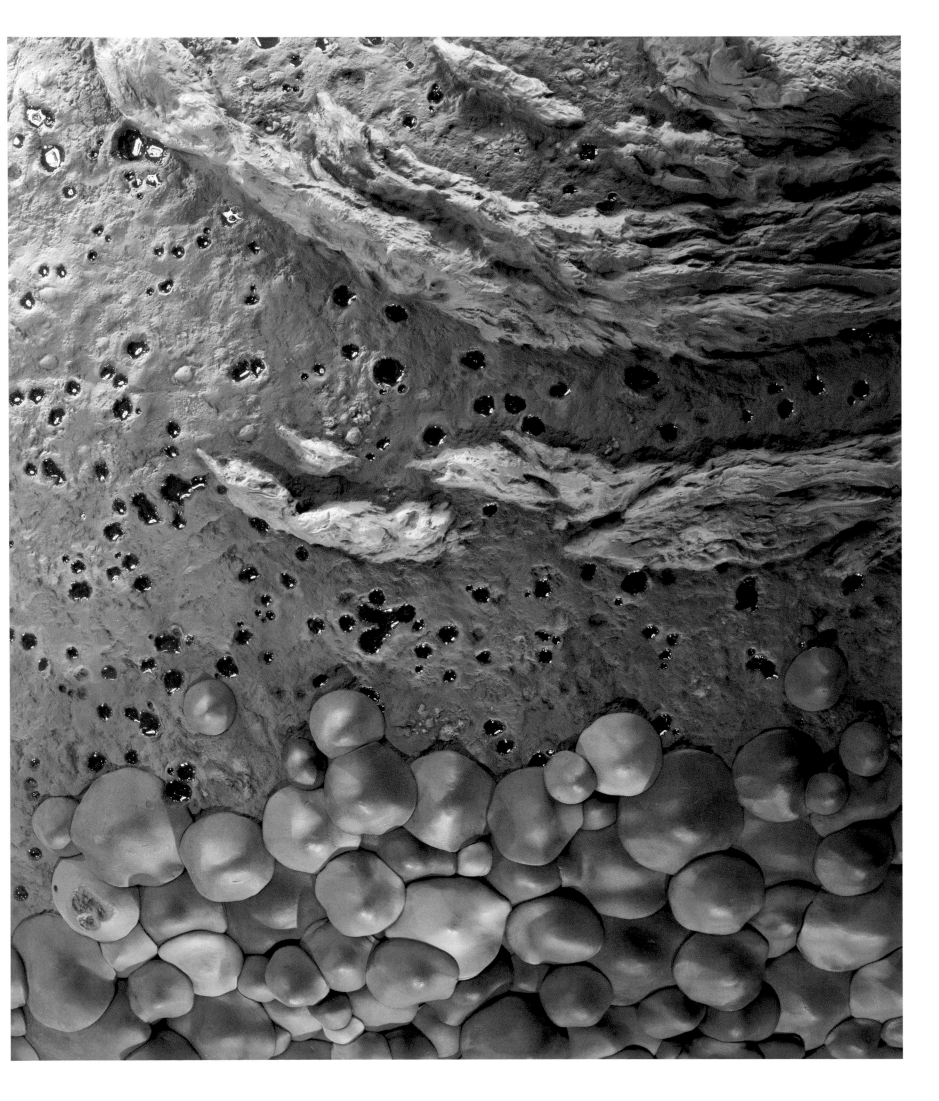

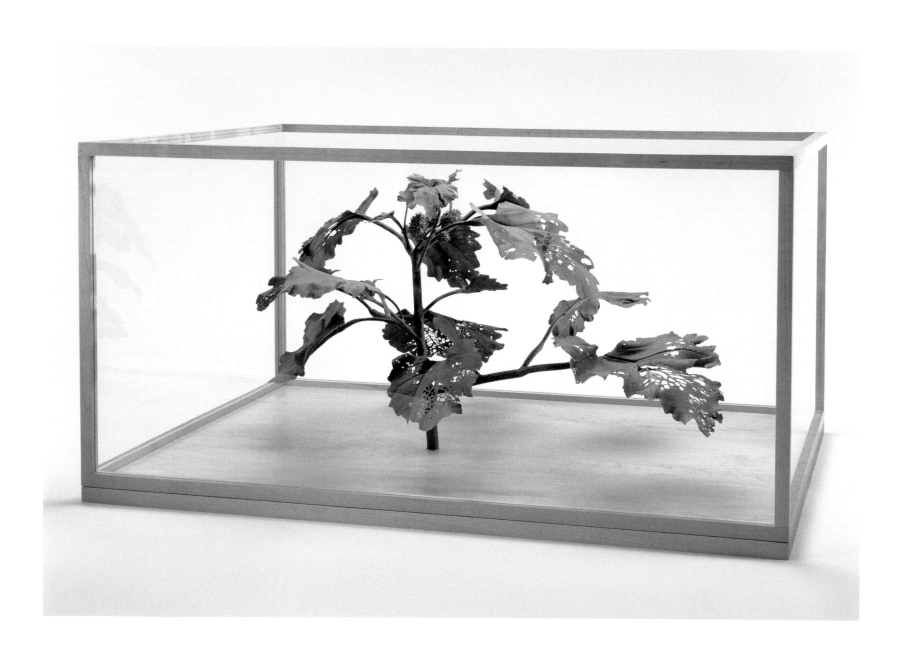

230 **Cocklebur**, 2005

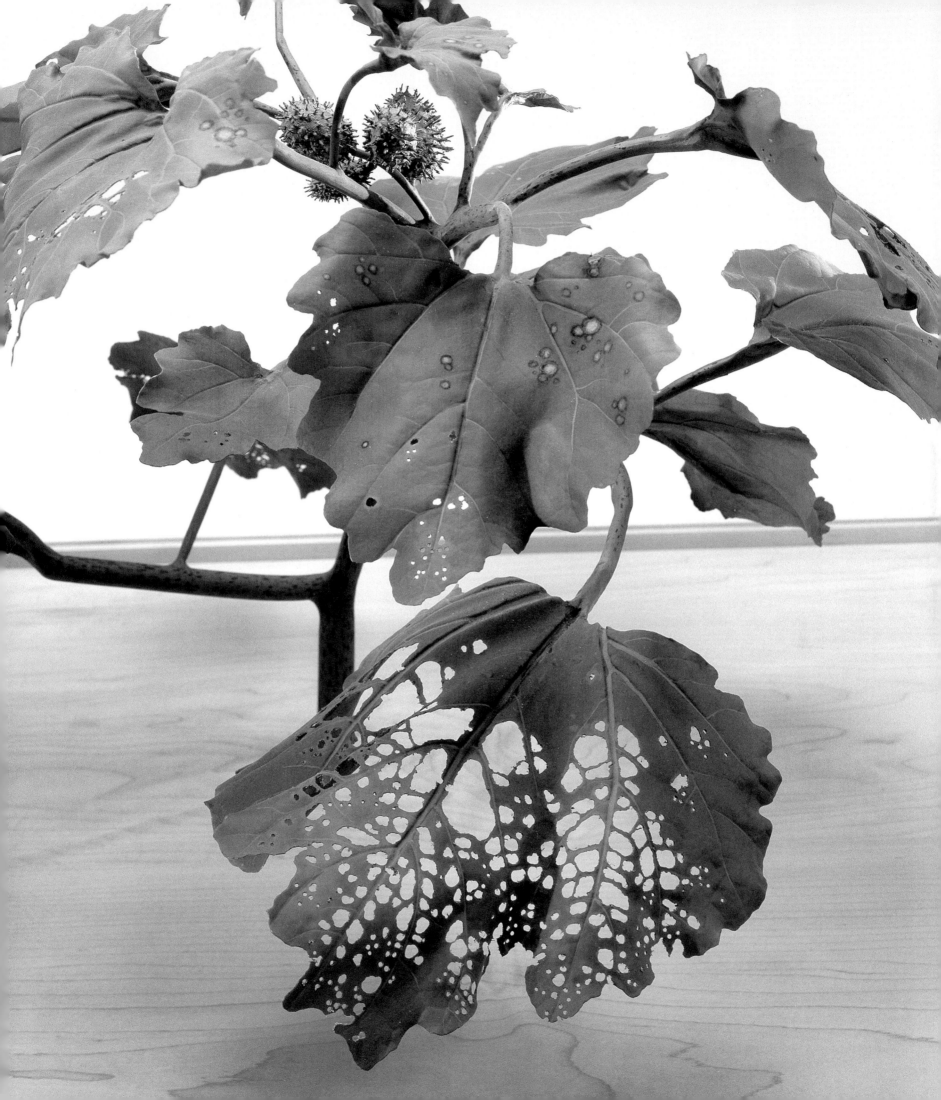

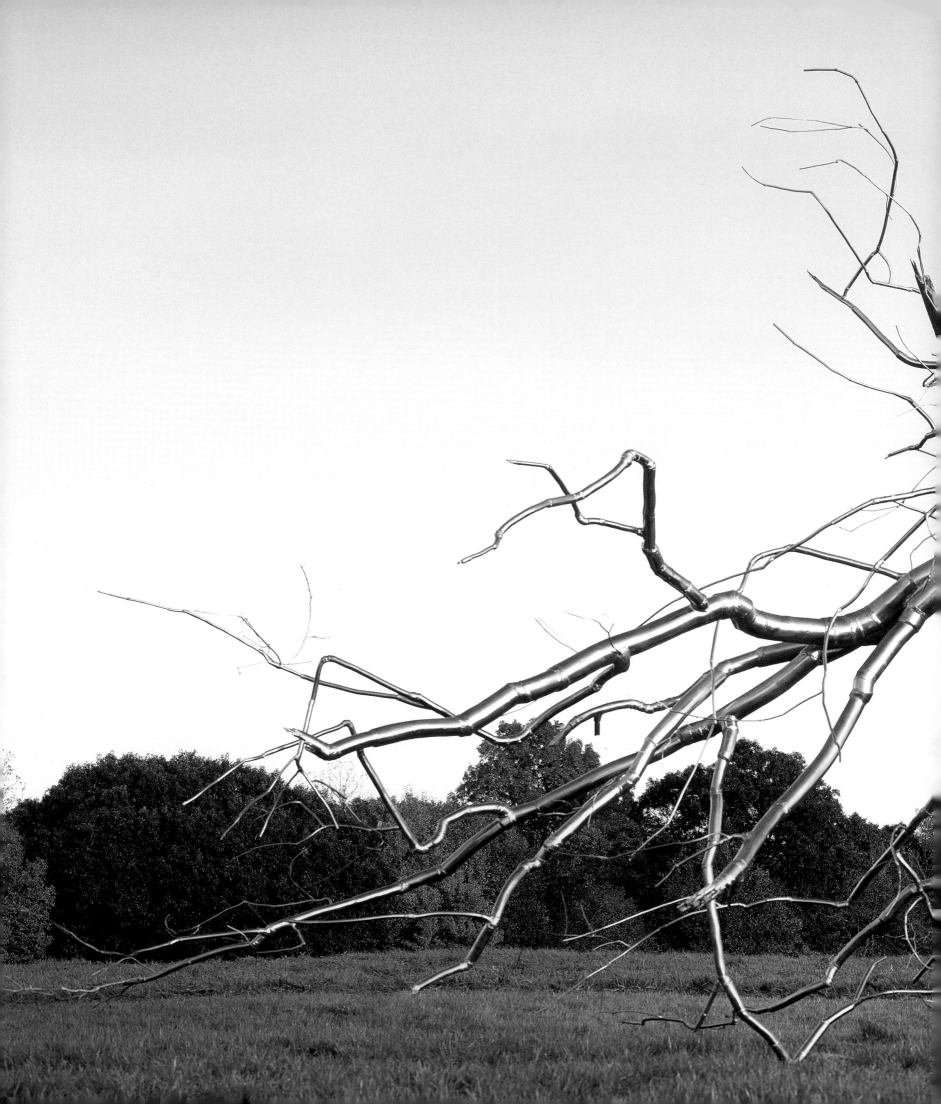

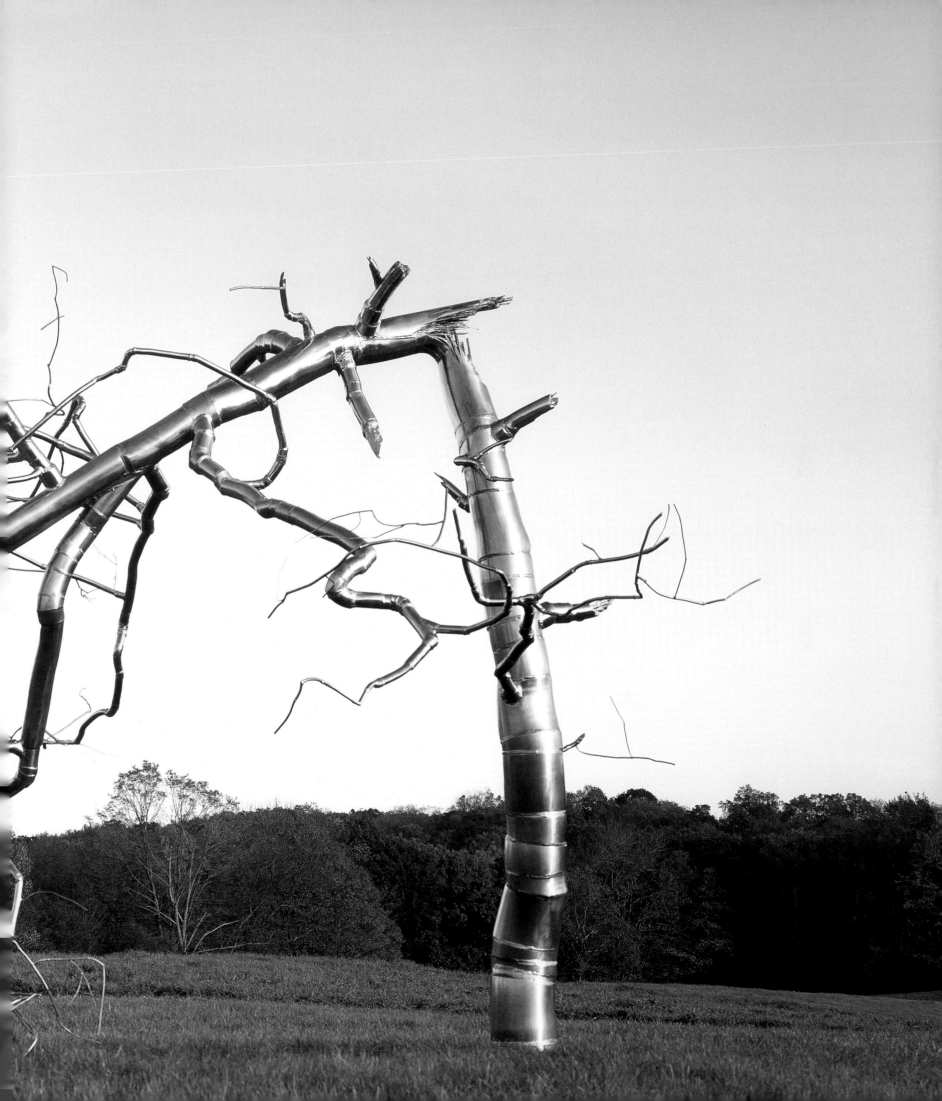

Pages 232–33 and 235: **Fallen Tree**, 2006; pages 236–41: **Conjoined**, 2007

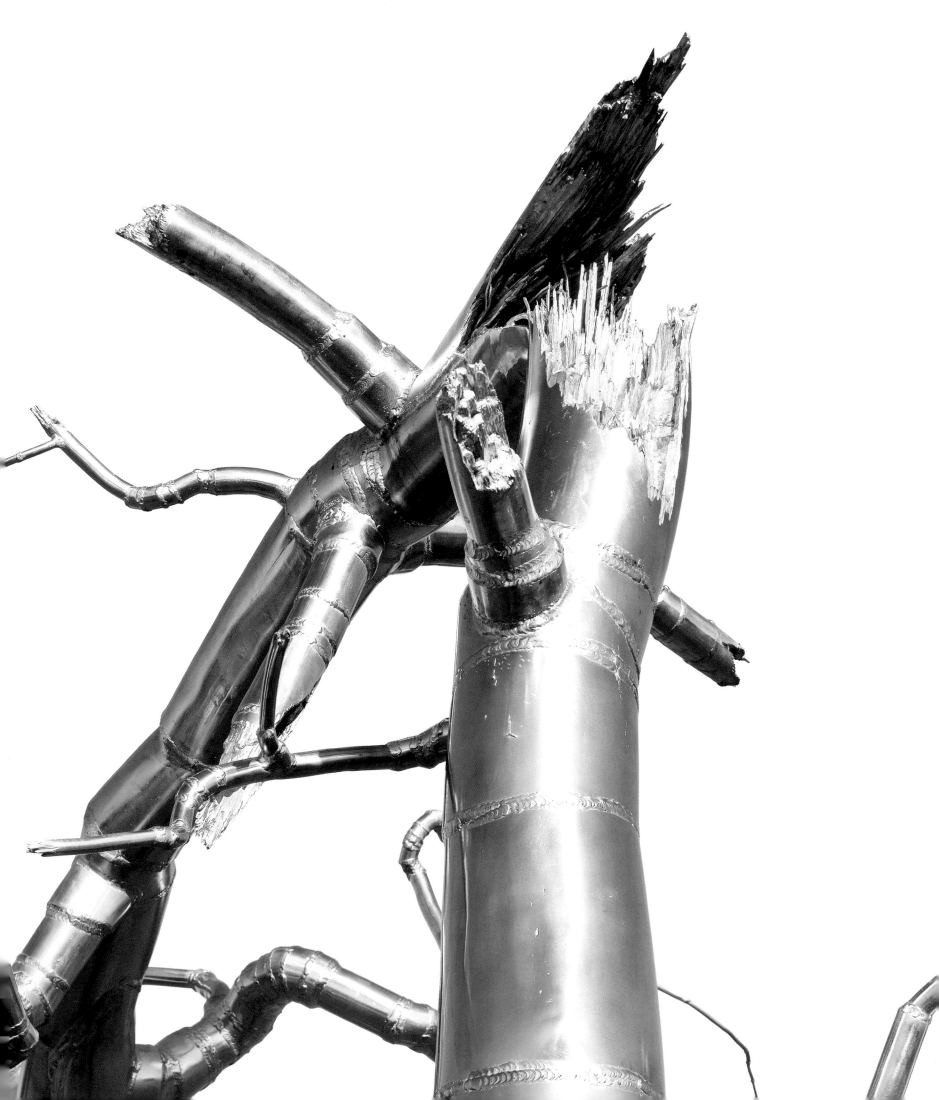

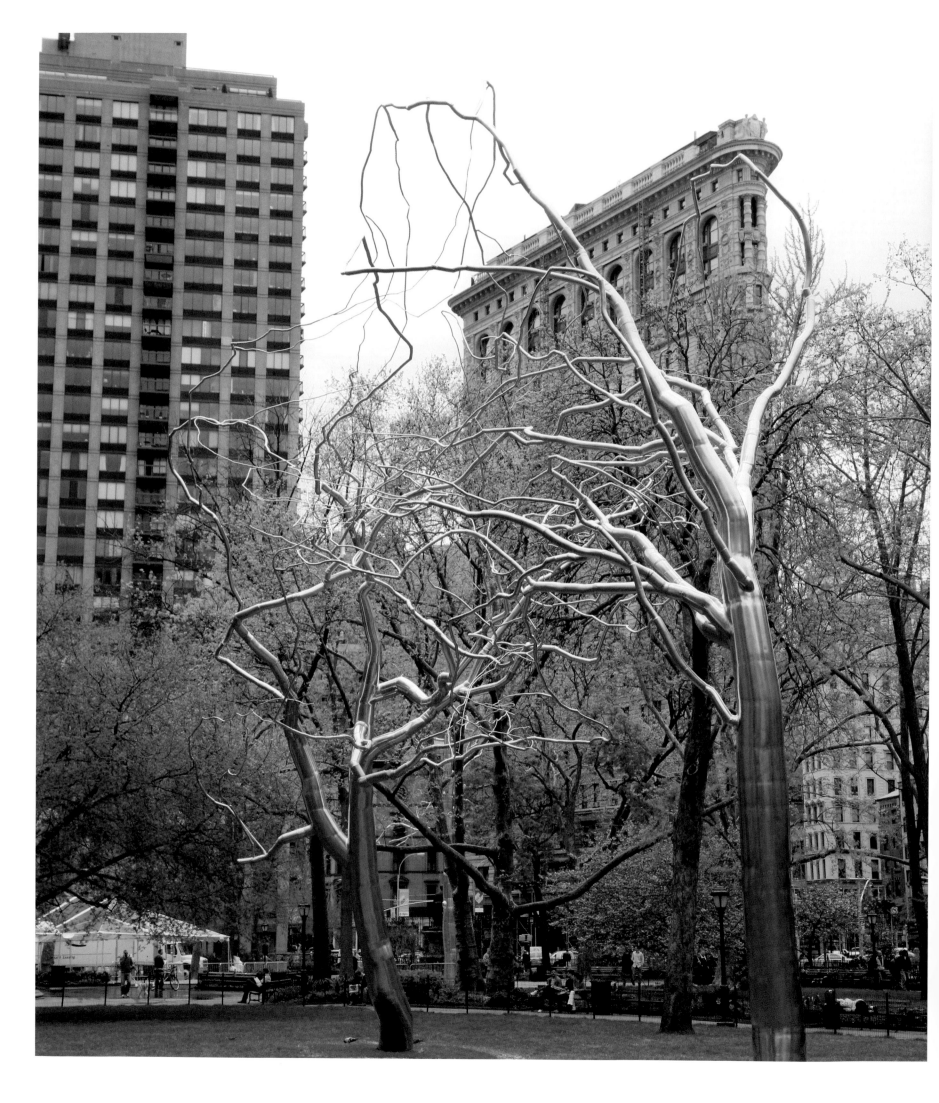

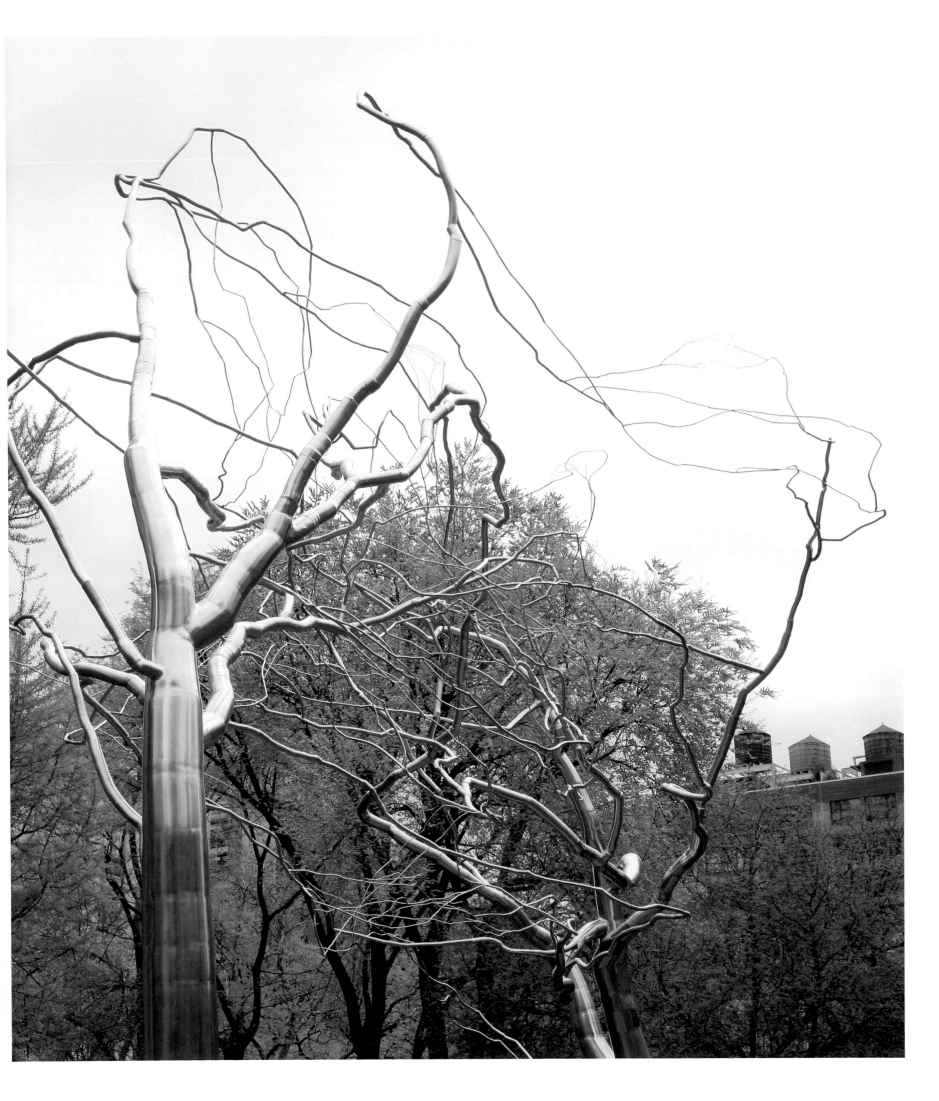

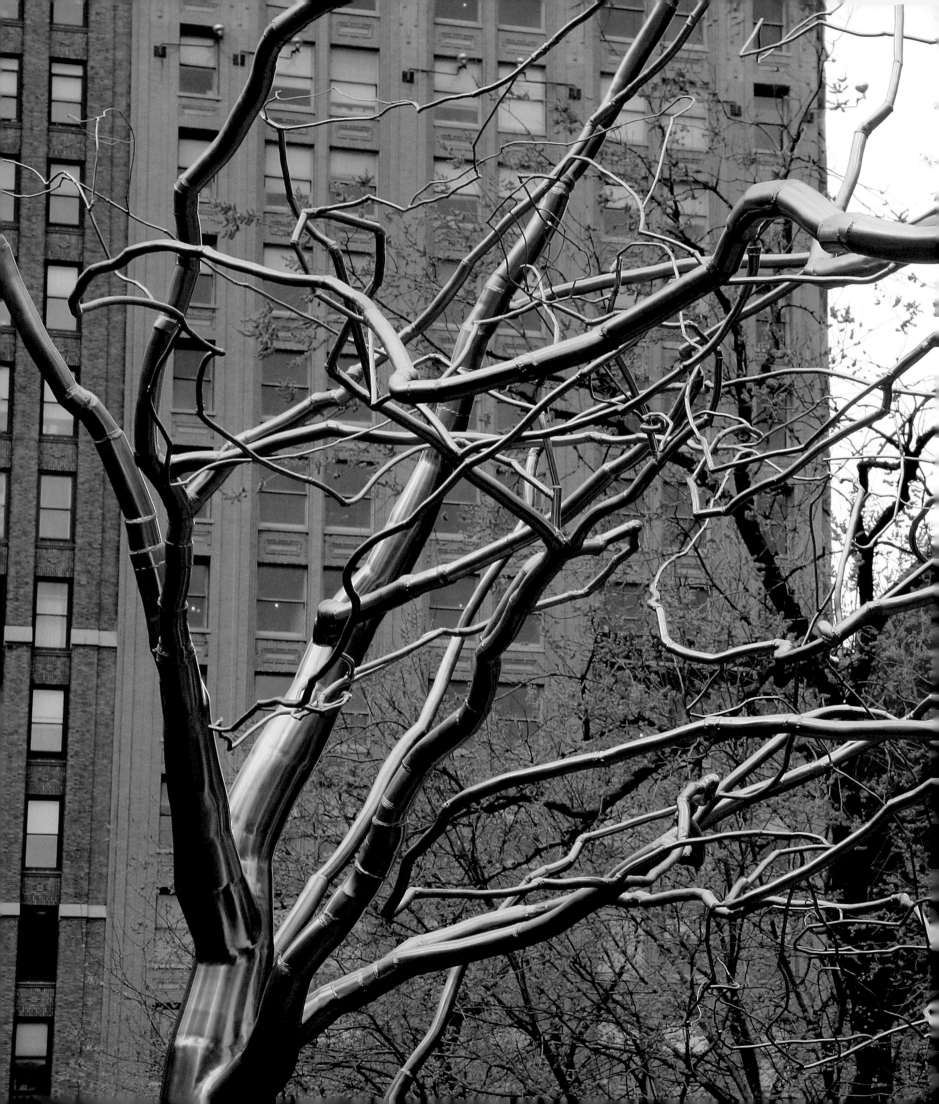

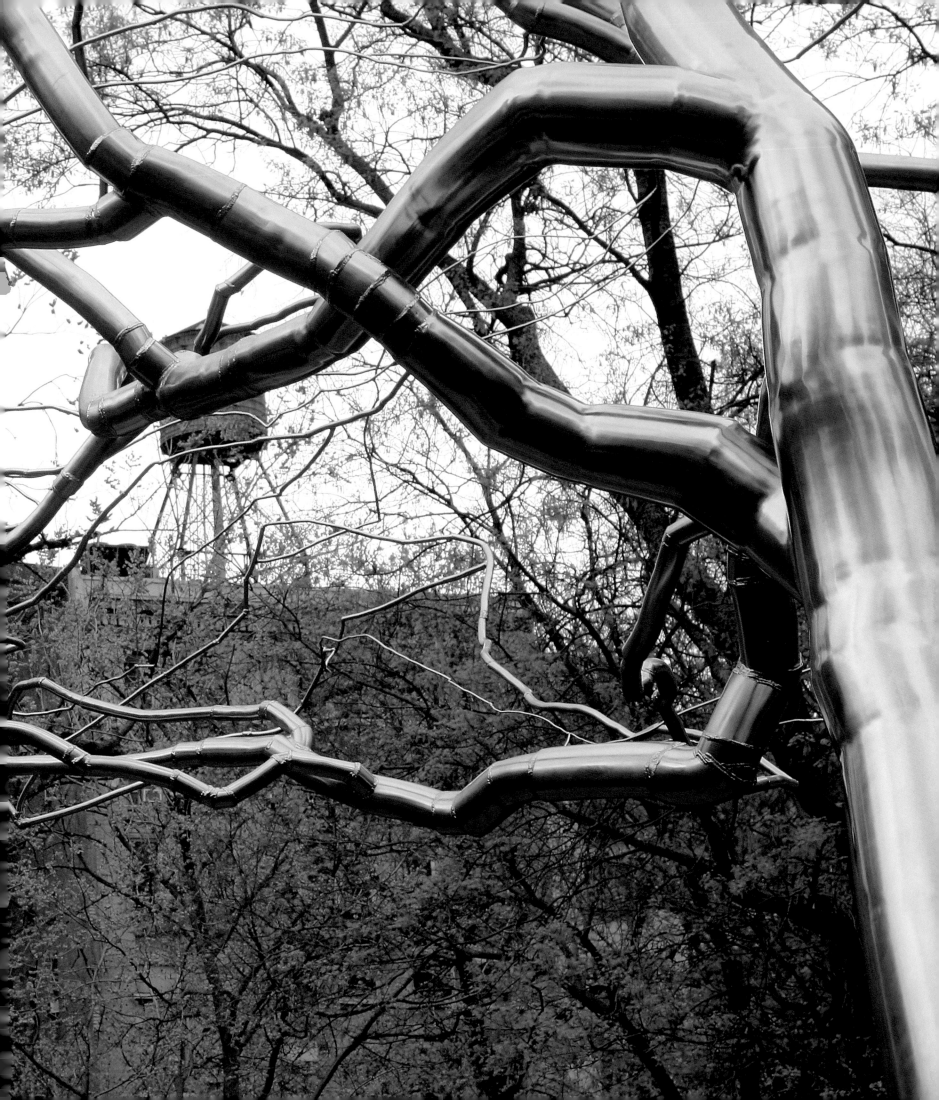

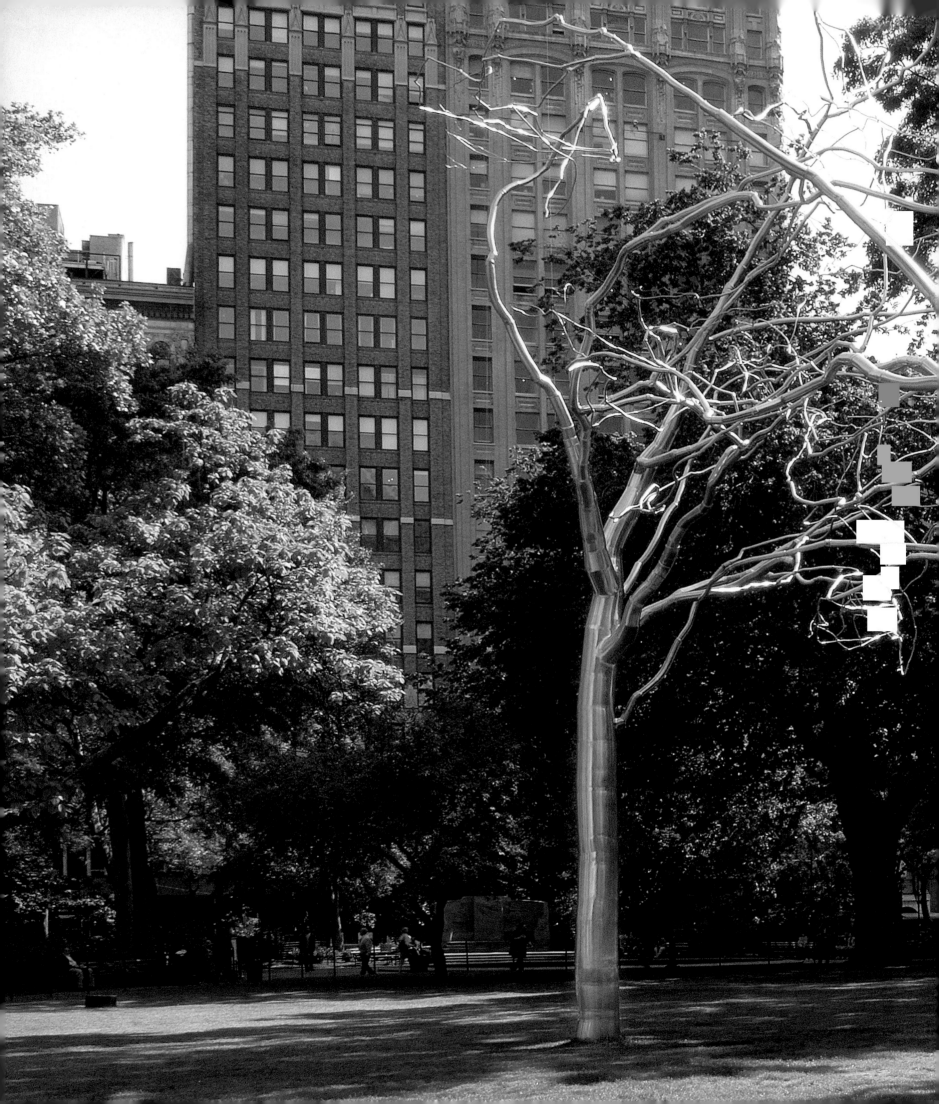

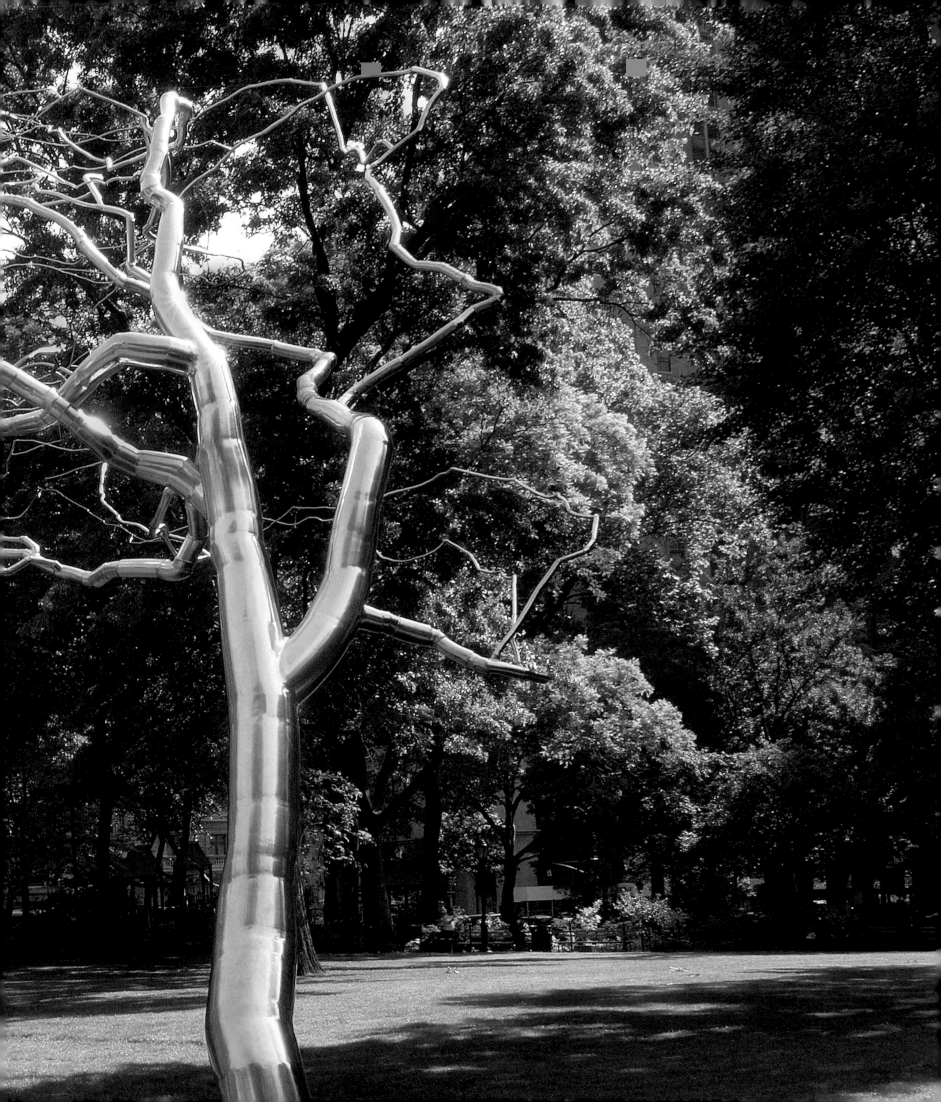

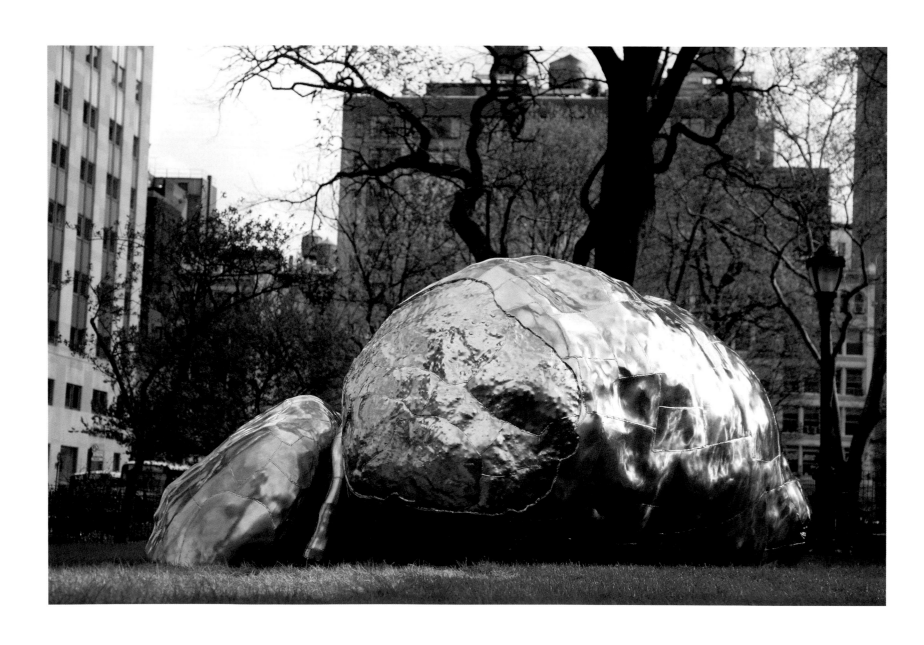

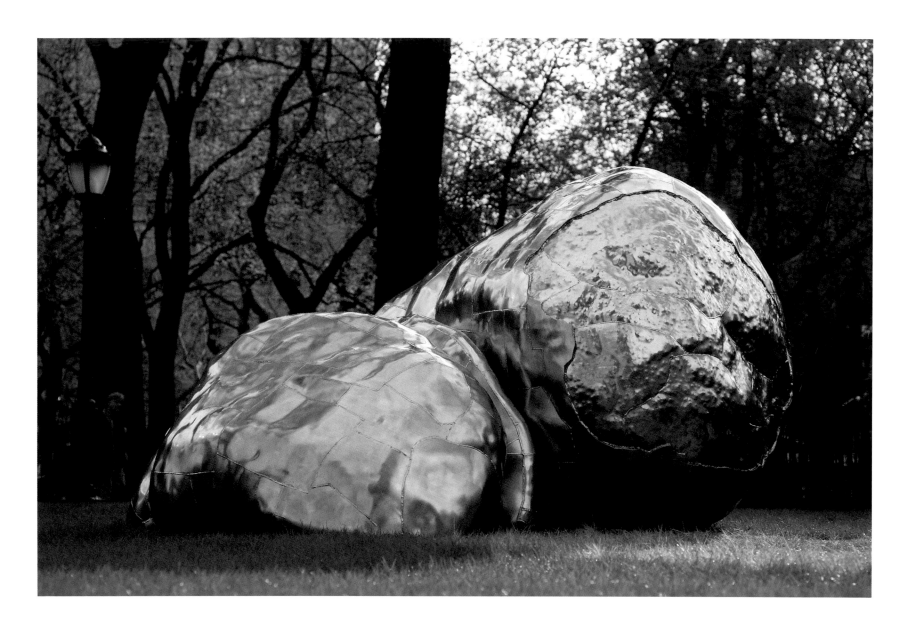

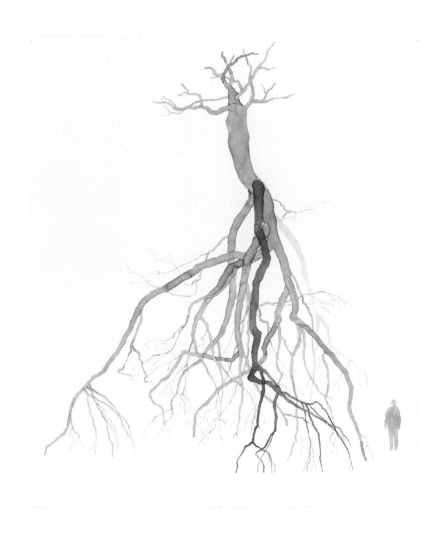

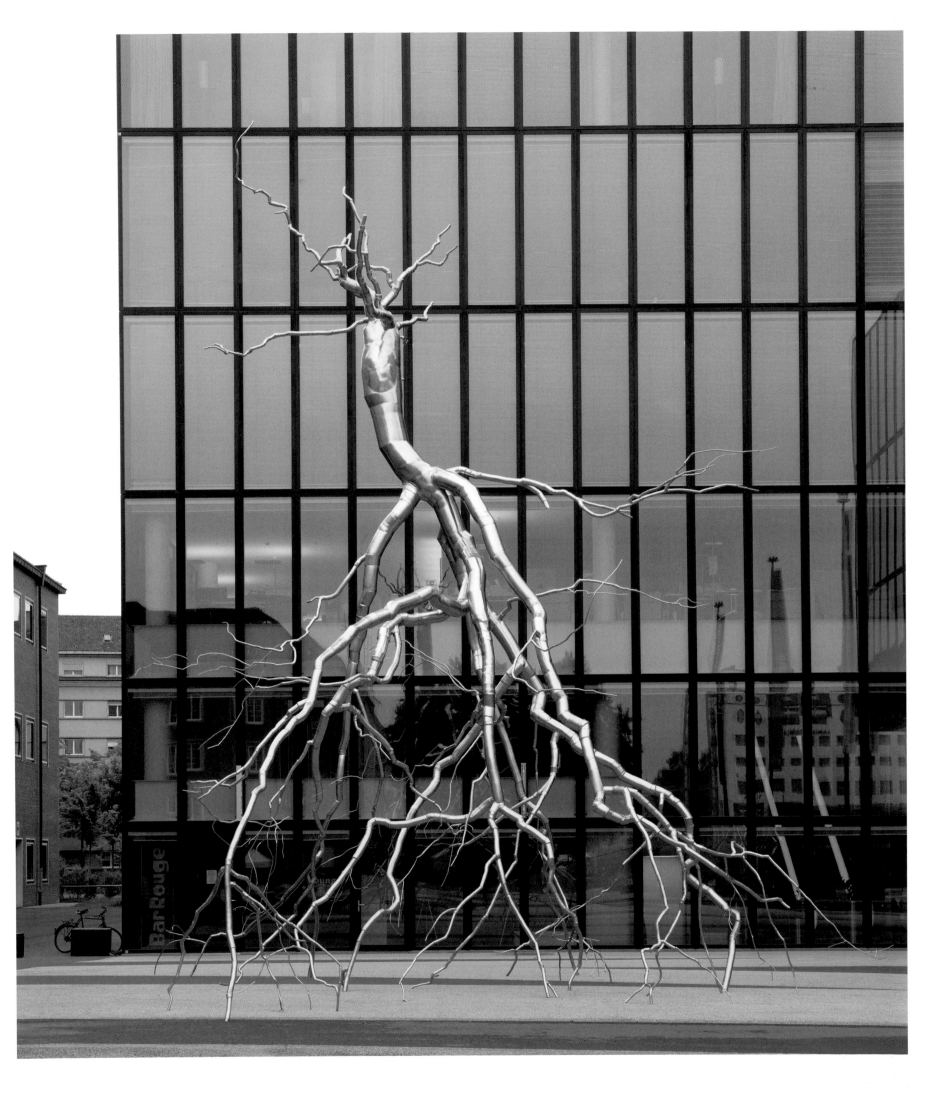

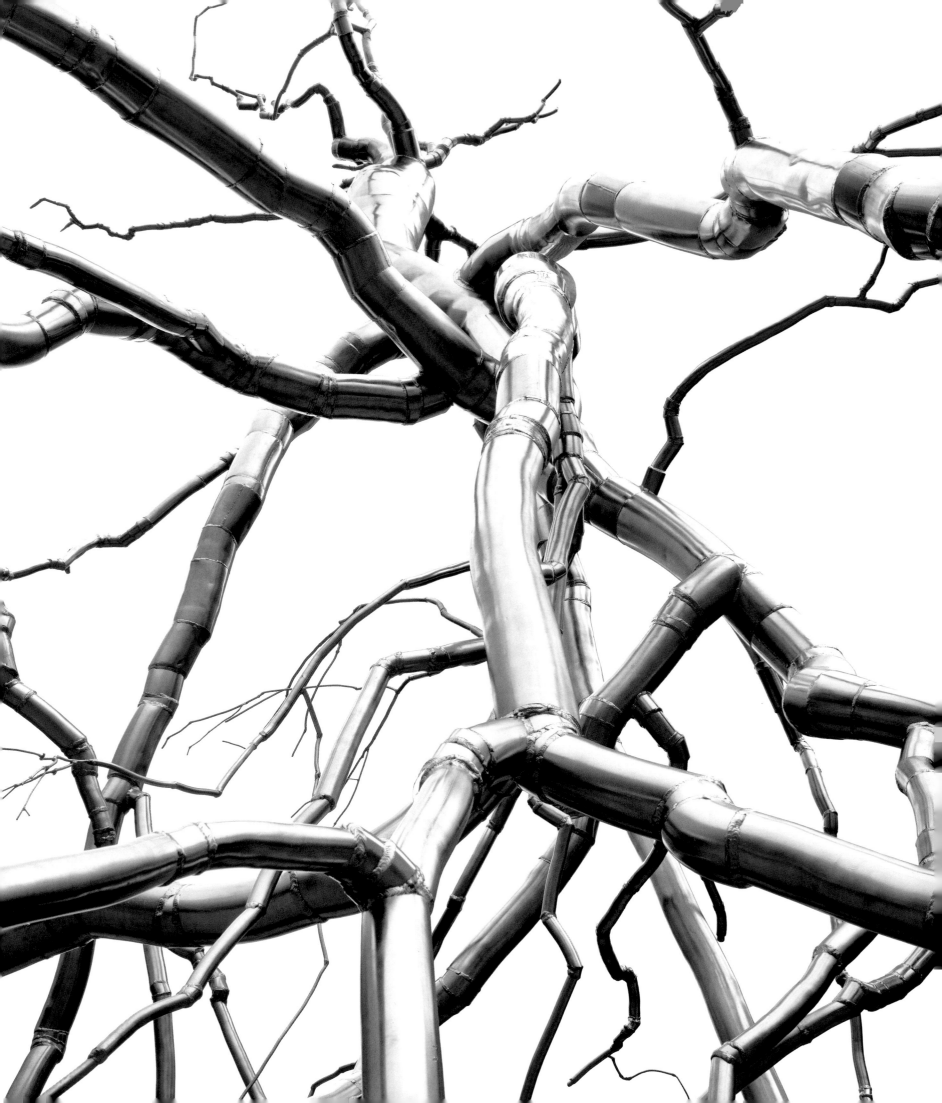

ILLUSTRATIONS OF WORKS BY ROXY PAINE

Front endpapers: Drawing for **Maelstrom**, 2008. India ink on paper, 22 ¼ x 30 in. Collection of the artist

Pages 2–9: **Impostor**, 1999. Stainless steel and concrete, 27 x 18 ft. The Wanås Foundation, Knislinge, Sweden (p. 2)

Transplant, 2001. Stainless steel and concrete, 42 x 26 ft. Fundación NMAC Montenmedio Arte Contemporáneo, Cadiz, Spain (p. 2)

Bluff, 2002. Stainless steel and concrete, 52 x 32 ft. Private collection, Ossining, N.Y. A project of the Public Art Fund; included in the 2002 Whitney Biennial and installed in Central Park, New York, Mar. 7–Jun. 30, 2002 (p. 2)

Substitute, 2003. Stainless steel and concrete, 39 x 28 ft. Collection Marianne and Sheldon B. Lubar, Milwaukee, Wis. (p. 3)

Interim, 2003. Stainless steel and concrete, 36 x 24 ft. Collection Georgia and David Welles; promised gift to the Toledo Museum of Art, Ohio (p. 3)

Split, 2003. Stainless steel and concrete, 51 x 26 ft. Olympic Sculpture Park, Seattle Art Museum; promised gift of the Virginia and Bagley Wright Collection, in honor of the 75th anniversary of the Seattle Art Museum, Seattle, Wash. (p. 4)

Breach, 2003. Stainless steel and concrete, 40 x 28 ft. Sheldon Memorial Art Gallery, University of Nebraska, Lincoln, Olga N. Sheldon Acquisition Trust (p. 4)

Defunct, 2004. Stainless steel and concrete, 46 x 18 ft. Collection Dmitry Kostygin, Switzerland; exhibited at Madison Square Park, New York, May 15, 2007–Feb. 28, 2008 (p. 4)

Placebo, 2004. Stainless steel and concrete, 56 x 39 ft. Saint Louis Art Museum, St. Louis, Mo. (p. 5)

Palimpsest, 2004. Stainless steel and concrete, 28 x 21 ft. Collection Margaux Tarantino and Thomas Lesinski, Beverly Hills, Calif. (p. 5)

Misnomer, 2005. Stainless steel and concrete, 12 x 16 ft. Collection Donald Mullen, East Hampton, N.Y. (p. 5)

Fallen Tree, 2006. Stainless steel and concrete, 13 x 21 ft. Collection Jill and Peter Kraus, Millbrook, N.Y. (p. 6)

Conjoined, 2007. Stainless steel and concrete, 42 x 46 x 28 ft. Modern Art Museum of Fort Worth, Texas; museum purchase (p. 6)

Olive, 2007. Stainless steel and concrete, 22 x 24 ft. Private collection, Mocksville, N.C. (p. 7)

Inversion, 2008. Stainless steel, 42 x 35 ft. Originally created for Public Art Projects, Art Basel 39, presented by Jablonka Galerie, Berlin/Köln, and James Cohan Gallery, New York. Collection of the artist (p. 7)

Model for **Maelstrom**, 2008. Stainless steel, 19 x 80 x 36 in. Full scale work (22 x 140 ft.) shown at the Metropolitan Museum of Art, New York, in the exhibition *Roxy Paine on the Roof:* Maelstrom, Apr. 28–Oct. 25, 2009 (pp. 8–9)

Pages 16 (detail) and 27: **Drug Ziggurat**, 1993. Steel, aluminum, plastic, glass, ceramic, paper, ink, fungi, herbs, and cork, 94 x 72 x 72 in. Collection of the artist

Page 18: Drawing for **Dinner of the Dictators**, 1992. Casein, ink, and paper, 16 x 20 in. Private collection

Pages 24 and 25 (detail): **Dinner of the Dictators**, 1993–95. Freeze-dried food, place settings, glass, wood, and dehumidifier, 47 ¼ x 118 ½ x 50 in. New School for Social Research, New York

Page 26: Drawings for **Drug Ziggurat**, 1993. Casein and ink on paper, 17 x 15 in. Collection Yael Danieli

Page 28: **Every Ear in the NY Times on February 28, 1996**, 1996. Vinyl, paint, pencil, and ink on paper, 19 x 24 in. Collection of the artist

Page 29: **Every Shoe in the NY Times on November 12, 1995**, 1995. Vinyl, paint, pencil, and ink on paper, 19 x 24 in. Private collection

Pages 30–31: **Large Soap**, 1996. 840 bars of soap encased in resin, 60 ¼ x 84 ¼ in. Private collection, Miami

Page 32 (detail of map) and 33: **Where I'm at**, 1993–95. Black-and-white photograph, desk, computer with laser pointer, GPS unit, and cellular phone, 96 x 96 x 54 in. Collection of the artist

Pages 34–35: **Model Painting**, 1996. Durham rock hard water putty, thermoset polymer, steel, auto paint, 4 x 96 x 138 in. Collection of Vicki and Kent Logan, Colorado

Pages 36–37: **Model for an Abstract Sculpture**, 1997. Polymer, mahogany, and plexiglass, 61 x 85 x 5 ¼ in. Collection Mark and Kirsten Feldman, Boston

Pages 38–39: **Pigeon Holes**, 1997. Polymer, mahogany, alkyd paint, insect pins, and plexiglass, 72 x 96 x 6 in. Private collection

Pages 40, 41 (detail), and 42–43 (detail): **Poison Ivy Field**, 1997. PETG and vinyl with lacquer, oil paint, earth, plexiglass, thermoset polymer, and epoxy, 41 x 48 x 66 in. The Rose Art Museum, Brandeis University, Mass. Rose Purchase Fund

Pages 44–45 and 47 (detail): **Psilocybe Cubensis Field**, 1997. Thermoset polymer, lacquer, oil, and steel, 4 ¼ x 328 x 222 in. Israel Museum, Jerusalem

Pages 48–49 and 51 (detail): **Bad Lawn**, 1998. Epoxy, PVC, polymer, steel, wood, PETG, lacquer, oil paint, and earth, 48 x 120 x 84 in. The Wanås Foundation, Knislinge, Sweden

Pages 52 and 53 (detail): **Crop**, 1997–98. PETG, thermoset polymer, vinyl, lacquer, epoxy, oil paint, earth, and plexiglass, 58 x 96 x 72 in. Private collection, New York

Pages 54–55: **Dry Rot**, 1998. Thermoset polymer, epoxy, lacquer, oil, plexiglass, mahogany, and plywood, 37 ½ x 61 ¼ x 5 in. Private collection

Pages 56–57 and 59 (detail): **New Fungus Crop**, 1999. Epoxy, thermoset polymer, aluminum, wood, PETG, lacquer, oil paint, and earth, 35 x 84 x 108 in. Hirshhorn Museum and Sculpture Garden, Smithsonian Institution, Washington, D.C., Joseph H. Hirshhorn Purchase Fund, 2002

Pages 60 and 61 (detail): **Vibrating Field**, 1998. Aluminum, rubber, soil, oil, lacquer, epoxy, PETG, and vibrator, 50 x 96 x 73 in. Collection of Vicki and Kent Logan, Colorado

Pages 62–63: **Fungus Formica Field**, 1998. Wood, fiberglass insulation, polymer, oil, lacquer, linoleum, and formica, 48 x 83 x 15 in. Private collection

Pages 64 and 65 (detail): **Puff Ball Field**, 1998. Aluminum, carpet, pigment, polymer, oil and lacquer, and wood, 40 x 120 x 84 in. The Wanås Foundation, Knislinge, Sweden

Pages 66–67: **Competing Crusts**, 1999. Thermoset polymer, epoxy, lacquer, oil paint, plexiglass, mahogany, and plywood, 37 ¼ x 73 ½ x 5 ⅛ in. Whitney Museum of American Art, New York; gift of Nancy Portnoy, 2005

Page 68 top (detail) and bottom: **Placard Flinger**, 1995. Steel, pneumatics, rubber, motor, and ink on cardboard, 48 x 60 x 24 in. Collection of the artist

Page 71: **Untitled (Drawing for Placard Flinger)**, 1994. Ink and gouache on paper, 19 x 24 in. Private collection

Page 73: Branch layout for **Bluff**, 2001

Page 76, top: Drawing for **Paint Dipper**, 1996. Pencil, casein, and varnish on paper, 19 x 24 in. Private collection

Pages 76, bottom (detail) and 77: **Paint Dipper**, 1997. Steel, acrylic paint, computer, motors, interface, relays, and chair, 124 x 99 x 24 in. Collection of the artist

Page 78: **9405282002A**, 2002. Acrylic, linen, oak, and plywood, 18 x 21 x 3 ½ in. Collection Sue Stoffel, New York

Page 79, top left: **17499112002A**, 2002. Acrylic, linen, oak, and plywood, 17 x 13 x 3 ½ in. Private collection, New York

Page 79, top right: **17499112002B**, 2002. Acrylic, linen, oak, and plywood, 15 x 13 x 3 ½ in. Collection Peter Remes, Minneapolis

Page 79, bottom left: **17499112002C**, 2002. Acrylic, linen, oak, and plywood, 15 x 13 x 3 ½ in. Private collection

Page 79, bottom right: **17499112002D**, 2002. Acrylic, linen, oak, and plywood, 16 x 13 x 3 ½ in. Collection Dara and Evan Kingsley, Pleasantville, N.Y.

Page 80: **15127101997B**, 1997. Acrylic, linen, oak, and plywood, 33 x 35 x 4 in. Feldman Fine Arts, New York

Page 81: **15127101997A**, 1997. Acrylic, linen, oak, and plywood, 33 x 35 x 4 in. Collection Alison Katz, New York

Pages 82–83 and 84 bottom (detail): **SCUMAK (Auto Sculpture Maker)**, 1998. Aluminum, computer, conveyor, electronics, extruder, stainless steel, polyethylene, and Teflon, 163 x 96 x 48 in. Private collection, London

Page 84 top: **SCUMAK (Auto Sculpture Maker)**, 1998. Detail of screen of computer monitoring sculpture-making process.

Page 85: **S1-P2-W3**, 2000. Low-density polyethylene, approx. 12 x 14 x 13 in. Private collection

Page 86, top left: **S1-P2-W1**, 2000. Low-density polyethylene, approx. 10 x 18 x 15 in. Private collection

Page 86, top right: **S1-P2-W2**, 2000. Low-density polyethylene, approx. 10 x 21 x 20 in. Private collection

Page 86, bottom left: **S1-P2-W30**, 2000. Low-density polyethylene, approx. 10 x 19 x 14 in. Private collection

Page 86, bottom right: **S1-P2-W4**, 2000. Low-density polyethylene, approx. 11 x 14 x 12 in. Private collection

Page 87, top left: **S1-P2-W6**, 2000. Low-density polyethylene, approx. 10 x 18 x 13 in. Private collection

Page 87, top right: **S1-P2-W8**, 2000. Low-density polyethylene, approx. 9 x 19 x 13 in. Private collection

Page 87, bottom left: **S1-P2-W33**, 2000. Low-density polyethylene, approx. 11 x 13 x 12 in. Private collection

Page 87, bottom right: **S1-P2-W14**, 2000. Low-density polyethylene, approx. 11 x 14 x 12 in. Private collection, St. Louis, Mo.

Page 88, top: **SCUMAK No. 2**, 2001. Detail of screen of computer monitoring sculpture-making process.

Page 88, bottom, and 89 (detail): **SCUMAK No. 2**, 2001. Aluminum, computer, conveyor, electronics, extruder, stainless steel, polyethylene, Teflon, 90 x 276 x 73 in. Collection of the artist

Page 90, top left: **S2-P2-M19**, 2003. Low-density polyethylene, 18 x 24 x 21 in. Private collection

Page 90, top right: **S2-P2-024**, 2003. Low-density polyethylene, approx. 20 x 30 x 28 in. Collection Donald Mullen, New York

Page 90, bottom left: **S2-P2-M30**, 2003. Low-density polyethylene, approx. 18 x 27 x 26 in. Private collection

Page 90, bottom right: **S2-P2-M6**, 2003. Low-density polyethylene, approx. 21 x 16 x 14 in. Collection of the artist

Page 91, top left: **S2-P2-05**, 2002. Low-density polyethylene, 30 x 25 x 25 in. Private collection, La Jolla, Calif.

Page 91, top right: **S2-P2-M10**, 2003. Low-density polyethylene, approx. 18 x 36 x 26 in. Collection Avv. Carla Garofalo

Page 91, bottom left: **S2-P2-M28**, 2003. Low-density polyethylene, approx. 19 x 28 x 26 in. Private collection

Page 91, bottom right: **S2-P2-CR20**, 2007. Low-density polyethylene, 14 x 32 x 20 in. Private collection, New York

Page 92: **DM No. 9A**, 2003. Ink on paper mounted on aluminum, 38 ½ x 58 ½ in. Private collection, New York

Page 93: **DM No. 9B**, 2003. Ink on paper mounted on aluminum, 38 ½ x 58 ½ in. Collection of the artist

Page 94: **DM No. 7A**, 2003. Ink on paper mounted on aluminum, 38 ½ x 58 ½ in. Private Collection, Cincinnati

Page 95: **DM No. 7B**, 2002. Ink on paper mounted on aluminum, 38 ½ x 58 ½ in. Collection of William Lieberman, Chicago

Page 96: **Damn A**, 2002. Paper and ink on aluminum, 39 ⅛ x 58 ¼ in. The Art Institute of Chicago, restricted gift of Kaye and Howard Haas, 2003

Page 97: **Damn B**, 2002. Paper and ink on aluminum, 40 ⅛ x 58 ¼ in. Private collection

Pages 98 (details) and 99: **Drawing Machine**, 2001. Aluminum, stainless steel, glass, valve, servo motors, track, computer, custom software, bearing, ink, and paper, 92 x 94 x 94 in. Collection of the artist

Page 100: **PMU No. 19**, 2005. Acrylic, linen, oak, and plywood, 38 x 59 ¼ x 4 ½ in. Collection Darlene Bossen, Menlo Park, Calif.

Page 101: **PMU No. 33**, 2007. Acrylic, linen, oak, and plywood, 40 x 59 x 4 ¼ in. Private collection, New York

Page 102: **PMU No. 27**, 2006. Acrylic, linen, oak, and plywood, 40 x 60 x 4 ¼ in. Collection Anabeth and John Weil, St. Louis, Mo.

Page 103: **PMU No. 8**, 2002. Acrylic, linen, oak, and plywood, 36 x 59 x 4 in. Private collection

Page 104, top: **PMU No. 10**, 2002, with computer screen shot of the data used to generate the painting. Acrylic, linen, oak, and plywood, 36 x 59 x 4 in. The Rose Art Museum, Brandeis University, Mass. Rose Purchase Fund

Page 104, middle: **PMU No. 20**, 2005, with computer screen shot of the data used to generate the painting. Acrylic, linen, oak, and plywood, 38 x 59 ¼ x 4 ½ in. Collection Geoffrey C. Beaumont

Page 104, bottom: **PMU No. 6**, 2001, with computer screen shot of the data used to generate the painting. Acrylic, linen, oak, and plywood, 37 x 59 x 4 in. Collection Ninah and Michael Lynne, New York

Page 105, top: **PMU No. 31**, 2007, with computer screen shot of the data used to generate the painting. Acrylic, linen, oak, and plywood, 38 x 59 ¼ x 4 ½ in. Collection Jeff and Erica Keswin, New York

Page 105, middle: **PMU No. 12**, 2003, with computer screen shot of the data used to generate the painting. Acrylic, linen, oak, and plywood, 36 x 59 x 4 in. Private collection, Beijing

Page 105, bottom: **PMU No. 28**, 2006, with computer screen shot of the data used to generate the painting. Acrylic, linen, oak, and plywood, 40 x 60 x 4 ½ in. Private collection, Italy

Pages 106–7: **PMU No. 17**, 2005. Acrylic, linen, oak, and plywood, 38 x 59 ¼ x 4 ½ in. Collection Cleve Carney, Glen Ellyn, Ill.

Pages 108–9: **Painting Manufacture Unit**, 1999–2000. Aluminum, stainless steel, computer, electronics, relays, custom software, acrylic, servo motors, valves, pump, precision track, glass, and rubber, 110 x 157 x 176 in. Collection of the artist

Page 110: **PMU No. 18**, 2005. Acrylic, linen, oak, and plywood, 38 x 59 ¼ x 4 ½ in. Private collection

Page 111: **PMU No. 23**, 2005. Acrylic, linen, oak, and plywood, 38 x 59 ¼ x 4 ½ in. Private collection, New York

Page 112, top: Studies for **Erosion Machine**, 2004. Ink on paper, 14 x 20 in. Collection of the artist

Page 112, bottom: Renderings for **Erosion Machine**

Pages 113 (detail), 114–15 (detail), and 116–17: **Erosion Machine**, 2005. Stainless steel, rubber, felt, glass, galvanized steel, sandstone, silicon carbide, electronics, dust collector, reclaimer, computer, robot, and air, 138 x 252 x 137 in. Collection of the artist

Page 118: Renderings for **Erosion Machine**

Pages 119 (detail) and 120–21: **Erosion Machine Stone No. 2**, 2006. Sandstone, 31 x 66 x 36 in. Collection Angela and Massimo Lauro, Naples

Pages 122–23: **Erosion Machine Stone No. 3 (Crime Data)**, 2006. Sandstone, 10 x 32 x 19 in. Private collection

Page 124: **Unexplained Object**, 2005. Canvas, stainless steel, electronics, pneumatic cylinders, valves, compressor, and Geiger counter, 96 x 96 x 96 in. Collection of the artist

Page 127: Drawing for **Weed Choked Garden**, 1998

Page 129: **Conjoined**, 2007. Stainless steel and concrete, 46 x 42 x 28 ft. Originally commissioned by the Madison Square Park Conservancy. Modern Art Museum of Fort Worth, Texas, museum purchase.

Pages 132–33: **Specimen Case**, 1995. Polymer, mahogany, pins, and plexiglass, 48 x 60 x 5 in. Private collection

Pages 134–35: **Blob Case (No. 8)**, 1998. Acrylic, lacquer, insect pins, mahogany, and glass, 48 x 72 x 6 in. Collection Jenette Kahn, New York

Pages 136–37: **Large Fungus Painting**, 1998–99. Thermoset polymer, aluminum wood, lacquer, and oil, 96 x 120 x 5 in. Feldman Fine Arts, New York

Page 138: Study for **Impostor**, 1999. Faxed drawing, 8 ½ x 11 in. The Wanås Foundation, Knislinge, Sweden

Pages 139 and 141: **Impostor**, 1999. Stainless steel, 27 x 18 x 18 ft. The Wanås Foundation, Knislinge, Sweden

Page 140: **Impostor** under construction, 1999

Pages 142 (detail), 143 (detail), and 145: **Transplant**, 2001. Stainless steel and concrete, 44 x 29 x 29 ft. Fundación NMAC Montenmedio Arte Contemporáneo, Cadiz, Spain

Pages 146–47: **Dry Rot**, 2001. Fiberglass, epoxy, lacquer, and oil, 68 x 90 x 8 in. Collection Roger Conn and Anne Hoger, La Jolla, Calif.

Pages 148–49, 150 (details), and 151 (detail): **Weed Choked Garden**, 1998–2006. Thermoset polymer, oil paint, PETG, stainless steel, lacquer, epoxy, and pigment, 65 x 139 x 96 ½ in. Museum of Contemporary Art, Los Angeles; purchased with funds provided by the Glenstone Foundation, Mitchell P. Rales, Founder

Pages 153 and 155 (detail): **Amanita Muscaria Field**, 2000. Thermoset polymer, epoxy, stainless steel, lacquer, and oil paint, 162 x 115 x 20 in. The West Collection, Oaks, Penn.

Pages 156–57: **Amanita Virosa Wall**, 2001. Thermoset polymer, epoxy, stainless steel, lacquer, and oil paint, 155 x 265 x 5 in. Whitney Museum of American Art, New York; purchased with funds from Neuberger Berman, LLC, and the Contemporary Committee, 2004

Pages 159 (detail) and 160–61: **Sulfur Shelf Wall**, 2001. Thermoset polymer, epoxy, stainless steel, lacquer, and oil, 155 x 292 x 7 in. Collection of the artist

Pages 162–63: **Untitled**, 2002. Thermoset polymer, epoxy, stainless steel, lacquer, oil, and wood, 60 ½ x 90 ⅛ x 9 ½ in. Private collection, New York

Page 165: **Tapioca Slime Painting**, 2001. Thermoset polymer, lacquer, oil, and aluminum, 48 ¼ x 66 ¼ x 14 in. Collection of the artist

Pages 166–67: **Untitled**, 2002. Thermoset polymer, epoxy, stainless steel, lacquer, oil, and wood, 60 ½ x 90 ⅜ x 9 ½ in. Private collection, Barcelona

Pages 168–69: **Untitled**, 2002. Thermoset polymer, epoxy, stainless steel, lacquer, oil, and wood, 60 ¼ x 84 ¼ x 5 in. Private collection, Chappaqua, N.Y.

Pages 170–71: **Untitled**, 2002. Thermoset polymer, epoxy, stainless steel, lacquer, oil, and wood, 60 ½ x 90 ⅛ x 9 ½ in. Private collection

Pages 172–73 and 175 (detail): **Bluff**, 2002. Stainless steel and concrete, 52 x 32 ft. Private collection, Ossining, N.Y.; a project of the Public Art Fund

Page 174: Engineering studies for **Bluff**, 2002.

Page 177: **Split**, 2003. Stainless steel, 51 x 26 ft. Olympic Sculpture Park, Seattle Art Museum; promised gift of the Virginia and Bagley Wright Collection, in honor of the 75th anniversary of the Seattle Art Museum

Pages 178–79: **Interim**, 2003. Stainless steel and concrete, 36 x 24 ft. Collection Georgia and David Welles; promised gift to the Toledo Museum of Art, Ohio

Page 180, top: **Ill Tomato**, 2005. Thermoset polymer, epoxy, stainless steel, lacquer, oil paint, maple, and glass, 16 x 25 ¼ x 21 ¼ in. Collection Judy and Don Rechler, New York

Page 180, bottom: **Azurescens Case**, 2006. Thermoset polymer, epoxy, stainless steel, lacquer, oil paint, maple, and glass, 10 ¼ x 30 x 16 ½ in. Private collection

Page 181: **A vs. B**, 2004. Thermoset polymer, epoxy, stainless steel, lacquer, oil paint, maple, and glass, 75 ½ x 75 ½ x 45 in. Peter Remes Collection, Minneapolis, Minn.

Pages 182–83: **Specimen Case No. 11**, 2000. Acrylic and mahogany, plexiglass, and insect pins, 42 x 60 x 6 in. Collection Jill and Peter Kraus, New York

Pages 184–85: **Specimen Case No. 12**, 2006. Acrylic and mahogany, plexiglass, insect pins, and clipboard (key); case: 49 ½ x 85 ¼ x 5 in.; clipboard: 15 ½ x 9 x 2 in. Private collection, London

Pages 187 and 189 (detail): **Breach**, 2003. Stainless steel and concrete, 40 x 28 ft. Sheldon Museum of Art, University of Nebraska, Lincoln, Olga N. Sheldon Acquisition Trust

Pages 190 and 191 (detail), 192–93 (details), and 194–95 (details): **Defunct**, 2004. Stainless steel, approx. 46 x 18 ft. Collection of Dmitry Kostygin, Switzerland

Pages 197 and 199 (detail): **Palimpsest**, 2004. Stainless steel and concrete, 28 x 21 ft. Collection Margaux Tarantino and Thomas Lesinski, Beverly Hills

Pages 201 and 202–3 (details): **Placebo**, 2004. Stainless steel and concrete, 56 x 39 ft. Saint Louis Art Museum, St. Louis, Mo.; commissioned by the Saint Louis Art Museum with funds given in memory of John Wooten Moore

Page 204 (detail): **Large Soap**, 1996. 840 bars of soap encased in resin, 60 ¼ x 84 ¼ in. Private collection, Miami

Page 207: Detail of **Bad Lawn**, 1998

Page 209: **Abstract No. 6**, 2000. Lacquer, fiberglass, and oil paint, 35 x 48 x 4 in. De Pont Museum of Contemporary Art, Tilburg, The Netherlands

Page 211: **Maelstrom** in progress, 2008.

Pages 212, top (internal circuitry), bottom left (internal view), bottom right (assembled without cover), 213, and 214–15 (various configurations): **Unexplained Object**, 2005. Canvas, stainless steel, electronics, pneumatic cylinders, valves, Geiger counter, and compressor, 96 x 96 x 96 in. Collection of the artist

Pages 217 and 219 (detail): **Substitute**, 2001. Stainless steel and concrete, approx. 39 x 28 ft. Collection Marianne and Sheldon B. Lubar, Milwaukee, Wis.

Pages 220 (detail) and 221–23 (selected slices): **Head Cheese, Loaf and 7 Large Slices**, 2004. Pigmented cast epoxy resins; loaf approx. 19 x 21 x 26 in.; slice size approx. 19 x 21 x 2 in. Courtesy the artist and Graphicstudio, University of South Florida, Tampa

Pages 224–25: **Misnomer**, 2005. Stainless steel, 12 ft. 4 in. (ht.) x 16 ft. x 11 ft. 7 in. Collection Donald Mullen, East Hampton, N.Y.

Page 226, left: Drawing for **Bad Planet**, 2004. Ink and graphite on paper, 8 ½ x 6 ¼ in. Collection of the artist

Page 226, right: Drawing for **Bad Planet**, 2004. Ink and graphite on grid paper, 8 ½ x 11 in. Collection of the artist

Pages 227, 228 (details), and 229 (detail): **Bad Planet**, 2005. Foam, epoxy, lacquer, oil, and stainless steel, 65 x 60 x 60 in. Gary Tatintsian Collection

Pages 230 and 231 (detail): **Cocklebur**, 2005. Thermoset polymer, epoxy, stainless steel, lacquer, oil paint, maple, and glass, 16 x 32 x 23 ½ in. The Museum of Contemporary Art, North Miami; museum purchase with funds provided by Pop Ten / Partial gift of the artist and James Cohan Gallery, 2005

Pages 232–33 and 235 (detail): **Fallen Tree**, 2006. Stainless steel and concrete, approx. 11 x 20 x 20 ft. Collection Jill and Peter Kraus, New York

Pages 236, 237 (detail), 238–39 (detail), and 240–41 (all views in Madison Square Park, New York): **Conjoined**, 2007. Stainless steel and concrete, 46 x 42 x 28 ft. Originally commissioned by the Madison Square Park Conservancy for an exhibition in Madison Square Park, New York, May 15, 2007–Feb. 28, 2008. Modern Art Museum of Fort Worth, Texas; museum purchase

Pages 242 and 243: **Erratic**, 2007. Stainless steel, approx. 7 x 18 x 11 ft. Originally commissioned by the Madison Square Park Conservancy for an exhibition in Madison Square Park, New York, May 15, 2007–Feb. 28, 2008; City of Beverly Hills, Calif.

Page 244: Drawing for **Inversion**, 2007. Ink and pencil on paper, 22 x 18 ½ in. The Museum of Modern Art, New York, Committee on Drawings Funds

Pages 245 and 246 (detail): **Inversion**, 2008. Stainless steel, 42 x 35 ft. Originally created for Public Art Projects for Art Basel 39, presented by Jablonka Galerie, Berlin/Köln, and James Cohan Gallery, New York. Collection of the artist

EXHIBITIONS AND SELECTED BIBLIOGRAPHY

Roxy Paine was born in New York City in 1966. He studied at Pratt Institute, New York, and the College of Santa Fe, New Mexico. He has received a John Simon Guggenheim Memorial Foundation Fellowship, in 2006, and the Trustees Award for an Emerging Artist, from the Aldrich Museum of Contemporary Art, Ridgefield, Connecticut, in 1997.

EXHIBITIONS

Selected Solo Exhibitions

Roxy Paine on the Roof: Maelstrom, Metropolitan Museum of Art, New York, Apr. 28–Oct. 25, 2009

Roxy Paine: SCUMAKS, James Cohan Gallery, New York, Jun. 26–Aug. 1, 2008

Roxy Paine: Three Sculptures, commissioned by Madison Square Park Conservancy, Madison Square Park, New York, May 15, 2007–Feb. 28, 2008

Roxy Paine: PMU, curated by Bruce Guenther, Portland Museum of Art, Portland, Ore., Feb. 25–May 28, 2006

Roxy Paine: New Work, James Cohan Gallery, New York, Jan. 14–Feb. 25, 2006

Defunct, Aspen Art Museum, Aspen, Colo., Jul. 23, 2004–Nov. 20, 2006

Roxy Paine: Inoculate, James Cohan Gallery, New York, Nov. 8–Dec. 22, 2002

Scumaks, Bernard Toale Gallery, Boston, Apr. 24–May 25, 2002

Roxy Paine: Second Nature, curated by Joseph Ketner and Lynn Herbert, Rose Art Museum, Brandeis University, Waltham, Mass., Apr. 25–Jul. 14, 2002. Traveled to Contemporary Arts Museum, Houston, Oct. 19, 2002–Jan. 12, 2003; SITE, Santa Fe, New Mexico, Apr. 26–Jul. 6, 2003; De Pont Museum for Contemporary Art, Tilburg, The Netherlands, Sep. 20, 2003–Jan. 11, 2004

PMU (Painting Manufacture Unit), Museum of Contemporary Art, North Miami, Fla., Nov. 11, 2001–Jan. 27, 2002

Grand Arts, Kansas City, Mo., Jun. 29–Aug. 11, 2001

Christopher Grimes Gallery, Los Angeles, May 26–Jun. 30, 2001

Roxy Paine: New Work, James Cohan Gallery, New York, Apr. 5–May 5, 2001

Roxy Paine: Amanita Fields, Galerie Thomas Schulte, Berlin, Germany, Feb. 13–Apr. 20, 2001

Roger Bjorkholmen Gallery, Stockholm, Sweden, Feb. 26–Mar. 31, 1999

Ronald Feldman Fine Arts, New York, Jan. 9–Feb. 13, 1999

Renate Schroder Galerie, Cologne, Germany, Apr. 24–Jun. 6, 1998

Musée d'Art Americain Giverny, Giverny, France, Jun. 1–Nov. 15, 1998. Traveled to Lunds Kunsthall, Lund, Sweden, Mar. 6–Apr. 18, 1999

Temple Gallery, Tyler School of Art, Temple University, Philadelphia, Sep. 5–Oct. 11, 1997

Ronald Feldman Fine Arts, New York, Mar. 15–Apr. 26, 1997

Ronald Feldman Fine Arts, New York, Apr. 29–Jun. 3, 1995

Herron Test-Site, Brooklyn, Oct. 9–Nov. 8, 1992

Horns, Knitting Factory, New York, Dec. 3–31, 1991

Selected Group Exhibitions
*Accompanied by an exhibition catalogue

2008

Bizarre Perfection, Israel Museum, Jerusalem, Dec. 20, 2008–Jun. 6, 2009

Freedom, Den Haag Sculptur 2008, The Hague, The Netherlands, Jun. 15–Aug. 31, 2008

Public Art Projects, Art Basel 39, Basel, Switzerland, Jun. 3–9, 2008

Paragons: New Abstraction from the Albright-Knox Gallery, Doris McCarthy Gallery, University of Toronto–Scarborough, Toronto, Jan. 17–Mar. 9, 2008

2007

Delicatessen, Florida Atlantic University Dorothy F. Schmidt Center Gallery, Boca Raton, Fla., Nov. 9, 2007–Jan. 26, 2008

Art Machines/Machine Art, Schirn Kunsthalle, Frankfurt, Germany, Oct. 18, 2007–Jan. 27, 2008. Traveled to Museum Tinguely, Basel, Switzerland, Mar. 5–Jun. 29, 2008

The Outdoor Gallery: 40 Years of Public Art in New York City Parks, Arsenal Gallery in Central Park, New York, Sep. 25–Nov. 23, 2007

Drawings from the Collection of Martina Yamin, Davis Museum and Cultural Center, Wellesley College, Wellesley, Mass., Sep. 19–Dec. 9, 2007

Molecules That Matter, Tang Teaching Museum, Saratoga Springs, N.Y., Sep. 8, 2007–Apr. 13, 2008. Traveled to Chemical Heritage Foundation, Philadelphia, Aug. 18, 2008–Jan. 9, 2009; College of Wooster Art Museum, Wooster, Ohio, Mar. 24–May 10, 2009; Mayborn Museum Complex, Baylor University, Waco, Tex., Jun.–Aug 2009; and Faulconer Gallery, Bucksbaum Center for Arts, Grinnell College, Grinnell, Iowa, Sep.–Dec. 2009

2006

Recent Acquisitions, Musée d'art contemporain de Montréal, Oct. 28, 2006–Mar. 25, 2007

Meditations in an Emergency, Museum of Contemporary Art Detroit, Oct. 28, 2006–Apr. 29, 2007

A Brighter Day, James Cohan Gallery, New York, Jun. 9–Jul. 14, 2006

Garden Paradise, curated by Lacy Davisson Doyle and Clare Weiss, Arsenal Gallery in Central Park, New York, Apr. 20–May 24, 2006

American Academy Invitational Exhibition of Painting & Sculpture, American Academy of Arts and Letters, New York, Mar. 7–Apr. 9, 2006

Uneasy Nature, curated by Xandra Eden, Weatherspoon Art Museum, University of North Carolina, Greensboro, N.C., Feb. 18–May 28, 2006

2005

Ecstasy: In and About Altered States, organized by Paul Schimmel with Gloria Sutton, Museum of Contemporary Art, Los Angeles, Oct. 9, 2005–Feb. 20, 2006

The Empire of Sighs, Numark Gallery, Washington, D.C., Sep. 16–Oct. 29, 2005

Extreme Abstraction, Albright Knox Art Gallery, Buffalo, N.Y., Jul. 15–Oct. 2, 2005

Sculpture, James Cohan Gallery, New York, May 7–Jun. 25, 2005

Flower Myth. Vincent van Gogh to Jeff Koons, Fondation Beyeler, Riehen/Basel, Switzerland, Feb. 27–May 22, 2005

MATERIAL TERRAIN: A Sculptural Exploration of Landscape and Place, curated by Carla Hanzal, commissioned by Laumeier Sculpture Park, St. Louis, Mo., Feb. 11–May 15, 2005. Traveled to Santa Cruz Museum of Art and History, Santa Cruz, Calif., Jul. 2–Sep. 25, 2005; University of Arizona Museum of Art, Tucson, Ariz., Jan. 13, 2006–Apr. 2, 2006; Memphis Brooks Museum of Art, Memphis, Tenn., Sep. 16–Nov. 26, 2006; Cheekwood Museum of Art, Nashville, Tenn., Mar. 17–Jun. 17, 2007; Columbia Museum of Art, Columbia, S.C., Jul. 6–Aug. 26, 2007; Lowe Art Museum, University of Miami, Coral Gables, Fla., Sep. 15–Nov. 27, 2007

2004

PILLish: Harsh Realities and Gorgeous Destinations, curated by Cydney Payton, Museum of Contemporary Art, Denver, Oct. 1, 2004–Jan. 2, 2005

The Flower as Image, Louisiana Museum for Moderne Kunst, Humlebæk, Denmark, Sep. 10, 2004–Jan. 16, 2005

Paintings That Paint Themselves, or So It Seems, Kresge Art Museum, Michigan State University, East Lansing, Mich., Sep. 7–Oct. 31, 2004

The Summer Show, James Cohan Gallery, New York, Jul. 9–Aug. 20, 2004

Natural Histories: Realism Revisited, Scottsdale Museum of Contemporary Art, Scottsdale, Ariz., May 29–Sep. 12, 2004

Between the Lines, James Cohan Gallery, New York, May 7–Jun. 12, 2004

2003

Work Ethic, Baltimore Museum of Art, Baltimore, Md., Oct. 12, 2003–Jan. 11, 2004. Traveled to Des Moines Center for the Arts, Des Moines, Iowa, May 15–Aug. 1, 2004

The Great Drawing Show 1550–2003 AD, Michael Kohn Gallery, Los Angeles, Apr. 12–May 31, 2003

Decade, Schroeder Romero, Brooklyn, Apr. 11–May 19, 2003

* *UnNaturally*, organized by Independent Curators International (iCI), curated by Mary-Kay Lombino. Contemporary Art Museum, University of South Florida, Tampa, Fla., Jan. 13–Mar. 8, 2003; Traveled to H & R Block Artspace at the Kansas City Art Institute, Kansas City, Mo., Sep. 19–Oct. 29, 2003; Fisher Gallery, University of Southern California, Los Angeles, Nov. 19, 2003–Jan. 17, 2004; Copia: The American Center for Wine, Food and the Arts, Napa, Calif., Apr. 30–Aug. 16, 2004; Lowe Art Museum, University of Miami, Coral Gables, Fla., Sep. 14–Nov. 14, 2004

2002

Early Acclaim: Emerging Artist Award Recipients 1997–2001, Aldrich Museum of Contemporary Art, Ridgefield, Conn., Sep. 22–Dec. 31, 2002

Painting Matter, James Cohan Gallery, New York, May 3–Jun. 15, 2002

Whitney Biennial 2002, curated by Tom Eccles, organized by the Public Art Fund, New York, in collaboration with the Whitney Museum of American Art, Central Park, New York, Mar. 7–Jun. 30, 2002

2001

Brooklyn!, Palm Beach Institute of Contemporary Art, Lake Worth, Fla., Sep. 4–Nov. 25, 2001

* *Arte y naturaleza*, Montenmedio Arte Contemporaneo (NMAC), outdoor sculpture garden, Cadiz, Spain, Jun. 2–Oct. 2, 2001

* *Waterworks: U.S. Akvarell 2001*, curated by Kim Levin, Nordiska Akvarellmuseet, Skarhamn, Sweden, May 19–Sep. 2, 2001

Present Tense 6, Israel Museum, Jerusalem, Israel, May–Dec. 2001

* *01.01.01: Art in Technological Times*, San Francisco Museum of Modern Art, Mar. 3–Jul. 8, 2001

All-Terrain, Contemporary Art Center of Virginia, Virginia Beach, Va., Feb. 22–Apr. 29, 2001

A Contemporary Cabinet of Curiosities: Selections from the Vicki and Kent Logan Collection, California College of Arts and Crafts, San Francisco, Jan. 17–Mar. 3, 2001

Give and Take, Serpentine Gallery in collaboration with the Victoria and Albert Museum, London, Jan. 30–Apr. 1, 2001

Making the Making, Apex Art, New York, Jan. 5–Feb. 3, 2001

2000

From a Distance: Approaching Landscape, curated by Jessica Morgan, Institute of Contemporary Art, Boston, Jul. 19–Oct. 8, 2000

WILDflowers, Katonah Museum of Art, Katonah, N.Y., Jul. 18–Oct. 3, 2000

Working in Brooklyn: Beyond Technology, Brooklyn Museum of Art, Jul. 1–Sep. 12, 2000

5th Lyon Biennale of Contemporary Art: Sharing Exoticism, Lyon, France, Jun. 27–Sep. 24, 2000

Vision Ruhr, Dortmund Coal Factory, Dortmund, Germany, May 11–Aug. 20, 2000

The Greenhouse Effect, Serpentine Gallery, London, Apr. 4–May 21, 2000

Sites around the City: Art and Environment, curated by Heather Sealy Lineberry, Arizona State University Art Museum, Tempe, Ariz., Mar. 4–Jun. 4, 2000

Greater New York: New Art in New York Now, P.S.1 Contemporary Art Center in collaboration with the Museum of Modern Art, New York, Feb. 27–Apr. 16, 2000

The End, Exit Art/The First World, New York, Jan. 29–Apr. 8, 2000

* *As Far As the Eye Can See*, Atlanta College of Art Gallery, Atlanta, Jan. 29–Mar. 7, 2000

Visionary Landscape, Christopher Grimes Gallery, Santa Monica, Calif., Jan. 8–Feb. 19, 2000

1999

Best of the Season: Selected Work from the 1998–99 Gallery Season, Aldrich Museum of Contemporary Art, Ridgefield, Conn., Sep. 26–Jan. 9, 1999

1998

Interlacings: The Craft of Contemporary Art, Whitney Museum of American Art at Champion, Stamford, Conn., Sep. 10–Nov. 21, 1998

22/21, Emily Lowe Gallery, Hofstra University Museum, Hempstead, N.Y., Sep. 8–Oct. 25, 1998

Elise Goodheart Fine Art, Sag Harbor, N.Y., Jul. 24–Aug. 16, 1998

DNA Gallery, Provincetown, Mass., Jul. 17–Aug. 5, 1998

Nine International Artists at Wanås 1998, Wanås Foundation, Knislinge, Sweden, May 24–Oct. 18, 1998

Landscapes, Meyerson & Nowinski, Seattle, Jan. 8–Mar. 1, 1998

1997

Redefinitions: A View From Brooklyn, California State University, Fullerton, Calif., Nov. 9–Dec. 11, 1997

9 to 5 at Metrotech: New Commissions for the Common, Public Art Fund, Brooklyn, Oct. 30, 1997–May 31, 1997

* *Best of the Season 1996–97*, Aldrich Museum of Contemporary Art, Ridgefield, Conn., Sep. 14–Jan. 4, 1997

Current Undercurrent: Working in Brooklyn, Brooklyn Museum of Art, Jul. 25, 1997–Jan. 25, 1998

Sculpture, James Graham & Sons, New York, Jul. 10–Aug. 29, 1997

Summer of Love, Fotouhi Cramer Gallery, New York, Jul. 2–Aug. 2, 1997

Artists Respond to "2001: Space Odyssey," Williamsburg Art and Historical Society, Brooklyn, Jun. 21–Jul. 26, 1997

Benefit for Pat Hearn, Morris-Healy Gallery, New York, Feb. 26–Mar. 9, 1997

1996

Imaginary Beings, Exit Art/The First World, New York, Dec. 2–Jan. 27, 1996

* *Art on Paper*, Weatherspoon Art Gallery, University of North Carolina, Greensboro, N.C., Nov. 12–Jan. 21, 1996

Inside Out, Momenta Art, Brooklyn, Sep. 15–Oct. 7, 1996

Currents in Contemporary Art, Christie's East, New York, Jul. 22–Jul. 31, 1996

Inside: The Work of Art, California Center for the Arts, Escondido, Calif., Jun. 16–Oct. 13, 1996

Human/Nature, New Museum of Contemporary Art, New York, Apr. 20–May 18, 1996

Wish You Were Here, Bronwyn Keenan Gallery, New York, Mar. 1–30, 1996

Better Living through Chemistry, Randolph Street Gallery, Chicago, Mar.–Apr. 1996

New York State Biennial, New York State Museum, Albany, N.Y., Feb. 8–May 26, 1996

NY Withdrawing, Ronald Feldman Fine Arts, New York, Jan. 13–Feb. 17, 1996

1995

Lookin' Good-Feelin',' 450 Broadway Gallery, New York, Dec. 5–Dec. 9, 1995

Multiples, Pierogi 2000, Brooklyn, Dec. 2, 1995–Jan. 15, 1996

1994

Red Windows: Benefit for the Little Red School House, Barneys, New York, Nov.–Dec. 1994

Spring Benefit, Sculpture Center, New York, Apr. 19, 1994

Garden of Sculptural Delights, Exit Art/The First World, New York, Mar. 2–Apr. 23, 1994

Free Falling, Berlin Shafir Gallery, New York, Jan. 22–Feb. 19, 1994

1993

UNTITLED (14), Ronald Feldman Fine Arts, New York, Nov. 13–Dec. 23, 1993

INFLUX, Gallery 400, Chicago, Nov. 3–Dec. 4, 1993

Fantastic Wanderings, Cummings Art Center, New London, Conn., Oct. 9–Nov. 10, 1993

4 Walls Benefit, David Zwirner Gallery, New York, Oct. 28–30, 1993

Extracts, Islip Art Museum, Islip, N.Y., Aug. 8–Sep. 19, 1993

Popular Mechanics, Real Art Ways, Hartford, Conn., Jun. 19–Jul. 16, 1993

Outside Possibilities '93, Rushmore Festival at Woodbury, N.Y., Jun. 5–Jul. 4, 1993

**The Nature of the Machine*, Chicago Cultural Center, Chicago, Apr. 3–May 30, 1993

**Out of Town: The Williamsburg Paradigm*, Krannert Art Museum, University of Illinois, Champaign, Ill., Jan. 22–Feb. 28, 1993

1992

Fever, Exit Art, New York, Dec. 14, 1992–Feb. 6, 1993

1991

Group, Jimenez-Algus Gallery, Brooklyn, Sep. 13–Oct. 13, 1991

Entropy, Generator 547, New York, Aug. 2–Sep. 5, 1991

Tweeking the Human, Brand Name Damages and Minor Injury Galleries, Brooklyn, Jun. 7–31, 1991

The Ego Show, Minor Injury, Brooklyn, Apr. 5–May 2, 1991

1990

Desire and Deception, Brand Name Damages, Brooklyn, Oct. 9–21, 1990

Group Show, Ridge Street Gallery, New York, Sep. 3–26, 1990

Roxy Paine & David Fasoldt, Brand Name Damages, Brooklyn, Mar. 29–Apr. 16, 1990

Public Collections

De Pont Museum of Contemporary Art, Tilburg, The Netherlands

Denver Art Museum

Fundación NMAC, Cadiz, Spain

Hirshhorn Museum and Sculpture Garden, Washington, D.C.

The Israel Museum, Jerusalem

Modern Art Museum of Fort Worth, Texas

The Museum of Modern Art, New York

The New School, New York

The Rose Art Museum, Brandeis University, Waltham, Mass.

Saint Louis Art Museum, St. Louis, Mo.

San Francisco Museum of Modern Art

University of Nebraska, Lincoln

Wanås Foundation, Knislinge, Sweden

Whitney Museum of American Art, New York

SELECTED BIBLIOGRAPHY

Books

Fineberg, Jonathan. *Art since 1940: Strategies of Being.* 2nd ed. New York: Harry N. Abrams, 2000.

Richer, Francesca, and Matthew Rosenzweig. *No. 1: First Works by 362 Artists.* New York: D.A.P., 2006.

Robertson, Jean, and Craig McDaniel. *Themes of Contemporary Art: Visual Art after 1980.* New York: Oxford University Press, 2005.

Siegel, Katy, and Paul Mattik. *Art Works: Money.* New York: Thames & Hudson, 2005.

Skov Holt, Steven, and Mara Holt Skov. *Blobjects & Beyond: The New Fluidity in Design.* San Francisco: Chronicle, 2005.

Exhibition Publications

A Brighter Day. Edited by David Humphrey. New York: James Cohan Gallery, 2006.

Ecstasy: In and About Altered States. Edited by Lisa Mark; texts by Carolyn Christov-Bakargiev, Diedrich Diedrichsen, Chrissie Iles, Lars Bang Larsen, Midori Matsui, and Paul Schimmel. Los Angeles: Museum of Contemporary Art, 2005.

Flower Myth. Vincent van Gogh to Jeff Koons. Texts by Ernst Beyeler Christoph Vitali, Robert Kopp, Philippe Büttner, and Ulf Küster. Riehen/Basel, Switzerland: Fondation Beyeler, 2005.

The Flower as Image. Texts by Poul Erik Tøjner and Ernst Jonas Bencard. Humlebæk, Denmark: Louisiana Museum for Moderne Kunst, 2004.

Open House: Working in Brooklyn. Introduction by Charlotta Kotik and Tumelo Mosaka. Brooklyn: Brooklyn Museum of Art, 2004.

Plop: Recent Projects of the Public Art Fund. Edited and written by Tom Eccles, Anne Wehr, and Jeffrey Kastner. New York: Public Art Fund with Merrell, 2004.

Some Trees. Edited by Paul Andriesse. Amsterdam: Andriesse, 2004.

Wanås Historia. Introduction by Marika Wachtmeister. Knislinge, Sweden: Wanås Foundation, 2004.

Intricacy: A Project by Greg Lynn FORM. Introduction by Claudia Gould; essay by Greg Lynn. Philadelphia: Institute of Contemporary Art, University of Pennsylvania, 2003.

Roxy Paine: Bluff. Edited by Anne Wehr; introduction by Susan K. Freedman and Tom Eccles. New York: Public Art Fund, 2003.

UnNaturally. Edited by Mary-Kay Lombino. New York: Independent Curators International, 2003.

Work Ethic. Edited by Helen Molesworth. University Park, Penn.: Pennsylvania State University Press in collaboration with the Baltimore Museum of Art, 2003.

Roxy Paine: Second Nature. Texts by Lynn Herbert, Joseph Ketner, and Gregory Volk. Houston: Contemporary Arts Museum Houston, 2002.

01.01.01: Art in Technological Times. San Francisco: San Francisco Museum of Modern Art, 2001.

Arte y naturaleza: Montenmedio Arte Contemporaneo. Preface by Magda Bellotti; essay by Marika Wachtmeister. Cadiz, Spain: Fundación NMAC, 2001.

A Contemporary Cabinet of Curiosities: Selections from the Vicki and Kent Logan Collection. San Francisco: California College of Arts and Crafts, 2001.

Konsten på Wanås: [Art at Wanås]. Text by Marika Wachtmeister. Stockholm, Sweden: Byggförlaget Kultur, 2001.

Roxy Paine. Edited by Scott Rothkopf. New York: James Cohan Gallery, 2001.

Waterworks: U.S. Akvarell 2001. Foreword by Berndt Arell; introduction by Kim Levin. Skarhamn, Sweden: Nordiska Akvarellmuseet, 2001.

The Greenhouse Effect. Essays by Julia Peyton-Jones and Lisa Corrin. London: Serpentine Gallery, 2000.

Sites around the City: Art and Environment. Texts by Heather Sealy Lineberry and Ronald Jones. Tempe, Ariz.: Arizona State University Art Museum, 2000.

As Far As the Eye Can See. Atlanta: Atlanta College of Art Gallery, 1999.

In Vitro Landscape. Edited by Christiane Paul. Cologne, Germany: Buchandlung Walther Koenig in collaboration with Architektur-Galerie am Weissenhof, 1999.

22/21. Edited by Robert Morgan. Hempstead, N.Y.: Emily Lowe Gallery, Hofstra University, 1998.

Wanås 1998. Essay by Robert Storr. Knislinge, Sweden: Wanås Foundation, 1998.

Best of the Season: Selected Works from 1996–97 Gallery Exhibition. Ridgefield, Conn.: Aldrich Museum of Contemporary Art, 1997.

Redefinitions: A View from Brooklyn. Texts by Annie Herron and Matt Freedman. Fullerton, Calif.: Main Art Gallery, California State University, Fullerton, 1997.

Art on Paper. Edited by Tom Kocheiser. Greensboro, N.C.: Weatherspoon Art Gallery, University of North Carolina, 1995.

The Nature of the Machine: An Exhibition of Kinetic and Biokinetic Art. Texts by Lanny Silverman, Michael Lash, and Douglas Davis. Chicago: Chicago Cultural Center, Chicago Public Library, 1993.

Out of Town: The Williamsburg Paradigm. Edited by Jonathan David Fineberg. Champaign, Ill.: Krannert Art Museum, University of Illinois at Urbana-Champaign, 1993.

Articles and Reviews

2008

"Roxy Paine on the Roof: *Maelstrom.*" *Huliq News,* Dec. 18, 2008.

Hsieh, Catherine Y. "Faux Naturale." *NY Arts,* Sep. 2008.

Robinson, Gaile. "Whether you see an embrace or conflict on the Modern's lawn depends on your eye." *Star Telegram,* Jul. 21, 2008.

Vogel, Carol. "Ellsworth Kelly, Basking in Basel." *New York Times,* Jun. 6, 2008.

Robinson, Walter. "Baselmania 2008." *Artnet,* Jun. 5, 2008.

"Roxy Paine: getting back to his roots." *Art Newspaper Art Basel Daily Edition,* Jun. 4, 2008.

Brener, Julie. "John Powers in New York." *ArtInfo,* Feb. 28, 2008.

2007

"Madison Square Park: Roxy Paine." *Sculpture,* Oct. 2007.

Baker, R. C. "Rust Never Sleeps." *Village Voice,* Aug. 28, 2008.

New Yorker. Goings On about Town, Aug. 27, 2007.

Halle, Howard. "Centerfold: Growing Season." *Interior Design,* Jun. 2007.

Saltz, Jerry. "Beyond Serra." *New York,* Jun. 18, 2007.

Genocchio, Benjamin. "Mad. Sq. Art 2007: Roxy Paine." *New York Times,* May 18, 2007.

Sheets, Hilarie M. "Trunk Show." *Time Out New York,* May 17, 2007.

Cohen, David. "How Green Is My Sculpture?" *New York Sun,* May 10, 2007.

2006

Vogel, Carol. "Madison Square Art." Inside Art. *New York Times,* Dec. 1, 2006.

Neil, Jonathan T. D. "Do Androids Dream of Making Art?" *Art Review,* Aug. 2006.

Baker, R. C. Best in Show. *Village Voice,* Jun. 29, 2006.

Green, Tyler. "Acquisition Alert: MOCA and Roxy Paine." *Modern Art News,* May 25, 2006.

Volk, Gregory. "Roxy Paine at James Cohan." *Art in America,* May 2006.

Castro, Jan Garden. "Collisions: A Conversation with Roxy Paine." *Sculpture* 25, no. 4 (May 2006).

Yau, John. Interview with Roxy Paine. *SourceCode TV,* season 3, episode 7, Apr. 2006.

Trembley, Nicolas. "Déraciné." *Numéro,* Apr. 2006.

Hall, Emily. "Review: Roxy Paine." *Artforum,* Apr. 2006.

Marchini, Claudia. "Readers Talk: Rage at the Machine." *Oregonian,* Mar. 31, 2006.

Motley, John. "Roxy Paine." *Portland Mercury,* Mar. 22, 2006.

Row, D. K. "Jackson Pollock, Meet 'PMU.'" *Oregonian,* Mar. 5, 2006.

Wolfe-Suarez. "Ecstasy: In and About Altered States." *Art Papers,* Mar./Apr. 2006.

Lowenstein, Kate. "Roxy Paine at James Cohan." *Time Out New York,* Feb. 23, 2006.

Wright, Karen. "Roxy Paine at James Cohan." *Modern Painters,* Feb. 2006.

Sung, Ellen. "Look Who's Coming: Jonathan Fineberg, Ph.D." Interview with Jonathan Fineberg. *News & Observer,* Jan. 31, 2006. http://www.newsobserver.com/105/story/394330.html.

Johnson, Ken. "Roxy Paine." *New York Times,* Jan. 27, 2006.

Cohen, David. "Theaters of the Absurd." *New York Sun,* Jan. 19, 2006.

Peters, Sue. "Sculpting Controversy." *Seattle Weekly,* Jan. 18, 2006.

Ribas, João. The AI Interview. Interview with Roxy Paine. *Artinfo.com,* Jan. 13, 2006. http://www.artinfo.com/news/story/9448/roxy-paine/.

McCarthy, John. "Roxy Paine in Ponderland." *Art and Living,* Jan. 2006.

Davis, Erik. "Ecstasy In and About Altered States." *Artforum,* Jan. 2006.

MoCA at the Moment. "Roxy Paine." Winter/Spring 2006.

2005

Kimmelman, Michael. "A Mind-Bending Head Trip (All Legal)." *New York Times,* Nov. 4, 2005.

Casadio, Mariuccia. "Grow a Mushroom." *Vogue Italia,* Aug. 2005.

———. "Aspen Art Museum Presents Roxy Paine." *Artdaily.com,* Jul. 28, 2005. http://artdaily.com/indexv5.asp?int_sec=2&int_new=14390.

Baker, R. C. "Decaying Pixels." *Village Voice,* Jun. 1, 2005.

Johnson, Ken. The Listings: Sculpture. *New York Times,* May 20, 2005, Arts section.

———. "Outdoor Sculpture Gains Media Acclaim." *Saint Louis Art Museum Magazine,* Apr. 2005.

2004

Weinberg, Michelle. "Get Unreal." *Miami New Times,* Oct. 21, 2004.

Bonetti, David. "The 'Placebo' Effect." *St. Louis Post-Dispatch,* Sep. 5, 2004.

Robinson, Walter. Weekend Update. *Artnet.com,* Sep. 17, 2004. http://www.artnet.com/magazine/reviews/walrobinson/robinson9-17-04.asp.

MacMillan, Kyle. "Art Unchained Graces Aspen." *Denver Post,* Aug. 27, 2004.

Wolgamott, L. Kent. "Artist Goes Once More unto the 'Breach.'" *Lincoln Journal Star,* Jun. 13, 2004.

Giles, Gretchen. "Natural Fool." *North Bay Bohemian,* Apr. 28, 2004.

Hassebroek, Ashley. "Sculpture Takes Root at Sheldon." *Omaha World Herald,* Apr. 23, 2004.

Wenz, John. "Tree Sculpture Brings Typical Art Environment Outdoors." *Daily Nebraskan,* Apr. 22, 2004.

Wolgamott, L. Kent. "New Sculpture Branches Out." *Lincoln Journal-Star,* Apr. 21, 2004.

Moseman, Andrew. "Metallic Tree Look-alike Takes Root on Campus." *Daily Nebraskan,* Apr. 16, 2004.

Hassebroek, Ashley. "Sheldon Adds a 21st-Century Sculpture." *Omaha World-Herald,* Apr. 4, 2004.

Pagel, David. "Reality and Irony Collide." Review. *Los Angeles Times,* Jan. 2, 2004.

2003

Lafuente, Pablo. "8th International Istanbul Biennial." *Art Monthly,* Nov. 2003.

Van Malsen, Annemarie. "Koud Kunstje." *Barbants Dagblad,* Oct. 28, 2003.

Gopnik, Blake. "Redefining Art? They Managed." *Washington Post,* Oct. 19, 2003.

O'Sullivan, Michael. "BMA Tests Audience's 'Work Ethic.'" *Washington Post,* Oct. 17, 2003.

McNatt, Glenn, and Mary Carole McCauley. "Pass the Art, Please." *Sun,* Oct. 13, 2003.

Flash Art. "Work Ethic: Baltimore." Review. Vol. 36, no. 232 (Oct. 2003): 44.

Schoonen, Rob. "'Ik hou van tegenstellingen." *Brabants Dagblad,* Sep. 18, 2003.

Volkskrant. "Botanische vormen." Review. Sep. 18, 2003.

Smith, Roberta. "Washington's Museums Traverse Miles and Eras." Art Review. *New York Times,* Aug. 22, 2003.

Wilson, Peter. "Intersections: Art and New York Green." *Paper Sky* 6, no. 6 (Summer 2003): 53.

Bennett, Lennie. "Fooling around with Mother Nature." *St. Petersburg Times*, Jan. 26, 2003.

Hu, Li. "Timecode." 32 *Beijing/New York*, no. 2 (2003): 6–9.

2002

Klaasmeyer, Kelly. "Nature vs. Nurture: Roxy Paine Turns Fake Flowers and Painting Machines into High Art." *HoustonPress.com*, Dec. 5, 2002. http://www.houstonpress.com/2002-12-05/culture/nature-vs-nurture/.

Dwell. "Exhibits: 'Roxy Paine/Second Nature' at the Contemporary Arts Museum in Houston, TX." Dec. 2002.

Madoff, Steven Henry. "Nature vs. Machines? There's No Need to Choose." *New York Times*, Jun. 9, 2002.

Week. "Roxy Paine at Bernard Toale Gallery, Boston." May 10, 2002.

McQuaid, Cate. "A Striking Show at the Rose Museum Explores Art in the Machine." *Boston Globe*, May 7, 2002.

Henry, Clare. "The Art of Listening Carefully." *Financial Times* (London), Mar. 27, 2002.

New York. "Happening; Museum Parking." Mar. 18, 2002.

Giuliano, Charles. "Narcotics and Robotics: The Post Mechanical Duality of Roxy Paine." *East Boston Online*, Apr. 28, 2002. http://www.eastboston.com/Columnists/CharlesG/042802MavArts.htm.

Schoeneman, Deborah. "Gallery on Grass, Take a Sculpture Hike through Central Park." *New York Post*, Mar. 7, 2002.

Robinson, Walter. Weekend Update. *Artnet.com*, Mar. 7, 2002. http://www.artnet.com/Magazine/reviews/robinson/robinson3-7-02.asp

Gardner, James. "Witless Whitney." *New York Post*, Mar. 7, 2002.

Bischoff, Dan. "Moving Images" *Star Ledger*, Mar. 7, 2002.

Budick, Ariella. "Pieces of the Biennial Take to the Park." *Newsday* (New York), Mar. 6, 2002.

Plagens, Peter. "This Man Will Decide What Art Is." *Newsweek*, Mar. 4, 2002.

McGee, Celia. "A Breath of Fresh Air." *Daily News*, Mar. 3, 2002.

Schmidt, Jason. "Outsider Art." *V Magazine*, Mar./Apr. 2002.

Vogel, Carol. "Sometimes, Man Can Make a Tree." *New York Times,* Feb. 27, 2002.

Griffin, Tim. "Bi Curious." *Time Out New York*, Feb. 21, 2002.

2001

Vogel, Carol. "A Homegrown Biennial." *New York Times*, Nov. 16, 2001.

Hammond, Anna. "Roxy Paine at James Cohan." *Art in America*, Sep. 2001.

Iannaccone, Carmine. "Roxy Paine at Christopher Grimes Gallery." *Frieze*, Sep. 2001.

Thorson, Alice. "Art Machines That Make Big Decisions." *Kansas City Star*, Jul. 29, 2001.

Molina, Margot. "El sueño de un bosque de verano." *El País*, Jun. 23, 2001.

Knight, Christopher. "Roxy Paine." *Los Angeles Times*, Jun. 15, 2001.

El País. "Naturaleza en el nuevo Museo de Montenmideo." Jun. 6, 2001.

Sichel, Berta. "El arte interviene en el paisaje." *El Periódico del Arte*, Jun. 20, 2001.

Gonzalez, Maria. "Arte en Liberato." *Ideal*, Jun. 3, 2001.

Bonetti, David. "High on Tech." *San Francisco Chronicle Datebook*, Jun. 3, 2001.

Werthem, Margaret. "Worlds Apart." *LA Weekly*, May 18, 2001.

Goldberg, David. "'01.01.01: Art in Technological Times' at SFMOMA." *Artweek*, May 2001.

Rogina, Kresimir. "Izlozaba '01.01.01.'" *Croatian Daily*, May 2001.

Yablonsky, Linda. "Roxy Paine: New Work." *Time Out New York*, Apr. 26, 2001.

Levin, Kim. Voice Choices. *Village Voice*, Apr. 24, 2001.

New Yorker. "Roxy Paine." Review. Apr. 23, 2001.

Hand, Eric. "SF MOMA's '01.01.01': Digital Art for Analog People." *Stanford Daily*, Apr. 12, 2001.

Sheets, Hilarie. "Spring Art Walk." *New York Observer*, Apr. 2, 2001.

Rugoff, Ralph. "Virtual Corridors of Power." *Financial Times* (London), Mar. 31, 2001.

Gonzalez-Barba, Andres. "Nueve artistas exponen sus obras en plena redacción, 'La Primera E Sculptura En Montenmideo.'" *Diario de Cadiz*, Mar. 23, 2001.

Muchnic, Suzanne. "Museum Chief." *Los Angeles Times*, Mar. 18, 2001.

Landi, Ann. "The Big Dipper." *ARTnews*, Jan. 2001.

2000

Johnson, Ken. "Extra Ordinary." *New York Times*, Jun. 9, 2000.

Tumlir, Jan. "The Visionary Landscape." *Frieze*, May 2000.

Staple, Polly. "The Greenhouse Effect." *Art Monthly*, May 2000.

Searle, Adrian. "Stuck in the Woods." *Guardian*, Apr. 4, 2000.

Heiss, Alanna. "Greater New York." *NY Arts*, Mar. 2000.

Nordlinger, Pia. "Double Dipping." *ARTnews*, Mar. 2000.

Saltz, Jerry. "Greater Expectations." *Village Voice*, Mar. 14, 2000.

O'Connel, Kim. "Fungus among Us." *Landscape Architecture*, Mar. 2000.

Cambell, Clayton. "The Visionary Landscape." *Flash Art*, Mar./Apr. 2000.

1999

Nahas, Dominique. "Roxy Paine." *Flash Art* 32 (May/Jun. 1999): 114–115.

Weil, Rex. "Roxy Paine." *ARTnews*, Apr. 1999.

Lin, Tan. "Fungi of False Reproduction." *ArtByte* 2, no. 1 (Apr./May 1999): 64.

Klein, Mason. "Roxy Paine." *Artforum*, Apr. 1999.

Kjellgren, Thomas. "Tillbaka till naturen: Roxy Paines omsorgsfulla lekfullhet smittar." *Hallandsposten* (Sweden), Mar. 26, 1999.

Kjellgren, Thomas. "Under ytans ordning finns det okontrollerbara." *Kristianstedsbladet* (Sweden), Mar. 25, 1999.

Jonsson, Dan. "Tur och retur till naturen." *Express* (Sweden), Mar. 25, 1999.

Klinthage Lorgen. "Vart behov att beharska naturen." *Arbetet Nyheterna* (Sweden), Mar. 22, 1999.

Ellerstrom, Jonas. "Drogromantik eller kulturkritik?" *Helsingborgs Dagblad* (Sweden), Mar. 22, 1999.

Malmqvist, Conny C-A. "Roxy Paine gorett konststycke...." *Kv Kvallsposten* (Sweden), Mar. 16, 1999.

Strom, Eva. "Nice Flowers with Chilly Undertone." *Svenska Dagbladet* (Sweden), Mar. 13, 1999.

Kyander, Pontus. "Art Gallery Filled with Unnature." *Sydsvenskan* (Sweden), Mar. 9, 1999.

Nordstrom, Nicklas. "2000 svampar ger eftertanke." *Lund Langlordag* (Sweden), Mar. 6, 1999.

Hall, Kim. "Brooklyn-komstnar pa Lunds konsthall." *Skanska Dagbladet* (Sweden), Mar. 6, 1999.

Billgren, Cecilia. "Utvecklingsstord lamnades ensam." *Arbetet Nyheterna* (Sweden), Mar. 6, 1999.

Burrows, David. "Dunkin' Donuts." *Art Monthly*, Mar. 1999.

Bakke, Erik, and Shelley Ward. "Mob Rule: Sculpture after Hanson." *NY Arts*, Mar. 1999.

Kino, Carol. "Roxy Paine." *Time Out New York*, Feb. 4, 1999.

New Yorker. "Roxy Paine." Feb. 1, 1999.

Maxell, Douglas. "Roxy Paine." *Review*, Feb. 1, 1999.

Multer, Mario. "Roxy Paine." *Review*, Feb. 1, 1999.

Pinchbeck, Danie. "Our Choice of Contemporary Galleries in New York." *Art Newspaper*, Feb. 1999.

Pedersen, Victoria. Gallery Go 'Round. *Paper Magazine*, Feb. 1999.

Simon Says. "Roxy Paine." Vol. 3, no. 6 (1999): 2.

Levin, Kim. "Roxy Paine." *Village Voice*, Jan. 26, 1999.

Johnson, Ken. "Roxy Paine." *New York Times*, Jan. 15, 1999.

Henry, Max. Gotham Dispatch. *Artnet.com*, Jan. 15, 1999. http://www.artnet.com/magazine_pre2000/reviews/henry/henry1-15-99.asp.

Levin, Kim. "Roxy Paine." *Village Voice*, Jan. 12, 1999.

Schwabsky, Barry. "Surrounded by Sculpture." *Art in America*, Jan. 1999.

Lautman, Victoria. "No Weeding Necessary." *Interview*, Jan. 1999.

Bakke, Eric. Studio Visit. *NY Arts*, Jan. 1999.

1998

Costa, Eduardo. "Crafty Contemporanea." *Artnet.com*, 1998. http://www.artnet.com/magazine/reviews/costa

Zimmer, William. "Seven Artists Apply Craft to Fine Art." *New York Times*, Oct. 11, 1998.

Cooney, Beth. "The Craft of Art." *Advocate & Greenwich Time*, Oct. 11, 1998.

Frey, Jennifer. "Lacing Art and Craft into One Form." *Weekend*, Sep. 10, 1998.

Gignoux, Sabina. "Les jeux ambigus d'une naturelle inspiration." *La Croix* (France), Aug. 1998.

Lind, Ingela. "Naturen som hot." *Dagens Nyheter* (Sweden), Jul. 30, 1998.

La Depeche d'Evreux (France). "Les champs de Roxy Paine." Jul. 2, 1998.

Le Democrata (France). "Champs artificiels et machine a peindre au musée d'art américain de Giverny." Jul. 1, 1998.

Schon, Margaretha. "Med freestyle och insiders I Wanås Walk." *Svenska Dagbladet* (Sweden), Jun. 13, 1998.

Ahistrom, Crispin. "Intelligenta naturlekar." *Goteborgs-Posten* (Sweden), Jun. 5, 1998.

Inprocess. "In the Public Realm." Vol. 6, no. 3 (Spring 1998): 5.

Kyander, Pontus. "Elegant och intelligent." *Sydsvenskan* (Sweden), May 27, 1998.

J. K. "An Opium Field: Deceptively Natural." *Kolner City-Observer* (Germany), May 14, 1998.

Fredericksen, Eric. "Landscapes and Suburbs: Beyond Nature." *Stranger*, Feb. 5, 1998.

Glueck, Grace. "A Chair, a Fireplace, Binoculars: Sculpture to Be Seen on the Street." *New York Times*, Jan. 16, 1998.

Updike, Robin. "Beyond Pretty Scenery." *Seattle Times*, Jan. 15, 1998.

Bonetti, David. "What It Is 'To BE Real.'" *San Francisco Examiner*, Jan. 12, 1998.

Hackett, Regina. "Warmth and Romance Prove Elusive in Meyerson & Nowinski's 'Landscape.'" *Seattle Post-Intelligencer*, Jan. 9, 1998.

On Paper. "Paper Trail." Vol. 2, no. 3 (Jan./Feb. 1998): 7.

1997

Baker, Kenneth. "When Reality is Just Another Medium." *San Francisco Chronicle Datebook*, Dec. 23, 1997.

Pollack, Barbara. "Buying Smart: Top Collectors Share Their Secrets." *ARTnews*, Dec. 1997.

Nassau, Lawrence. "Current Undercurrent: Working in Brooklyn." *NY Arts*, Oct. 1997.

Chaiklin, Amy. Studio Visits. *NY Arts*, Oct. 1997.

Ridgefield Press. "Aldrich Gives Award to 'Emerging' Artist." Oct. 23, 1997.

NY Press. "Best Do-It-Yourself Art Kits: Roxy Paine." Best of Manhattan. Sep. 24, 1997.

Arning, Bill. "Brooklyn in the House." *Village Voice*, Aug. 26, 1997.

Schmerler, Sarah. "Last Exit to Brooklyn." *Time Out New York*, Jul. 31, 1997.

Dalton, Jennifer. "Just What Do You Think You're Doing Dave?" *Review* 2, no. 19 (Jul./Aug. 1997): 20.

Gibson, David. "Roxy Paine: Dunk/Redunk; Ronald Feldman Fine Arts." *Zingmagazine*, no. 4 (Summer 1997): 249–50.

Levin, Kim. Voice Choices. *Village Voice*, Apr. 8, 1997.

Smith, Roberta. "Roxy Paine." *New York Times*, Apr. 4, 1997.

Pedersen, Victoria. Gallery Go 'Round. *Paper Magazine*, Apr. 1997.

Dellolio, Peter. "Roxy Paine." *New York Soho*, Apr. 1997.

1996

Smith, Roberta. "Inside/Out." *New York Times*, Sep. 20, 1996.

Levin, Kim. Voice Choices. *Village Voice*, Mar. 12, 1996.

1995

The Print Collector's Newsletter. Check It Out. Vol. 26, no. 5 (Nov./Dec. 1995): 177.

Humphrey, Jacqueline. "Art on Paper Acquisitions Reflect a New Weatherspoon." *Greensboro News & Record*, Nov. 17, 1995.

Heartney, Eleanor. "Roxy Paine at Ronald Feldman." *Art in America*, Nov. 1995.

Light, Flash. "The Neo-Kinetic Closet." *Movements* 4, no. 1 (Fall 1995): 1–11.

Paine, Roxy. "Sacraments for a High Priest." *Harper's*, Jul. 1995.

New York Press. Listings: Galleries. May 24, 1995.

Levin, Kim. Voice Choices. *Village Voice*, May 16, 1995.

Hess, Elizabeth. "Cross Hatching." *Village Voice*, May 16, 1995.

Clarke, Donna. "Chowing with Mao." *New York Post*, May 1, 1995.

Drucker, Johanna. "The Next Body: Displacements, Extensions, Relations." *Les Cahiers du Musée national d'art moderne*, Spring 1995.

1994

Art in America. "1993 in Review: Alternative Spaces." Aug. 1994.

Levin, Kim. Voice Choices. *Village Voice*, Apr. 5, 1994.

Wallach, Amei. "An Exuberant Celebration of Life." *Newsday* (New York), Apr. 1, 1994.

Larson, Kay. "The Garden of Sculptural Delights." *New York*, Mar. 28, 1994.

Hicks, Robert. "Group Seeks to Wed Sculpture and Theater." *Villager*, Mar. 23, 1994.

1993

Smith, Roberta. "Examining Culture through Its Castoffs." *New York Times*, Nov. 28, 1993.

Robinson, Julia. "Flesh Art." *World Art*, Nov. 1993.

Bulka, Michael. "The Nature of the Machine." *New Art Examiner*, Sep. 1993.

Zimmer, William. "How Physics Is Raised to Metaphysics in a Real Art Ways Show in Hartford." *New York Times*, Jul. 4, 1993.

1992

Hess, Elizabeth. "Give Me Fever." *Village Voice*, Dec. 29, 1993.

Kimmelman, Michael. "Promising Start at a New Location." *New York Times*, Dec. 18, 1992.

Egert, Robert. "Roxy Paine at Test-Site." *Breukelen* 1 (Jan. 1992).

1991

Sellers, Terry. Review. *Artist Proof*, Fall 1991, 4–6.

1990

Blake, Kit. Review. *Word of Mouth*, Sep. 1990.

Photograph Credits

John Berens: 52, 53, 62–63, 76 top, 80, 81, 96, 97, 103, 104 top right, 104 bottom right, 134–35

Christopher Burke Studio: 78, 79 top left, 79 top right, 79 bottom left, 79 bottom right, 90 top left, 90 bottom left, 90 bottom right, 91 top right, 91 bottom left, 91 bottom right, 92, 100, 101, 102, 104 middle right, 105 top right, 105 middle right, 105 bottom right, 106–7, 110, 111, 113, 114–15, 116–17, 124, 127, 148–49, 150 left, 150 right, 151, 162–63, 166–67, 168–69, 170–71, 180 top, 180 bottom, 182–83, 184–85, 213, 214–15, 225–25, 225 right, 226 left, 226 right, 227, 228 top, 228 bottom, 229, 230, 231, U2–U3

John Cliett/© Dia Art Foundation: 210

Mitch Cope: 88 bottom, 89

Dennis Cowley: 30–31, 68 top, 68 bottom, 204

John R. Glembin: 217, 219

Gilsanz, Murray, Steficek: 174 top, 174 bottom

Sheila Griffin: 193

Erik Karlsson: 48–49, 51

Cal Kowal: 95

John Lamka: 16, 24, 25, 26, 27, 28, 29, 32, 33, 34–35, 36–37, 40, 41, 42–43, 44–45, 47, 54–55, 59, 60, 61, 64, 65, 66–67, 76 bottom, 77, 82–83, 84 bottom, 108–9, 132–33, 136–37

John Lamka and Matthew Suib: 126, 172–73, 175

J. Littkemann: 153, 155

Graphicstudio, University of South Florida, Tampa/Will Lytch: 220, 221, 222 top, 222 bottom, 223 top, 223 bottom

Jason Mandella: cover, 8–9, 119, 120–21, 190, 191, 194–95, 232–33, 235, 236, 237, 238–39, 240–41

Modern Art Museum of Fort Worth/David Wharton: 129

Museum of Modern Art, New York/Tom Griesel: 244

Fredrik Nilsen Studio: 93, 197, 198, 199

Wanås Foundation/Anders Norsell: 138, 139, 141, 140 left, 140 right

Bill Orcutt: 98 bottom, 99

Roxy Paine: 73, 84 top, 85, 86 top left, 86 top right, 86 bottom left, 86 bottom right, 87 top left, 87 top right, 87 bottom left, 87 bottom right, 88 top, 211, 242, 243

Sofia M. Paine: 212 top, 212 bottom left, 212 bottom right, U6 (back inside cover)

Gerrit Scheurs Photography: image extractions, 2–9

Seattle Art Museum/Paul Macapia: 177

Hirshhorn Museum and Sculpture Garden/Lee Stalsworth: 56–57

Tom Van Eynde: 94

Joshua White: 146–47, 156–57, 159, 160–61

Ellen Page Wilson: 245, 246

Zindman/Fremont: 122, 123

Specimen Case No. 11 Key

FCG	False Creamy Gnarled
DC	Depressed Center
RGMA	Rough Gnarled Multiple Appendage
CIC	Crested Indented Curve
LEA	Low Elongated Appendage
CF	Convoluted Fold
EBMA	Explosive Bulbous Multiple Appendage
SC	Slender Convoluted
CLR	Common Low Round
CLRP	Common Low Round Peaked
CB	Creamy Bulbous
ELEA	Explosive Low Elongated Appendage
CLD	Common Low Double
PCP	Partially Collapsed Peak
PC	Peaked Creamy
FPC	False Peaked Creamy
CCB	Clustered Creamy Bulbous
LSCBMA	Large Smooth Creamy Bulbous Multiple Appendage
LLR	Lipped Low Round
FS	Fragile Slender
LRSA	Low Round Single Appendage
CCC	Creamy Clustered Convoluted

Specimen Case No. 12 Key

EBMA	Explosive Bulbous Multiple Appendage
CSA	Creamy Single Appendage
CPSA	Creamy Peaked Single Appendage
BMA	Bulbous Multiple Appendage
LCA	Low Creamy Angular
PA	Peaked Arc
FCG	False Creamy Round
DCR	Double Creamy Round
TCR	Triple Creamy Round
SP	Small Peaked
SCSA	Small Creamy Single Appendage
SEC	Small Elongated Creamy
MDA	Micro Double Appendage
MP	Micro Peaked
MCR	Micro Creamy Round
CS	Creamy Sinewy
DCSA	Double Creamy Single Appendage
CBMA	Creamy Bulbous Multiple Appendage
DCB	Double Creamy Bulbous
CS	Creamy Bulbous
SGC	Small Gnarled Creamy
SCR	Small Creamy Round
CCP	Creamy Collapsed Peak
LCSA	Low Creamy Single Appendage
LCMA	Low Creamy Multiple Appendage
CA	Creamy Arc
CP	Creamy Peak
FCB	False Creamy Bulbous
RCS	Robust Creamy Stroke
ELMA	Explosive Low Multiple Appendage
LS	Long Sinewy
LMP	Low Multiple Peak
SCDA	Small Creamy Double Appendage
SLS	Small Long Sinewy
LSR	Long Sinewy Return
FP	False Peak
MCCP	Multiple Creamy Collapsed Peak
SLSDR	Small Long Sinewy Double Return
LC	Low Creamy
SE	Sinewy Explosive
CEA	Creamy Energetic Arc
CRS	Creamy Return Stroke
CSS	Creamy Smooth Stroke
LDRS	Long Double Return Stroke

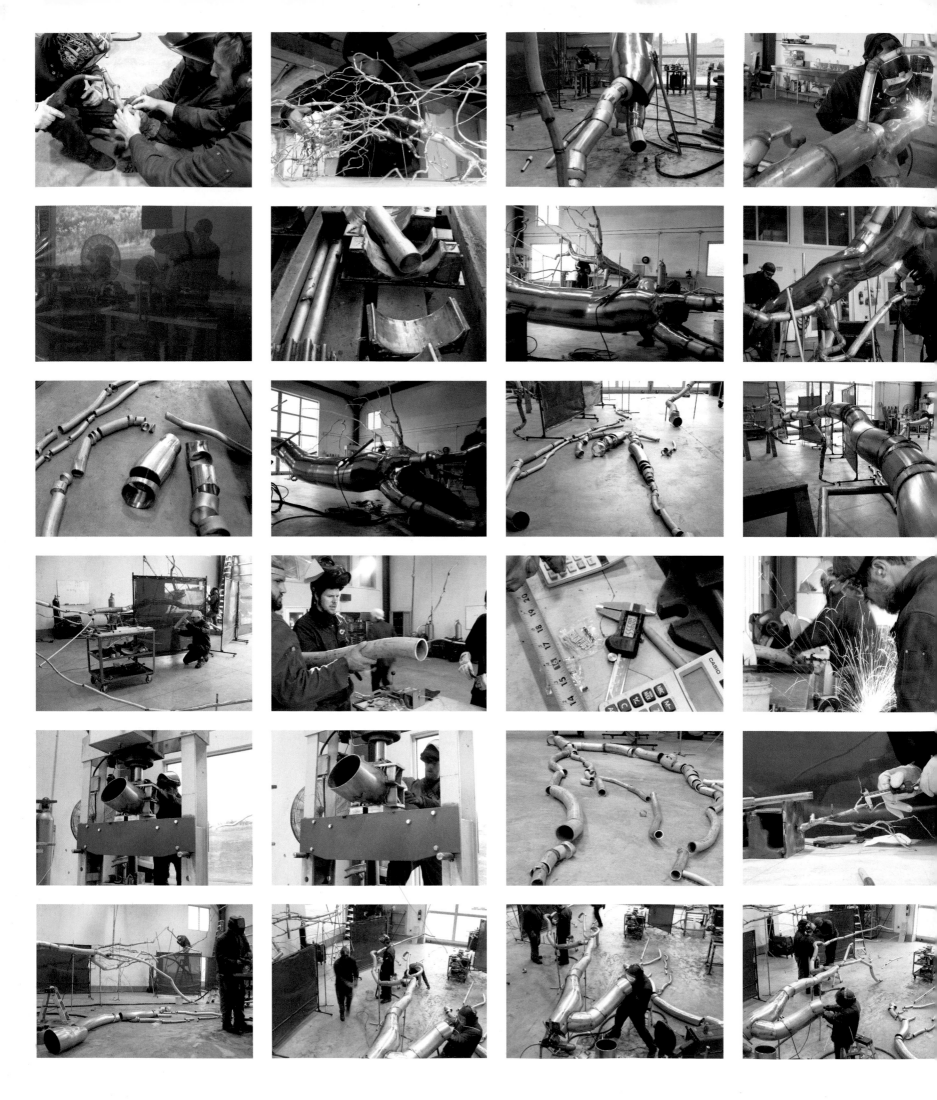